A Garland Series

OUTSTANDING DISSERTATIONS IN THE

FINE ARTS

Antonio and Francesco Guardi: Their Life and Milieu

With a Catalogue of their Figure Drawings

Alice Binion

Garland Publishing, Inc., New York & London

1976

Library of Congress Cataloging in Publication Data

Binion, Alice.
 Antonio and Francesco Guardi, their life and
milieu.

 (Outstanding dissertations in the fine arts)
 Originally presented as the author's thesis,
Columbia University, 1971.
 Bibliography: p.
 1. Guardi, Francesco, 1712-1793. 2. Guardi,
Giovanni Antonio, 1698-1760. 3. Figure drawing--
Catalogs. I. Title. II. Series.
NC257.G8B56 1976 741'.092'2 75-23782
ISBN 0-8240-1979-2

Printed in the United States of America

A N T O N I O A N D F R A N C E S C O G U A R D I :

THEIR LIFE AND MILIEU,

WITH A CATALOGUE OF THEIR FIGURE DRAWINGS

Alice Binion

1971

Submitted in partial fulfillment of the requirements
for the degree of Doctor of Philosophy, in the Faculty
of Philosophy, Columbia University.

PREFACE

This dissertation grew out of a seminar on Venetian painting conducted by Professor Rudolf Wittkower during the winter semester 1964-1965. In the summer of 1965 I visited Venice, where a Guardi exhibition was being held, and decided to make Giovanni Antonio Guardi the subject of a dissertation. I then spent the year 1965-1966 doing research in Europe. I soon realized that Antonio's oeuvre was so entangled with that of his younger brother Francesco that the two had to be studied conjointly. I also realized that it was risky to try disentangling them, a task which for some four decades had obsessed and frustrated many critics and historians of art. Yet as only some of the many difficult problems involved had been solved I undertook to try my own hand at the others.

I took the following approach. As the lives of the Guardi are only scantily documented, I first set about checking all the known records (some had not been published in full) and searching for new ones in the likeliest places--Venice, Trent, Vienna, Hannover. In the end I could only add bits of information here and there. But with the complete documentation in hand I could purge the commonly accepted Guardi biographies of the myths which, periodically reiterated, had come to be accepted as hard facts. I made a history of their lives the second chapter of my dissertation.

Innumerable inferences about the Guardi had been drawn from what was known of living and working conditions in eighteenth-century Venice. Again, most of these inferences had gone unquestioned for so long that they had been sanctioned as facts. Thus I decided to investigate more closely the painters' trade in Venice at the time of the Guardi. The results were rewarding. Drawing on contemporary sources I soon came to view the conditions under which Venetian painters lived and labored in a somewhat new perspective. Most important, I could establish that the lives of the painters were not so strictly conditioned and regulated by corporative laws as had hitherto been believed. Thus my first chapter deals with the times in which the Guardi lived.

The first two chapters are logical components of a study intended to encompass the entire lives and oeuvres of the Guardi brothers. I realized belatedly, however, that this subject was too vast for a dissertation. I consulted my sponsor, Professor Rudolf Wittkower, and with his consent decided to limit myself to the figure drawings of the two brothers. The unavoidable consequence is that the dissertation lacks the unity it would have had had it comprised the whole vast Guardiesque oeuvre. The material in the first chapter provides a necessary and valuable background for the study of the pictorial oeuvre of the Guardis although it is less clearly relevant to the study of their drawings alone. To give precedence to the study of the drawings makes sense, however, as they are less likely to be works of collaboration and as they have previously been studied far less intensively than

the paintings.

Of the two Guardi, Francesco is the better known as draughts-
man. But his sketches of views, capricci, and landscapes have received
far more scholarly attention than his figure drawings. His many draw-
ings at the Correr Library in Venice have become especially popular--
and hence have been better studied--thanks to the excellent facsimiles
in Rodolfo Pallucchini's useful edition I disegni del Guardi al Museo
Correr di Venezia (Florence, 1943). The most instructive writings to
date on Francesco's graphic oeuvre are J. Byam Shaw's few but compact
articles and his admirable introduction to The Drawings of Francesco
Guardi (London, 1951). Byam Shaw is the first scholar to have at-
tempted to date some of Francesco's drawings on other than intuitive
grounds, and he established some reliable signposts for a chronology.
The elder Guardi, Antonio, found a devoted researcher in Antonio
Morassi, who has published many of the master's works over the
decades, yet without always submitting them to rigorous scrutiny.
In recent publications Terisio Pignatti has reviewed and re-evaluated
previous contributions to Guardi scholarship. His writings on Guardi
drawings have been the subject of a long critical discussion by
Fernanda de Maffei, published in Arte in Europa (Milan, 1966). Most
of Maffei's objections are valid, and some of her own contributions
are valuable, although her polemical tone has prevented her from being
taken seriously.

My greatest difficulty in cataloguing the Guardi drawings was to order them chronologically. This task was particularly difficult in Antonio's case: his stylistic development remains somewhat elusive, and several of the dates proposed are tentative. I believe that I was relatively successful in establishing a sound chronological sequence of Francesco's drawings, however, and I like to think that I did not err significantly, except perhaps with regards to two or three difficult items.

I wish to thank Professor Rudolf Wittkower for having introduced me to the study of Venetian painting and for having guided my research with deep understanding and great patience. I am also indebted to Professors Howard Hibbard and David Rosand for their close scrutiny of the dissertation and their valuable suggestions for its last-minute improvement. I am most grateful to my husband, Rudolph Binion, for his judicious advice on the organization of the material and the attribution of certain drawings, and for his sustained endeavors to render my English readable.

New York, April 1971

I did not revise my dissertation for the present publication, as few new scholarly contributions have been made to Guardi studies since 1971. Moreover, I intend someday to rework the material presented here, integrating it into a comprehensive monograph on the Guardi.

Boston, April 1975

TABLE OF CONTENTS

LIST OF ILLUSTRATIONS

Figure Page

Figure Page

Figure Page

Figure Page

Figure Page

Figure Page

Figure Page

CHAPTER I

THE PAINTER'S TRADE IN VENICE AT THE TIME OF THE GUARDI

Venice, capital of a small oligarchic republic, never exceeded some 130,000 inhabitants during the eighteenth century, not counting the visitors, whose number is said to have averaged 30,000 a year.[1] By the middle of the century, one Venetian out of eight was a beggar and one out of ten a domestic servant.[2] During his stay in Venice in 1765, the traveler Lalande counted seventy-two parishes and some sixty convents,[3] next to innumerable gambling salons and coffee-houses, all lavishly adorned with paintings.

The Serenissima was governed by the aristocracy, which represented 2.5 per cent of the total population. The middle class and the popolani were forbidden even to discuss affairs of the State--and they never did. No allusions to politics are to be found in Venetian newspapers of the time, in Goldoni's plays, in Gozzi's essays, or in Pietro Longhi's depictions of Venetian life.

[1]Charles de Brosses, Lettres familières écrites d'Italie en 1739 et 1740, 2nd ed. (Paris, 1858), I, 171.

[2]Amintore Fanfani, "Il mancato rinnovamento economico," in La civiltà veneziana del Settecento (Florence, 1960), pp. 39, 49.

[3]Joseph Jerôme le Français de Lalande, Voyage d'un Français en Italie fait dans les années 1765 et 1766 (Yverdon, 1769), VII 330.

Sagacious Cardinal de Bernis, who knew Italy well, considered Venice
the safest possible place to live and ascribed its extraordinary
public order to the townsmen's conviction that the government was
informed of everything.[1] Most likely the dread of the Inquisition--
weak as it was by then--and the fear of censorship explain the extraor-
dinary dearth of written records left by Venetians about themselves.
Visitors and foreigners did not feel the same inhibitions, however.
Accordingly, in seeking information about any aspect of Venetion
cultural life, one must turn to the records left by outsiders. Yet
it was difficult for outsiders to gain insight into the Venetian
world. The Venetians were polite but reserved, and their government
discouraged social intercourse with visitors; Venetian patricians
even incurred the death penalty if they spoke to foreign diplomats.

During the eighteenth century, Venice was the most important
art market in Europe, though French competition grew as the century
advanced. An astounding number of paintings today in German and
Central European museums and collections were acquired in Venice
during the eighteenth century.[2] In fact, Venice was crammed with
pictures old and new, Venetian and non-Venetian. Well-informed

[1]François-Joachim de Pierres de Bernis, *Memoirs et lettres
1715-1758*, éd. Frédéric Masson (Paris, 1878, I, 181.

[2]No study of the importation of pictures into the Germanies
has so far been undertaken. Relevant indications are to be found
in various eighteenth-century German inventories and in Niels von
Holst, "La pittura veneziana tra il Reno e la Neva," *Arte Veneta*,
V (1951), *passim*.

Charles de Brosses reported in one of his letters that there were
more paintings in Venice than in all the rest of Italy.[1] A perusal
of the surviving inventories of art collections owned by patrician
families--some of these collections had been started two centuries
before--reveals their extraordinary richness and, at the same time,
how very similar they were in composition.[2] They included, predom-
inantly, works by Venetian masters from the sixteenth and seventeenth
centuries as well as a fair number of Bolognese works often labeled
merely maniera del Carracci. Of the Bolognese masters, Guido Reni and
Guercino are those most frequently recorded; they could not possibly
be the authors of all the paintings ascribed to them. The names of
French masters are exceedingly rare, with the exception of Claude Lorrain,
whereas the number of Flemish works listed is of consequence.[3] By
the eighteenth century, the taste for Flemish and, to a lesser extent,
Dutch art had already been part of the Venetian tradition for some time.
The impact of Dutch and Flemish art on the Venetian School is not easy to
gauge, yet scattered references at least show how very much painters and
patrons were aware of it and valued it. In appraisals of paintings, those

[1] De Brosses, I, 173.

[2] The best sources--so far unexplored--for Venetian art collections
are the unpublished inventories included in the Giudici di Petizion
at the Archivio di Stato, Venice; also Cesare Levi, Le collezioni
veneziane d'arte e d'antichità (Venice, 1900)

[3] It is not possible to give precise figures, as the Venetian
inventories are laconic and vague. In the famous Savorgnan collec-
tion (inventory published in Levi, pp. 81-117), roughly one-tenth
of all works are Bolognese and one-fifth Flemish.

masters from the Netherlands usually rated high. Thus Piazzetta certified in a _fede_ of a landscape by Matteo Brill: "Ho veduto il stupor del Arte cioe Paese di Mattio Brill il piu famoso Pitore che sia mai stato al mondo in quel genere."[1] Tassi in his _Vite_ referred occasionally to a Flemish (or Dutch) way of painting adopted by Zuccarelli and Nazzari: he described a portrait by the former as "colorito su gusto fiammengo" and a head by the latter as "dipinta con tanta forza sull'elegante e singolar maniera del Reinbrant."[2] And so was Nogari reported as having "adottato lo sistema della scuola Fiammenga."[3] Anton Maria Zanetti owned three albums of Rembrandt's rarest etchings,[4] and the only engraving made by Piazzetta himself is the self-portrait of 1738 which he "intaglio . . . sullo stile di Rembrandt."[5] The personal art collection of the Rococo master _par excellence_, Pellegrini, consisted in large part of Flemish and Dutch paintings, including Vermeer's _Lady at the Virginals._[6]

[1] Hannover, Staatsarchiv, Dep. 82, Abt. III, No. 37, folder inscribed _Fedi del Piazzetta ed altri Pittori_.

[2] Francesco Maria Tassi, _Vite de'pittori e architetti bergamaschi_ [ca. 1750] (Bergamo, 1793), II, 87, 93.

[3] Giannantonio Moschini, _Della letteratura veneziana del secolo XVIII fino a' nostri giorni_ (Venice, 1806), III, 65.

[4] Giannantonio Moschini, _Dell'incisione in Venezia_ [ca. 1808] (Venice, 1924), p. 172.

[5] See the biographical sketch on Piazzetta in Giambattista Albrizzi, _Studij di pittura_ (Venice, 1760), unpaged.

[6] Frances Vivian, "Joseph Smith and Giovanni Antonio Pellegrini," _The Burlington Magazine_, CIV (1962), 330-333.

The economic situation in Venice in the eighteenth century has not been systematically investigated to date. Decadenza, the term applied to the period, implied gradual impoverishment and would lead one to expect that no great encouragement was given to the arts. According to Giovanni Antonio Moschini, probably the first to comment on Venetian patronage, the arts did not receive significant support during the eighteenth century in Venice,[1] and the reference in official documents of the period to some painters' unemployment would seem to corroborate Moschini's view.[2] Likewise, the unprecedented emigration of Venetian painters during the first decades of the century can be seen as a consequence of declining patronage.[3] Yet in this present early stage of research[4] one is rather inclined to think that the contrary was the case. Though the State was no longer the foremost patron, as it had been in the sixteenth century, aristocrats and churchmen were spending enormous sums on the decoration of palaces and churches.

Certain rich families (the Zenobios, the Manins, the Grassis, and others), who had recently purchased their titles of nobility,

[1] Moschini, Della letteratura, II, 105, et passim.

[2] See letters of the Collegio dei Pittori to the Collegio Maritimo at Venice, Archivio di Stato, Milizia da Mar, Busta 550. Thus a passage in an undated letter from the beginning of the century reads: "Sono quelli che vagando vanno hor qua hor la per lo stato a procurarsi il semplice vito non essendo qui opera sufficienti per il loro mantenimento."

[3] For a more plausible explanation of this emigration, see below p. 64.

[4] See Francis Haskell, Patrons and Painters (New York, 1963).

were consolidating their status through lavish acquisition.[1] But they confined their extravagant patronage mostly to large-scale decorations of their new _palazzi_ in town and villas along the Brenta River. Perhaps it was a desire to make their dwellings look like those of the old nobles that prompted them to give their commissions primarily to artists who were still working in the traditional Baroque manner, such as Zanchi, Balestra, Dorigny, and Bambini. They also started galleries very like those of the old patricians. Thus the gallery of the Grassi, formed entirely in the eighteenth century, was made up of "i Tiziani, i Paoli Veronese, i Bassani, i Vandick, i Guidi, i Guercini e gli Schiavoni."[2]

As the aristocrats were on the whole oriented toward the past in their artistic tastes, it has been surmised that their patronage did not extend markedly to contemporary easel painters. Yet the nobles did encourage and support contemporary easel painters in many small ways. The demand for portraits was contstant; in fact, it seems never to have been so great as during the eighteenth century. Not infrequently a painter practised portraiture as a sideline to his own field of specialization. The landscapist Zuccarelli made occasional portraits,[3] and so did Francesco Guardi in his later life.[4] Painters

[1] _Ibid._, Chap. IX, _passim._

[2] Moschini, _Della letteratura_, II, 105.

[3] Irene Hauman, _Das oberitalienische Landschaftsbild des Settecento_ (Strasburg, 1972), p. 33.

[4] Giuseppe Fiocco, "Francesco Guardi rittratista," _Emporium_ XCVIII (1943), 91-102.

were also frequently hired to duplicate and even multiply valued
paintings from the galleries. As a rule commissions for copies
were given to painters of little renown. One exception was success-
ful Gregorio Lazzarini--according to Orlandi, "_il miglior pittore di_
Venizia."[1] Perhaps the best-known example of the rule was the Guardi
brothers. During the late 'twenties they made numerous copies for
the Giovanelli princes,[2] and between 1730 and 1746 Antonio Guardi
supplied Marshal von der Schulenburg with at least a hundred
copies.[3]

Understandably, the patricians showed little inclination to
commission history paintings, of which they owned whole galleries,
but a good many were enthusiastic purchasers of certain types of
cabinet pictures that were fashionable off and on during the century.
Thus from the late seventeenth century through the first decades of
the eighteenth, a fad for battle pieces swept Venice: entire walls
of some _palazzi_ were covered with them from top to bottom. Rooms
in the _palazzo_ Donà dalle Rose as well as old family

[1] Lazzarini copied works by Pietro Liberi for the patrician da
Lin. See Vincenzo da Canal, _Vita di Gregorio Lazzarini_ [1732]
(Venice, 1809), p. XXI.

[2] Giuseppe Fiocco, "Il Ridotto ed il Parlatorio del Museo
Correr," _Dedalo_, VI (1925-1926), 538.

[3] Antonio Morassi was the first to write about Antonio Guardi's
activity as copyist: "Antonio Guardi ai servigi del feldmaresciallo
Schulenburg," _Emporium_, CXXXI (1960), 147-164, 199-212. For particu-
lars concerning Antonio's copies see the Schulenburg papers at
Hannover, Staatsarchiv, Dep. 82, Abt. III, Nos. 37, 57, 61, etc.

inventories still testify to this perfervid collecting.[1] The demand
was significant enough for some painters to devote themselves exclu-
sively, and lucratively, to depicting battles; they included Agostino
Lamma, the Stoms (today forgotten, yet so very popular in their day),
and somewhat later Francesco Simonini. Others, such as Carlevarijs
and Zais, contributed to the genre occasionally. The many battle pic-
tures by Antonio Guardi, today in diverse private collections, are of
such unusually high quality and evidence such extraordinary mastery of
the genre that his activity as <u>battaglista</u> must have been more than
casual, at least at one point of his career.[2]

Toward the middle of the century, Venetian nobles began to relish
depictions of Venetian life and turned to Pietro Longhi and his
imitators (who included one of the Guardi for a time)[3] when decorating
small rooms. Next to battle scenes and Venetian

[1]Family archive of the Donà dalle Rose family, Venice, Box 56.

[2]Guardi's activity as <u>battaglista</u> has been most neglected to
date. Attilio Rossi in "Di una battaglia del Guardi," <u>Arte figurativa</u>
<u>antica e moderna</u>, VII, 2 (1959), 38, refers to some fifty battle paint-
ings by Guardi distributed among different collections.

[3]Pietro Longhi is traditionally considered as the painter of the
Venetian middle class--as a counterpart to Goldoni. Yet his genre
scenes by no means confirm this accepted view. Ernesto Massi's judg-
ment in <u>Sulla storia del teatro italiano nel secolo XVIII</u> (Florence,
1891), pp. 240-241, is far more accurate: he sees Longhi's paintings
as "<u>rappresentazioni di scene domestiche, particolarmente della classe</u>
<u>patrizia</u> Di rado v'è atteggiato il popolo; più di rado la
<u>borghesia</u> Se intervengono nei quadri del Longhi, o sono in
<u>attitudine di servilità verso i patrizi, in attitudine di mercanti e</u>
<u>di bottegai o in quella più frequente di pubblico.</u>" The Aristocrats
seem indeed to have been Longhi's principal patrons. As Alessandro
Longhi wrote in his <u>Compendio</u>: "<u>Sono desiderati i suoi quadri da</u>
<u>tutte le Case Patrizie</u>" Cf. Moschini, <u>Della letteratura</u>, III,
66: "<u>Divennero moltissimo ricercate onde i nobili volevano fregiarne</u>
<u>i proprij gabinetti.</u>"

genre pieces, a not negligible number of pictures which may be gen-
erically described as landscapes (marine, porti di mare, fortune di
mare, paesi, vedute, and architetture) came to enlarge the patrician
collections.[1] Unfortunately, the authors of these paintings were
rarely named in inventories.

It was not unusual for noble families, or for wealthy merchants
aspiring to nobility, to secure for a time the services of certain
painters who often became regular members of their households with
the title of pittore di casa.[2] Gregorio Lazzarini worked for several
years almost exclusively for the Lini, patricians whose palace he so
to speak transformed into his private museum.[3] Alessandro Lanfranchi
lived for thirty years in the house of his major patron, Melchiorre
Fontana, and was treated as a member of the family.[4] Similarly the
patrician Miani, enamored of Giuseppe Camerata's art, housed its
author "a titolo di pittore di Casa."[5] Carlevarijs came to be nick-
named Luca di Ca' Zenobio because questa patrizia famiglia gli
assegnò nobile appartamento nel proprio palazzo.[6] The household

[1]The taste for this type of depiction was not new, as inventories
of collections assembled during the preceding century show.

[2]For the advantage derived by the painters from dwelling in a
patrician household, see p. 65 below.

[3]Da Canal, p. XLVI.

[4]Tassi, II, 30, 32.

[5]See the biographical sketch on Camerata in Alessandro Longhi,
Compendio (Venice, 1762), unpaged.

[6]Moschini, Della letteratura, III, 87.

painter of the Giustiniani, Pietro Grazioli, was for his part <u>Piero di Ca' Giustinian</u>.[1] And in a document of the early 'forties Antonio Guardi is referred to--though only once--as <u>pittor di Ca' Donà</u>.[2]

Far more important to contemporary painters than the nobility's patronage was the support of the Church, which gave major commissions for altarpieces as well as large-scale decorations. These ecclesiastical commissions are far better documented than the secular ones-- for which no contracts survive--and a good deal has been written about them.[3]

The patronage of the Venetian middle-class has not been regarded to date as being of any possible consequence. Yet the listings of personal possessions included in testaments or drawn up posthumously reveal how many small collections there were in Venice.[4] Paintings seem to have figured among the indispensable furnishings of a middle-class household, and cabinet pictures covered entire walls of the studies of gentlemen of fashion. Thus, in a letter of 1725 written from Venice to the Luccan collector Conti, the painter Marchesini refers to landscapes by Marco Ricci as being suitable for a "<u>gabinetto come qui moltissimi cavaglieri ne possiede</u>."[5] Unfortunately, the painters'

[1] Hannover, Staatsarchiv, Dept. 82, Abt. III, No. 61, fol. 30.

[2] <u>Ibid</u>., No. 77, fol. 84.

[3] Haskell, pp. 267-275, <u>et passim</u>.

[4] See Venice, Archivio di Stato, Giudici di Petizion.

[5] Letter reproduced in Francis Haskell, "Stefano Conti, Patron of Canaletto and Others," <u>The Burlington Magazine</u>, IIC (1956), p. 109.

names are rarely indicated in Venetian inventories--least of all in those of smaller collections--so that the patronage of the middle class is not easy to study. But some data found in inventories, such as descriptions of the paintings themselves, seem to indicate that a large part of these works were by contemporary artists. Modest collections, ranging typically from twenty to forty items, consisted in the main of small devotional pictures, portraits, copies, landscapes, battle scenes, views, framed drawings or engravings, and heads. These heads, "teste fatte a capriccio"--also called "teste di carattere" or "capricciose teste"--ultimately derive from two principal sources: Veronese and Rembrandt. During the first half of the century they were very popular with Venetians and foreigners alike. Of the twenty-one paintings and drawings purchased in Venice in 1736 by the Swedish diplomat Tessin, twelve were heads.[1] Compared with other genres, heads were generally inexpensive. Marshal von der Schulenburg, who acquired a very large number of heads by Nogari, Nazzari, Ghislandi, Ceruti, Guardi, and others, never disbursed more than a few zecchini for any one of them.[2] Nor did Algarotti, who acquired heads by Nazzari for five zecchini apiece.[3]

Though Moschini is a most precious source of information on eighteenth-century Venice, his reflections on patronage must be viewed

[1]Osvald Siren, Dessins et tableaux de la Renaissance italienne (Stockholm, 1902), p. 109.

[2]Hannover, Staatsarchiv, Dep. 82, Abt. III, Nos. 51, 57, 61, 80.

[3]Luigi Ferrari, "Gli acquisti dell'Algarotti pel Regio Museo di Dresda," L'Arte, III (1900), 154.

with caution. Encouragement of the arts by Venetians was undeniably lively, and its significance is easily underestimated in view of the extraordinary and better-documented patronage by non-Venetians. A good deal is known of the lavish commissions given by Englishmen to some painters of views, landscapes, portraits, and miniatures, such as Canaletto, Cimaroli, Zuccarelli, and Rosalba. Comparatively little is known about purchases of souvenir pictures from lesser masters by visitors of lesser means. Fortunately Count Rezzonico recorded among his travel expenses small pictures by Guardi acquired at one _scudo_ apiece.[1] For a pastel of average size, Rosalba normally charged fifty times as much.

Besides orders for views and portraits, important commissions for large decorative works, history paintings, and altarpieces poured steadily into Venice from all parts of Europe at highly competitive rates of remuneration. Thus Venetian figure painters did not have to rely exclusively on local patrons if they did not choose to travel. At all times painters had received long distance commissions, yet never, it seems, in such impressive quantity as during the eighteenth century in Venice. Vincenzo da Canal records some sixty important commissions executed for foreign patrons by the sedentary Lazzarini, and his listing is incomplete.[2] Cignaroli's activity for foreigners,

[1] Giuseppe Fiocco, "Francesco Guardi," _Allgemeines Lexikon der bildenden Künste_, ed. Ulrich Thieme and Felix Becker (Leipzig, 1922), XV, 167.

[2] Da Canal, pp. XXXVII-XXXIX, _et passim_.

by Tomaso Temanza's report, was as impressive as Lazzarini's.[1] In
the year 1700 alone Bellucci painted, in Venice, decorations for six
very large ceilings commissioned by Prince Liechtenstein for his new
Palais in Vienna.[2] Pittoni is perhaps the best case in point. He
seems never to have left Venice, but his history paintings and large
altarpieces were painted almost exclusively for foreign patrons,
while his small devotional pictures--for a good part, reduced copies
of the former--found purchasers among Venetian amateurs. In a letter
to his patron Conte Tassis, Sebastiano Ricci refers to the very many
("moltissimi") paintings he dispatched from Venice.[3] Thus between
1724 and 1733 Sebastiano painted series of large pictures for
the Duke of Savoy without ever setting foot in Turin.[4] Not a single
altarpiece by Antonio Guardi has so far been discovered in a Venetian
church, the religious paintings by him that have come to light
during the past decades belonged without exception to modest North-
Italian churches.

Drawings were as much in demand as paintings among publishers

[1]Tomaso Temanza, Zibaldon [1738], ed. Nicola Ivanoff (Venice-
Rome, 1963), p. 9. See also Alessandro Longhi, Compendio, biograph-
ical sketch on Cignaroli, unpaged.

[2]From a letter by Prince Johann Adam to his jeweler, dated
July 28, 1700. Communication from Dr. G. Wilhelm, Director of the
Liechtenstein Archiv in Vaduz. It has been previously assumed,
probably in view of the number and size of the works, that they had
all been painted in Vienna.

[3]Giovanni Bottari and Stefano Ticozzi, Raccolta di lettere . .
. . . (Milan, 1822), IV, 95.

[4]Noemi Gabrielli, "Aggiunte a Sebastiano Ricci," Proporzioni,
III (1950), 210.

and collectors alike. More books and pamphlets were printed in
Venice during the eighteenth century than anywhere else.[1] "Books
were sold in the streets as apples in other cities,"[2] and their
illustrations were at times so lavish as to make the text appear
a mere adjunct. Tiepolo, Balestra, Nazzari, and Piazzetta all
worked copiously for publishers. For the Oeuvres de Bossuet alone,
Piazzetta supplied the publisher Albrizzi with some two hundred drawings.[3]
Many other painters drew a modest yet steady income doing book illus-
trations. Numerous books printed in the 'fifties evidence Fontebasso's
rich contribution as illustrator, which so far has not been closely
investigated.

Innumerable books were mere collections of bound engravings,
chiefly of views of Venice or after paintings of old or contemporary
masters, Venetian and non-Venetian alike. In the early 'forties, for
example, 112 engravings after famous paintings in Venetian collections,
ranging from Veronese to Sebastiano Ricci, were engraved for publication
by Pietro Monaco,[4] while almost simultaneously Giuseppe Wagner pub-
lished a lavish edition of bound engravings after works by Pellegrino
Tibaldi and Nicolò dell'Abate.[5] These engravings could also be

[1] According to Maria Lanckoronska, Die venezianische Buchgraphik
des XVIII Jahrhunderts (Hamburg, 1950), p. 7, a third of all books
printed in Italy were printed in Venice.

[2] Philippe Monnier, Venise au XVIII^e siècle (Paris, 1908), p. 108.

[3] Lanckoronska, p. 13.

[4] Moschini, Dell'incisione, pp. 70-75.

[5] Ibid., pp. 113-114.

purchased by the sheet, and they were relatively cheap.[1] Piles of
them were displayed on certain days in the Merceria together with
"old" engravings which, however, given their relative scarcity and
the extraordinary demand for them, went for unheard-of prices.[2]

Thus the "new" engravings were at one and the same time a source
of income for the artists who supplied the drawings for them and,
as they were readily available, a source of inspiration to others.
Artists in search of compositional schemes most often turned to
engravings or to the illustrations found in books. Even
the resourceful Carlevarijs and Canaletto painted after engravings
at least once.[3] Nicola Grassi seems to have depended on them.
Several of Antonio Guardi's historical paintings are close copies
of books illustrations,[4] and so many of Francesco Guardi's views
have antecedents in prints that one is entitled to doubt whether

[1]Purchases of prints are frequently recorded in Marshal von der
Schulenburg's Libri-cassa. The average price ranged between two and
five lire apiece. See Hannover, Staatsarchiv, Dep. 82, Abt. III,
Libri cassa, passim.

[2]Moschini writes in Della letteratura, II, 100: "Rivolsero
pure i Veneziani con larghezza di argento e di oro all' acquisto
di stampe." Some collections were extraordinarily rich; thus the
patrician Sagredo owned 22,500 pieces. See Mario Brunetti, "Un
eccezionale collegio peritale: Piazzetta, Tiepolo, Longhi," Arte
Veneta, V (1951), 158n.

[3]Hannover, Staatsarchiv, Dep. 82, Abt. III, No. 37, undated
inventory.

[4]Mainly after the illustrations in Albrizzi's Gerusalemme
Liberata of 1745, for which the drawings had been supplied by
Piazzetta. See Antonio Morassi, "Aggiunta al Guardi. Le cinque
tele 'Storie' della Gerusalemme liberata," Emporium, CXXXI (1960),
247-256.

any of his compositions was of his own invention.

Private collectors, like publishers, also commissioned drawings though
in a smaller way. Frequently they would commission drawings directly
from an artist as they would paintings. As the drawings were in most
cases assembled in albums and portfolios, the patrons gave precise in-
dications as to the size of the sheet, while relative freedom seems to
have been left to the artist in the choice of subject matter.[1] The
identical size of so many of the 3380 drawings owned by Zaccaria
Sagredo suggests that they were mostly commissioned. Antonio Guardi's
large set of some sixty sheets representing scenes from Venetian his-
tory shows an unusual degree of finish and may well have been made on
order for a collector. During the eighteenth century, collectors
still seem to have shown a marked preference for finished drawings
over primo-pensiero sketches and studies of details, except naturally
those by old masters. Mariette's taste was quite typical of his age
in this respect: for him a drawing had to be "arrêté et bien fini."[2]
Of the 190 drawings belonging to an important eighteenth-century
Venetian collection (probably Zanetti's) which were exhibited in
Venice in 1966, not a single one could convincingly pass for a primo-
pensiero sketch, and very few could be regarded as studies.[3] The low

[1] The letters of Balestra, Marco Ricci, Zanetti, Temanza, Gabburi,
Jeaurat, Mariette, and others in Bottari and Ticozzi, II, passim, give
an excellent picture of the insatiable quest for drawings on the part
of collectors, as well as of how commissions were transmitted and
executed.

[2] Giving instruction for the purchase of a drawing by Crespi,
Mariette specified: "un disegno magistrale, non qualche piccolo
schizzo." See Bottari and Ticozzi, IV, 509.

[3] Alessandro Bettagno, Mostra di disegni di una collezione del

evaluation of a sketchbook by the Tiepolo which did not include fin-
ished drawings is further evidence of the taste of the age; it con-
tained eighty-seven folios covered on both sides with studies of
details and rough sketches, and was put up for sale for merely
eight zecchini in 1770.[1]

The prices of works of art and the remuneration for commissions
in the eighteenth century cannot be converted into today's currency.
Prices of paintings can only be compared among themselves or with
certain other prices of the time. The currency used in Venice was
the zecchino, and less frequently the ducat.[2] The yearly income of the
Foscarini family amounted to some 32,000 zecchini,[3] while the yearly
cost of "bare subsistence" has been estimated at fourteen
zecchini.[4] In the middle decades, the average bourgeois citizen--

Settecento (Venice, 1966). In the introduction to the catalogue
Bettagno expresses the opposite view, which seems hardly defensible
considering the drawings exhibited.

[1]The sketchbook was reproduced in facsimile by Giulio Lorenzetti,
Il quaderno del Tiepolo al Museo Correr di Venezia (Venice, 1946). The
last page bears the inscription: "questo libro di disegni originalli
tutti al naturale di Gio. Batta e Figlio Tiepolo Pittori al anno 1770
Costa Secchini N. .8." It may be mentioned for comparison's sake that
some forty "finished" drawings made by Piazzetta for Albrizzi were
offered to Algarotti in 1743 for three hundred golden ducats. See
Hans Posse, "Die Briefe des Grafen Francesco Algarotti an den säch-
sischen Hof," Jahrbuch der preussischen Kunstsammlungen, LII (1931),
42.

[2]Three ducats were roughly equivalent to a zecchino, and there
were twenty-two lire in a zecchino.

[3]Haskell, Patrons and Painters, p. 262.

[4]Marino Berengo, La Società veneta alla fine del '700 (Florence,
1950), p. 87. The estimate was made for the population in the Terra
ferma. It must have been somewhat higher in cosmopolitan Venice.

which is what the successful painter was--paid roughly somewhere
between twelve and twenty-five zecchini in annual rent for his
house. Francesco Fontebasso paid twenty-three zecchini, Nicola
Grassi slightly over twenty-five, Pietro Longhi fifteen, Diziani
seventeen, Antonio Canal eighteen.[1] Considering the prices paid to
Canaletto for his works, he needed to paint only one view to cover
his yearly rent. The rent for the caseta occupied by Antonio Guardi
during the last years of his life is recorded at two zecchini,[2] one
of the lowest rents in Venice.

Comparatively speaking, large figure paintings were less expen-
sive than paintings in other genres.[3] In the middle 'thirties, major
commissions were given for the church of the Santo in Padua. Balestra
and Pellegrini were each remunerated with one hundred zecchini for
their respective altarpieces, and Pittoni and Tiepolo with eighty for
theirs.[4] In 1734 Antonio Balestra was paid fifty-five zecchini by
Schulenburg for a large commissioned mythological painting including
many figures,[5] and at approximately the same date Pittoni supplied
the same patron with two history paintings with life-size figures at

[1]All data pertaining to rents were compiled from the Dieci Savi
sopra le Decime in Rialto, Estima 1740, Archivio Venice. Busta 434
for Diziani; Busta 435 for Fontebasso, Grassi, Canaletto; Busta 436
for Longhi.

[2]Ibid., Busta 436.

[3]Haskell, Patrons and Painters, p. 262.

[4]Antonio Sartori, "Il Piazzetta della Basilica del Santo a
Padova," Arte Veneta, XIII (1959), 232.

[5]Hannover, Staatsarchiv, Dep. 82, Abt. III, No. 55, fol. 203.

sixty <u>zecchini</u> apiece.[1] But in 1736 the very same patron paid

Canaletto the astounding sum of 120 <u>zecchini</u> for a view of Venice,[2]

and acquired two rather small landscapes by Marco Ricci for 100

<u>zecchini</u>.[3] Rosalba Carriera charged thirty <u>zecchini</u> for a small

pastel,[4] and Zuccarelli could ask up to 130 <u>zecchini</u> for a couple

of staffaged landscapes.[5] In 1742 Antonio Guardi painted a series

of cabinet pictures representing the customs of the Turks; he re-

ceived two <u>zecchini</u> and a half apiece.[6] In 1750, at the peak of

his career, he received fifty ducats (about sixteen <u>zecchini</u>) for

an altarpiece for the church of Pasiano.[7]

Prices varied widely according to the customer, the local pur-

chaser having the advantage over the foreigner. In an undated letter,

the popular Cimaroli asked six <u>zecchini</u> apiece for small landscapes

yet requested discretion "<u>stante che io opero continuamente per</u>

<u>l'Inghiltera con prezzi assai maggiori</u>."[8] And indeed in a letter

of 1736 the Swedish ambassador noted that the English imagine

[1]<u>Ibid</u>., No. 37, inventory of 1738.

[2]<u>Ibid</u>., No. 57, fol. 19.

[3]<u>Ibid</u>., No. 51, fol. 170.

[4]De Brosses, I, 203.

[5]Ferrari, 152.

[6]Hannover, Staatsarchiv, Dep. 82, Abt. III, no. 77, fol. 181.

[7]Vittorio Querini, "I documenti sulla pala di G. Antonio Guardi della arcipretale di Pasiano di Pordenone," <u>Messagero Veneto</u>, November 21, 1963, p. 3.

[8]Bottari and Ticozzi, VI, 33.

the smallest of Cimaroli's pictures to be worth thirty _zecchini_.[1]

Eighteenth-century sources are not very informative about the
painters' trade in Venice or about the management of the _bottega_.
The family workshop was firmly rooted in the Venetian tradition,
and studios in which members of the same family worked together were
still numerous in the eighteenth century. In some cases the collab-
oration lasted for a lifetime, as it did with the Ricci, the Tiepolo,
and the Carriera; in others it was of relatively short duration, end-
ing after the younger members completed their apprenticeship, as was
the case with the Nazzari and the two Canaletto. Yet a young painter-
to-be was not necessarily trained by his own family: Carlevarijs sent
his daughter Marianna to Rosalba Carriera, and Alessandro Longhi
learned the trade from Giuseppe Nogari. Members of the same family
working in or even owning separate _botteghe_ in the city are also
recorded.[2]

Many workshops included women. Occasional references in docu-
ments indicate that in those days the number of women painters was
significant. Few reached the status of Rosalba Carriera, who ran an
independent _bottega_, or of Giulia Lama, who received important com-
missions for altarpieces on her own. Most seem to have worked on a
modest scale with a father, brother, or husband, as did Nazzari's
daughter, Maria Giacomina, who copied heads after her father's

[1]Siren, p. 107.

[2]Venice, Archivio di Stato, Milizia da Mar, Busta 55 0, writ
inscribed "Rollo di tutti i pittori"

models,[1] or the highly competent Elisabetta Lazzarini, who painted
in the shadow of her brother Gregorio all her life,[2] or again
Cimaroli's wife, who assisted in Cimaroli's studio.[3]

The Venetian botteghe seem to have been relatively small.
Usually they consisted of a master and of a few apprentices who were
his scolari or discepoli (the two appellations were synonymous). As
a group, the discepoli made up the scuola of the master, and the
word scuola appears to have had a very precise meaning at the time.
Thus when a full-fledged painter was described as scolaro or discepolo,
or as being or having been "della scuola di," this evidently meant not
that he was a mere follower or imitator of a certain artist, but
rather that he had once been or still was working directly under that
artist. This is the sense of all such references that can be checked
against known facts. Thus Antonio Guardi must once have been appren-
ticed to Sebastiano Ricci unless the reference to him in a document of
1751 as "della scuola di Bastiano Rizzi" is erroneous.[4] The same may
hold for the reference of 1764, in the diary of the patrician Gradenigo,
to Francesco Guardi as "scolaro del Canaletto."[5]

The curriculum to be followed by the apprentices does not seem

[1]Tassi, II, 95.

[2]Da Canal, annotazione 13.

[3]Hannover, Staatsarchiv, Dep. 82, Abt. III, No. 37, inventory of
first shipment to Germany (1736). The moglie del Cimaroli is recorded
as the author of flower pieces.

[4]Querini, p. 3.

[5]George Simonson, Francesco Guardi (London, 1904), p. 81.

to have varied widely from one Venetian <u>bottega</u> to the next. During
the formative years, the most rigorous emphasis was given to the
study of the <u>disegno</u>, in Zanetti's words "<u>parte essenziale della</u>
<u>pittura</u>."[1] Only after having acquired proficiency in <u>disegno</u>--which
often took several years of practice--could an apprentice attempt the
<u>colorito</u>. In fact, references to the thorough training in <u>disegno</u>
given to apprentices are numerous in the sources of the time, whereas
the study of <u>colorito</u> is but rarely mentioned, as if the mastering
of the latter was no great concern. During his apprenticeship,
Nazzari drew indefatigably for many years: "<u>ora disegnando sulle</u>
<u>opere del maestro, ora studiando sugli antichi rilievi, ora frequent-</u>
<u>ando le accademie del nudo</u>."[2] So did Battista Bellotti, who for six
years worked "<u>sotto la direzione d'Antonio Bellucci, e con applica-</u>
<u>zione al disegno, che no lasciò mai di vista . . . e riuscito franco</u>
<u>e buon Pittore</u>"[3] About Girolamo Brusaferro's apprenticeship
Zanetti found worth recording only that he had learned the "<u>buone</u>
<u>regole del disegno dal Bambini.</u>"[4] Tassi wrote of Giacomo Cotta that
only "<u>dopo molto studio, vedendosi in questo [in disegno] ben fondato,</u>
<u>s'avvisò d'incominciare a colorire.</u>"[5] And dal Pozzo related of

[1]Anton Maria Zanetti, <u>Della pittura veneziana e delle opere pub-</u>
<u>liche dei veneziani maestri</u>, 2nd ed. (Venice, 1792), II, 543.

[2]Tassi, II, 83.

[3]Bartolomeo dal Pozzo, <u>Le vite de' pittori degli scultori et</u>
<u>architetti veronesi</u> [<u>Aggiunta</u>] (Verona, 1718), p. 12.

[4]Zanetti, II, 560.

[5]Tassi, I, 237.

Domenico Pandolfi that he "entrò giovinetto nella scuola d'Alessandro Marchesini ove attese per molt'anni al disegno finche impossessatosene a sofficienza potè passare al colorito."[1]

Drawing after the model was emphasized. In fact the painters' chief reason for wanting an Academy--which in their view was not to supersede but to complement the teaching dispensed in the bottega----was to give their pupils more opportunity to draw from the model.

Copying works by the master seems to have been another basic practice in the bottega. "Fino dalla fanciullezza [Francesco Polazzo] diedesi a copiare le opere del Piazzetta,"[2] and Lazzarini is on record for his "assiduo studio del disegno e del copiare dalle opere del maestro."[3] Studying and copying of other painters' works must have been practiced too, but the imitation and eventual assimilation of the technique and style of one's own master seems to have been the goal set for apprentices, and those who attained it were highly praised. What Guarienti wrote of young Bellotto, "prese ad imitarlo [Canaletto] con tutto lo studio ed assiduità,"[4] could have been said of most Venetian discepoli with respect to their masters. Having admitted to Amigoni's scuola, Antonio Zucchi "Con ogni diligenza cercò imitare

[1]Dal Pozzo, p. 19.

[2]Moschini, Della letteratura, III, 73.

[3]Da Canal, p. XXII.

[4]P. Orlandi and P. Guarienti, Abecedario Pittorico (Venice, 1753), p. 101.

quel suo vago colorire."[1] Fontebasso "attese con tutta la diligenza
ad imitar la maniera del suo maestro."[2] It was with praise intended
that Tassi wrote of Tiepolo's scolaro Giovanni Raggi that he studied
his master's style so intensely "che potè condurre una copia di un
. . . dipinto dal [Tiepolo], con tanta somiglianza . . ., che appena
si distingue da l'originale."[3] And again it was in a laudatory tone
that Alessandro Longhi wrote that il Chiozzotto was of Piazzetta's
many pupils the one "che imitò più d'ogni altro la sua maniera, si
nella forza del colorire come d'arditezza dei lumi."[4] The heavy
stress laid on imitation produced bottega styles and consequently
problems of attribution, which seem to be more vexing for Venice
than anywhere else. Temanza reports of Diziani that he
"tanto studiò la maniera del Ricci che molte sue opere furono credute
del Maestro"[5]--and probably still are. Guarienti's comment on
Bellotto's views: "un gran intendimento ricercasi in chi vuole dis-
tinguerle da quelle del zio [Canaletto]"[6] is still quite valid today,
and so is Vincenzo da Canal's comment on Elisabetta Lazzarini's imita-
tion of her brother's style: "la cui maniera imitò per modo, che si

[1]Alessandro Longhi, biographical sketch on Zucchi, unpaged.

[2]Ibid., on Fontebasso, unpaged.

[3]Tassi, II, 104.

[4]Alessandro Longhi, on Marinetti, unpaged.

[5]Temanza, 12n.

[6]Orlandi and Guarienti, p. 101.

<u>confusero tavolta le di lei opere con quelle del fratello</u>."[1] And
the <u>bottega</u> contained ample material for instruction, as it seems
to have been customary for the master to keep copies of his com-
missioned paintings as records.[2]

The apprenticeship seems to have spread over many years in
Venice and the Veneto. To spend ten years in the same <u>scuola</u> does
not appear to have been exceptional. Yet once a <u>discepolo</u> had reached
a certain competence, a relative freedom seems to have been left to
him: though still a member of the <u>bottega</u>, he could receive commis-
sions of his own and benefit from the advice of the master. In 1733
the young and talented Fontebasso was still apprenticed to Sebastiano
Ricci, yet he received personally a well-remunerated commission for
two paintings which Sebastiano touched up after their completion.[3]
So did a certain Sanuldi personally receive commissions while he was
in Tiepolo's <u>scuola</u>.[4] Francesco Daggiù is another case in point.
At a very early age he became apprentice to Piazzetta "<u>sotto la</u>
<u>direzione del quale si tratenne lunga serie di anni sino alla morte</u>

[1]Da Canal, annotazione 13.

[2]Da Canal, p. LXVIII, noticed in Lazzarini's <u>bottega</u> "<u>copie di</u>
<u>quadri spediti fuori dello stato</u>." A good number of the <u>bozzetti</u>,
paintings, and drawings inventoried in Sebastiano Ricci's house after
his death may have been copies kept as records. See Pietro Zampetti,
"Il testamento di Sebastiano Ricci," <u>Arte Veneta</u>, XIII-XIV (1959-1960),
229-230.

[3]Hannover, Staatsarchiv, Dep. 82, Abt. III, No. 51, fol. 190,
and No. 42, inventory of first shipment.

[4]Hannover, Staatsarchiv, Dep. 82, Abt. III, No. 57, fol. 85.

di tanto professore "[1]--that is, twenty-five years. Yet in 1749 the church of Alzano commissioned several altarpieces from him for which he was personally remunerated, though they were "fatte sotto la direzione del maestro."[2] Diziani was in Sebastiano's scuola from about 1710 until 1717, yet his artistic personality emerged sufficiently during that period for Augustus the Strong to invite him to Saxony.[3] The master himself would at times suggest a discepolo for the execution of a commission. Thus Sebastiano Ricci wrote to Conte Tassis, who wished to commission two paintings, that they could be executed by "un mio bravissimo scolare, che con la sua abilità e con la mia direzione sono sicuro che averanno un' opera di che saranno . . . contenti."[4] These facts contradict the widespread view that, as long as a painter was a subaltern member of a bottega, his artistic identity remained unknown and the money and glory went to the master.[5] There is no serious evidence either that subaltern members of a bottega were helplessly subjected to the master's authority and could not leave it at any time they chose. Abuses as reported by the painter Chilone in his autobiographical sketch did certainly

[1]Tassi, II, 138.

[2]Ibid.

[3]Temanza, pp. 11-12.

[4]Bottari and Ticozzi, IV, 96.

[5]For this view see especially Michelangelo Muraro, "The Guardi Problem and the Statutes of the Venetian Guilds," The Burlington Magazine, CII (1960), passim.

exist.[1] But talent seems always to have been recognized if only post-
humously, and "a case of exploited or suppressed genius has yet to be
discovered in the history of Venetian painting."

The hiring of assistants--that is, full-fledged painters who
had not been trained by the master they served--appears to have been
rare. From the detailed register of painters enrolled in the
Collegio dei Pittori in 1726, we learn that only six out of some
eighty painters hired a pittore to work for them, and neither
Sebastiano Ricci, nor Pittoni, nor Piazzetta, nor Canaletto, nor
Tiepolo, Venice's leading painters, was among them.[2] Obviously the
assistance the master needed was given him by the advanced discepoli,
who in turn appear to have received help and advice from the master,
under whose direction they executed their own works.[3] Thus the Vene-
tian bottega may be conceived primarily as a school, but also as a
group of professionals assisting one another yet retaining more or
less independent relationship with the outside world.

Unfortunately, little is know about reciprocal assistance,
collaboration, and division of labor in the workshop. Each bottega
certainly had its own particular modus operandi, but in conformist

[1]Ibid., 423. Chilone, however, who had been hired by Mauro as
paid assistant--perhaps even as partner--remained with the latter of
his free volition.

[2]Venice, Archivio di Stato, Milizia da Mar, Busta 550, document
inscribed: "Rollo di tutti i pittori che sono nel Collegio nuovo
[1726].

[3]The assistance of the discepoli may have been remunerated, but
proof of this is lacking.

and tradition-bound Venice, working habits and practices must not have differed widely from one workshop to the next. Some passages in Schulenburg's papers indicate that Sebastiano Ricci corrected and touched up the works of his _scolari_ once they had been completed,[1] and Temanza writes that the same Sebastiano would entrust an advanced _discepolo_ to "sketch in" his own compositions ("_la sua maniera_ [Diziani's] _fece progressi tali che in pochi anni_ [Sebastiano] _gli faceva sborzare de suoi quadri anche di molto impegno._"[2] In the latter case the contribution of Sebastiano's most brilliant _dis-cepolo_ was of no great significance, as the sketching-in must have been done after a drawing of Sebastiano and the actual painting over the sketched-in composition was done by the master himself.

The only type of collaboration to which sources allude profusely was one between members of different studios: history painters frequently contributed the staffage to the paintings of _vedutisti_ and _paesisti_, and conversely—though less frequently—the latter furnished the backgrounds to history paintings. The practice was most common in Venice, and the collaboration between Sebastiano and Marco Ricci comes first to mind. In fact, every history painter seems to have tried his hand at least once on a _macchietta_. Antonio Bellucci painted the figures in Tempesta's landscapes,[3] Carlevarijs in

[1]Hannover, Staatsarchiv, Dep. 82, Abt. III, No. 42, first inventory of first shipment.

[2]Temanza, 12.

[3]Filippo Boni, _Biografia degli artisti_ (Venice, 1840), p. 74.

Eismann's vedute,[1] Tiepolo and Zuccarelli in Visentini's architetture.[2] Pittoni and Piazzetta both painted figures in allegories for which Canaletto had "supplied the architectures" and Cimaroli the "fogliage."[3] In a letter to Tiepolo, Algarotti requested the master to set three or four weeks at his disposal as he intended to bring him a "gallery" of unfinished paintings and "tutti questi quadri aspettano di essere animati da macchiette di sua mano."[4] Marieschi's vedute are peopled with macchiette which differ in style so widely from one painting to the next that they could only have been authored by different hands.[5] Some seem to be by Tiepolo, others perhaps by Diziani or Simonini, many by Antonio Guardi, and most likely none by Marieschi himself.

[1]Hannover, Staatsarchiv, Dep. 82, Abt. III, No. 37, inventory of first shipment.

[2]Moschini, Dell'incisione, p. 151.

[3]Rodolfo Pallucchini, Piazzetta (Milan, 1956), p. 22.

[4]Bottari and Ticozzi, VII, 448.

[5]Hermann Voss in "Studien zur venezianischen Vedutenmalerei des 18. Jahrhunderts," Repertorium für Kunstwissenschaft, XLVII (1926), 30n, first formulated the hypothesis of a possible collaboration between Marieschi and Antonio Guardi. Antonio Morassi, in Michele Marieschi [exhibition catalogue] (Bergamo, 1966), passim, pointed out stylistic similarities between some of Antonio's works with some of the macchiette in Marieschi vedute.

The corporate system survived in Venice until the fall of the Republic. No one could legally practice a trade or a craft without belonging to one of the Venetian corporations. Until the late seventeenth century, the painters belonged to the Arte dei depentori. This corporation, however, did not consist of painters exclusively, but included the related crafts of the gilders, miniature painters, textile designers, leather workers, makers of playing cards, and sign painters.[1]

The arti were more or less identical in their internal constitution. Each year all members gathered to elect their officers, the most important among these being the gastaldo (president) and the tansadori (tax assessors and collectors). Individuals were not taxed, but each arte as such was--a system that functioned more or less successfully until Napoleon's conquest of Venice. Each year the Presidenti del Collegio della Milizia da Mar notified each gastaldo of the amount his arte was to be taxed for that year, and the tansadori set out to divide the tax among their brethren and to collect it.[2] Each member of an arte had to contribute a capital tax, called taglione, which was equal for all, and another tax, called insensible, which was proportional to his yearly income.[3] The system worked well on the whole except in the cases of corporations which comprised

[1]Agostino Sagredo, Sulle consorterie delle arti edificative in Venezia (Venice, 1857), p. 157.

[2]Ibid., p. 56.

[3]Ibid.

related yet different professions, such as the <u>arte dei depentori</u>--
or the <u>arte dei tagliapietra</u> which included stone cutters as well
as sculptors.

There is no reason to believe that Veronese and Titian were
annoyed at belonging to a corporation which included gilders and
textile designers. But in the last decades of the seventeenth
century, Venetian painters came to resent this situation. Painters
abroad enjoyed a respectable status, and academies of art had been
founded in other Italian cities, whereas in Venice painting was
assimilated to the "mechanical crafts" under a <u>gastaldo</u> who was
usually not a painter but a low artisan. In 1679 the painters
petitioned the Senate to be separated from the <u>arte dei depentori</u>
and grouped in an academy which would not fall under the same juris-
diction as the <u>arti</u>: "<u>le supplichiamo commandar che noi puramente
Pittori possiamo escorporarsi da si proffusa unione d'operarij, e
sotto nome d'Accademia di Pittori obedire per nostro giudice il
Maggistrato</u>."[1]

In 1682 only thirty out of the 200 painters residing in Venice
registered with the <u>arte</u>, and their arrears in tax payments attained
5000 ducats.[2] The large number of delinquents made prosecution diffi-
cult, so the Senate consented to the separation instead. Ignoring

[1]Letter reproduced in Elena Bassi, <u>La regia Accademia di Belle
Arti di Venezia</u> (Florence, 1941), pp. 127-128.

[2]Venice, Correr Library, Cicogna, fol. 7, copy of a memorandum
of October 24, 1682, addressed to the Senate by the magistrates of
the Giustizia Vecchia.

the word "accademia," it authorized the painters to form a Collegio

dei Pittori.[1] Only liberal professions assembled in collegi, but

whereas the Venetian collegi were normally exempted from taxes, the

Collegio dei Pittori remained subjected to very heavy impositions.[2]

Only eighty years later, in 1761, was the Senate finally to decree

that the Collegio was a nontaxable body.[3] The scrupulous patrician

Gradenigo inscribed this event in his diary: "Il Senato con suo

generoso Decreto esenta il Collegio de Pittori dalla Tansa annuale.[4]

Until 1761, then, the Collegio dei Pittori was treated as an

arte in that it remained subject to taxation, and in all matters

of taxation it stood under the authority of the inexorable magistrates

of the Milizia da Mar exactly as did the other corporations. Yet in

other respects painting was recognized as a liberal profession obeying

its own internal laws.[5] Thus the corporative prescriptions which rig-

orously regulated the relations between a master and his apprentices

[1]Separation decree reproduced in Bassi, p. 129.

[2]Venice, Archivio di Stato, Milizia da Mar, Busta 550. See
letters addressed by the Collegio dei Pittori to the magistrates of
the Milizia da Mar, passim.

[3]Venice, Correr Library, Cicogna, foll. 118-130 [copy of]
Decreti e Privilegi commessi dall'Ecc^mo Senato a detto Collegio l'anno
1761.

[4]Pietro Gradenigo, Notizie d'Arte, ed. Lina Livan (Venice, 1942),
p. 78.

[5]This is emphatically stated in numerous documents. See Venice,
Archivio di Stato, Milizia da Mar, Busta 550, letters from the Collegio
dei Pittori to the Milizia da Mar, passim. Cf. Michelangelo Muraro,
"The Guardi Problem and the Statues of the Venetian Guild," The Bur-
lington Magazine, CII (1960), 422.

and journeymen did not apply to painters: "nella Pittura no si sono
lavoranti ne si accordano Garzoni essendo L'Arte libera et li scolari
dai Maestri vanno et vengono."[1] Inasmuch as the internal laws derived
from the old statutes of the arte dei depentori--just a bit rephrased
and amended--the Collegio dei Pittori preserved a corporative char-
acter to a degree.[2] But this does not mean that the Collegio remained
an arte.[3] The decrees and laws promulgated for corporations after
1682 did not affect it. The Inquisitorato alle Arti established in
1705 to deal with matters pertaining to the arti had no power over it.
And it did not fall under the same jurisdiction as the corporations:
". . . il collegio sia sotto la direzione del Mag[to] de Proveditori
alla Giust[a] Vecchia com'è già decretato dovendo giudicare le con-
troversie attive, e passive mentre alli Giust[ri] Vecchi resterano le
altre arti, come prima. . . ."[4]

The statutes of the Collegio dei Pittori remained nominally in
force during the eighteenth century. Whenever they were disregarded
too flagrantly, the government had solemn reminders of their exis-
tence and admonitions to apply them posted in the Piazza San Marco

[1] Venice, Archivio di Stato, Milizia da Mar, Busta 550, letter
of ca. 1690 by the Prior of the Collegio dei Pittori to the Collegio
Maritimo.

[2] Venice, Marciana, Rossi, fol. 49.

[3] Some eighteenth-century documents and letters refer to the
arte dei pittori, or merely to the arte--an enormous appellation in
use for some time even among the painters themselves.

[4] Venice, Correr Library, Cicogna, fol. 22, copy of a memorandum
of November 18, 1683, addressed to the Senate by the magistrates of
the Giustizia Vecchia.

and at the Rialto Bridge for every painter to read.

Neither the texts of the original Mariegola dei Depentori nor the statutes of the Collegio dei Pittori have come down to us. But fragmentary copies, comments in contemporary literature, and references in official documents make it possible to reconstruct these laws which so greatly influenced the lives of painters in Venice during the eighteenth century.

To practice his profession legally in Venice, a painter had to belong to the Collegio dei Pittori. The texts are unequivocal in this respect: "Che tutti quelli si eserciterano nella Pittura debbano matricolarsi." And again: "che niuno sia che si voglia, che non sara descritto o matricolato nel Collegio de Pittori non possa aver alcuna ingerenza in detta professione."[1] Thus in a proclama of 1693 the Senate ordered all masters to report the names of painters who worked under them to the head of the Collegio: "Sia et s'intende obligato cadaun pittore che facesse lavorare da altri dare in nota al Priore di detto Coll° tutti quelli che per essi lavorassero, ed incontrare se sone descritti o matricolati."[2] Those who were found not to belong to the Collegio had to suspend their work until they were admitted. Evidently these injunctions applied even to members of a family workshop, as references to the registration of "figliuoli di Pittori" indicate.[3] Therefore the supposition that

[1] Venice, Correr Library, Cicogna, foll. 20, 59, respectively copy of the statutes and copy of a proclamation of May 9, 1693.

[2] Ibid., fol. 59.

[3] Ibid., fol. 20.

Francesco Guardi's name does not figure in the extant documents of the Collegio prior to 1760 because he was a subaltern member in a bottega run by Antonio (who died in 1761) is hardly defensible.[1] For that matter, not even Antonio's name is to be found in those documents.

There was no age requirement for entering the Collegio dei Pittori, but a member had to be twenty or over to vote.[2] No candidate for membership was accepted unless he submitted a painting that had been executed in the presence of some officer of the Collegio[3] and that established his proficiency as painter: "l'ascrizione facevasi imediante l'esibizione d'una opera della quale decidevano alcuni esaminatori et approvato questa concedevasi al candidato l'esercizio libero della pittura."[4] Once a candidate had passed this entrance test to the Collegio, he might practice painting[5] and nothing stood in his way to "apir stanza." There is no evidence whatsoever that the number of painter's workshops was limited by law.[6]

[1] Cf. Muraro, 424. (Muraro's error derives from his assumption that the Collegio was an arte. But even for the arti the prescriptions in this respect were not uniform. Thus Sagredo, p. 52: "In alcune arti tutti che vi erano scritti, in altri i soli maestri formavano il corpo dell'arte.")

[2] Venice, Correr Library, Cicogna, fol. 13, copy of the statutes.

[3] Ibid.

[4] Venice, Marciana, Rossi, fol. 54.

[5] Ibid., fol. 49.

[6] Cf. Muraro, 422.

A foreigner intending to practice painting in Venice had to belong to the Collegio. Before the separation of 1682 non-Venetian painters (forestieri and terrieri) had to register with the Collegio within three days following their arrival in the city, afterwards within six months: "Sia però permesso alli Forestieri che capiterano in questa Dominante essercitarsi in detta Professione invece delli giorni tre che anticamente erano stabiliti per il corso di mesi sei senza l'obbligo d'entrar in detto collegio quali spirati siano debbino esser obligati a matricolarsi ed entrar in collegio con le condizioni espresse nel Capitolo."[1] Foreign painters in Venice were subjected to the same obligations as Venetian painters. But they also had the same rights: they could open a bottega, take apprentices, sell pictures, vote and hold office in the Collegio. Peter Strudel, the later founder of the Viennese Academy, was a member of the Collegio in the 1680's, as was Carlo Loth;[2] Johann Anton Eismann, Pieter Muliers (Pietro Tempesta), and Lodovico Dorigny belonged as of 1690;[3] so did Giuseppe and Domenico Valeriani, and Gasparo Camperdeck as of 1726.[4] In 1739 the Neapolitan Antonio Joli was even elected Prior.[5] Thus the supposition that Antonio Guardi had

[1] Venice, Correr Library, Cicogna, fol. 21, copy of the statutes.

[2] Venice, Archivio di Stato, Busta 550, Libri di tanse 1683-1686.

[3] Venice, Archivio di Stato, Milizia da Mar, Busta 550, Rollo de Pittori Mri Matricolati ne Coll. [1690].

[4] Venice, Archivio di Stato, Milizia da Mar, Busta 550, Rollo de tutti i pittori che sone nel Coll° nvo [1726].

[5] Venice, Archivio di Stato, Magistrati alla Giustizia Vecchia, Busta 204.

difficulty in entering a professional organization because he was not Venetian does not hold.[1]

Within the Collegio, a sharp distinction was drawn between the "pittori provetti, ed eccelenti maestri, e chiamansi matricolati" and those who were merely "ascritti" or "contribuenti."[2] The matricolati had far greater weight; they were called professori, and the officers were elected from among them. Though most of them probably were heads of workshops, not all of them were. In 1744 Francesco Daggiù, while he was called professore, was still working under Piazzetta.[3]

The distinction between the two groups seems to have been based on talent and competence rather than age and social status.[4] A painter became ascritto automatically upon passing the entrance test, but rarely did one qualify from the start as a matricolato. The ascritti might vote but not hold office.[5] Among them were of course many young painters "che si vanno allevando anch'essi nella Pittura e ponno divenir eccelenti."[6] But many were also elderly men who were never recognized as being of sufficient stature to make the grade even

[1]Cf. Muraro, 423.

[2]Venice, Correr Library, Cicogna, fol. 122, and Venice, Marciana, Rossi, foll. 53, 54.

[3]Tassi, II, 138.

[4]Venice, Marciana, Rossi, fol. 54. Cf. Muraro, 422.

[5]Venice, Marciana, Rossi, fol. 53.

[6]Venice, Correr Library, Cicogna, fol. 122. Copy of a memorandum, dated August 12, 1761, by the Collegio della Milizia da Mar, addressed to the Senate.

though some of them were heads of workshops. A complete list of the members of the Collegio drawn up in 1726 survives.[1] Sixty _matricolati_ and sixty-two _ascritti_ figure on it. It does not follow that there were only 122 painters in Venice at the time. As will be seen,[2] some painters found the means to avoid registration and thereby evade taxation.

One way to graduate from the lower to the upper groups was to exhibit one's painting in public and win general approval of its artistic quality: "_e se espongono qualche opera al Pubblico, se viene dagl' intendenti riputata degna di laude, si fanno merito per esser matricolati._"[3] Sporadic allusions to such one-man shows in the Piazza San Marco or in the Merceria (usually of only one or two works) are encountered in the literature of the time, but it is not easy to determine in which cases the object was promotion as against mere self-gratification or publicity.[4] Paintings exhibited were never for sale.[5] Thus Nazzari, in his early twenties while still in Trevisani's _scuola_, "_mise in pubblico alcune operette_,"[6] but at

[1] Venice, Archivio di Stato, Milizia da Mar, Busta 550.

[2] See below, p. 65.

[3] Venice, Correr Library, Cicogna, fol. 122, copy of a memorandum of August 12, 1761, addressed by the Collegio della Milizia da Mar to the Senate.

[4] Cf. Francis Haskell and Michael Levey, "Art Exhibitions in 18th Century Venice," _Arte Veneta_, XII (1958), 180-181.

[5] Venice, Archivio di Stato, Giustizia Vecchia, Busta 31, Proclama 1689 a 3 Gen?.

[6] Tassi, II, 83.

twenty-six he was recorded as matricolato,[1] and it may be guessed that his show led to his promotion. According to Orlandi, Pittoni "comparve in pubblico con applauso in eta di anni 26"[2]--probably with the same result as Nazzari. And Francesco Guardi may well have been an aspirant matricolato when in 1764 he exhibited two views commissioned by an Englishman and received "applauso generale."[3] But Lazzarini was already a long-standing matricolato when he impulsively exhibited a new painting in the Merceria one day.[4] And so was Maggiotto when in 1760 he exhibited a commissioned altarpiece.[5]

There was a third group in the Collegio: the pittori-bottegheri, or painters who were also picture dealers. Some pittori-bottegheri seem to have been picture-dealers rather than painters, however, for they did not take the entrance test to the Collegio but paid a benentrada fee instead.[6]

[1] Venice, Archivio di Stato, Milizia dar Mar, Busta 550, Rollo de tutti i pittori che sone nel Coll.o nvo.

[2] P. Orlandi and P. Guarienti, Abecedario Pittorico (Florence, 1776), p. 661.

[3] Simonson, p. 15, and Pietro Gradenigo, Notizie d'Arte, ed. Lina Livan (Venice, 1942), p. 106: "25 Aprile 1764--Francesco Guardi, Pittore della Contrada de' S:ti Apostoli su le Fondamente nove buon Scolaro del rinomato . . . Canaletto, essendo molto riuscito per via della Camera Optica dipingere sopra due non picciole Tele, ordinate da un Forestiere Inglese, le vedute della Piazza di S. Marco verso la Chiesa, e l'Orologio, e del Ponte di Rialto, e sinistre Fabbriche verso Canareggio, oggi le rese esposte su laterali delle Procuratie Nove, mediante che si procaccio l'universale applauso."

[4] Da Canal, p. LXX.

[5] Gradenigo, p. 48, and Archivio Venice, Magistrati alla Giustiza Vecchia, Busta 204.

[6] Venice, Correr Library, Cicogna, fol. 51, copy of the statutes.

.

A _pittore-bottegai_ might not buy or sell paintings by contempo-
rary Venetians who were not inscribed in the _Collegio_. Nor might he
sell a painting by an old master without having previously obtained a
certificate of its authenticity from some officer of the _Collegio_:
"_E percio che riguarda il negoziato di pitture antiche non e permesso_
a chi che sia farne smerzio, se prima non le fa riconoscere dai Reg-
genti del Collegio, il cui Priore o sia Presidente dovrebbe relasciare
une fede intorno all'autenticita del quadro stesso."[1] These prescrip-
tions were designed to prevent the sale of forgeries, which already at
that time were executed in Venice with great skill and on a wide scale.

The commerce of paintings was chiefly in the hands of painters
during the first half of the century. Thus a very large proportion of
the 900 paintings Schulenburg acquired was purchased from painters or
through an intermediary.[2] In fact, with the exception of Antonio
Guardi, all the painters in Schulenburg's entourage seem at one point
or another to have sold him paintings or supplied certificates of
authenticity or acted as agents. Needy patricians turned to collegiate
painters as reliable intermediaries when disposing of works from their

[1] Venice, Marciana, Rossi, fol. 52.

[2] Hannover, Staatsarchiv, Dep. 82, Abt. III, Libri-cassa, _passim_.
Pittoni dealt in pictures on a grand scale. Among those he sold
Schulenburg were a _Deposition_ by Veronese, a _Ruth and Booz_ by Titian,
a _Modonna with Children_ [sic] by Leonardo da Vinci, _Nude Figures_ by
Palma Vecchio, and several landscapes by Marco Ricci (See Dep. 82,
Abt. III, No. 51, fol. 170 and 248; No. 57, fol. 157 and 217; No. 61,
fol. 170). Francesco Simonini supplied Schulenburg principally with
battle scenes, Bernardo Benzoni with heads and portraits, Santo-Piatti
with all genres.

galleries. So did the prospective purchasers on their side, as only a member of the Collegio could supply them with creditable certificates of authenticity. Here Algarotti is an excellent case in point: whenever he bought from Venetian patricians in the early 'forties, painters were involved in one capacity or another, and yet he was at least as good a connoisseur as any one of them.[1]

Sales of paintings could take place in the workshops and nowhere else. This applied to all painters and not exclusively to the bottegheri: "Sij sempre prohibito a chi si sia, etiam alli Pittori matricolati, di vender, or far vender tanto di festa, come di lavoro quadri per le strade, o ponerli fuori per le cale, et balconate delle Botteghe o in qual sisia altro luogho della città."[2] And in another context: "Non dovendo ne meno ne giorni feriali esser venduti quadri in altro luogho che nelle botteghe aperte di detta professione."[3] Only the works of deceased painters might be exhibited outdoors for sale, but here again the authorization of an officer of the Collegio had to be obtained.[4] As the century advanced, violations of the laws pertaining to the sale of paintings increased rapidly, and the authorities were increasingly less able to cope with them. Paintings were

[1]Posse, 41, 54-58.

[2]Venice, Archivio di Stato, Giustizia Vecchia, Busta 31, Proclama 1689 a 3 Gen°.

[3]Venice, Correr Library, Cicogna, fol. 21, copy of the statutes.

[4]Venice, Correr Library, Cicogna, fol. 59, Proclamation of May 9, 1693.

peddled in the street,[1] forgeries of old masters multiplied, and gradually the Collegio lost its authority over most transactions in the art trade. After mid-century, pictures for sale were displayed all over the city--especially in coffee-houses and pharmacies, where traffic was heaviest.[2] And gradually art dealers unconnected with the Collegio or the Academy entered the art market and took it over.

Each year the members of the Collegio gathered in the house of one of their members or in the Scuola di S. Vicenzo a SS. Giovanni e Paolo to elect their banca, or executive committee. They chose a prior, or president, and two consiglieri or counselors; two tansadori to apportion the tax bill among the Collegiates; two scoditori (later called esatori) to collect the bill; and two or three custodians of the paintings that were public property, who would restore them if the need arose.

The regular annual and occasional special meetings of the Collegio were none too well attended.[3] A gathering of forty was quite

[1]Outdoor sales of pictures seem to have begun in the late seventeenth century already. They became very common with the development of tourism in the eighteenth century. See Cicogna, fol. 13.

[2]Gradenigo, passim.

[3]The Collegio had to report to the authorities after each meeting. Some reports were addressed to the Proveditori alla Giustizia Vecchia, under whose jurisdiction the Collegio stood, and others to the Magistrati alla Milizia da Mar, to whom it was fiscally responsible. What determined the choice of the addressee is not always clear. The report had to specify the place and date of the meeting, the reasons for which it was held, and the names of the members who attended. This invaluable documentation is today located at the Archivio at Venice, partly with the papers of the Giustizia Vecchia (Busta 204, Filza 236) and partly with those of the Milizia da Mar (Buste 543, 550, 674-676, 678, 679-680).

unusual, and gatherings of only twelve are on record.[1] It seems that control of the Collegio always lay with a small group of matricolati from whose ranks the banca was elected.[2] This dominant group came to be called the "Collegietto" and later the "Collegio Maggiore." It comprised the elite of the profession: the respected and celebrated masters. Thus Sebastiano Ricci busied himself in the Collegio during the last years of his life (some meetings took place at his house); Tiepolo participated whenever he was in Venice; and Piazzetta, Pittoni, Diziani, Visentini, and Pietro Longhi rarely skipped a meeting.[3]

These were no meetings of beaux esprits theorizing on the nature of beauty and art. The collegiati were practical men who assembled to deal with practical matters. By and large, they were neither educated nor cultured, as Algarotti so bitterly observed. The few papers that survive show that most of them were semiliterate.[4]

The story of the Collegio from its foundation in 1682 through the eighteenth century is one of continual disarray often verging on chaos and of continued disgruntlement often verging on defiance. It could hardly have been otherwise, as the statutes of the Collegio were

[1]Venice, Archivio di Stato, Magistrati alla Giustizia Vecchia, Busta 204, passim.

[2]Venice, Marciana, Rossi, fol. 51.

[3]Venice, Archivio di Stato, Magistrati alla Giustizia Vecchia, Busta 204, passim.

[4]See, for example, the certificates of authenticity (fedi) by Venetian painters among Schulenburg's papers at Hannover, Staatsarchiv, Dep. 82, Abt. III, No. 37.

in many ways anachronistic and the public ordinances governing the
sale of pictures too unrealistic to be obeyed. But the chief source
of trouble must have been fiscal.

With the advantage to a painter of belonging to the Collegio,
which was that he could practice his profession legally, went the
disadvantage of being subject to taxation. Because one of the annual
taxes (the insensibile) was apportioned among them, the members of
the Collegio wished their number to be as large as possible, and had
all painters in Venice joined as the law required, the burden might
have been bearable. This was never the case. The established suc-
cessful master with workshop and scuola had no possibility of staying
out. But the painter of little renown could escape enrollment; if
detected and faced with penalties, he could lie low or skip town
while the danger lasted--or even if enrolled, he could do likewise
whenever tax time came around. Those who, willy-nilly, paid for
the delinquency of the others were, in their own words, the "infelici
successori dell'aggravio."[1] Given his stature, Piazzetta was inescap-
ably among the payers, and in a letter of 1744 he anxiously begged
for an advance on a commission so as to round out a payment due:
"Ricordo alla carità e benignita de V.S. Ill.ma che per l'amor di Dio
faci questo favore di quattro Filippi per supplire allo cento e
novanta una che debbo a S. Ecc.za mentre questa matina d'ordina di

[1]Venice, Correr Library, Cicogna, fol. 32, copy of a supplica-
tion of the Collegio dei Pittori to the Senate.

S. Ecc.za deve venire da me l'esattor [tax collector] del nostro arte
per riscuotere la detta summa di soldo e consignarlo al Magistrato
con altro numeroso soldo di raggione del nostro Arte . . ."[1]

These trying circumstances help to explain why so many Venetian
painters left their city for prolonged periods of time during the
first decades of the century. True, their services were in demand
abroad; but they were also attached to their native city--and besides,
except for frescoes, most foreign commissions could be executed at home.[2]
Early in the eighteenth century, the prior of the Collegio warned the
authorities that the leading painters might leave the city if pressed
too hard for taxes, as these "vertuosi vogliono attendere al loro
studio e acquistarsi gloria, et Honorare la Patria, da questi bisogna
riscuotere [collect] quello che danno, altrimenti se si sforzano sene
vanno altrove."[3] Definitive departures were rare, however, as against
temporary absences or brief disappearances during critical periods:
"E fuori" was a familiar refrain to the tax collector as he went the
rounds of painters' domiciles. In another writ of the early eighteenth
century, the prior de Coster described the situation vividly: "Nostro
povero Collegio qual'è composto di persone volanti differentiss[mo]
d'ogn'altro Arte, che hora vi sone et hora no . . . pochi sono quelli

[1]The letter is reproduced in Antonio Sartori, "Il Piazzetta
della Basilica del Santo a Padova," Arte Veneta, XIII (1959), 236.

[2]See above, p. 31.

[3]Venice, Archivio di Stato, Milizia da Mar, Busta 550, draft of
an undated letter addressed to the Collegio Maritimo.

che obbligati o dall'Età, o dalli impegni non ardiscono porsi in viaggi, se fermano qui, e contribuiscono parte della cuota di tansa, li altri poi si nascondono."[1] And in a supplication of July 14, 1713, the Collegio referred to departures of specific painters who could not cope with the taxes: "Fatta l'anno Corr^te la Tansa [the imposition] a matricolati per farne Pagamento in qsto Ecc^mo Mag^to sono partiti Il Raus [sic], Il Brussaferrato, et questo a motivo di non haver lavori non ponno ne meno pagar le Tanse et in qsti momenti partono anco il Balestra, et l'Abbate Cassana."[2]

A painless way for a painter to avoid joining the Collegio and paying taxes was for him to belong to the household of a distinguished Venetian family. As was previously indicated, such pittori di casa were numerous in Venice.[3] Nominally they were not exempted from joining the Collegio and paying taxes: "Non intendendosi mai che possino esser essentati dal descriversi in detto Collegio con il pretesto o di habitazione o di servizio che prestassero in case de particolari . . ."[4] But before the protection of their patrons, the law proved idle: "Nelle Dominante vi è un gran numero de Pittori, ma si come questi non sono matricolati nel Collegio per esser al Servitio di

[1]Ibid.

[2]Venice, Archivio di Stato, Milizia da Mar, Busta 550, letter addressed to the Collegio Maritimo by the prior of the Collegio dei Pittori, July 14, beginning with "Sopra il ricevuto commando . . ."

[3]See above, p. 28.

[4]Venice, Correr Library, Cicogna, fol. 61. Proclamation of May 9, 1693.

molti particolari non corrispondono tansa.[1]

During the first half of the century, the Collegio addressed petitions and supplications galore to the Senate for abatements of the overall annual imposition--to little avail. So tax evasion spread. And the wider it spread, the more sufferance it gained, and the worse the plight of the non-evaders grew in consequence: a vicious circle.

The registers of the arte dei depentori and of the Collegio are no longer traceable.[2] In the early nineteenth century the antiquarian Gian Antonio Moschini came across several of them and listed the painters' names he found inscribed together with dates. running from 1530 to the fall of the Republic.[3] Moschini's lists must be used with caution. The dates shown for a given painter are

[1]Venice, Archivio di Stato, Milizia da Mar, Busta 550, letter dated July 14, 1713 addressed by the collegiate painters to the Collegio Maritimo.

[2]But I had the good fortune of discovering two of the Collegio's registers among the documents of the Milizia da Mar, Busta 550, at the Archivio di Stato in Venice. They cover the years 1683-1686, and each bears the inscription Libro di Tansa (tax book). They contain the names and, in some instances, addresses and ages of the members, the amount of tax apportioned to each, and the amount already paid. The same busta also contains complete rosters of its membership prepared by the Collegio for the years 1690, ca. 1710, and 1726.

[3]Moschini's manuscript is today at the Biblioteca Correr at Venice. See Mss. Moschini XIX cartaceo sec. XVIII, cc. 32. Moschini's lists were published by Giulio Nicoletti, "Per la storia dell'arte veneziana--lista di nomi di artisti tolta dai libri di tanse o luminarie della fraglis dei pittori," Ateneo Veneto, XIV (1890), 378-382; 500-506; 631-639; 701-712. Terisio Pignatti reprinted the lists in "La fraglia dei pittori di Venezia," Bollettino dei Musei Civici veneziani, X, 3(1965), 16-39.

certainly ones for which that painter was registered, yet extant docu-
ments prove that many a painter was registered in other years too--
including years shown for other painters on Moschini's lists.[1] One
case in point is that of Matteo Stom, the famous painter of battle
scenes, who is down for the years 1687, 1688, and 1700 in Moschini's
lists, but whose membership in the Collegio is additionally documented
for 1682-1686.[2] Another is that of Piazzetta, whose name is followed
by the dates 1711, 1726, and 1730, but who was inscribed in the Col-
legio uninterruptedly from 1730 until his death in 1754.[3] Thus
Francesco Guardi, whose name appears on Moschini's lists for 1761
and 1763, may well have been registered with the Collegio in earlier
years as well.[4] Indeed, painters whose names do not appear at all on
Moschini's lists or in extant Collegio documents may nonetheless have
been registered at one time or another--in particular Lanfranchi,
Grazioli, Doxaras, and Antonio Guardi, who all resided in Venice for
prolonged periods. It is true that all four belonged to patrician
households more or less continuously. But it is also true that

[1]Either Moschini saw only partial lists for certain years or
his notation of dates was unsystematic.

[2]Venice, Archivio di Stato, Milizia da Mar, Busta 550, Libri
di tansa 1683-1686.

[3]Venice, Archivio di Stato, Giustizia Vecchia, Busta 204, passim.

[4]Cf. Muraro, 424.

among the twenty-six painters who founded the Academy in the middle
'fifties only Michiel Angelo Morlaiter and Antonio Guardi cannot be
counted as having belonged to the Collegio.

Only in 1756 was an Academy finally established in Venice.[1]
Though it emanated from the Collegio, the Collegio continued to func-
tion independently until the fall of the Republic. Already in their
petition of 1682 for separation from the arte dei depentori, the
painters had expressed the wish to be grouped in an Academy. At that
time they conceived of an Academy that would be primarily a profes-
sional association and secondarily a public school for drawing. Some
painters went further: Pietro Liberi, for example, envisaged lectures
on art and painting which would subsequently be printed.[2] But the
Senate responded with a lordly silence on the proposed Academy, and the
Collegio had been instituted instead. The Collegio thereupon launched
a public academy for instruction in drawing. In 1684 it stipulated that
no painter might keep apprentices who had not also been admitted by
the prior to this academy "che lo Collegio stava sul punto d'eriggere."[3]
But the new academy, depending as it did on private subsidies, was
short-lived.[4]

Small private academies already existed during the Seicento, the
most popular of them having been Pietro della Vecchia's, which da Canal

[1]On the founding of the Academy see Bassi, passim.

[2]Giambattista Verci, Notizie intorno alla vita e alle opere de'
pittori scultori e intagliatori della citta di Bassano (Venezia, 1775),
p. 249.

[3]Bassi, p. 14.

[4]Venice, Marciana, Rossi, fol. 57.

recalled at length[1] and which apparently served as a model for later ones. Such academies flourished during the eighteenth century as long as a public school for drawing was not established. Pitteri made an engraving of one such establishment, and a Guardi did a painting of another.[2] A certain Accademia di Nudo seems to have been particularly popular in the early decades of the century; numerous apprentices frequented it, and some virtuosi also came in order to keep in shape, among them Pittoni and even old Sebastiano Ricci.[3] In 1724, the Senate approved a project for a public Academy but the final decree was slow in emerging from the chancelleries of the Ducal Palace. In 1750, the authorities provided a room on the second floor of the Fontego della Farina for a provisional, small-scale academy that Piazzetta then set up. Finally in 1756, at the issuance of the long-awaited decree, Tiepolo with the assistance of Pittoni and Morlaiter chose twenty-three additional painters and ten sculptors to be the founding members of the Academy.

Just as there had been no Academy in Venice before the mid-eighteenth century, so there had been no organized painting exhibitions,

[1]Da Canal, p. XXIV: "Accademia che a quel tempo fioriva nella contrada di S. Trovaso, dove aveavi a primo per istruirvi la gioventù il famoso matematico, nostro pittore, Pietro della Vecchia. Questi, dopo avere esercitato i giovani nel disegno, compariva con qualche diversa lezione o di prospettiva o di notomia, o di ottica con applauso e concorso di molti virtuosi, e illuminava i meno intelligenti con erudizioni necessarie a grande profitto dell'arte."

[2]The engraving is reproduced in Antonio Morassi, Disegni antichi della collezione Rasini in Milano (Milan, 1937), pl. LXVIII. For the painting see Giuseppe Fiocco, Francesco Guardi (Florence, 1923), fig. 57.

[3]Moschini, Dell'incisione, p. 167.

with printed catalogues, similar to the French Salons.[1] As has been
seen an individual painter might exhibit a painting on his own ini-
tiative provided it was not for sale.[2] During the yearly Ascension
Fair only two painters were authorized to sell in the open (from a
stall on Piazza San Marco).[3] How the two were chosen is not on
record; the privilege was probably bought.

Once a year, however, on August 16--in Algarotti's words, the
"day dedicated to painting"--pictures were exhibited in the Campo
San Rocco. This yearly show was an event of importance. Several
engravers and painters recorded it, and Algarotti called it the
"tribunale, in certo modo, della pittura tra noi come è il Salone
in Parigi."[4] How the exhibitions were organized cannot be determined,
but it seems that every painter had the right to exhibit. Many a
beginner seized on the occasion to make his name known to the public:
"Per antica e lodevole usanza sogliono certi giovani Pittori oggidi
esponere al pubblico nella Piazza di San Rocco le prime opere loro
per attendere il giudizio di chi vi concorre, e megli profittare in
avvenire con onorato concetto."[5] The other paintings were old as

[1]On Venetian exhibitions see Francis Haskell and Michael Levey,
"Art Exhibitions in 18th Century Venice," Arte Veneta, XII (1958),
179-185.

[2]See above, p. 57.

[3]Venice, Archivio di Stato, Procuratia de Supra, Busta 53.
Cf. Haskell and Levey, 179.

[4]Bottari-Ticozzi, VII, 373.

[5]Gradenigo, p. 59.

well as modern, Venetian as well as non-Venetian. A painting was
not necessarily exhibited by its author: in 1737 Bernardo Bengozi
displayed a head by Ghislandi that he owned,[1] and in 1743 Algarotti
displayed a Maratta and a Cignani just purchased for the Elector of
Saxony.[2] Praise at San Rocco brought distinction to the artist.
Most painters in Venice seem to have exhibited their works at one
point or another in their careers. References to the San Rocco
exhibition abound in the literature of the time--and yet none involves
the Guardi.

[1]Hannover, Staatsarchiv, Dep. 82, Abt. III, No. 57, fol. 183.

[2]Posse, 54.

CHAPTER II

THE LIVES OF THE PAINTERS GUARDI

The lives of Venetian painters are not well documented--least
of all, it seems, the lives of the Guardi. The special scarcity
of documents on the Guardi can be explained at least to some extent.
All eighteenth-century Venetian painters who are esteemed today were
already esteemed during their life time, except the Guardi. Hence
it was only natural that the memorialists of the time, who took small
note of painters in any case, should have ignored the Guardi. The
purpose of this chapter is to reconstruct the lives of the Guardi
as far as the sparse documentary evidence permits.

There were three generations of painters named Guardi. Domenico
(1678-1716); Domenico's sons Giovanni Antonio (1699-1761), Francesco
(1712-1793), and Nicolò (1715-1789); Francesco's son Giacomo (1764-
1835)--and perhaps a cousin of Giacomo's.[1] No artistic traces left
by Domenico or Nicolò have been uncovered to date, though some draw-
ings and paintings have been speculatively attributed to them.[2]

[1]See below, pp. 94-95.

[2]See Rodolfo Pallucchini, Die Zeichnungen des Francesco Guardi
im Museum Correr zu Venedig (Florence, 1943), pp. 58-59; Giuseppe
Fiocco, "Il problema di Francesco Guardi," Arte Veneta, VI (1952),
102, 106, 120; Edoardo Arslan, "Per la Definizione dell'arte di
Francesco, Giannantonio e Nicolò Guardi," Emporium, V (1944), 9-10;
Estella Brunetti, "Considerazioni guardesche in margine alla Mostra,"
in Problemi guardeschi (Venice, 1957), p. 43.

Little known in their time, the Guardi--like most of their
more celebrated Venetian contemporaries--fell into oblivion during
the nineteenth century, except that interest in Francesco's views
of Venice survived, primarily in England.[1] Some of these had already
been purchased by English collectors during the eighteenth century--
generally as "Canaletti."[2] But only in the nineteenth century did
they enter England in significant numbers, to be "cherished in their
own right" as "Guardi pictures."[3] With rare exceptions they were
bought in Venice and in the Veneto as souvenir pictures, in series or
in batches, as one would buy picture postcards or commercial photo-
graphs today. The later benefactor of the National Gallery at
London, George Agar-Ellis, bought ninety-six of them

[1]Stefano Ticozzi, Dizionario dei pittori (Milan, 1818), p. 258:
"[Guardi] prese a dipingere le più vaghe vedute di Venezia con si
grande fortuna, che i suoi quadri venivano avidamente acquistati dai
nazionali e dagli stranieri."; Girolamo Dandolo, La caduta della
Repubblica di Venezia ed i suoi ultimi cinquant'anni (Venice, 1855),
p. 440: "I suoi dipinti sono sempre ricercatissimi e dagli Italiani
e dagli stranieri, e massime dagli Inglesi" In Venice itself
Francesco's fame as vedutista grew during the nineteenth century even
though his views were being sold to foreigners. In 1844 an unsatis-
factory appraisal of four of his views led to a lawsuit in Venice
during which two academicians, Bevilacqua and Astolfoni, called for
consultation, declared: "Li quattro dipinti . . .li riconosciamo
indubitamente pennello di Francesco Guardi e dei migliori di tale
autore che al giorno d'oggi è in molto pregio" See Trento,
Biblioteca Comunale, No. 2980, foll. 37-38.

[2]Guardi views also entered continental collections as "Canaletti".
Thus two important series of views today at the Akademie in Vienna were
purchased by Graf Anton Lamberg-Sprinzenstein as "Canaletti" at some
point in the latter eighteenth century (thus during Guardi's lifetime).
See Akademie der bildenden Künste, Vienna, Abschrift des Original
Inventars des Grafen Lamberg.

[3]Francis J. B. Watson, "Guardi and England," in Problemi guard-
eschi (Venice, 1967), pp. 209-212.

in Venice in 1828, and thirty-one were found in the collection of the famous connoisseur George Cavendish-Bentick upon his death in 1891.[1]

As "scholarship often follows the taste of collectors," it is not surprising that the first study of Francesco should have appeared in England: a monograph by George Simonson published in 1904.[2] Yet Simonson was not the first Guardi scholar. In the mid-nineteenth century Pietro Bernardelli, an attorney from Trent, had conducted research on the Guardi, obviously with a view to future publication. He died in 1868, leaving over a hundred sheets of transcribed documents and scribbles, but no manuscript.[3] Simonson drew heavily on Bernardelli's rich notes, reproducing some of the documents. Inexplicably, although he mentioned Nicolò, he ignored Antonio, thereby unnecessarily retarding further research. It was first announced that Francesco had an elder brother, also a painter, when in 1913 Gino Fogolari identified Antonio among the founding members of the Venetian Academy and drew attention to a signed painting by him, labeling it portentously "una povera cosa."[4] Thereupon Guardi scholars set to work with a zeal and an emotionalism rare

[1] Watson, p. 211.

[2] George Simonson, Francesco Guardi (London, 1904).

[3] Trento, Biblioteca Comunale, No. 2980.

[4] Gino Fogolari, "L'Accademia veneziana di pittura e scoltura del Settecento," L'Arte, XVI (1913), 249.

in art-historical research.[1] For the purposes of this biographical

inquiry, their multiple hypotheses and counter-hypotheses are best

disregarded in favor of a fresh look at the fragmentary documentary

record.

The Guardi family was native to the Val di Sole in the Trentino.[2]

Guardi are recorded in church documents of the Trentino as early as

the sixteenth century. By the seventeenth century the family had

split into two branches residing respectively in the neighbouring

villages of Mastellina and Almazzago. The painters descended from

the Mastellina branch. An imperial title of nobility was bestowed

upon this branch in 1643, but it is not known on what occasion and

for what services.[3] On its side, the Almazzago branch enjoyed great

esteem and relative wealth in the Trentino, and in time it too

acquired--or assumed--the privilege of using a seal.[4] The Almazzago

seal, a diagonally barred shield with two stars on each side, has

[1]For an almost exhaustive bibliography, see Pietro Zampetti, Mostra dei Guardi (Venice, 1965), pp. 383-410--and for the works that followed the Guardi exhibition of 1965, see Bibliografia della Mostra di Francesco e Gian Antonio Guardi, ed. Pietro Zampetti (Venice, 1966).

[2]Next to Pietro Bernardelli's papers the best source on the Trentino Guardi is Giovanni Ciccolini, "La famiglia e la patria dei Guardi," Studi trentini di scienze storiche, XI (1953), 105-131, 324-354 and XII (1954), 29-56, 189-200, 341-356. Ciccolini's manuscript had been completed and accessible to scholars some two decades before its posthumous publication.

[3]A copy of a fragmentary excerpt (no longer extant) from the certificate of nobility is at Trento, Biblioteca Comunale, No. 2980. It is reproduced in Simonson, p. 79.

[4]Trento, Biblioteca Communale, No. 2980, fol. 18.

been erroneously taken to be the coat of arms of the Mastellina

branch, which is represented by a shield divided into four quarters

with the first and fourth each containing a griffin, the second and

third a duck apiece.[1] The fact is of importance in view of the

presence of blazons in some Guardi paintings. The current view that

the Guardi were feudatory vassals of the Thuns rests on no documenta-

tion or tradition.[2]

The Guardi who were ennobled in 1643 were two brothers: Stefano

and Domenico. Domenico died in 1689, leaving three sons. The eldest,

Giovanni (1641-1717), took orders and had a successful ecclesiastical

career in Vienna as beneficiary at Saint Stephen's Cathedral. An

undated letter from him to the art-lover Count Harrach indicates that

he had close ties with the Harrach family and was introduced at

[1]The confusion originated with Ciccolini, 1954, 36-37, et
passim. Having noticed a sculptured, diagonally barred shield above
the entrance of a house at Mastellina, presumably the Guardis',
Ciccolini mistook it for the coat of arms of the Mastellina branch.
However, the whole masonry of the facade of that house is of very
recent construction, and the last Mastellina Guardi (Francesco
Guardi's sons Vincenzo and Giacomo) had sold the family house
already in 1793, most likely to relatives from the Almazzago branch.
See Trento, Biblioteca Comunale, No. 2980, fol. 65. Furthermore,
some documents from the early eighteenth century at the Diözesan
Archiv in Vienna, Pfarrakten St. Stephan, and at Trento, Archivio
di Stato, Carton 6287, foll. 8-9, signed by Mastellina Guardi, still
include original seals on which the four bids can clearly be seen.
Almazzago seals can be seen on documents at the Archivio della Com-
mezzadura, Mastellina; Archivio Arcivescovile, Trento, Causa Marcolla-
Guardi, No. 855; Trento, Archivio di Stato, Carton 6287, fol. 11

[2]Cf. Fernanda de Maffei, Gian Antonio Guardi pittore di figura
(Verona, 1951), p. 26. The Guardi are nowhere recorded in the docu-
ments of the Thun family archive at Vigo di Ton, Trentino. The pre-
sent Count Thun, Zdenko, assured me that the supposed Thun-Guardi
connection is backed by no tradition.

Court.[1] From Vienna Don Giovanni kept a vigilant eye on his posses-
sions in Mastellina and even managed to enlarge them, while in Vienna
he came to own real estate.[2] The youngest of Domenico's sons, Marc'
Antonio (1650-1717), left Mastellina early and made a brilliant career
in the Bavarian army. He died commander of Ingolstadt. The third
brother, Guardo de Guardi (1644-1718), stayed in Mastellina to rear
a large family in difficult financial circumstances. Three of
Guardo's sons reached adulthood. The oldest of them became a priest.
The youngest, Tomaso (1680-1771), joined his uncle Marc'Antonio in
Bavaria and had an equally brilliant military career. The remain-
ing son, Domenico, became a painter, the first Guardi ever to have
chosen that career.

Domenico was born in Mastellina on May 22, 1678.[3] He is re-
corded next in Vienna, where on March 12, 1698, he contracted
marriage with Maria Claudia Pichler. The bride, five years his
senior, was also from the Trentino.[4]

Despite the total absence of documentation on Domenico's youth,
it is generally believed that his uncle Don Giovanni invited him to
Vienna in the early 1690's to study painting.[5] This may well have

[1]Graflich Harrach'sches Familienarchiv, Vienna, Karton 24.

[2]Diozesanarchiv, Pfarrakten St. Stephan, Vienna, writ begin-
ning: Reither et Feldsperg.

[3]His birth certificate is reproduced in Maffei, p. 19.

[4]Quellen zur Geschichte der Stadt Wien (Vienna, 1908), VI,
p. 85.

[5]First asserted in a brief unsigned sketch by Pietro Bernardelli
(the draft for it is at Trento, Biblioteca Comunale, No. 2980):

happened. But a related hypothesis, that he studied under Peter Strudel, is less compelling.[1] No evidence of a link between Domenico and Strudel has come to light. Domenico may have received some early training in the Trentino, as it seems unlikely that the boy should have been sent from Mastellina to far-off Vienna to begin his apprenticeship when studios were flourishing in the Trentino, the most distinguished having been that of Giuseppe Alberti in Cavalese, in which Paul Troger, Johann Georg Grasmair, and Michelangelo Unterperger were trained.[2] But because Bernardelli called Domenico "eccelente nella parte ornamentale e decorativa e nei quadri di genere,"[3] Strudel came to be considered--oddly--as his probable master. That Domenico specialized in ornamental and decorative painting is conceivable, since decorative elements disclosing a non-Venetian influence abound in the early works of Antonio, who was most likely his pupil.[4] But Strudel himself did not specialize in decorative painting, nor is he known to have painted genre pieces. He was a figure painter whose work shows great affinity with that of the late seventeenth-century Venetian masters--especially Carlo Loth, whose _scuola_ he had

"Francesco Guardi pittore," La Gazzetta di Trento, November 12, 1862, p. 1, and thereafter variously formulated by Simonson, p. 13; Ciccolini, 1954, p. 38; Pietro Panizza, _Francesco Guardi_ (Trento, 1912), p. 9; Maffei, p. 25; etc.

[1]Nicolo Rasmo, "Recenti contributi a Giannantonio Guardi," _Cultura Atesina_, IX (1955), p. 155; Muraro, p. 423; etc.

[2]Nicolo Rasmo, "Per una biografia del pittore Giuseppe Alberti," _Cultura Atesina_, I (1947), pp. 85-88.

[3][Pietro Bernardelli], "Francesco Guardi pittore," p. 1.

[4]Especially _putti_ playing with flowers and garlands. The hollyhock frequently depicted by the Guardi does not figure in paintings by their Venetian contemporaries.

frequented in earlier years.[1] The floral and decorative elements found in some of his works are generally attributed to an occasional collaborator, such as Werner Tamm.

During his stay in Vienna, Domenico was, however, acquainted with another painter who did play a personal, and perhaps also an artistic, role in the Guardi's lives. This was Antonio Bellucci, after whom Domenico named his first-born son. Indeed on May 27, 1699, Bellucci stood a‿ godfather to Joannes Antonius Guardi at the baptismal font in the Schottenkirche in Vienna, together with a second godfather, the sculptor Johann Stanetti, after whom the new-born child was also named.[2] Bellucci was then at the height of his career, acclaimed as one of the great *virtuosi* of the time. His presence in Vienna is recorded in 1695 and 1697, years for which his name appears in the parish books of St. Michael[3] and in Prince Liechtenstein's account books respectively.[4]

[1] Peter Strudel's artistic personality has until recently been totally neglected. Dr. Manfred Koller of the Denkmalamt in Vienna is presently completing a monograph on Strudel including a catalogue raisonne. I am greatly indebted to Dr. Koller for letting me see his notes, copies of documents, and the reproductions of all the Strudel paintings he has so far been able to identify.

[2] Giovanni Antonio Guardi's birth certificate first published (in parts undeciphered) by Roberto Bassi-Rathgeb, "Un nuovo documento guardesco," *Arte Veneta*, IX (1955), p. 226, was republished by Nicolo Rasmo, "Recenti contributi a Giannantonio Guardi," *Cultura Atesina*, IX (1955), p. 152. The name of Antonio's second godfather, questioned by Rasmo, is indeed Stanetti, as the original birth certificate at the Schottenpfarre at Vienna shows.

[3] Pfarre St. Michael, Vienna, Ehematriken 1695. Bellucci witnessed at a wedding on October 15, 1695. He was described as "Antonius Beluzzi, Maler bei Fürst Montecuccoli."

[4] Archiv Liechtenstein, Vienna, Kastchen 91, Hoff Zahl Ambts Rechnung 1697: "18 Xbris Dem Antonio Bellucci contractor 7 Stück Mahlerei 3300 [Gulden].

That Domenico worked with him is quite possible,[1] though to dub him a decorative painter would be a misrepresentation. He was a figure painter in the full sense of the term. Yet a number of extant works usually ascribed to his workshop suggest that a decorative sideline was practiced there. (An example is reproduced in Fig. 1) Indications of a continuing acquaintance between the Guardi and the Bellucci are recorded for several later dates.[2]

Bellucci left Vienna by mid-1700.[3] And Domenico must have left at about the same time, since he is documented as residing in Venice in 1702, where his second child, Maria Cecilia, the future wife of Tiepolo, was born.[4] The baptismal certificate of Domenico's

[1] The documents reproduced in Quellen zur Geschichte der Stadt Wien indicate that it was customary in Vienna to have one's master or collaborator be godfather at a baptism or witness at a wedding ceremony.

[2] See p. 83n.

[3] Kind communication of Dr. Robert Wilhelm, Director of the Archiv Liechtenstein, Vaduz. In a letter of July 28, 1700, Prince Johann Adam wrote to his jeweler that Bellucci was in Venice again, painting soffiti.

[4] Archivio della parrochia di San Polo, Venice, Libro dei battezzati (1697-1725), fol. 84: "Adi 23 Giugno 1702 Maria, Cecilia, figa del Sigr Domco Grandi [sic] dal qm Gotardo et della Sigra Chiara [sic] sua consorte nata si detto. Battezzata [illegible word] il Signor Pievano sud. Compare il N.H. Gio: Paulo Giovanelli de qm Gio: Andrea Comare Maria Balbi della nostra contra." Pompeo Molmenti, Acque-Forti dei Tiepolo (Venice, 1896), p. XIVn, mentioned 1702 as the year of Cecilia's birth.

daughter gives the patrician Giovanni Paolo Giovanelli as godfather. It is the first record of the relationship between the Guardi and the Giovanelli, that was to last until the late 1780's. The Giovanelli, who favored the arts so richly, were then newcomers to Venice from the Trentino, where they retained much property. They regularly sent caseloads of paintings from Venice to their family castle at Tevana.[1] As the Giovanelli later patronized Antonio and Francesco, it is a safe guess that they sponsored Domenico as well.[2]

Nothing is known about Domenico's artistic activity in Venice and next to nothing about his personal life. A further connection with Bellucci is doubtful, as by 1703 Bellucci was back in Vienna,[3] where he was to stay for a prolonged period. However, Bellucci's son, Giovanni Battista, a painter himself, is inscribed in a document of 1715 as godfather to Domenico's youngest son, Nicolò.[4]

Domenico's name figures on Moschini's lists--thus as member of the Collegio dei Pittori--for the year 1715. As has been pointed out previously, this does not mean that he was a master of a workshop or

[1] See correspondences and receipts pertaining to paintings dispatched from Venice to Tevana, and the inventories of pictures at Trento, Archivio Castel Tevana, Giovanelli, filza 29.

[2] Unfortunately the private Venetian archive of the Giovanelli family was dispersed at the beginning of the century, including the valuable libri-cassa. The few paper rescued from it that are at the Archivio in Venice yield no information on the Guardi, nor does the vast Giovanelli archive at the Archivio di Stato in Trento.

[3] Archiv Liechtenstein, Vienna. Kästchen 92: "1703 20 Martij dem H Bellucci lauft quitiert 1500 [Gulden]."

[4] See p. 83n.

even that he had not been a member of the Collegio before that
date.[1] Soon after Maria Cecilia's birth in 1702, Domenico moved
with his family to the parish of Santa Maria Formosa,[2] where he
remained until, in 1716, he died at the age of thirty-eight.[3]
The church papers refer to his funeral as "con capitolo," which
signifies the presence of twelve priests with candles, a luxury
that not all Venetians could afford.

At Santa Maria Formosa four more children had been born to
Domenico: Iseppo Benedetto, on February 3, 1706 (more veneto
1705),[4] who died the following June 8;[5] Iseppo Piero, baptised on

[1]But he was not inscribed in 1712, the date of a full list
of collegiate members that is still extant. See Venice, Archivio
di Stato, Milizia da Mar, Busta 550.

[2]He must have moved in 1703 or 1704, as his wife's death
certificate of 1744 (see below p. 83n) records that she had
resided at Santa Maria Formosa for forty years uninterruptedly.

[3]The death certificate is reproduced in Ciccolini, 1954,
197n.

[4]According to the Venetian system of measuring time, the
more veneto, the year began on March 1st and ended on the last
day of February.

[5]Archivio della parrochia di Santa Maria Formosa, Venice,
Libro dei Battezzati (1694-1712), fol. 232: "Adi 3 Febraro a
N.e D.ni - Iseppo Benedetto et Com.co Fig⁰ di Ms. Dom.co Guardi
de D⁰ Guardo da Val di Mastellina Pitor e di Mad.a Claudia
Pichler giugali, nato hieri battezzato da me Piev. Raddi, Comp.
e d⁰ Gerardo q. Zuanne Bettini dall'acqua vita di nostra Contra,
quale ha tenuto in luoco del Sigʳ Ant⁰ Algiburg Co. Michiel di
Contra di S.ta M.a Nova, Com.e Laura Lanzetti di nostra Contrà."
Iseppo's death certificate is in the same archive, Libro Morti
(1695-1709), fol. 235.

June 29, 1709;[1] Francesco Lazzaro, the later _vedutista_, on October 5,

1712;[2] and Nicolò, on December 9, 1715, the year preceding Domenico's

death.[3] Domenico's widow remained in the parish of Santa Maria

Formosa until her death in 1744 (_more veneto_ 1743).[4] At first, with

her five underage children, her situation must have been a difficult

one, the more so since Domenico does not seem to have left an inherit-

ance[5] and she herself does not appear to have had a dowry.[6] Financial

assistance probably came from Don Giovanni, Domenico's ecclesiastical

uncle in Vienna.[7]

[1]Archivio della parrocchia di Santa Maria Formosa, Venice, Libro
dei Battezzati (1694-1712), fol. 320: "Iseppo Piero Candido Biasio
fio di D° Domenico Guardi de Guardo Pittor e della Sig^ra Claudia
Picheter, jiugali, nato hoggi, battezzato dal Sig^r P. Pietro Romano
2° Diac. Tit° e Sagrestano de Licentia Parocchi, Comp^e il Sig^r Biasio
da Balter di nostra contrada, Com^e Pavanella sta a S^ta Maria Nova."

[2]The birth certificate reproduced in Simonson, p. 78.

[3]Ciccolini, 1954, pp. 195, 199n, gives a shortened version of
Nicolò's birth certificate. The original at the Archivio della par-
rocchia di Santa Maria Formosa, Venice, Libro dei Battezzati (1712-
1727) fol. 32, reads: "Adi 9 dicembre 1715 - Nicolò Dom.co Giuliano
fio di D° Dom^co Guardi di Guardo e di donna Claudia Pichler giugali
nato oggi battez.o dal P. Pietro Romano s° diac° Tit° e sag. pe Lic^a
Parocchi Comp^e il Sig. Gio: Batta Belluzzi del Sig^r Ant° sta a
S. Zulian, Com^e Lanzetti di Contrà."

[4]Archivio parrocchiale di Santa Maria Formosa, Venice, Libro
dei Morti (1738-1748), fol. 157: "Adi 21 Gennaio 1743 - La Sig^a
Claudia Picler velita del q^m Dom^co Guardi d'anni 70 in c.a. dimor-
ante in contra da anni 40 amalata da Febbre e Cattaro giorni sette
mori questa mattina all'ore 15 come da fede de medico Ferro al n.o
753. La faranno sepellir suoi figli con capto."

[5]No testament by him has yet been discovered, and his name is
not recorded at the Archivio di Stato in Venice, Calcoli intestati,
Inquisitorato alle Acque, where inventories of the goods of intestate
deceased are recorded.

[6]Her name does not figure as widow with dowry on the Registri
Vadimoni, Giudici del Proprio at Archivio Venice.

[7]Don Giovanni de Guardi died in Vienna in 1717. Shortly before

The generally accepted story of the Guardi after Domenico's
death is that Antonio became head of the Guardi bottega and sup-
ported the whole family.[1] It is unfounded and implausible. First
of all, there is no telling whether Domenico had a bottega or, like
some of his contemporaries, was still working "under the direction"
of a better known master at the time of his death. But even had a
Guardi bottega existed prior to 1716, could an adolescent have
assumed its direction and supported a family of six? At his father's
death Antonio was three years short of his majority; he had no legal
rights;[2] and no other instance is known of a master--painter or not--

his death he made a will (a complete copy is at the Biblioteca Comun-
ale in Trento, No. 2980, foll. 85-89, and a short excerpt was pub-
lished by Ciccolini, 1954, p. 52n). He left his entailed properties
in Mastellina to his poor brother Guardo, specifying, however, that
after Guardo's death, in accordance with the right of primogeniture,
the estates should pass to Guardo's oldest living son, who had been
Tomaso since Domenico's death. Only if Tomaso had no male descend-
ants was the inheritance to revert to Domenico's first-born, Antonio.
In 1718 Guardo died and Tomaso came into the inheritance that would
have been Domenico's had he lived. However, shortly before dispos-
ing of his possessions by testament, Don Giovanni had sold, in some
haste, a valuable piece of property (a house in the fashionable Tra-
bantenstrasse in Vienna) for 6000 Gulden that were then disposed of
immediately. See Diözesanarchiv, Wien, Pfarrakten St. Stephan. The
identity of the recipient is not recorded, but a guess may be taken
that the money was sent to Venice.

[1]For various versions of this story see Max Goering, Francesco
Guardi (Vienna, 1944), p. 9; Nicolò Rasmo, "Recenti contributi a
Gianantonio Guardi," Cultura Atesina, IX (1955), 158; Antonio Morassi,
"Antonio Guardi ai servigi del Feldmaresciallo Schulenburg," Emporium,
CXXXI (1960), 208; Francis J. B. Watson, "The Guardi Family of Painters,"
Journal of the Royal Society of Arts, XIV (1965-1966), 268; Fritz
Heinemann, "Mostra dei Guardi," Kunstchronik, XVIII (1965), 234.

[2]Trento, Biblioteca Comunale, No. 2980, fol. 88. A document of
October gives Giovanni Andrea Rossi as the guardian of Domenico
Guardi's children.

running a <u>bottega</u> in Venice at the age of seventeen. Had Antonio
shown unusual artistic precocity, the assumption would be more
acceptable; this was not the case, however, as a devotional picture
painted and signed in 1717 clearly demonstrates (Fig. 2). Awkward
as it is, this picture constitutes a precious biographical document.
In its mystical pietism it is far more akin to Central European than
to Venetian art. It may reflect Domenico's imprint on his son.
Then again, it may reflect a direct exposure to foreign influence.

And indeed, the next document to speak of Antonio signals his
presence in Saint Stephen's Cathedral at Vienna on February 15, 1719,
as witness at the wedding of Giuseppe Galli-Bibiena,[1] the court stage
designer who was also in charge of erecting catafalques whenever the
occasion arose.[2] A professional relationship cannot be inferred
from this single source. But it is tempting to envisage Antonio
beginning his career as a <u>Komödienmaler</u> painting stage sets,[3] the
more since the mannered figures so carelessly brushed into his later

[1]Pfarre St. Stephan, Vienna, Ehematriken, Band 42, fol. 107.
Guardi is recorded as "<u>Carl Antonius Guardi Mahler</u>." The "Carl"
should raise no doubts about who was meant. The name Guardi was
exceedingly rarely encountered in eighteenth-century Austrian and
Venetian documents. Furthermore, the transcript into the parish
books was made from the original marriage certificate on which
Antonio must have signed his name in Italian (Gian Antonio Guardi)
and which was transcribed by the church clerk. Incorrectly tran-
scribed foreign names are frequent in St. Stephan's parish books.
Thus Galli-Bibiena is recorded in the same document as born in
Wollonien instead of Bologna.

[2]For Giuseppe Galli-Bibiena's activity in Vienna see Franz
Hadamovsky, <u>Die Familie Galli-Bibiena in Wien</u> (Vienna, 1962), <u>passim</u>.

[3]Dr. Franz Hadamovsky from the Theatersammlung, Hofkammerarchiv,
Vienna, informed me that no documentation on Bibiena's workshop or on
his collaborators has yet been unearthed.

works require viewing from a distance.

If Antonio left Venice after his father's death to complete his training abroad, he would presumably have chosen Vienna, where he had relatives and family friends, over traditional Bologna or Rome. By then his second godfather, Johann Stanetti, had achieved great fame in Austria.[1] A protégé of Prince Eugene, who commissioned works from him for the Belvedere, Stanetti was also court sculptor and contributed to the adornment of catafalques, which may have brought him into contact with Bibiena. Furthermore, Antonio had two cousins in Austria at the time: Don Bonifacius de Guardi was attached to a grandee at court,[2] and Stefano Alberto de Guardi, who resided in Salzburg and occasionally in Vienna, was on his way to becoming Kriegsrat. Around 1715 Stefano Alberto had married the daughter of the court painter Johann Michael Rottmayr[3] who was on intimate terms with Stanetti. Rottmayr and Stanetti both had ties with a group of sculptors from the Trentino of whom one, Johann Pichler, was related to Antonio's mother.[4]

In the present state of research no more can be said

[1] See "Vergessene Künstler Oesterreichs," Wiener Zeitung, 1884, p. 4.

[2] Diözesanarchiv, Wien, Pfarrakten St. Stephan, writ entitled: "Wohl Edel Hochweisser Statt Rath."

[3] Information in a letter to me from Dr. Georg Simmerstatter, Generalvikar, Erzbischöfliches Ordinariat, Salzburg.

[4] For the relationships among the artists mentioned see Quellen zur Geschichte der Stadt Wien (Vienna, 1908), VI, passim.

about Antonio's stay and possible activity in Vienna.[1] Nor does any document disclose his whereabouts during the 1720's, so that, as in the case of his father, virtually nothing is known of his training and early professional life. Apart from the signed picture of 1717, his extant figure paintings show no affinities with Austrian culture. True, the superabundant floral elements in some of his works argue a non-Venetian influence--perhaps a Central-European one--but his oeuvre as a whole springs straight from the Venetian milieu. Thus he would seem to have spent most of the 1720's, which in a way were still his formative years, in Venice, and if so he must have had some contacts with Tiepolo, Bellucci, and Sebastiano Ricci.

Tiepolo had become Antonio's brother-in-law on November 21, 1719, when he married Maria Cecilia,[2] and the aging Antonio Bellucci had returned to Venice in the early 'twenties to spend the last years of his life there. As for Sebastiano Ricci, a document of 1750 at the parish archive of Pasiano speaks of Antonio as "de la scuola di Bastiano Rizzi."[3] The reference must be viewed with caution, however, as it was inserted at a later date (in another ink). Antonio may well have belonged for a time to the important scuola that

[1]His name appears neither in the Hofzahlamtbucher at the Hofkammerarchiv, nor in the Steuerbücher of the Archiv der Stadt Wien, nor in any of the documents in the parishes of St. Stephan, St. Michael, St. Ulrich, zu den Schotten, Mariatreu, or Lichtenthal.

[2]Pompeo Molmenti, Acque-Forti del Tiepolo (Venice, 1896), p. xiv.

[3]Vittorio Querini, "I documenti sulla pala di G. Antonio Guardi della Arcipretale di Pasiano di Pordenone," Messagero Veneto, November 21, 1966, p. 3.

Sebastiano directed during the 1720's in Venice. But it is to be
doubted that the connection was a long-lasting one, or for that
matter that young Antonio ever submitted to rigorous training by
a single master. Rather, his works arouse the suspicion that he
was self-taught. In the works--especially the early works--of
most Venetian and Austrian painters the imprint of a master is
visible, but not in Antonio's. His weak draughtsmanship, his total
lack of compositional originality, and his inability to cope with
elementary anatomical problems also suggest that basic training
was wanting. A want of professional training may indeed have led
him to become a copyist at an earlier date, though the first docu-
ments to speak of Guardi copies date from 1731.

In a will drawn up on December 15, 1731, Count Giovanni Bene-
detto Giovanelli bequeathed to a certain Antonio de Caroli several
copies of paintings made by the Guardi brothers.[1] The passage in
the will could only apply to Antonio and Francesco; Nicolò was too
young, and Iseppo had died in 1720 (1719 more veneto) at the age of
ten.[2] Given Francesco's age the copies could not have been in
Giovanelli's collection long before 1731.

Except for brief absences, Antonio Guardi resided in Venice
from 1730 to 1761, the year of his death. His name appears only

[1] Giuseppe Fiocco, "Il Ridotto ed il Parlatorio del Museo
Correr," Dedalo, VI (1925-1926), p. 538.

[2] Archivio parrochiale di Santa Marina, Venice, Libro Morti
1714-1736, fol. 42: "Adi 9 Gen^ro 1719 M.V. Iseppo fio del Sig^r
Dom^co Guardi d'anni 10 in c^a ammalato già giorni 8 da febre e
varole. Visitato dall'Ecc^te Steffani. Lo fara sepelir suo Padre
[sic] con capto."

rarely in official or notarial documents of the time, and not at all
in the surviving documents of the Collegio dei Pittori. The richest
source of information on him are the papers of Marshal von der
Schulenburg[1] for whom he worked as copyist and hack-painter between
May 1730 and December 1746.[2]

In 1715, at the end of a long and successful military career,
Johann Matthias Reichsgraf von der Schulenburg (1661-1747) entered
the service of the Venetian Republic to defend it against the Turks
and defeated them at Corfù.[3] Acclaimed as the liberator of Venice,
he settled there. He rented the palazzo Loredan and, surrounded
with a predominantly non-Venetian staff of secretaries and servants,
held a small court, participated in affairs of state, and avidly col-
lected works of art.[4] Despite the wealth of documents on the gallery
he assembled, it is not easy to gain an adequate conception of him
as collector. His taste was much in keeping with that of his Venetian

[1]A large part of the Schulenburg documentation concerning
Antonio Guardi was published by Antonio Morassi, "Antonio Guardi ai
servigi del feldmaresciallo Schulenburg," Emporium, CXXXI (1960),
147-164, 199-212. Schulenburg's papers at the Staatsarchiv at
Hannover constitute the richest source on artistic life in Venice
during the fourth and fifth decades of the eighteenth century: see
Alice Binion, "From Schulenburg's Gallery and Records," The Burlington
Magazine, CXII (1970), 297-301.

[2]Hannover, Staatsarchiv, Dep. 82, Abt. III, No. 80, fol. 159.
Cf. Morassi, pp. 149-150.

[3]On Schulenburg's military career see Antonio Morassi, "Sette-
cento inedito," Arte Veneta, VI (1952), pp. 85-88.

[4]At his death Schulenburg's collection amounted to 957 items,
including some thirty pieces of sculpture. See Hannover, Staats-
archiv, Dep. 82, Abt. III, No. 37, inventories.

contemporaries, as the inventories of their collections show; he shared their taste for Flemish and distaste for French painting. He does not seem to have discovered unknown talents or influenced known talents. He did buy treatises on painting and lives of painters, and must have developed some artistic discernment over the years. But collecting for the sake of collecting, with a view to establishing a permanent gallery,[1] appears to have been the best part of the fun for him.

A great collector, Schulenburg was also a great patron. With the exception of Tiepolo, most leading artists of the Veneto seem to have come into contact with him at one time or another. He was well acquainted with Sebastiano Ricci, of whom he had a portrait painted by Nazzari.[2] Pittoni was his chief adviser, restorer, and supplier of pictures during the 'thirties.[3] He was the only eighteenth-century collector to boast of owning thirteen paintings by Piazzetta,[4] including the two intriguing pastorales today at Chicago and Cologne respectively.[5] And the largest view ever painted by Canaletto was

[1] In spite of Schulenburg's testamentary dispositions, his collection was dispersed after his death. A residue of his gallery, amounting to one ninth its original size (some 130 pieces), is in the depository at the Landesmuseum at Hannover, forgotten and unnoticed.

[2] Hannover, Staatsarchiv, Dep. 82, Abt. III, No. 51, fol. 180. The painting is presently at the depository at the Landesmuseum Hannover, unattributed.

[3] Ibid., Libri-cassa, Nos. 51, 61, passim.

[4] Ibid., No. 33, inventories of 1741 and 1747.

[5] The final payment for the Pastoral Scene (today at Chicago) was made on June 2, 1740, and the last payment of the Group on the

commissioned by him.[1]

Antonio Guardi is recorded seventy-seven times in Schulenburg's libri-cassa,[2] which cover roughly the period 1730-1747 (the records for the years 1731-1732, 1734-1735, and 1741 are incomplete). The documents refer to at least 103 different items commissioned from Antonio. The entries in the libri-cassa do not always specify whether the works commissioned were copies, but complementary information in the inventories indicates that most of them were. Only a series of four history paintings and a group of genre pictures depicting the customs of the Turks are nowhere described as copies.[3] The inventories also list many portraits by Antonio of the Marshal or of his fellow grandees. To infer from this that Antonio was Schulenburg's personal portraitist would be to give him a status he certainly never had. The Marshal most likely never sat for him, for most of the portraits are listed as copies after originals or engravings from the gallery.

Of all painters gravitating in Schulenburg's orbit, Antonio was the least well remunerated, and in the inventories his works are

Seashore (today at Cologne) at the delivery of the painting on April 30, 1745. See Libri-cassa, No. 61, fol. 296, and No. 80, fol. 29 respectively.

[1]Ibid., No. 57, fol. 19.

[2]See Appendix A.

[3]Several of these Turqueries were discovered in recent years. They derive largely from engravings after Van Mour. See Francis J.B. Watson, "A Series of 'Turqueries' by Francesco Guardi," The Baltimore Museum of Art News Quarterly, XXIV (1960), 3-13. Watson's attribution is erroneous: Antonio painted most of the Turqueries and Francesco none.

invariably classified as "mediocri" or even downright worthless. And yet he is the painter whose relationship with Schulenburg lasted longest, ending only with the latter's death. It is not possible to explain why Schulenburg should for sixteen years have patronized a man whom his favored advisers--Piazzetta, Diziani, and Simonini--disregarded and whose works he often relegated to servants' quarters. But then it is difficult to account for so many of the eccentric Marshal's doings.

Antonio Guardi's name first appears in Schulenburg's account books for May 1730, though he may have entered the Marshal's service at an earlier date.[1] From May 1730 to June 1736 he received a monthly salary;[2] thereafter he worked on commission only. As long as he remained salaried he must have resided with Schulenburg, as during these years he received a vito for his maintenance whenever he was engaged on some work "outside" just as did other members of the staff "che mangiano fuori."[3] Furthermore, in the libri-cassa his name appears grouped with those who belonged to Schulenburg's household. Thus he was in all likelihood pittore di casa, yet his position should not be regarded as that of a court painter.[4] The highest monthly

[1]The first extant libro-cassa is inscribed: "No. 3." Presumably two preceding ones have been lost.

[2]Cf. Morassi, 149, who implies that Antonio remained salaried for a longer period.

[3]Hannover, Staatsarchiv, Dep. 82, Abt. III, No. 61, fol. 24, et passim.

[4]Cf. Morassi, 149. No document speaks of Antonio as "Pittore di S.E."

pay he ever received was two _zecchini_, a remuneration about equal to
a manservant's pay at the time.

An entry of February 1, 1742 in the account books designates
Antonio as "_Pittor di Ca' Donà_."[1] Thus at some point he must have
left Schulenburg's household to enter the service of the Donà dalle
Rose family while continuing to work for the Marshal on commission.
Unfortunately, nothing is known of his connection with the Donà
family.[2]

Antonio's residence at Schulenburg's in the 'thirties and his
subsequent service with the Donà family raise the question of a
Guardi _bottega_. The reference to the Guardi brothers in Giovanelli's
testament of 1731 points to a collaboration between brothers within
a family workshop. It is difficult to imagine how Antonio could have
headed a workshop thereafter while serving as _pittore di casa_, and
yet indications of his having collaborated with someone cannot be
ignored. Thus some of the paintings he delivered to Schulenburg are
not manifestly by a single hand, nor are the three lunettes he painted
around 1738 for the Trentino church at Vigo di Ton.

In 1738 Antonio was in the Trentino. The previous year, on August
3, 1937, Commander Tomaso de Guardi had transferred to his nephew Antonio
all the properties in Mastellina he had inherited in 1718. The form-
alities of the transfer called for Antonio's personal appearance on

[1] Hannover, Staatsarchiv, Dep. 82, Abt. III, No. 77, fol. 84.

[2] One third of the Donà family papers were destroyed by fire some
decades ago, among them the _libri-cassa_ for the 1740's. Communication
to me by Count Donà dalle Rose.

the premises.[1] Two documents record his presence in the Trentino

in 1738. On October 6, 1738, he appeared at the Court at Clas,[2]

and on October 10, 1738, in the presbytery of Vigo di Ton, he gave

a power of attorney to the parish priest, Don Pietro Antonio Guardi,

a relative from the Almazzago branch.[3] An entry of October 14, 1738,

records a disbursement of 150 _ragnesi_ for three large paintings

placed on that day in the sacristy.[4] Undoubtedly they had been

brought from Venice by Antonio.[5] The three lunettes still hanging

in the sacristy are unanimously considered as "_guardeschi_"; but one

is distinctly not by Antonio, a fact which again speaks for a work-

shop or at least some form of collaboration.

An entry of December 26, 1742 in Schulenburg's _libri-cassa_

records that a payment for works commissioned from Antonio was made

to the "_putto Guardi_."[6] In eighteenth-century Venetian usage, the

word _putto_ could mean boy (or son) as well as apprentice. In the

[1]Maffei, pp. 27-31, _et passim_; Trento, Archivio di Stato, Carton 6287, _passim_ and Carton 1614, _passim_.

[2]_Ibid._, p. 28.

[3]Trento, Archivio di Stato, Carton 6287, fol. 27. But Maffei, p. 28, mentions a power of attorney on October 30, 1738--perhaps a misprint.

[4]Maffei, p. 34.

[5]Maffei, p. 38. In his testament of 1753 Don Pietro mentioned the paintings: "Ho fatto venire tre quadri grandi di nobile pennello da Venizia, che costano Ragnesi cento e cinquanta a ornamento della sacrestia." See Trento, Archivio di Stato, Atti G. B. Gottardi, Carton 1702, foll. 6-11.

[6]Hannover, Staatsarchiv, Dep. 82, Abt. III, No. 77, fol. 181.

present case it may well have meant both.[1] The boy could hardly
have been a son of Nicolo or Francesco old enough to be entrusted
with an errand of this kind. However, not the slightest indication
of Antonio's having been married has come to light. So the question
must be left open. Suffice it to bear in mind that there were per-
haps more Guardi who painted than has been suspected so far.

A passage in Casanova's memoirs could also be interpreted as
indicating that a regular Guardi workshop existed in the early
'forties. The author told of his brother Francesco Casanova (the
later battaglista) as lodging with the painter Guardi, who kept a
strict eye on him.[2] Seen in the broader context of the memoirs,
the reference can only apply to the year 1743 or shortly after.[3]
Furthermore, an earlier passage in the memoirs that refers to the
same period has Francesco Casanova living in a "bonne maison."[4]
"Decent house" is a typical French way of styling a boarding house,
but as Francesco Casanova, then aged 15, must have already started
his apprenticeship, he most likely lived at the house of his master,
as was then customary.

[1]Had the boy been an unrelated apprentice, the entry would have
read "putto del Guardi." But "putto Guardi" can only be interpreted
as meaning a boy--perhaps an apprentice--by the name of Guardi. The
distinction was always observed by Schulenburg's accurate bookkeeper.
Thus references are found to a "putto Nazzari" and it is known that
Nazzari had a son working in his bottega. Other references are made
to a "putto del Sebastiano [Ricci]," obviously a young apprentice,
but not a son as Sebastiano had none.

[2]Passage reproduced in English translation in Simonson, p. 14.

[3]Jacques Casanova de Seingalt, Histoire de ma vie (Paris, 1961),
I, chap. VI, passim.

[4]Ibid., p. 121.

In what relationship the three Guardi brothers stood to one
another is not to be learned from documents. Antonio certainly did
not work alone, and as Francesco's authenticated figure paintings
show stylistic affinities with Antonio's, a family workshop is usually
taken for granted--very plausibly. However, there is no sure basis
for ascertaining in what years a collaboration between the brothers
existed and whether it was a lifelong or even a prolonged one. The
Guardi _bottega_ problem is further complicated by the absence of docu-
mentation on Francesco before he reached middle age and the scarcity
of documentation on Nicolò.

Nicolò married in his early twenties--at some time before 1739,[1]
when his son Domenico Francesco was baptised in the parish of Santa
Marina.[2] His wife, Cecilia, was the daughter of Giovanni Antonio dal
Moro, a painter, nicknamed _Pittura_.[3] At least three more children

[1]Cf. Ciccolini, 1954, p. 195, who, without indicating his
source, dates the marriage 1741. Nicolò's marriage certificate has
not been discovered, but the baptismal certificate of Nicolò's first-
born, dated 1739, records that the parents were married. See
p. 96n.

[2]Archivio della parrocchia di Santa Marina, Venice, Libro dei
Battezzati 1715-1759, fol. 203: "Adi 2 Aprile 1739 nacque un putto
Adi r d.to fu batt^to p me Pio: e posto nome Dom^co Fran^co figlio del
Sig^r Nicolò de Guardi q. Dom^co Pittor e della Sig^ra Cecilia q. Gio.
Ant.^o dal Moro jugali Comp^e L'Ill^mo Sig^r Conte Diodaro Scerinian qm
Marcora di Contra di SS^ti Apostoli Com^e Virginia Vaira di Contra
di S. Silvestro."

[3]The marriage certificate of Cecilia's parents, dated 1713, is
at the Archivio della parrocchia di Santa Marina, Venice, Libro dei
Matrimoni 1710-1795, fol. 10. Her father is designated as "Zuanne
Ant^o dal Moro detto Pittura."

were born to Nicolò in the 'forties: Maria Anna in 1742,[1] Giacoma Elena in 1743,[2] and Antonio around 1746.[3] The baptismal certificates of Nicolò's children record as godfathers the wealthy patricians Giovanni and Vincenzo Loredan who may have been Guardi patrons. Little else is known about Nicolò: a nineteenth-century source characterizes him as "esimio pittore di camera" and the 1790 catalogue of pictures belonging to Giovanni Vianelli lists a drawing of his representing a landscape and designates him "pittore anch'egli di nome."[4]

Brief collective references to the three Guardi brothers are also found in some notarial writs of the 'forties and later that bear on the management of their properties in the Trentino. Though Captain Tomaso de Guardi had transferred his goods to his nephew Antonio exclusively,[5] the latter must have extended his rights

[1] Archivio parrocchiale di Santa Marina Formosa, Venice, Libro dei battezzati 1733-1748, fol. 175: "Maria Anna figa dell'Illmo Sigr Nicolò Guardi qm Domco e dell'Illma Sigra Cecilia del Moro, giugali, nata li 8 corrte battezata da P. Benedetto Lapetti Giovine e Sagno di Licenzo Parochi. Compe il N.H. Vincenzo Abbate Loredan fu de q. Domco di Contrà di S. Vio, Come Virginia Vaira di Contrà di S. Silvestro."

[2] Archivio parrocchiale di Santa Maria Formosa, Venice, Libro dei Battezati 1733-1748, fol. 194: "Adi 12 Xbre 1743, Giacoma Elena figa dell'Illmo Sigr Nicolò Guardi qm Domco e dell'Illma Sigra Cecilia dal Moro, giugali nata li corrte battez [sic] a P. Benedetto Lapetti Giovine e Sagrio de licenza Parochi, Compe il N.H. q. Zuanne Loredan fu de q. Domco di Contrà di S. Vio. Come Virginia Vario di Contra di S. Silvestro."

[3] Ciccolini, 1954, 200n. The baptismal certificate is no longer extant, but his death certificate indicates that he was born around 1746.

[4] Reproduced in Simonson, p. 76.

[5] Ibid., p. 19.

[6] Trento, Archivio di Stato, Carton 6287, foll. 8-9.

to his brothers and shared the profits with them, as most documents do not refer to him in particular but to the pittori or fratelli Guardi. Already in 1742 a Trento attorney recorded a transaction between the "siri [signori] figli qm Dom.co Guardi abitanti in Venecia" and a leaseholder of theirs in Mastellina.[1] In 1748-1749 a serious litigation ensued between the "Sigri Francesco, Nicolò and Gioan Antonio fratelli Guardi abiti in Venecia" and the tenant of their house in Mastellina.[2] The final clause in the agreement specified that they, their children, or their families might occupy the house whenever they chose to sojourn in Mastellina[3]--which suggests that they did occasionally so choose. Again in a notarial document of 1753 concerning the sale of a sepulchral tomb in Mastellina, all three Guardi are mentioned as residing in Venice.[4]

In 1755 the Guardi's brother-in-law Tiepolo was commissioned by the Reformatori di Padova to choose twenty-six painters and ten

[1]Maffei, p. 125.

[2]Trento, Archivio di Stato, Atti Giuseppe Rossi, Carton 1615, foll. 100-103.

[3]Ciccolini, 198n and Trento, Archivio di Stato Atti Giuseppe Rossi, Carton 1615, fol. 103: "Con questo fatto che rispetto alla casa, stabio e broilo venendo alla patria li Sig.ri Guardi Patroni Principali, o sia figli di questi, o sue famiglia e volendo essi abitare che in tal caso rispetto alla casa, broilo e stabbie sia annullata la locatione, ma questi debba il Thame lasciare ad essi Sig.ri Guardi intendendosi fra tanto che l'abiteranno, ma che no possino ad altri darla vita durante del Thame. Come pure se venisseron l'accenati Sig.ri Pli per qualche tempo dell'anno, ò sij alli Freschi, che pure in tal tempo possino abitare la casa non pero ad esclusione del Thame."

[4]Rodolfo Gallo, "Note d'archivio su Francesco Guardi," Arte Veneta, VII (1953), 153.

sculptors as founding members of the public Academy, which the Senate
finally sanctioned the following year. Antonio Guardi was one of
Tiepolo's nominees. Whether Antonio's nomination was based on recog-
nition of his merit or was due to nepotism is not known. His name
figures only once in the Academy protocols: he attended a general
meeting on August 26, 1759.[1] That same year he is also recorded for
July 18 as having countersigned a power of attorney issued in Venice
by a friend of the Guardi, Don Francesco Ferri.[2]

Antonio Guardi died on January 23, 1761 (not 1760 as usually
stated), at the age of sixty-one, in the parish of the Santi Apostoli,
where he was buried.[3] He had been ill for three months, probably with
sclerosis of the liver. He left no will, and the inventory of his
intestate possessions is no longer extant.[4] Whatever he owned must
have been inherited by his younger brothers, who are recorded as
having paid an inheritance tax shortly after his death.[5] And his

[1]Venice, Archivio dell'Accademia delle Belle Arti, Libro Ridu-
zioni ed atti accademici d'all' anno 1755-usq 1772. Cf. Fogolari,
p. 249n and Francis J. B. Watson, "The Guardi Family of Painters,"
Journal of the Royal Society of Arts, XIV (1965-1966), 270.

[2]Venice, Archivio di Stato, Atti Alvise Zuccoli, Busta 14409,
No. 81.

[3]Antonio's death certificate is reproduced in Giuseppe Fiocco,
Francesco Guardi (Florence, 1923), p. 18. The more veneto was used
by all Venetian parishes during the eighteenth century, not exclud-
ing the Santi Apostoli. Thus Antonio died in January 1761, but
according to the more veneto in 1760.

[4]This holds for all inventories of goods left by persons who
died intestate in 1761.

[5]Venice, Archivio di Stato, Inquisitorato alle Acque, Calcoli
intestati, Busta 548.

share of the income from Mastellina fell to his brothers as well. Don Pietro Antonio Guardi, who had looked after the brothers' interests in Mastellina since 1738, had died shortly before, so that now Francesco and Nicolò conjointly gave a power of attorney to Don Giovanni Andrea Rossi of Mastellina.[1] However, at some point between 1761 and 1763 they must have divided their Trentino possessions--or, more likely, Nicolò must have made over his share to Francesco, as from 1763 on only Francesco is named on documents, as acting for himself alone. Thus on April 8, 1763, at the office of the attorney Florio Bellan, Francesco revoked all powers of attorney previously given by him,[2] then granted a new power of attorney to Antonio Pedrini, who frequently went to the Trentino.[3] On September 14, 1763, he revoked the power of attorney granted to Pedrini,[4] and gave a new and apparently final one to a certain Giovanni Ijerlin.[5] And that same month he sent certified copies of his birth certificate and of Antonio's death certificate from Venice to Trento, presumably in connection with his inheritance.[6]

[1]Ciccolini, 1954, 193.

[2]Venice, Archivio di Stato, Atti Florio Bellan, Busta 2263, No. 23.

[3]Ibid., No. 24.

[4]Ibid., No. 164.

[5]Ibid., Busta 2264, No. 206.

[6]Trento, Biblioteca Comunale, No. 2980, fol. 9.

Even less is known about Francesco Guardi's life then about his elder brother's. No information has come to light on his apprenticeship or on his professional activity before his fortieth year, and no work of his can be assigned with certainty to those early years. Little is known about his personal life, and the few documents concerning him almost all date from the 1750's and after.

Francesco was just four years old to Antonio's seventeen when, in 1716, their father died. Presumably he was schooled by Antonio in the 'twenties, becoming Antonio's assistant at an early age: so much can be inferred from Giovanelli's testament of 1731.[1] That he spent his entire life in Venice generally goes unquestioned. However, some of his religious pictures--such as his famous Pietà, formerly in Munich (Fig. 3)--evidence intimate awareness of Austrian painting. It is doubtful whether he could have come by this awareness in Venice under Antonio's influence. Indeed, he far outdid Antonio's own early Austrian tendencies. In 1742 he was recorded as resident in Venice,[2] and again in 1749 the three brothers were recorded as residing there.[3] But at some point in the decade before 1742 or even in the middle 1740's (while Antonio was pittore di casa) he may have journeyed to the Trentino, to Salzburg, and to Vienna itself, where the Guardi still had relatives and friends. It is

[1]See above, p. 88.

[2]Maffei, p. 125.

[3]Trento, Archivio di Stato, Carton 1615, fol. 102: document dated January 2, 1749.

perhaps no mere coincidence that the Madonna in the above-mentioned

Pietà corresponds so closely to the Madonnas of Johann Michael

Rottmayr, to whom the Guardi were related.

Giuseppe Fiocco's famous thesis that, until 1761, Francesco

was only a figure painter in a family workshop headed by Antonio

has come to be seriously challenged.[1] Apparently Francesco tried

his hand at other genres already during Antonio's lifetime. Some

of his large landscapes and seascapes, his flower pieces and depic-

tions of Venetian life, could hardly have been painted after 1761.

Still less could several of his vedute. Though the problem of just

when, before 1761, he became a vedutista remains to be settled,[2]

it is by now all but incontrovertible that he was one by the 1750's.

So, if he did work in a family bottega, he appears to have been free

to pursue diverse lines of development rather than "compelled to

[1]Giuseppe Fiocco, Francesco Guardi (Florence, 1923), passim.

[2]Wart Arslan, "Contributo a Francesco Guardi," Bollettino
d'Arte, XXIX (1936), pp. 445-446, places Francesco's beginnings as
vedutista in the early 'thirties, offering as main pièce of convic-
tion the signed view of the Zattere at the Berlin Museum, which
represents the church of the Gesuati with an unfinished facade as it
was prior to 1736, the year of its completion. Arslan overlooks the
possibility of Francesco's having painted the view at a later date
after a pre-1736 engraving or painting. Antonio Morassi, "Circa gli
esordi del vedutismo di Francesco Guardi con qualche cenno al
Marieschi," in Studies in the History of Art. Dedicated to William
E. Suida on his Eightieth Birthday (London, 1959), p. 339, et passim,
dates Francesco's first vedute around 1740 because some of the
eleven vedute today in the collection of Duke Buccleuch, Bowhill,
Selkirk, appear to him to evidence collaboration by Guardi with
Marieschi, who was active in Venice around 1735-1743. Denis Mahon,
"When did Francesco Guardi become 'vedutista'?," The Burlington
Magazine, CX (1968), 70-71, assigns Francesco's earliest vedute to
the 'fifties because some of them contain topographical elements that
constitute a terminus post quem.

paint figure paintings which were foreign to his genius."[1] Indeed,
if figure paintings were not to his taste, why did he continue to
paint them for so many years after Antonio's death?

Francesco's training as vedutista is a vexed question. He
must have worked with a view painter at some time, as Antonio could
not have taught him perspective. Was his master Marieschi or Cana-
letto? He certainly took from both, especially the latter. The
only original source here is a passage in the diary of the patri-
cian Gradenigo, who in 1764 characterized Francesco as a "scolaro
del rinomato . . . Canaletto."[2] An apprenticeship with Canaletto
can only have preceded 1746, when Canaletto left for England, or
have followed 1755, when he returned. It would seem appropriate
to place such an apprenticeship at the earliest possible date, as
it is Canaletto's romantic manner of the 'twenties that is reflected
in Francesco's views. But some of those which reflect it could not
have been painted before 1756 (because certain features of the views
depicted did not exist before then).[3] Of course Francesco may have
learned that manner from Canaletto in the 'twenties, then retained
it for decades after it had been abandoned by the master, only to
outgrow it after the master's death. But a likelier hypothesis is
that Francesco, while painting figures with Antonio, taught himself
vedutismo on the side by copying, and that he found Canaletto's

[1]Victor Lasareff, "Francesco and Gianantonio Guardi," The Bur-
lington Magazine, LXV (1934), p. 71.

[2]Simonson, p. 15.

[3]Mahon, 70-71.

prima maniera most congenial.[1] He needed no schooling in perspec-
tive just to copy settings by others, and this he seems invariably
to have done.[2] A most propitious moment for him to have envisaged
a career as view painter was the later 'forties. Marieschi died in
1743; then Canaletto went to London and Bellotto to Dresden, leaving
no serious competitors behind to snatch the local tourist trade.

There is no historical basis whatever for the view, common
among Guardi scholars, that Antonio was a hard and jealous master
over his brothers:[3] a Guardi bottega may just as well have run in
a casual, brotherly way. The widespread notion that Antonio never
let Francesco sign a painting is also gratuitous; many more works
are known to have been signed by Francesco during Antonio's lifetime
than the two known to have been signed by Antonio himself. Probably
Antonio received most commissions and remittances if he was the recog-
nized bottega head. Yet two letters by Francesco, dated respectively
September 18 and November 26, 1750, and addressed to the attorney
Cordellina,[4] reveal that, ten years before Antonio's death, Francesco

[1]Francesco seems also to have taught himself landscape painting
by copying. His earliest landscapes bear so strong an impress of
Marco Ricci that they look as if they were painted under Marco's
direction. Yet Francesco was barely seventeen when Marco died.

[2]By now architectural elements (and even some macchiette) in
most Guardi views have been traced to paintings by other painters,
which suggests that the remainder will be in due course, Mahon,
p. 71, implies that some of Francesco's drawings, including annota-
tions of colors, were made on the spot and then used again and again.
But many drawings by Guardi, some even including annotations of
colors, can be matched with prototypes.

[3]See especially Muraro, 423, 427.

[4]Both letters are reproduced in Simonson, p. 79. Their present
whereabouts is unknown.

dealt directly with patrons of his own. Their content indicates that
Francesco had received a commission from the nobleman Grimani, to
whom he had submitted modelli; that he had been summoned to lower his
prices, which he had done; and that, having received no further notice
from his patron, he was wondering whether he should proceed with the
work. As it was not customary to submit modelli for views, landscapes,
or genre scenes, the pictures commissioned from Francesco must have
been history paintings. His negotiating on his own behalf could indi-
cate that he had parted company with his brother by 1750. But a more
natural inference would be that the Guardi workshop was an association
of equal partners, who, according to circumstances, worked separately
or in collaboration.

Antonio's death certificate records that he belonged to the
parish of the Santi Apostoli, and Gradenigo's diary refers to
Francesco's bottega in 1764 as being located in that same parish.[1] Most
likely there was only one Guardi bottega at the Santi Apostoli, in
which Francesco continued to work after Antonio's death.

On May 16, 1756, Francesco, aged forty-three, signed a
marriage agreement with Marianna Dimurat, a merchant's daughter.[2]
The fiancée was to bring him a modest middle-class Venetian dowry
of 2000 ducats (part in money, part in goods). The engagement was

[1]Gradenigo, p. 116. Francesco is also recorded in his marriage
certificate of February 15, 1757, as residing at the Santi Apostoli.
See

[2]Venice, Archivio di Stato, Atti Florio Bellan, Busta 2253,
Contratto Nozze 34.

broken because his prospective father-in-law repeatedly postponed

producing the inventory of the dowry.[1] Or perhaps this was just a

pretext, for eight months later, on February 15, 1757 (more veneto

1756), Francesco married Maria Pagani, fourteen years his junior.[2]

Four children were born to the couple: Vincenzo on August 28, 1760;[3]

Giovanni on September 12, 1762,[4] who died in infancy;[5] Giacomo on

April 17, 1764[6] and Giovanni Battista, who died at birth on January

16, 1769.[7] A few days after having given birth to Giovanni Battista,

Maria Pagani also died.[8]--in the Salizada all'Ospedaletto, in what

[1]Ibid. The reason for the annulment of the marriage agreement was supplied by the attorney at a later date in the margin of the document.

[2]Simonson, p. 81, and Archivio parrocchiale di Santa Marina, Venice, Libro dei Matrimoni 1710-1795, fol. 115: "Adi 15 Febro 1756 M.V. [1757] sono state dispensate da [illegible word] Vica Gente le sue solite publ del Matri sono per contrare Il Sigr Francesco Lazaro figlio del qm Domenico Guardi della Contra di SS. Appostoli e la Sigra Maria Mattaea figlia del qm Matteo Pagani della nostra Contra." Maria Pagani's birth certificate of 1726 at the same parish archive does not indicate that her father was painter as has hitherto been believed. Cf. Pietro Zampetti, Mostra dei Guardi (Venice, 1965), p. LXXIX.

[3]Baptismal certificate reproduced in Simonson, p. 191.

[4]Ibid., p. 226.

[5]Giovanni's death certificate is recorded at the parish of Santa Maria Formosa on October 25, 1762.

[6]Simonson, p. 252.

[7]Pietro Zampetti, p. LXXX.

[8]Simonson, p. 81.

seems to have been a typical middle-class dwelling.[1] Francesco was left widower with two children in charge. Vincenzo was to become a priest and Giacomo a painter.

The last three decades of Francesco's long life are no better documented than the rest. He is not known to have left Venice except for one trip to the Trentino and possibly a second. The papers of his local attorney signal his presence in Piano (Trentino) on October 7, 1778.[2] A second trip has been inferred from an inscription found on the back of one of two small pendants stating that they were painted by Francesco in 1782 and presented to Don Felice di Manfroni of Caldes.[3] But the present could have been offered in, or dispatched from, Venice.

The revenues Francesco drew from his possessions in the Trentino did not amount to much,[4] yet the trouble he took to secure them seems to indicate that they were welcome all the same. So must have been two inheritances that came his way in the 'seventies. In 1771 Tomaso de Guardi died in Bavaria without descendants, leaving his estate to his nephews Francesco and Nicolò. And in 1777 Cecilia Tiepolo willed

[1]Venice, Archivio di Stato, Dieci Savi sopra le Decime in Rialto. Sestiere Castello. Stima 1740. Busta 435. The rent of the house is recorded as of twenty zecchini a year.

[2]Maffei, p. 42.

[3]Simonson, p. 52; Panizza, p. 16; Ciccolini, 1954, 193. The inscription reads: "Capricci del Guardi, 1782, pittore Veneto nativo di Mastellina in Val di Sole - Dono dell'Autore a Don Felice di Manfroni di Caldes."

[4]Trento, Archivio di Stato, No. 2980, fol. 65. In 1787 the yearly revenues amounted to about hundred Venetian lire (or five zecchini).

[5]Ciccolini, 1954, 193.

a small legacy to her "most beloved brothers Francesco and Nicolò,"[1]
who presumably came into it in 1779, the year she died.

Francesco's pictures never seem to have fetched high prices.
In 1782 the Inspector of Fine Arts at Venice, Pietro Edwards, com-
missioned him to paint four views commemorating the visit of Pope
Pius VI to Venice.[2] Though this was a major commission, perhaps the
most important ever given to Francesco, the total remuneration amounted
to only forty zecchini--a good price for Guardi, it seems, but one that
a recognized master would never have agreed upon. If Guardi's views
and capricci could be had cheaply, he compensated by turning them out
in large numbers. He is said to have painted fast and often alla
prima.[3] He appears to have considered his paintings as merchandise
to be disposed of quickly if a taker was at hand. Had he considered
them works of art to be transmitted to posterity he would have bought
better canvases and used durable colors. "He painted to earn his
daily bread," Inspector Edwards reported to the sculptor Canova in a
letter of 1804, adding that his pictures were not painted to last.[4]

[1]Simonson, p. 82.

[2]Ibid.

[3]From a letter by Pietro Edwards of June 13, 1804, to the
sculptor Canova. Reproduced in Francis Haskell, "Francesco Guardi
as vedutista and Some of his Patrons," Journal of the Warburg and
Courtauld Institutes, XXIII (1960), 276: "Ella sa però che questo
pittore lavorava per la pagnotta giornaliera; comprava telaccie da
scarto con imprimiture scelleratissime; e per tirar avanti il lavoro
usava colori molto ogliosi e dipingeva bene spesso alla prima, Chi
acquista de suoi quadri deve rassegnarsi a perderli in poco
tempo"

[4]Ibid.

Most of Francesco's views of Venice that survive were painted during the last three decades of his life. But during that period he by no means engaged exclusively in _vedutismo_. Versatile to the last, perhaps out of necessity as much as by temperament, he appears to have accepted every commission that came his way: for altarpieces, devotional pictures, copies after old masters, architectural and romantic _capricci_, genre heads, flower pieces, and portraits. Even a bird's eye view of Venice by him is on record. Furthermore, an important group of his drawings--some of which are today at the Museo Correr at Venice,[1] others scattered among public and private collections--were evidently preparatory sketches and studies for purely ornamental works destined to adorn fashionable Venetian dwellings. This points to an activity which today would be called interior decorating. As no paintings corresponding to the drawings have yet emerged, it may be supposed that at least some of the decorations were executed in fresco.[2]

Many other late drawings by Francesco were for religious works, a few of which have been documented. In 1763 he received a commission to paint two large octagonal pendants for the church of San Pietro Martire at Murano, one representing a miracle by a saint (today at the Kunsthistorisches Museum at Vienna), the other

[1]Reproduced in Rodolfo Pallucchini, _I Disegni del Guardi al Museo Correr di Venezia_ (Venice, 1943), _passim_.

[2]Only two frescoes indubitably by Francesco have been discovered: two large _capricci_ in a room of the Seminario Patriarcale at Venice. See H.A., "Scoperti due affreschi di Francesco Guardi," _Emporium_, CXXVII (1958), 81.

a view of the Murano church itself (no longer extant).[1] Around 1777
he painted a large altarpiece for the church of Roncegno in the
Trentino (still _in situ_),[2] and at some unknown date after 1771, but
probably very much later, he made a copy of a painting by Bellini
for the church of San Cristoforo della Pace.[3]

Even without documentation it would be easy to guess for what
manner of client Francesco painted religious works. But for whom
did he paint views? Tourists come to mind first, and this was
certainly so to some extent. As for Venetians, it might seem that
they would not be interested in pictures representing what they
could see from their balconies. And yet it is uncertain whether
his views were predominantly acquired by Venetians or by foreigners
during his lifetime. None is recorded in eighteenth-century inven-
tories of English collections or, as far as is known, of German ones
either. Joseph Smith's vast gallery held not a single identified
Guardi.[4] Only late in the century do some documents register an
interest in Francesco on the part of the English,[5] though some of

[1]Roberto Gallo, "Note d'archivio su Francesco Guardi," _Arte Veneta_, VII (1953), 155-156.

[2]Michelangelo Muraro, "Further Information about the Roncegno Guardi," _The Burlington Magazine_, CII (1960), 79.

[3]Gallo, 79.

[4]None is recorded in the inventory of his art collections drawn up at his death, though it is possible that some of the many views listed without indication of author were by Guardi. See Cesare Levi, _Le collezioni veneziane d'arte e d'antichita_ (Venice, 1900), _passim_.

[5]Haskell, "Francesco Guardi as _Vedutista_," _passim_; and Francis J. B. Watson, "Guardi and England," in _Problemi guardeschi_ (Venice, 1967), _passim_.

his views may well have entered England and the Germanies earlier

as "Canaletti."[1] On the other hand, some educated middle-class and

perhaps also some upper-class residents of Venice and environs owned

whole series of his views and capricci.[2]

Francesco was never in his lifetime acclaimed as a painter of

genius. But a certain very personal talent was granted him, espe-

cially toward the end of his life. If some of his clients were angered

by the topographical inaccuracies of his vedute, they were charmed all

the same by the spirited brushstroke and wistful handling. He was

sufficiently well known for the printer Gabriele Marchio to have

bothered requesting authorization from the Senate in 1788 to engrave

Venetian views "del celebre Francesco Guardi."[3] The 1790 printed

catalogue of Don Giovanni Vianelli's paintings noted that Francesco's

fame as painter of views was not slight.[4] A few individuals appear

to have discerned more than mere attractiveness in Francesco's art.

[1]The word "Canaletti," frequently recorded in English inven-
tories, may have meant just views of Venice and not necessarily
views thought to be by Canaletto.

[2]Most of Francesco's views acquired by Englishmen after his
death came from private owners in Venice and the Veneto. But what
social class he catered to there is difficult to ascertain. Accord-
ing to well-informed Pietro Panizza, p. 79n: "A Venezia fino alla
metal del secolo scorso tutte le famiglie patrizie avevano quadri
del Guardi: ivi nel 1878 in un solo palazzo vi erano 32 Guardi
autentici, nel 1905 non ne rimaneva neppur uno." But Haskell, "Fran-
cesco Guardi as Vedutista," 256-276, suggests that Francesco patrons
came mostly from the enlightened middle-class. Some letters addressed
to the Guardi afficionado Bernardelli in the middle years of the nine-
teenth century contain precious information on several Guardi collec-
tors in Padova, who apparently came from varied backgrounds: see
Trento, Biblioteca Communale, No. 2980, foll. 26-36.

[3]Simonson, p. 83.

[4]Catalogo di quadri esistenti in casa del Signor D.n Giovanni
Vianelli (Venice, 1790), p. 42, and Simonson, p. 19.

In a speech to the Accademia in 1784, a Bolognese, Francesco
Albergati-Capacelli, praised Guardi elaborately.[1] In a letter of
1786 Abbate della Lena, again a Bolognese, expressed his admira-
tion for Guardi's "inventive phantasy."[2]

What Francesco's fellow painters thought of him is not known.
Possibly not much, as only on September 12, 1784, at just under
seventy-two years of age, was he elected to the Venetian Academy--
as "pittore prospettico," together with Antonio Mauro, to succeed
two deceased members. Only on December 6, 1789, is he recorded as
having attended a session of the Academy, one during which two paint-
ings believed to be Canaletto's were attributed to Marieschi's
school.[3]

Faithful to the Guardi tradition, Francesco made copies after
famous masters to the last. An inventory of 1800 attached to the
testament of Monsignor Federigo Giovanelli,[4] a descendant of the

[1]Fogolari, pp. 383-384.

[2]Passage reproduced in Haskell, "Francesco Guardi," p. 262.

[3]Fogolari, p. 383.

[4]Luigi Gaudenzio, "A proposito di Francesco Guardi figurista,"
Arte Veneta, II (1948), 148. Terisio Pignatti, "Nuovi disegni di
figura dei Guardi," Critica d'Arte, XI, 1964, 69n, argues that these
"Guardi copies" inventoried in 1800 could have been the same ones
recorded in Giovanni Benedetto Giovanelli's testament of 1731 as
made by the "fratelli Guardi," the more since the inventory of 1800
does not name Francesco. However, the copies recorded in the testa-
ment of 1731 did not remain in the possession of the Giovanelli
family, as they were bequeathed to a certain Antonio de Caroli. See
Archivio Venice, Atti Marcello Girolamo - Testamenti 612, No. 345:
"Al sunominato Sigr Antonio de Caroli mio amorevole . . . lascio le
copie de quadri, che egli tiene di mia ragione, fatte dalli Fratelli
Guardi"

Giovanni Benedetto Giovanelli who had been patron to the Guardi
some seventy years before, lists Guardi copies after Tintoretto,
Veronese, Salviati, Carletto, and Sebastiano Ricci. The exact date
of the execution of these copies is not known, but they were most
likely commissioned around 1776 when Monsignor Giovanelli is known
to have ordered other copies of religious paintings to replace the
secular paintings which hung in his villa at Noventa.[1] The Giovanelli
collection included additional Guardi pictures, among them a large
genealogical tree of the Giovanelli (Fig. 4)--unpublished so far--
which brings up the problem of a Guardi bottega again. The tree could
not possibly have been painted prior to 1784 (the date that figures
on the picture). Yet the author was decidedly not Francesco, though
the floral elements, the figure of the youth beneath the tree, and
the view of Venice in the background are blatantly "guardeschi."
Nor was the likely author Giacomo. So another Guardi, or another
painter using Guardi's idiom, must have been active at the time in
Venice, perhaps in Francesco's bottega. To view Nicolò as Francesco's
collaborator is tempting, the more since Nicolò is reported to have
been "pittore da camera," which Francesco was too on occasion, as has
been seen. Furthermore the pendants for the church of Murano, com-
missioned in 1763, are recorded in the inventories simply as "by
Guardi." The one still extant is undoubtedly by Francesco, whereas
the preparatory drawing for the lost one could never be ascribed to

[1]Bruno Brunelli and Adolfo Callegari, Ville del Brenta e degli
Euganei (Milan, 1931), p. 150.

him but bears great stylistic affinity to the veduta behind
Giovanelli's tree. The indication is not that Francesco employed
assistants during the 'seventies and 'eighties, for the anomalous
guardeschi works at issue are only the genealogical tree, a few
vedute, and some puzzling drawings (most of the innumerable Guardi-
style vedute on the market today cannot be considered as having
been produced during Guardi's lifetime)--all of which seem to have
been painted by the same hand. The indication is rather that
Francesco shared a workshop with another painter who may have been
Nicolò. Collaboration with Nicolò could only have lasted until
1786, the year of the latter's death.[1]

Francesco spent the last years of his life in the Campo della
Madonna with his son Vincenzo, who was priest in the parish of San
Canciano. They occupied a modest house (still standing today) in
which, on the second floor, old Guardi had his studio.[2] There he
died on January 1, 1793. His son Giacomo, whom he had trained
as vedutista, was the last of the Guardi to paint. After his
father's death, Giacomo continued to turn out modest views of Venice
in his father's style until his death in 1837.

[1]Ciccolini, 1954, 196, 200n.

[2]Trento, Archivio di Stato, No. 2980, fol. 44.

CHAPTER III

THE GUARDI AS DRAUGHTSMEN

In trying to sort out the respective works of two such closely
related artistic personalities as the Guardi, it would seem reason-
able to study the drawings intensely, as they are less likely to
have been done in collaboration.

Guardi research centered on the paintings until the mid-1950's,
even though as many Guardiesque figure sketches as paintings had
been coming to light over the previous five decades.[1] Only when
the drawing Allegory of Martial Virtue (Fig. 71), signed unequivoc-
ally by Antonio Guardi[2], emerged in 1953 was the comparative study
of the graphic works of the Guardi seriously envisaged. Since
then, the corpus of Guardiesque drawings has continued to grow. But
while some sheets, usually the least problematical, have been repro-
duced and discussed over and over again, others stylistically more

[1]"Guardiesque" refers, in the present study, to works executed
by a member of the Guardi family. It is used mostly in connection
with figure drawings and applies then only to Antonio and Francesco,
as Giacomo did not paint or draw histories.

[2]Antonio Morassi, "A Signed Drawing by Antonio Guardi and the
Problem of the Guardi Brothers," The Burlington Magazine, XCI (1953),
263.

complex fell into oblivion once they were published, such as the

puzzling Flagellation at Dresden (Fig. 93) or the disconcerting

Allegory of Reward in Vienna (Fig. 115).[1]

Close to two hundred Guardiesque figure drawings are extant--

studies and sketches for religious, historical, mythological, and

genre paintings. These are the subject of the present catalogue.

The catalogue does not cover the numerous sketches for staffage in

vedute[2] which may safely be attributed to Francesco as Antonio did

[1]For Die Zeichnungen des Francesco Guardi im Museum Correr
zu Venedig (Florence, 1943) Rodolfo Pallucchini selected with great
care from the drawings preserved at the Correr Library those he
attributed to Francesco Guardi and a few he thought to be by other
members of the family. The drawings selected are mostly sketches
for views, capricci, and staffage. I believe that none of the forty-
two figure drawings included is by Antonio Guardi, although Palluc-
chini assigned four of them to him (Nos. 154, 155a, 156a, 157).
J. Byam Shaw's introduction to The Drawings of Francesco Guardi
(London, 1951) is to this day the most sensitive and informative
piece of writing on Francesco as draughtsman. But it concentrated
on Guardi as view painter and discusses only nine of his figure
drawings. Morassi, "A Signed Drawing . . .," 260-267, discusses
briefly, along with the large group of the Fasti Veneziani, twenty-
odd drawings, some of them previously unknown, which he believed to
be by Antonio. In "Un disegno di Antonio Guardi donato al Museo
Correr," Bollettino dei Musei Civici Veneziani, II, 1-2 (1957),
21-32, Terisio Pignatti compiled a summary catalogue of Antonio
Guardi's drawings which includes thirty-one items. It provided no
new information. Nor did Pignatti's I disegni dei Guardi (Florence,
1967).

[2]Such sketches are easily distinguishable from figure studies
on the basis of size, costuming, and context except that one item at
the Correr Library is betwixt and between: the Merchant Displaying
Fabrics to a Couple (Fig. 137). I have grouped it with the figure
studies because of its size and the relatively detailed treatment of
the figures.

not paint vedute.[1] Of the drawings here catalogued, few can be
authenticated, and few can be assigned on external evidence. Only
five can be dated with precision; only fourteen can be linked to
paintings; only two bear signatures that are incontrovertibly genuine,
though others bear inscriptions that provide clues as to their authen-
ticity and authorship. So many of these inscriptions have been con-
sidered autograph at one point or another that this question must be
examined before all else.

Byam Shaw was the first to publish an authentic sample of
Francesco's handwriting: an undated receipt for a payment, which is
reproduced below in view of its importance (Fig. 5).[2] Byam Shaw
demonstrated, moreover, that the descriptive notations to be found
on many veduta and capriccio drawings from Francesco's late period,
which were supposed to be Francesco's own, had been added after his
death by his son Giacomo.[3] Another authentic specimen of Francesco's

[1]Antonio did insert small figures in Marieschi's views (see
Chapter I, p. 47). But none of the Guardiesque studies for macchiette
can be connected with Marieschi's views, whereas most of them can be
connected with Francesco's vedute and landscapes.

[2]Byam Shaw, Drawings, p. 41. The receipt was attached to the
back of a staffage study formerly in the Sarre collection in Berlin;
Byam Shaw considered the study to be an early work of Francesco's.

[3]Ibid., pp. 41-43. However, Byam Shaw, p. 43, considers the
long inscription along the upper edge of the Bissona drawing at the
Correr Library (Pallucchini, Zeichnungen, no. 102) as possibly by
Francesco. This is unlikely: the writing is too loose, the strokes
slant too much toward the right, and the words are spaced too far
apart. The penmanship bears a greater resemblance to Giacomo's, a
specimen of which is reproduced in Byam Shaw, Drawings, p. 41.

handwriting appears on the back of a capriccio sketch (Fig. 6) in
the collection of Mr. Janos Scholz. It is a brief inscription con-
cerning the size and shape of the altarpiece he was commissioned to
paint ca. 1777 for the church of Roncegno.[1] And lastly, a drawing
of four half-figures by Francesco at the Correr Library (Fig. 197)
bears extensive indications of colors which can only have been
inscribed by the draughtsman.[2] It is to these solid samples
of Francesco's cursive handwriting that cursive inscriptions presumed
to be his must be compared.[3] Numerous sheets by Francesco, represent-
ing for the most part capricci and macchiette, are inscribed
F.co Guardi or f.co Guardi on the recto in rather large, clear
formal characters.[4] Byam Shaw believed the inscriptions to

[1] For particulars bearing on the sheet, on its inscription, and
on the date of the altarpiece, see Venetian Drawings from the Collec-
tion Janos Scholz, Venice: Fondazione Cini, 1957, pp. 55-56; Michel-
angelo Muraro, "An Altar-piece and other Figure Paintings by Francesco
Guardi," The Burlington Magazine, C (1958), 3-4; Michelangelo Muraro,
"Further Information about the Roncegno Guardi," The Burlington
Magazine, CII (1960), 79-80.

[2] It is a preparatory drawing for small pictures of heads
(circa 1785) now in private French collections. See Antonio Morassi,
"Settecento veneziano inedito. Cinque Teste ed una Immacolata,"
Arte Veneta, III (1949), 80-84. Also authentic are the notes for
color or tone which appear on several of Francesco's early vedute
(Byam Shaw, Drawings, Nos. 11, 12, 16, 17, 18, 19, 24, 25); they
hardly exemplify his handwriting, however, as most of them are
abbreviated to a single letter (R for rosso, S for scuro, etc.).

[3] Thus Terisio Pignatti, I disegni dei Guardi (Florence, 1967),
no. XXXIV, wrongly attributed the inscription on the Veduta di
Levico in the Stralem collection to Francesco.

[4] For typical examples see Venetian Drawings from the Collection
Janos Scholz, pl. 92A, and Byam Shaw, Drawings, figs. 50, 51.

be signatures.[1] The calligraphy is clearly of the period and has
been observed only on Guardiesque drawings the authenticity of which,
on style alone, could hardly be disputed. In one case, however--on
the Berlin sketch The Holy Family (Fig. 165)--the inscription reads
[An]t.[o] Guardi.[2] Furthermore, whenever I could see the originals
I noticed that the inscriptions were all in the same ink and the
drawings themselves in different inks: the indication is that the
sheets were all inscribed at the same time. Possibly Francesco sold
the lot to a collector and inscribed each sheet with its author's name
for the occasion.[3]

 Authentic autographic material is as slight for Antonio as it
is for his younger brother. A long descriptive notation on the
verso of the Allegory of Martial Virtue at the Correr Library is
unquestionably in Antonio's hand (Fig. 7), as a full signature in
the same hand follows in duplicate (once it is smudged in parts and
once clearly legible).[4] Another sheet by Antonio at the Correr

[1]Byam Shaw, Drawings, p. 41.

[2]The first name Ant.o has been slightly scratched out but is
still faintly discernible. Two other drawings by Antonio--inscribed,
but in another hand--have been mutilated in similar ways: the
Fauchier-Magnan Head of a Magus (Fig. 94) and Saint Roch Visiting
the Sick in Warsaw (Fig. 98).

[3]It is hardly conceivable that a collector inscribed the draw-
ings. For Francesco's name appears on them sometimes with a capital
F and sometimes with a small f, exactly as it does on his signed
paintings. The collector would, then, have had to share this idio-
syncracy with the artist.

[4]Morassi, "A Signed Drawing . . .," 263. Surprisingly,
Morassi does not mention that the signature is in duplicate. (The
smudges must have necessitated the second signing, with greater care
paid to legibility and neatness.)

Library is autographed. Referred to variously as Contadinello or as
February, it represents a farm boy (Fig. 116) and is inscribed
"febraro" at the top in black chalk and signed "Antonio Guardi fecit
Anno 1760" in ink at the bottom. Antonio has always been considered
the author of the Contadinello and of its two inscriptions, except
that Terisio Pignatti assigned the lower inscription to Francesco.
Pignatti's arguments against the authenticity of the signature are
unconvincing,[1] the more since it is akin to the two signatures on
the drawing of the Allegory of Martial Virtue (especially to the
less deliberate "smudged" one).

Of the various other nonautographic inscriptions found on some
of the figure drawings, one series is in a hand characteristic of
the time of the Guardi. It consists merely of the name "Ant.o Guardi"
or "Fran.o Guardi" or "Guardi." When the name appears in one of the

[1]Pignatti, "Un disegno di Antonio . . .," 21-23, argues that
the pen and ink used for the signature differed from those used in
the drawing itself. But many signatures on Domenico Tiepolo's sheets
--some of which Pignatti himself has studied--are recognized as auto-
graphs even though the ink used for the signing differs from that used
in the drawings: see Byam Shaw, The Drawings of Domenico Tiepolo
(Boston, 1962), p. 63. (Numerous parallel cases could be cited.)
Pignatti considers the inscription "febraro" on the top of the draw-
ing to be autographic because it is in the same chalk as the under-
drawing and is graphically similar to that on the Allegory of Martial
Virtue. Pignatti forgets that others accepted the inscription and
signatures on the back of the Allegory of Martial Virtue as Antonio's
because they were graphically similar to the inscription at the
bottom of the Contadinello (see Morassi, "A Signed Drawing . . .,"
263). Furthermore, the penmanship of the inscription at the bottom
of the Contadinello is dissimilar to that of Francesco's two authentic
inscriptions mentioned above.

lower corners of a drawing, it is inscribed in black ink; when it
appears on the _verso_ of the sheet it is written in black chalk or
black ink. In most cases it appears on both sides of a sheet.
Pallucchini and Byam Shaw have drawn attention to five drawings
bearing this type of inscription,[1] but in fact it appears on at
least fifteen,[2] six of which are inscribed "_Ant.o Guardi_," one
"_Fran.o Guardi_," and the rest "_Guardi_". In all likelihood the
hand was that of a contemporary collector, as corresponding in-
scriptions are to be found on Tiepolesque sheets and on sheets by
Fontebasso.[3] Except for the _Bacchus and Ariadne_ sketch at Oxford
(Fig. 60) the Guardi drawings at issue are more or less elaborate
and were executed with unusual care. Several of them may have been
designed as works in their own right, to be inserted into the port-
folio of one of the many amateurs of graphic art who preferred
"finished" to sketchy works.[4] It is most regrettable that the

[1]Pallucchini, _Zeichnungen_, p. 15, and Byam Shaw, _Drawings_,
p. 43. Pallucchini refers to four inscriptions, three of which he
regards as autographic; Byam Shaw mentions five and ascribes all
of them to a collector.

[2]Several Guardiesque sheets identically inscribed were dis-
covered after the publication of Byam Shaw's book. They are Figs.
60, 66, 68, 94, 98, 99, 109, 113, 114, 115, 128, 148, 203 of the
catalogue below and _The Entrance to the Canareggio_ at the Correr
Library (Pallucchini, _Zeichnungen_, no. 164 as by Nicolò Guardi)
and _Four Venetian Gentlemen_ in Mr. Harry Sperling's collection
(Byam Shaw, _Drawings_, pl. 48).

[3]Byam Shaw, _Drawings_, p. 44.

[4]In view of the scant consideration in which the Guardi were
held during their lifetime, the unknown collector must have been a
man of unusual discernment to have acquired so many of their draw-
ings--unless he belonged to their circle of intimates.

amateur who acquired them did not consistently indicate the author's first name. Perhaps he did not know it when he omitted it. As most of the fifteen inscribed drawings seem to be by Antonio, and as the two undeniably by Francesco belong to his earliest known period (the 1750's), the unknown collector presumably acquired the sheets in the middle years of the century--that is, during Antonio's lifetime or shortly after.[1] Be that as it may, his inscriptions are valuable indications of authenticity.

Before proceeding to sort out the Guardiesque figure drawings, we must first investigate and differentiate the graphic styles of the two brothers. In so doing, we shall confine ourselves initially to those sheets which are of indubitable authenticity and which can be assigned on external evidence. The authenticated figure drawings by Francesco are ample for this purpose; those by Antonio are so sparse, though, that it will not always be possible to juxtapose drawings in

Thus he may have been a relative, Iuseppino Guardi. A drawing at the Cooper Union Museum entitled Chronos Entrusting Cupid to Venus [sic] bears the inscription in the upper left: "Lo Fece il Tiepolo che me lo dono Iuseppino Guardi." The handwriting is most similar to that of the unknown collector. The drawing dates from the Tiepolo's Spanish period and is certainly by Domenico Tiepolo. It was published (as Giambattista's) by George Simonson, "Guardi and Tiepolo," The Burlington Magazine, XI (1907), 247-248, and has not been mentioned since. Simonson wrongly identified this Iuseppino Guardi with another, who was a cousin of Domenico Guardi: the cousin was a parish priest in Denno, a small village in the Trentino, which he seems never to have left and where he died shortly before 1750 (Archivio Arcivescovile di Trento. Visite Pastorali. Chiesa di Denno. fol. 202), hence well before the drawing was made.

[1] Antonio seems to have fallen into total oblivion shortly after his death. It is therefore unlikely that a collector would have acquired any of his drawings during the later part of the century.

the same medium or of similar subjects. Also a comparison of draw-
ings executed at about the same time would have been particularly
desirable for ascertaining reciprocal influences, but is hardly
possible, as few of the figure drawings authenticated as Francesco's
date from Antonio's lifetime, and those only from Antonio's very last
years.

Wash drawings form a prominent category of the two brothers'
graphic works. It is thus appropriate, for a start, to juxtapose
two pieces executed in that technique: Antonio's signed Allegory
of Martial Virtue (Fig. 8) and Francesco's Dancing Peasants (Fig. 9),
both in the Correr Library. The two belong to two different sets
of five sheets each, most likely preparatory designs for two series
of decorative paintings. Antonio's set cannot be dated except that
the year of his death, 1761, provides a terminus ante quem. Fran-
cesco's series can be dated roughly 1760 or shortly thereafter.[1]
Structurally, Antonio's allegorical scene does not form a coherent
ensemble. The figures relate to one another clumsily, as if they
had been assembled without due planning. Trumpeting Fame has hardly
enough room to move: her bulk hems in the central protagonist. The
clumsily inserted temple just barely fits. Slight ineptitudes betray

[1]One of the peasant sketches in Francesco's series is drawn on
a sheet which includes a small view of the Giudecca (in the same ink)
dating from circa 1760 (see An Exhibition of Drawings from the Alfred
de Pass Collection belonging to the Royal Institution of Cornwall,
Truro: The Art Council of Great Britain, 1957, no. 165). The
Giudecca view justifies assigning the whole peasant series to Fran-
cesco and the same date to all five sheets.

a want of clear design. There is no telling whether the puzzling
figure at the lower right is trying to hang onto the chariot or
to dismantle it. The wheel came loose without its disturbing the
balance of the vehicle or the equanimity of its occupant. Time
makes strenuous efforts to move the chariot, but he pulls on frail
dangling ropes. The half-camouflaged crown is out of Fame's hands
and off Martial Virtue's head.

By contrast, Francesco's sketch of Dancing Peasants relates
the two figures to each other, as well as to the trees and the boat
harmoniously in a graceful rhythmic whirl. The figures are scaled
in apt proportion to the rest and, in spite of the loose handling,
are skillfully rendered. Another sketch by Francesco belonging to
the same series, Two Peasants Drinking (Fig. 147) at the Staedelsche
Kunstinstitut, likewise exemplifies his ability to represent the
human body accurately with the utmost economy of lines, in fact with
a few dashing strokes. Antonio could not cope with anatomical
problems quite so felicitously. This shows in his Martial Virtue
and, even more, in the other drawings from the same set (Figs. 72-
76), where correct shapes are not to be surmised beneath the shape-
less draperies.

The juxtaposition of Antonio's allegories and Francesco's
peasants brings out differences in graphic handling as well.
Francesco applied the wash with great dexterity in wide, rapid
strokes. Though it is of an exquisite transparency, it displays
hardly any variations in tonality and the division between washed

and unwashed areas is fairly rigid. Antonio applied the wash more
deliberately and with great refinement, producing the most varied
and sophisticated tonal modulations. He whipped in darker accents
here and there in the half-tone areas with the use of a smaller
brush, a trick which helped to lend the drawing its highly pictorial
appearance. Trumpeting Fame is more nearly painted than drawn. But
it is in the linework itself that the Guardi's two approaches to
drawing are most distinct. At first glance, individual lines are
hardly discernible in Antonio's allegory. On closer examination,
they appear to be of the most varied sorts. Many are long and fluid,
and often tremulous. Some are traced faintly, others more firmly;
some are drawn with chalk, others with a small brush; a few are gone
over, not necessarily in the same medium. Sharp edges are eschewed.
Except for the left arm of the Allegory proper, nowhere is an out-
line posited with a single forceful stroke. On the edges of a given
form, parallel lines of varying firmness often run side by side,
loosening the contours. Francesco's peasants are drawn in ink alone.
His strokes are all about equally firm. No line is gone over, and
none is altered. Short and broken though they are, the lines are
incisive, delimiting, binding. The contours are accentuated.

To juxtapose Antonio's <u>Allegory of Martial Virtue</u> with Fran-
cesco's <u>Pietà</u> at the Correr Library (Fig. 139), a drawing which cor-
responds in all particulars to a signed painting formerly in Munich
is particularly instructive in that both appear to be the designs

for paintings,[1] and are most likely modelli. Also, by the Guardi's standards they are both elaborate works, and the Pietà is the most pictorial of Francesco's known figure drawings. Placed side by side, they disclose further points of contrast between the brothers.

Antonio depicts faces most evasively: one is invisible and the others are half-hidden except the rather conventional one of Martial Virtue herself--which incidently, recurs in several of Antonio's other works (and which most likely derives from Sebastiano Ricci). Francesco's faces by contrast are sketchy but explicit, with great stress laid on physiognomic expression. Similarly, hands are indicated in slovenly fashion by Antonio and delineated summarily but clearly by Francesco. Only the hand on Antonio's central figure is drawn with relative precision. And this amorphous, plump, boneless hand, with the two short, pointed fingers sticking out, is frequently found--almost unaltered--in other works by Antonio, just as the expressive, nervous, bony hands in the Pietà recur in other works by Francesco. The exaggeratedly crushed-in abdomen and elongated left shoulder of Christ in the Pietà seem at first to contravene our previous assertion that Francesco, unlike Antonio, could draw the human body accurately. Such anatomical distortions are encountered in the few works by Francesco that represent dramatic scenes and in many of his late macchiette. They should perhaps be viewed as intentionally expressionistic.

[1]The Pietà sketch is pricked for transfer. The Allegory of Martial Virtue is signed and bears on the recto an elaborate description of the subject in formal lettering.

It is true that the dramatic realism which Francesco vested in the faces of the Correr drawing, while appropriate to a Pietà, would be somewhat out of place in an allegorical subject such as Antonio's. But other drawings to be considered below indicate that, as a rule, Antonio tends to avoid physiognomical expression and Francesco to stress it. Frequently Antonio's faces are slightly blurred, and when the subject or the format requires a detailed treatment the accent is laid on suavity. Francesco's visages are markedly of this world, to which he seems to have been far more attentive than his brother. The small Adoration of the Shepherds (Fig. 141)[1] is instructive in this regard. The whole composition is taken from Sebastiano Ricci's painting today in the church at Saluzzo, or more likely from the engraving Pietro Monaco made after the painting (Fig. 142). The conventionally beautiful features of Sebastiano's Madonna are transformed into a rather coarse yet pleasant peasant face.

Another case in point is the drawing by Francesco at Arlesheim (Switzerland) belonging to Mr. J. Zwicky (Fig. 148), which is a preparatory sketch for the small Madonna (signed on the verso) in the Tecchio collection at Vicenza: no other Venetian draughtsman, not even Piazzetta,would have given the Virgin such plain, unsophisticated, yet intensely human, features.

The Zwicky Madonna exemplifies another distinctive characteristic of Francesco's draughtsmanship: his peak-forming lines.

[1] In view of the macchiette drawn on the verso, the sheet can safely be assigned to Francesco.

Pointed strokes were already conspicuous in the Correr Pietà around
the Virgin's head and left arm and especially in the lower part of
her garments. To be sure, jagged lines and ragged outlines occur in
the works of other draughtsmen too, not excluding Antonio. What
singularizes Francesco here is the rate at which his peaked lines
appear and the fact that they appear not just on the edges of drap-
eries, but all over, like scattered saw-teeth of diverse shapes and
sizes. This graphic device is functionless in so many places
that it seems rather to have been a graphic mannerism. It pervades
his studies of macchiette--one dating from his mature period is re-
produced below (Fig. 10)--as well as his late works. His fragment
of an Immacolata (Fig. 218), drawn on the verso of one of his very
late capriccio studies,[1] shows how compulsive the practice had become
by the end of his life.

In addition to the wash sketches, drawings in red chalk form
another prominent category of Guardiesque works. Antonio's author-
ship of five such drawings is established on external evidence.
These are a Harem Scene (Fig. 87) corresponding to a still extant
cabinet picture for which Antonio received payment from Schulenburg,[2]
and a three-quarter figure of an archangel in the same style and on
the same sheet (on the recto) at the Accademia at Bergamo (Fig. 86);
Head of a Magus (Fig. 94), inscribed "Ant.o Guardi" in the lower

[1]Canaletto e Guardi, (Venice: Fondazione Cini, 1962), pl. 77.

[2]Hannover, Staatsarchiv, Depositum 82, Abteilung III, no. 77.
The payment was made in 1742 or 1743.

right by the unknown eighteenth-century collector,[1] which formerly belonged to Mr. Adrien Fauchier-Magnan; Saint Margaret (Fig. 99) and Saint Roch Visiting the Sick (Fig. 98), respectively on the recto and verso of a sheet at the Warsaw Museum inscribed "Ant.o Guardi" on both sides by that same collector. Antonio shaded these drawings with tightly--and in certain areas untidily--scribbled hatchings, some in bold and some in tenuous strokes, thereby creating varied tonalities not unlike those encountered on his wash sheets. His tendency to deemphasize contours reached its extreme in his works in chalk. Outlines are blurred into evanescence; tactile values no longer exist. The practice of drawing and painting without outlines, which goes back to Giorgione, had several Venetian exponents in the seventeenth century, but was not typical of Venetian artists then, and certainly not of Venetian draughtsmen in the eighteenth century, when Maratti's academic draughtsmanship was hailed in Venice as the criterion of excellence. Thus Antonio was not an innovator; rather he carried an outgoing tradition to its farthest limit. One step farther would have rendered his forms unrecognizable, dissolved them into pure abstractions. He came close to taking that step: one need only look at his Aurora in the Spector collection (Fig. 104) or his Virgin Enthroned with Attendant Saints at the Ashmolean Museum (Fig. 101) to be convinced of this. As for Francesco's draughtsmanship in red chalk,

[1]The "Ant.o" was subsequently changed to Fran.o" by another hand.

the one incontrovertible specimen is The Archangel Michael at the
Correr Library (Fig. 195), sketched on the back of a sonnet to
Doge Renier published in 1779, almost twenty years after Antonio's
death. Here too the lines are of different firmness, the heads
and extremities are merely alluded to, and the shadowy parts are
indicated with hatchings. However, the hatchings are without tonal
variations, and Francesco's short strokes and idiosyncratic peaks
are omnipresent. Two distinct personalities emerge from the works
mentioned so far. Of the two brothers, Francesco appears to have
been more akin to the draughtsmen of his time. Though even in his
most finished drawings he did not bother to delineate his forms
fully or to model them according to academic precepts, as a Pittoni
or a Piazzetta would have done, he nevertheless did not lose sight
of their structure, plasticity, and contours. His approach was far
more that of a draughtsman concerned with the language of lines,
Antonio's far more that of a painter concerned with their pictorial
aspect. And yet a given drawing by either brother may reflect
aspects of the artistic personality of the other. This should not
come as a surprise. In what relationship the two brothers stood to
each other is not known, nor is it possible to infer from their works
whether Antonio was Francesco's master. But the two must have been
well aware of each other artistically, and reciprocal influence most
likely accounts for the hybrid quality of some Guardiesque sheets.
Thus at a first glance the Archangel Michael (Fig. 195) does not
appear to be unequivocally by the one brother or the other, but on

close scrutiny telltale signs show up that would permit a correct
attribution even if external evidence were lacking. Similarly,
the graphic handling of the Contadinello (Fig. 116) does not look
typical of the older Guardi at first sight. True the lines are rather
fluid, and some are gone over twice (notably in the legs). But the
contours are clearly delineated, and the wash is evenly applied in
broad strokes reminiscent of Francesco's Dancing Peasants, which
dates from about the same time. But such plump, short-waisted
figures with heavy, somewhat shapeless legs recur frequently in
Antonio's works, especially in his paintings. Characteristically,
the features of the face are not drawn distinctly. But the most
telling detail is the chubby little hand which, wherever it appears,
can almost be taken as a signature. Conversely, The Archangel
Michael shows to what uncanny degree Antonio's graphic manner rubbed
off on Francesco: the attribution may well have remained contro-
versial were it not for the terminus post quem provided by Doge
Renier's sonnet. In general, however, the Guardiesque drawings
which cannot be assigned on external evidence can be attributed con-
clusively on stylistic grounds when studied against the authenticated
works.

In comparing the unauthenticated with the authenticated draw-
ings, one notes numerous differentiating peculiarities in the Guardi's
respective treatment of subjects, choice of materials, and working
methods.

Thus the Guardi each had a distinctive manner of treating the

morphology of a small child--a _putto_ or a Christ child. This is
immediately noticeable when one looks at the enlarged details illus-
trated in Figs. 11-16. Francesco drew the arms and legs in a succes-
sion of small curved lines, endowing his small creatures with a muscu-
lar, athletic appearance. Antonio, in contrast to his usual treatment
of bodies, delineated those of his _putti_ in a few rather long, form-
bounding strokes, emphasizing chubbiness and roundness rather than
muscularity and producing delightful little figures with smooth flesh
and barely accentuated ankles and wrists.

Most of Antonio's known sketches are drawn on large sheets of
good, white, sized artist's paper. For rougher studies he occasionally
took slightly toned leaves. Francesco, in his earliest drawings,
employed paper like his brother's. But with the passage of time, and
especially during the two last decades of his life, he became less
and less discriminating in his choice of paper. He drew frequently
on rough-textured wastepaper, on absorbent wrapping paper, on
the backs of old letters, and, in between, again on white paper of
good quality. The Archangel Michael (Fig. 195) is drawn on the back
of a broadsheet, and a little landscape at the Corror Library is on
used tobacco wrapping paper.[1] It has been suggested that Francesco
used these coarse papers because he liked fibrous surfaces which
soften the lines and give the drawing a more vibrating appearance.
Possibly so--but it is recorded that for his late paintings he used
pigments and canvases of the poorest quality because they were

[1]Pallucchini, _Zeichnungen_, No. 131a.

inexpensive.[1]

The known wash figure drawings by Francesco invariably show
that the lines were traced with a pen and that the same ink was used
in diluted form for the wash. He may not have employed this econom-
ical method from the start: his earliest known wash figure drawings
probably date from the 1750's. But so do his earliest known view
sketches, which, however, involve more complex techniques closer to
Antonio's: occasionally two colors of ink are used, and a small
brush frequently complements the penwork.[2] Antonio often utilized
more than one ink in a wash drawing--two shades of brown, or grey
and brown were usual. And he rarely executed linework in a single
medium: he would combine chalk and pen, or pen and a small brush,
or brush and chalk, or several media. The Holy Family in the Anda-
Bührlé collection in Zurich (Fig. 77) was drawn with red chalk and
brush, then washed in brown, and blue-green water color was applied
in places. Frequently Antonio applied the wash directly on the under-
drawing, then reinforced the design with the original or another
material. Francesco, more conventionally, spread the wash over a
finished pen drawing. The faint preliminary tracings discernible
in so many Guardiesque drawings served different purposes in each
draughtsman's case. Francesco used the underdrawing for guidance
only, and frequently did without it. For Antonio it often formed a

[1]Pietro Edwards' letter of June 13, 1804, to the sculptor
Canova, reproduced in Francis Haskell, "Francesco Guardi as Vedu-
tista and Some of his Patrons," Journal of the Warburg and Courtauld
Institutes, XXII (1960), 276.

[2]Some such sketches are reproduced in Byam Shaw, Drawings:
see plates 11, 12, 16, 18.

component part of the whole design. In many instances, as in the
Allegory of Martial Virtue, some parts of the underdrawing are
not gone over at all and are exploited per se as defining elements
as much as the brush or pen lines.

Antonio drew a good deal in red chalk, a medium which suited
him particularly well to judge by the quality of the results. For
his part, Francesco can hardly have relished the medium, as few
chalk sketches of his are extant, and none of these except The Arch-
angel Michael exhibits his fanciful virtuosity. His tool par excel-
lence was the pen. He used both a quill and a reed, though the
latter only toward the end of his life. Pure pen drawings consti-
tute close to half of his total graphic oeuvre, whereas only one pure
pen drawing attributable to Antonio has so far come to light.

As the corpus of known Guardiesque figure drawings consists of
close to two hundred pieces, the complete absence of studies of
details such as hands or drapery and the dearth of individual
figure studies of compositional components are remarkable. In a
figure drawing by either Antonio or Francesco, a whole composition
is usually set down, no matter how sketchy or loose the handling.
The degree of finish varies, but even in the most elaborate works
no passages are developed markedly enough to suggest that studies
of details might have preceded them. Some of Antonio's few sketches
that represent single figures are occasionally regarded as studies
of compositional components--quite erroneously, it seems, as they
appear to be fragments of larger drawings. Thus the Aurora (Fig. 104)

and the Archangel Raphael (Fig. 86) figure on sheets which were
visibly trimmed down. The only drawing by Antonio with a real
claim to being a study of a detail is the Fauchier-Magnan Head of
a Magus (Fig. 94), possibly made for an Adoration of the Magi. And
yet, as the sketch is rather large, as it bears the unknown collec-
tor's inscription, and as heads were then at a premium with art
lovers, it just may have been made as a work in its own right after
all. As for Francesco's numerous sketches of one or two figures,
they appear to be complete preparatory drawings rather than studies
of individual figures to be integrated into a larger ensemble. It
is indicative of Francesco's working habits that, with two excep-
tions (Figs. 160, 194), a given figure or motif is never repeated
in modified form on the same sheet. That far more one- or two-figure
drawings by Francesco than by Antonio exist finds a sufficient
explanation in Francesco's preference for paintings involving one
or two figures only.

In comparison with their contemporaries--with Pittoni and the
Tiepolo in particular--the Guardi did not take great pains to pre-
pare their paintings. Carelessness may account in part for the
anatomical incoherence and compositional incongruities frequently
encountered in Antonio's paintings, though it does not appear to
have flawed Francesco's. That they made few preparatory studies
for their paintings is not, however, surprising in view of the
extent to which they relied on others for their compositions. They
probably copied for the most part from etchings and engravings, of

which they must have had a goodly supply. There is no telling
whether the faculty of invention was just weak in their case or
whether it was stunted by their early training as copyists. Their
plagiaristic practice raises the question of why the drawings were
made if as a rule the compositions were borrowed with little alter-
ation.

In all likelihood some drawings that were copies, faithful or
free, were produced as ends in themselves. Antonio's sixty-odd
pieces usually referred to as Fasti Veneziani (Figs. 1-34), which
are free copies of famous pictorial works adorning Venetian public
buildings, were most likely made to order for an interested patron.
They are all of the same size, all numbered, and all executed in
the same technique with a finish and definiteness not usually en-
countered in Antonio's graphic oeuvre. Other Guardi drawings may
have been made after paintings of their own, as ricordi: thus the
famous Ridotto drawing at Chicago (Fig. 113). And certain sketches
after works of others were probably made for future reference when
the originals were not permanently accessible. Some of Tiepolo's
drawings certainly passed through the hands of the Guardi, who may
have taken the opportunity to note compositions that could come in
handy later. An original by Tiepolo can be surmised behind
Antonio's Coronation of the Virgin (Fig. 82) at the Pushkin Museum,
and his Archimedes (Fig. 95) at the Cologne Museum is a faithful
copy of his brother-in-law's drawing of the same subject.[1] However,

[1]Reproduced in Eduard Sack, Giambattista and Domenico Tiepolo
(Hamburg, 1910), fig. 294.

no such Guardi copies on paper--with the original composition unaltered, that is--have yet been matched with Guardi copies in paint.

When a Guardi sketched a composition by another artist, his graphic style seems not to have been much affected by the original so long as it was an engraving or a painting. But when it was a drawing, and especially if he copied it in the same medium, he would absorb its style to some degree, as was only natural. This shows clearly in the copies after Tiepolo, whose idiosyncratic clumpy shadows, for instance, were so uncannily well imitated by Antonio that--somewhat surprisingly all the same--the copies were for a long time attributed to Tiepolo himself. On first confronting Antonio's Allegory of Reward (Fig. 115) in Vienna, even the most astute Tiepolo specialist would quite likely pause before declaring it--rightly--a copy. This suggests the possibility that some of Antonio's drawings formerly attributed to Sebastiano Ricci or Pellegrini were derived from drawings of theirs.

The fact that most or all of the Guardi's paintings and decorative schemes were derivative did not necessarily reduce their need for preparatory sketches. In some cases the borrowed composition was to be fitted into a format necessitating its readjustment. One such case is Antonio's Christ at Emmaus in the Hugelshofer collection in Zurich (Fig. 78), taken from a painting by Piazzetta in Cleveland (Dal Ricci al Tiepolo, Venice: Palazzo Ducale, 1969, fig. 58): a nearly upright composition had to be stretched out lengthwise.

In other cases the composition was a compound of diverse borrowings, usually from one main and several accessory sources. The Martyrdom of Saint Clement in the collection of Mr. Janos Scholz (Fig. 63) exemplifies a preliminary drawing for a pastiche painting. The central portion was taken unaltered from a painting Pittoni made circa 1735 for the Bishop of Cologne (Fig. 64), whereas the figure group on the left came from Sebastiano Ricci's Camillus and Brennus, of which Francesco Bartolozzi made an engraving.[1]

As far as the working habits of the two brothers can be reconstructed it seems that in planning a painting they first picked an acceptable composition out of their reference portfolios and then jotted it down on paper in more or less altered form. Generally that one jotting sufficed. In few cases do two preparatory drawings for a given Guardi painting exist. In only a single case are there more than two-- the three for a Saint Nicholas by Francesco (Figs. 210, 211, 212). In these cases the composition did not undergo structural or substantive change from one drawing to the next; only accessorial elements were reworked. Thus from the first to the second version of Antonio's Christ at Emmaus, respectively in the Eisemann Collection and at the Staedelsche Kunstinstitut (Figs. 88, 89), the principal figures and the furnishings in their vicinity remained practically unaltered; only the hovering cherubs were multiplied to people the large void created by the change of format from Piazzetta's original. Francesco's two drawings for the Pietà altarpiece formerly in Munich (Figs. 139, 140) are almost identical in composition. The

[1]Reproduced in Sebastiano and Marco Ricci in America, Memphis: Brooks Memorial Art Gallery, 1966, fig. 17.

obvious reason for the second was to bring the figures closer to the
picture plane--but that was a mere matter of enlarging them. The
primary reason emerges on closer examination: to define the light-
ing more pictorially. The preparatory drawings of both Guardi show
again and again how intensely the two occupied themselves with light
and dark--each in his own way. Francesco, in Baroque tradition,
strove after tense chiaroscuro contrasts, whereas Antonio, in true
Rococo spirit, passed serenely from lights to darks in crescendos
and diminuendos.

The borrowing of compositional material by the Guardi has been
noted in instance upon instance to date without, however, being con-
sidered integral, let alone central, to their practice. But time and
again figures and motifs that look like genuine, spontaneous creations
turn out to be derivative, and the conclusion is inescapable that bor-
rowing was not the exception with them but the rule, perhaps unbroken.
Their plagiarism is not frowned upon in our time, moreover, because it
is thought to have been typical of their age.[1] Nonetheless they
stand apart from their contemporaries on this ground. Sebastiano
Ricci and Giambattista Tiepolo were called, and indeed were, imitators
of Veronese, but their imitation of Veronese amounted to assimilating

[1]The subject of imitation, plagiarism and eclecticism during
the eighteenth century has drawn attention in recent years. See
especially Rudolf Wittkower, "Imitation, Eclecticism, and Genius,"
in Aspects of the Eighteenth Century (Baltimore, 1965), pp. 143-161.

his manner,not appropriating his compositions. Domenico Tiepolo
was far less inventive than his father, and his drawings show that
he often turned to Mantegna, Titian, Castiglione, Magnasco, and
Jacques Callot for inspiration;[1] still, no compositional appropria-
tions by him have so far been discovered. Pittoni's juvenilia are
mannered after Solimena and Piazzetta's after Crespi and Cignani,
but both stopped short of outright copying. It would seem that artists
did not borrow all that much in that golden age of imitation.[2] But the
Guardi did. Indeed, this may even be one reason why their contemporaries mis-
esteemed them.

Francesco's studies for macchiette are by far the most instruc-
tive material for investigating how he assembled a composition. A
small sketch at the Correr Library represents a group of Venetians
waiting in front of the Ridotto, the gambling house at S. Moisè
(Fig. 17).[3] They all seem to have been sketched on the spot, yet
the popolana at the extreme right and the gentleman at her left,
the bending man with outstretched hand, and the woman and child close
together were taken from the crowd in Brustolon's engraving The Doge
at Saint Mark--and taken intact except that a veil was removed from

[1]J. Byam Shaw, The Drawings of Domenico Tiepolo (Boston, 1962),
passim.

[2]Naturally, apprentices copied for training, and masters copied
for practice or on commission to duplicate famous works of art. In
the present context I mean "copy" in the restricted sense of inte-
grating figurative material from others' works into one's own.

[3]Reproduced in Pallucchini, Zeichnungen, no. 48.

the woman beside the child. This sketch presumably dates from the 1780's, when the hat à l'anglaise worn by the lady at the left became fashionable in Venice.[1] Around 1770 Francesco had copied the same engraving in its entirety for a painting now in the Museum at Brussels.[2] In fact he then painted the whole set of Venetian scenes with large crowds which Brustolon engraved around 1766 after designs by Canaletto.[3] Thereafter he over and over again picked out single figures from Brustolon's crowds and rearranged them on his study sheets.[4]

Another sheet of figure studies at the Correr Library (Fig. 18) could give the false impression that Francesco painstakingly created his own staffage. The figures of the bishop and of the priest holding the book, repeated several times, derive from Pitteri's engraving after Pietro Longhi's The Sacrament of Confirmation.[5] Francesco was merely trying out alternative positions for the bishop's right arm. Bishop and priest were both used in Francesco's large drawing at the Correr Library of the Duke de Polignac's wedding in 1790.[6]

[1]See below, p. 148.

[2]Mostra dei Guardi (Venice: Palazzo Grassi, 1965), p. 191, figs. 98, 98a.

[3]Max Goering, Francesco Guardi (Vienna, 1944), p. 44; W. G. Constable, Canaletto (Oxford, 1962), II, 480.

[4]For some examples see Tiepolo et Guardi dans les collections françaises, Paris: Galerie Cailleux, 1952, pl. 37; Canaletto e Guardi (Venice: Fondazione Cini, 1962), pl. 93; Byam Shaw, Drawings, plates 50, 51.

[5]Reproduced in Terisio Pignatti, Pietro Longhi (Venice, 1968), fig. 149a.

[6]Reproduced in Pallucchini, Zeichnungen, fig. 97.

Francesco had made a free copy of the Pitteri engraving over three decades earlier (Fig. 134), presumably in preparation for a painting.

It is most difficult to arrange the Guardi drawings in chronological sequence. Specialists differ radically over the dating of certain works. Some consider the Fasti Veneziani (Figs. 1-34) as relatively early works on which all brothers--including Nicolò-- collaborated,[1] but according to others the set was produced by Antonio alone at the very end of his life.[2] Dates suggested for Francesco's sketch of Saint Nicholas at the Correr Library (Fig. 211) begin with circa 1746,[3] but I see a material objection to dating it much before circa 1780.[4] It avails little that several of the drawings relate to known paintings, as those paintings are themselves hard to date in most cases. The dates suggested for the Pietà altarpiece at Munich, for which Francesco made important preparatory drawings, range over four decades, yet the respective arguments all make good sense.

Antonio's chronology is especially elusive because his drawings are so scantily documented. They are on loose sheets except that the Fasti Veneziani may originally have been bound. No sketchbook of

[1]Primarily Giuseppe Fiocco, "I fasti Veneziani dei Pittori Guardi," Le Tre Venezie, (July-December, 1944), 10.

[2]Primarily Terisio Pignatti, I disegni veneziani del Settecento (Venice, 1966), pp. 155-156.

[3]Denis Mahon, "The Brothers at the Mostra dei Guardi: Some Impressions of a Neophyte," in Problemi Guardeschi (Venice, 1967), pp. 112-113.

[4]See below, pp. 309-330.

his has been discovered; probably none ever will be.[1] Indications of
eighteenth-century provenances are available only in two cases.
The Allegory of Venice at the British Museum (Fig. 106) was acquired
(at a unkown date) by Joshua Reynolds, who may not have known whose
work it was. And John Skippe, who collected in Venice toward the
end of the century, acquired The Supper at Emmaus, presently in pri-
vate hands in London (Fig. 89), and attributed it to Sebastiano
Ricci.

It is now known from whom Antonio learned to draw. In style
his drawings often recall Pellegrini's. This is perhaps most striking
in The Family of Darius in Aalens (Fig. 55), although in technique its
affinities to Sebastiano Ricci's late manner are more tangible,
especially in the way Antonio combined several graphic materials
to achieve a pictorial effect.[2] Of all his contemporaries it is
also Sebastiano to whom Antonio came closest in his painting.[3] As
a document of 1750 styled him "scolaro di Bastiano Rizzi,"[4] he may
have attended the school Sebastiano directed in Venice in his last

[1]For the reasons see above, pp. 138-139.

[2]On Sebastiano Ricci's draughtsmanship, especially during his
last years, see Anthony Blunt, Venetian Drawings of the XVII and
XVIII Centuries in the Collection of Her Majesty the Queen at Windsor
Castle (London, 1957), pp. 45-67.

[3]Edoardo Arslan, "Per la definizione dell'arte di Francesco,
Giannantonio e Nicolò Guardi," Emporium C (1944), 25.

[4]The document is reproduced in Vittorio Querini, "I documenti
sulla pala di G. Antonio Guardi della arcipretale di Pasiano di
Pordenone," Messagero Veneto (November 21, 1963), p. 3.

years (until 1734). Yet Antonio's weakness in actual disegno
suggests that he was never adequately trained in it. For the
first half of his career his job was copying paintings, which
does not necessitate drawing. It is thus probable that his draw-
ings date from after 1740, when besides copying paintings he
created paintings of his own.

Quality does not always provide sure clues for chronology,
least of all in Antonio's case. His charming Harem in Bergamo
(Fig. 87), datable to 1742-1743, shows a deftness and control
that the pedestrian, awkward Contadinello, dated 1760, does not.
Except that it is dated, the Contadinello could pass for the work
of a beginner. Moreover, the quality of sheets from the same period
will vary drastically according to the purposes they served. The
deliberate and full drawing of The Ridotto (Fig. 113), datable in
the mid-1750's, is contemporaneous with the spirited and lively
sketch, Virgin Enthroned with Attendant Saints at the Ashmolean
Museum (Fig. 101), made circa 1754 in connection with the altar-
piece at Cerete Basso. The first was a record copy of a painting
already done, the second a study of lighting for a painting to
come.

Only five of Antonio's drawings can be dated with certainty.
To line up the others chronologically with exclusive reference to
those five would be all too hazardous. Therefore one must also
follow the guidelines provided by his evolution as painter in so
far as it can be retraced with precision. For

instance, his datable paintings show that he progressively acquired greater ease and competence in relating figures to each other, so that the same progression can be presumed in his drawings. Again, as his paintings show an increasing disregard for outlines, combined with increasing effervescence, it can be presumed that this stylistic development too was reflected, to a degree at least, in his graphic works. But these guidlines are not foolproof. Since no painting by him is known to have been executed after 1753, there is no saying for sure how he painted during his last years. And indeed, his three drawings datable to those years evince new concern for delineation and precision. Perhaps his younger brother was influencing him. Or perhaps, having become an academician, he went a little academic. On the other hand, these three drawings just may have been record copies.

Francesco's chronology presents lesser, but more intriguing problems. Apart from figure sketches, some 350 drawings of views, landscapes, capricci, and staffage figures have been attributed to him. Past attempts to retrace his evolution as draughtsman rest primarily on his drawings for his vedute.[1] His figure drawings have received little attention by comparison, though dates have been proposed for individual sheets. Few of the dates proposed have been late ones, as the old belief that he painted few histories after Antonio's death persists in spite of increasing evidence to the contrary. Upon close study, the majority of his

[1] Byam Shaw, Drawings, passim.

figure drawings can, however, most credibly be assigned to his last twenty years. And as many of his views and _capricci_ seem to date from those same years, one could conclude that he drew more as time went on. Perhaps he did. But perhaps it is just that more of his late drawings have survived.

At his death his reference material, including the drawings, must have passed to Giacomo, who also painted views, but who did not paint histories. In 1829 or shortly thereafter, the Venetian collector Teodoro Correr acquired from Giacomo some 300 drawings of widely ranging types.[1] By then Giacomo had probably sold many of his father's graphic works, presumably the best ones first. Teodoro Correr's collection, intact, is today at the Correr Library in Venice.[2] A large part of his Guardi material is known from excellent facsimiles published by Rodolfo Pallucchini,[3] but much of it remains unpublished.[4] Not all the drawings he purchased are by Francesco; possibly he himself did not suspect that many of them were by Giacomo and perhaps even by Nicolò.[5] The four Guardi

[1]On the particulars of the transactions between Giacomo and Correr, see Pallucchini, _Zeichnungen_, p. 9.

[2]Besides Teodoro Correr's large lot, the Correr Library has acquired a number of other drawings attributed to the Guardi: it is today by far the most important depository of their graphic works. Unfortunately, even Guardi specialists often forget to distinguish between Teodoro Correr's lot and subsequent unauthenticated acquisitions.

[3]Pallucchini, _Zeichnungen_, _passim_.

[4]Mostly studies and sketches by Giacomo.

[5]The inventory of Correr's collection made after his death records 225 drawings by Francesco, 18 by Giacomo, and 93 unidentified Guardiesque sheets.

specialists who have studied them have attributed different numbers

of them to Francesco.[1] For the most part the differences turned on

items of lesser quality--or thought to be such--which were often too

hastily attributed to Giacomo or even to elusive Nicolò. Quality is

not always a reliable criterion with Francesco. Some of his authen-

ticated drawings are undeniably worse than Giacomo's best.

In my own judgment, at most 125 of the drawings acquired by

Teodoro Correr are by Francesco,[2] and if this is correct the group

contains roughly one fourth of Francesco's known oeuvre. This corpus

is the logical point of departure for reconstructing the chronology

of his graphic works. Byam Shaw remarked astutely that one should

expect to find many late works in a collection consisting mainly of

what was left in an artist's workshop at his death.[3] Perhaps all the

[1] In Zeichnungen, Pallucchini published all of those he believed
to be by Francesco (121 pieces) and some of those he thought to be
by Giacomo. Byam Shaw, Drawings, passim, endorsed Pallucchini's
attributions on the whole. Arslan, "Per la definizione ...," passim,
and, after him, Carlo L. Ragghianti, "Epiloghi Guardeschi," Annali
della Scuola Normale Superiore di Pisa, XXII (1953), 86-96, sought
to weed out Pallucchini's catalogue drastically; Ragghianti, judging
chiefly by quality, relegated numerous sheets to the convenient
sphere of anonymity.

[2] The four figure drawings attributed by Pallucchini to Antonio
(Zeichnungen, Nos. 154, 155a, 156, 157) are certainly by Francesco,
and The Fire in the District of S. Marcuola, which Pallucchini
assigns to Francesco (no. 96), is probably a copy by Giacomo after
his father's original, today at the Metropolitan Museum of Art (cf.
Byam Shaw, Drawings, nos. 40, 41, and figs. 40, 41). Furthermore,
I fully share the opinion of Byam Shaw (Drawings, no. 18) that the
impressive Grand Canal at the Entrance to the Cannaregio is an early
work by Francesco.

[3] Byam Shaw, Drawings, p. 14.

Correr drawings by Francesco date from the last fifteen or twenty years of his life. On concrete evidence, many can be dated from the last decade of his life, and none from before. Moreover, the stylistic affinities are obvious between those that cannot be dated on concrete evidence and those that can.

The Correr drawings by Francesco include sixteen figure sketches, which are accordingly to be assigned to his old age. Several other figure drawings by him can be dated reliably. The Allegorical Scene with Satyrs (Fig. 220) bears the date June 1787, which also applied to the Decoration for a Theater Curtain (Fig. 221), as the two pieces were commissioned at the same time for an album to be presented to the Doge. For The Archangel Michael (Fig. 195) the printed broadsheet on which it is drawn provides a terminus post quem of 1779.

It is on the evidence of costume, however, that the greatest number of Francesco's drawings can be dated. The changes of ladies' fashion provide the most valuable clues.[1] During the late 1760's buffed-up hair replaced the flat hairdo, well known from Pietro Longhi's genre pieces, which had prevailed for several decades. Plumes were added during the next decade. By the 'eighties the coiffure had grown in width as well and was being topped by a panache. It is also during the 'eighties that the wide-brimmed straw hat, the hat à l'anglaise, made its appearance on the Venetian scene.

[1]Byam Shaw is so far the only Guardi specialist to have dated Guardi works on the evidence of costume. See Drawings, pp. 37-38.

Similarly a small felt hat, shaped like a cylinder, became very
fashionable during the two last decades of the century.[1] The
ladies' hats and hairdos provide a terminus post quem for many a
view by Francesco. It is true that the staffage is drawn or painted
on a small scale. Even so, plumes or small tricornes dangling on
the "sugar loaves" are almost always discernible in the works datable
after 1770. And in the figure drawings, costumes and fashionable
accessories are, of course, more explicit and visible. They are
also particularly instructive for attributing the figure drawings,
as Antonio could not very well have depicted costumes that first
came into fashion twenty years after his death.

Thus the elaborate, plumed hairdos of the Woman Standing on
a Chair at the British Museum (Fig. 176) and of the Woman Taming
a Lion in Janos Scholz's collection (Fig. 176) rule out a date much
earlier than 1780 and, of course, Antonio as author. The companion
Lady Holding Grapes and Lady Holding a Fan, both at the Correr Library
(Figs. 216, 217), respectively wear the types of straw hat and
felt cap which became fashionable in Venice in the middle 1880's.
A sheet of little distinction from Teodoro Correr's collection is
an excellent case in point of how much can be inferred from trivial
vestimentary accoutrements (Fig. 210). It comprises a Saint Anthony,
a Saint Nicholas, and a group of walking macchiette--

[1]My information on costume in Venice during the second half of
the century derives from G. Morazzoni, La moda a Venezia nel secolo
XVII (Milan, 1931); Byam Shall, Drawings, pp. 37-38; and from the
study of book illustrations and engravings.

all drawn on the recto with the same coarse pen, in the same ink,
and in the same style, thus obviously at the same time. A panache,
traced in a brief curly pen-stroke, dangles over the head of a
macchietta, and dates her as well as her companions, including the
Saint Nicholas at her left. But the Saint Nicholas is one of three
preparatory studies for a painting, so that the other two are thereby
dated in their turn. Now, the painting itself, which must have fol-
lowed in time has generally been regarded as a relatively early piece
by Francesco, or even attributed to Antonio. Clearly, the whole
Saint Nicholas series must be studied anew in view of the plumed
macchietta.

Genre sketches of ladies with flat hairdos can for their part
be dated before 1765. No greater precision than this is possible,
however, and the attribution is not thereby facilitated. Three such
drawings are extant: the Lady at the Spinet (Fig. 123) and its
companion Lady at her Dressing Table (Fig. 123), both at the Louvre,
and the Parlatorio sketch at the Correr Library (Fig. 128).

As against Antonio, who rarely used a sheet for more than a
single drawing, Francesco frequently drew on both sides of a sheet
and in several instances sketched figures on the one side and boats
or staffage or a Venetian campanile on the other. It is reasonable
to assume that in most of these cases recto and verso were executed
at about the same time, so that if either is datable the other is
too. But this is not always certain. The draughtsman may have pulled
an old design out of his reference portfolio to pick up a motive and
subsequently used the blank verso for a new sketch. Thus the

Parlatorio drawing (Fig. 128), certainly dates from the middle
years of the century, but the group of houses on the reverse is in
Francesco's familiar late manner. But where the style on both sides
of a sheet is similar, the date can be presumed to be the same for
both. This certainly holds for the sheet at the Metropolitan Museum
of Art with a View of the Grand Canal on one side[1] and Saint Philip
Neri and Saint Vincent Ferrer on the other (Fig. 122). The date
for both sides is provided by the view sketch, which belongs to a
well-defined group of drawings dating from 1755-1765 (Francesco's
early phase as vedutista).[2] The view reflects the hesitancies of a
beginner in vedutismo, so that it could hardly have been executed
much later than 1755. A sketch of S. Giorgio Maggiore at the Museum
at Truro[3] belongs to the same group, but shows a greater mastery of
vedutismo and must have been executed several years later. It is
interesting that the figure sketch on the reverse side of the Truro
sheet, Young Couple Conversing (Fig. 143), also exhibits greater sure-
ness and sophistication in the penwork, and already anticipates
Francesco's mature style as the figure sketch at the Metropolitan
Museum does not.

It would have been difficult to follow Francesco's evolution
as a draughtsman had his figure sketches alone survived. Those

[1]Reproduced in Byam Shaw, Drawings, fig. 10.

[2]Byam Shaw, Drawings, p. 34.

[3]Reproduced in An Exhibition of Drawings from the Alfred de
Pass Collection Belonging to the Royal Institution of Cornwall
(Truro: The Art Council, 1957), pl. 7.

which can be dated on external evidence can almost all be assigned
to the twenty last years of his life, and only four or five at most
to a period prior to 1765. Byam Shaw has--admirably--arranged a
good number of preparatory studies for views and landscapes in rough
chronological order. By taking the changes which occurred in Vene-
tian topography into account, Byam Shaw succeeded particularly well
in defining Francesco's development as draughtsman during the crucial
years of the 'fifties and early 'sixties, when Francesco was model-
ing himself on Canaletto.[1] This is precisely the period which yields
the least information on the figure drawings. By combining the informa-
tion that can be derived from both figure and view sketches, one can
follow Francesco as draughtsman from about 1750 to the very end of his
life.

Francesco's drawings of the 'fifties, the earliest known, are
more deliberate and careful in handling than the later ones. As
time went one, his penwork became freer, but also more angular and
more economical. This tendency can already be discerned in the
exquisite drawing of Two Dancing Peasants of circa 1760 (Fig. 144)
as compared with the two drawings from the Metropolitan Museum of
Art mentioned above (Fig. 122). By the middle 1760's Francesco
seems to have developed the distinctive graphic manner which is
usually known as the Guardi style. The Grand Canal with Palazzo
and S. Geremia is one of the masterpieces most illustrative of this
mature manner.[2] His style did not evolve significantly over

[1]Byam Shaw, Drawings, passim. [2]Reproduced ibid., Pl. 19.

the two next decades, though the trend toward increased abbreviation
in the rendering of forms persisted. Such sketches as the two
reproduced below, which should date from the late 1770's, are the
ultimate in conciseness (Figs. 19,20). Commonly, whatever Francesco
is thought to have drawn after 1770 is labeled "late," as if his
style did not change between 1770-1793. However the drawings that
can be assigned to the last five or seven years of his life exhibit
certain singularities which may well be due to the trembling of the
old artist's hand. Lines are never straight. Contours are frequently
reinforced with repeated strokes, as if the draughtsman had not suc-
ceeded in bounding the form straight off. When wash is used, it
flows over the outlines, often quite untidily. Some areas are
filled with a maze of lines for no good reason. All this seems to
indicate that the hand did not follow the mind so readily as before.[1]
Some of these very late drawings, particularly the figure sketches,
are aesthetically not very pleasing, yet others, particularly the
architectural _capricci_, are among the most poetic works Francesco
ever produced.[2]

From the 1750's until his death, Francesco's graphic style
evolved continually but gradually, without prolonged periods of
fixity or drastic new departures. Drawings assignable to specific
periods of his career are remarkable consistent in style. In his
case the purpose of a drawing does not seem to have

[1] Byam Shaw, _Drawings_, p. 36.

[2] For some examples, see Pallucchini, _Zeichnungen_, figs. 113a,
113b, 114, 115, 116, 128, 131a, 132, 134, 151a.

affected its style considerably. A finished presentation piece, such
as the large sheet at the Correr Library The Wedding Ceremony of the
Duke de Polignac,[1] is not more deliberate in its execution than are the
preliminary studies for it.[2] Thus it is much easier and less risky
in Francesco's case than in Antonio's to date a sketch by its
stylistic relation to others that can be dated independently. To
take Francesco's little known Adoration of the Shepherds at Chicago
(Fig. 141): it relates closely to his view sketches known to date
from around 1760, but only remotely to his drawings known to be
earlier or later.

The great unknown in Francesco's case is his activity as
draughtsman before 1750. As he was born in 1712, some twenty years
remain to be accounted for. It could be hypothesized that, like
his brother, he worked as copyist in his early years, and that he
dispensed with drawing then. The difficulty with such a hypothesis
would be that his earliest known graphic works already exhibit a
pronounced personal manner that can hardly have been acquired with-
out years of practice.

One of the very few sketches which could plausibly be assigned
to a period prior to 1750 is the Immacolata at the Correr Library
(Fig. 118). Stylistically it appears to antedate the Saint saying
Mass (Fig. 122) and the Sacrament series (Figs. 129-135), which are
among his earliest known drawings. And the naivete of the painting

[1] Reproduced ibid., fig. 99. [2] Ibid., figs. 97. 98.

to which it corresponds, the _Immacolata_ in the Crespi Collection,[1]
likewise argues an early date.

Because of the absence of early drawings by Francesco and the
dearth of biographical data on him, there is no way of telling who
taught him drawing. Antonio comes to mind as an obvious possibility,
though he does not seem to have been particularly well qualified for
the role of drawing master. The stylistic affinities between some
of their respective drawings do not necessarily tend to prove a
master-pupil relationship: they may well have come of a protracted
partnership in subsequent years, and the influence may then have
worked both ways.

The extraordinary recent fascination with the Guardi makes it
difficult to form a detached estimate of the place they deserve among
their fellow draughtsmen. Of the two brothers, Francesco certainly
drew better. His figure studies do not, however, bear the impress of
his genius in the same measure as his studies for _capricci_, views,
and staffage, sketched with the utmost economy of means. Antonio,
with his anti-academic approach, has been considered as having been
a century ahead of his time. His originality stemmed, however, from
the very weakness of his _disegno_. He may not have received training
in the rudiments of draughtsmanship. At all odds, it was in attempt-
ing to disguise his lack of conventional skill that he came to

[1]Reproduced in _Dal Ricci al Tiepolo_ (Venice: Palazzo Ducale,
1969), fig. 118.

dissolve contours, which he could not render adequately, and to adumbrate the forms he could not define. In so doing, he created a style all his own.

CHAPTER IV

CRITICAL CATALOGUE OF THE DRAWINGS OF
ANTONIO AND FRANCESCO GUARDI

I was unable to see the originals of roughly one fourth of the
drawings catalogued below. For these the published information on
techniques, measurements and inscriptions could not be verified, though
in certain cases more precise indications were supplied by collectors
and curators. All dimensions are given in millimeters, height preced-
ing width. Unless stated otherwise the ink used for the linework in
pen and wash drawings is of the same color as that used for the wash.
"No." without further specifications refers to the number in this
catalogue. "Fig." refers to the reproduction found in the back. In
spite of repeated requests made during the past two years, I could not
obtain photographs of several of the unpublished drawings which belong
to the set of the Fasti Veneziani; I did, though, see most of the
originals. The bibliography does not include writings in which draw-
ings are merely referred to without comment. The following abbrevi-
ations have been used for the works most commonly mentioned:

Zanotto 1846 Francesco Zanotto, Il Palazzo Ducale di
 Venezia, 4 vols. (Venice 1846-1861).

Fiocco 1923 Giuseppe Fiocco, Francesco Guardi (Florence,
 1923).

Lorenzetti 1936 Giulio Lorenzetti, Ca' Rezzonico (Venice, 1936).

Pallucchini 1943 Rodolfo Pallucchini, Die Zeichnungen des Francesco Guardi im Museum Correr zu Venedig (Florence, 1943).

Arslan 1944 Edoardo Arslan, "Per la definizione dell' arte di Francesco, Giannantonio e Nicolò Guardi," Emporium, C (1944), 1-28.

Fiocco 1944 Giuseppe Fiocco, "I fasti veneziani dei pittori Guardi," Le Tre Venezie, July-December (1944), 9-15.

Byam Shaw 1951 James Byam Shaw, The Drawings of Francesco Guardi (London, 1951).

Morassi 1953 Antonio Morassi, "A Signed Drawing by Antonio Guardi and the Problem of the Guardi Brothers," The Burlington Magazine, XCI (1953), 260-267.

Ragghianti 1953 Carlo L. Ragghianti, "Epiloghi Guardeschi," Annali della Scuola Normale Superiore di Pisa, XXII, 2 (1953), 75-107.

Pignatti 1957 Terisio Pignatti, "Un disegno di Antonio Guardi donato al Museo Correr," Bollettino dei Musei civici Veneziani, II, 1-2 (1957), 21-32.

Pignatti 1967 Terisio Pignatti, I disegni dei Guardi (Florence, 1967).

Mostra dei Guardi, 1965 Mostra dei Guardi, Venice; Palazzo Grassi, 1965 (Introduction and Catalogue by Pietro Zampetti). Unless stated otherwise, the number following this abbreviation refer to the second part of the catalogue, the part that deals with the drawings.

A. THE DRAWINGS OF ANTONIO GUARDI

THE FASTI VENEZIANI. Circa 1730.

Literature: J. Byam Shaw, "Some Venetian Draughtsmen of the Eight-
eenth-Century," Old Master Drawings, VII (1933), 50;
Pallucchini 1943, p. 16; Max Goering, Francesco Guardi
(Vienna, 1944), p. 18; Morassi 1953, p. 267n; Pignatti
1957, p. 32.

The thirty-four drawings listed hereafter (Nos. 1-34) belong to
a group of forty-two that are known as the Fasti Veneziani. Eight of
these, which are in Count Vittorio Cini's collection, were never pub-
lished, and I could not obtain access to them for study. Thus they do
not figure in the present catalogue. It is not known how many pieces
the set comprised originally, but it seems that there must have been
at least fifty-eight, as most of those still extant bear unlike numbers
in pencil on the verso, the highest of which is fifty-eight.

All drawings are executed on the same type of paper. They are
identical in technique and very close in size. Slight variations in
quality are naturally to be expected in such a large set, but on the
whole the style is consistent and the degree of finish is uniform.
It is not certain for what purpose the set was made. In view of their
number, the drawings can hardly be regarded as preparatory works for
paintings. If made for the engraver, as Fiocco suggested, they were
probably never used, as no engraved counterparts have come to light.
They seem rather to have been independent works made on commission
for a collector. Each represents some episode or event in Venetian
history. Fiocco and Bettagno observed that some were derived from
historical paintings located in the Ducal Palace in Venice. I could

trace many of the others' derivations. The models used were never replicated exactly. Usually the number of figures was reduced, especially in battle scenes, and the background was simplified. In many cases an upright composition was stretched out horizontally to fit the oblong format of the set. Antonio was not very successful in modifying the compositions; the battle scenes in particular are unconvincing, and even close to comical. Perhaps some of the uniden-tified drawings are related to lost paintings. In all of them the settings and apparels clearly bespeak historical subjects involving Venetians.

Byam Shaw was the first to draw attention to these drawings: he knew sixteen of them, which he attributed to Francesco. Fiocco published most of them without identifying them. No great attention has ever been paid to the set, though disagreement does surround it. It is viewed by some critics as a product of collaboration between the three Guardi brothers; according to Fiocco many of the sheets should be attributed to Nicolò, though no works of his are extant for comparison. For Morassi and Pignatti the drawings are by Antonio. This attribution is certainly correct. The set is believed to belong to the 1760's; no concrete evidence supports such a late date, however, and the drawings appear quite consistent with some of Antonio's rela-tively early works. Thus the distant landscape settings in so many of the Fasti are delineated with a very fine pen and in brisk strokes exactly like that in the drawing of Bacchus and Ariadne at the Ashmolean Museum (No. 40). Particularly instructive is the comparison

of the landscape in The League of Cambrai (No. 16) with the Ashmolean

piece. The figure of the executioner in the early beheading scene at

the Uffizi (No. 37) would fit perfectly if inserted in one of the

Fasti battle scenes and would strike a discordant note in any of

Antonio's late drawings. The singular curlicues with which the

draughtsman meant to suggest clouds in many of the Fasti are drawn in

exactly in the same manner as in the two apotheoses in Philadelphia

and Frankfurt respectively (Nos. 45, 47). These connections and

others clearly indicate that the Fasti are early works. A date circa

1730 is here proposed.

No. 1 Fig. 21
ARRIVAL OF SAINT MARK ON THE LAGOONS. Circa 1730.
Venice, Vittorino Cini.

White paper. Pen, brush and brown wash over black chalk. 532 X 777 mm.

Provenance: Morosini-Gatterburg; Stucky.

Exhibitions: Disegni veneti del Settecento della Fondazione Giorgio
 Cini e delle collezioni venete, Venice: Fondazione Cini,
 1963, no. 39 (Catalogue by Alessandro Bettagno);

Literature: Fiocco 1944, pp. 13-14; Giuseppe Fiocco, "Il Problema di
 Francesco Guardi," Arte Veneta, VI (1952), 116-117, fig.
 127.

 Fiocco attributed the drawing to Nicolò Guardi, judging it similar

to The Flagellation in Dresden (No. 69), which he also believed to be by

the youngest Guardi. It is a free copy of Domenico Tintoretto's paint-

ing in the Scuola di San Marco (Giulio Lorenzetti, Venice and its

Lagoon [Rome, 1961], p. 343.)

No. 2 Fig. 22

DOGE NICOLÒ PONTE PRESENTING THE SENATE TO VENICE. Circa 1730.
Munich, formerly A. Weinmüller.

White paper. Pen, brush and brown wash over black chalk. 530 X 770 mm.

Literature: Leporini, "Die Versteigerung von Handzeichnungen bei
A. Weinmüller, München," Pantheon, XXII (1938), 332.

This drawing is copied after Tintoretto's painting of the same
subject in the Ducal Palace, Sala del Maggior Consiglio (Zanotto 1846,
III, pl. CLXII).

No. 3 Fig. 23

PROCESSION OF THE DOGE. Circa 1730.
Venice, Vittorio Cini.

White paper. Pen, brush and brown wash over black chalk. 530 X 770 mm.

Provenance: Morosini-Gatterburg; Stucky.

Literature: Fiocco 1944, p. 14.

No. 4 Fig. 24

BANQUET WITH THE DOGE PRESIDING. Circa 1730.
Venice, Vittorio Cini.

White paper. Pen, brush and brown wash over black chalk. 540 X 780 mm.

Provenance: Morosini-Gatterburg; Stucky.

Exhibitions: Mostra dei Guardi, 1965, no. 15.

Literature: Fiocco 1944, p. 14.

No. 5 Fig. 25

THE PEACE OF BOLOGNA. Circa 1730.
Venice, Vittorio Cini.

White paper. Pen, brush and brown wash over black chalk. Circa
540 X 780 mm.

Provenance: Morosini-Gatterburg; Stucky.

Literature: Fiocco 1944, pp. 13-14.

The prototype for this drawing was Marco Vecellio's historical
painting representing Pope Clement VII and Emperor Charles V after the
Signing of the Peace of Bologna (1529). The painting is in the Ducal
Palace, Sala del Consiglio dei Dieci (Zanotto 1846, II, pl. CVI).

No. 6 Fig. 26

THE TRIUMPHAL ENTRY OF HENRY III INTO VENICE. Circa 1730.
Venice, Vittorio Cini.

White paper. Pen, brush and brown wash over black chalk. Circa
540 X 780 mm.

Provenance: Morosini-Gatterburg; Stucky.

Literature: Fiocco 1944, pp. 13-14.

This drawing was made after Andrea Vicentino's painting in the
Ducal Palace, Sala delle Quattro Porte (Zanotto 1846, II, pl. LXVI).

No. 7 Fig. 27

PERSIAN AMBASSADORS PRESENTING GIFTS TO THE DOGE. Circa 1730.
Venice, Vittorio Cini.

White paper. Pen, brush and brown wash over black chalk. Circa
540 X 780 mm.

Provenance: Morosini-Gatterburg; Stucky.

Literature: Fiocco 1944, pp. 13-14.

This drawing derives from Gabriele Caliari's painting located

in the Ducal Palace, Sala delle Quattro Porte (Zanotto 1846, II,

pl. LXVI).

No. 8 Fig. 28

PATRICIANS PAYING THEIR RESPECTS TO THE DOGE (?). Circa 1730.
Venice, Vittorio Cini.

White paper. Pen, brush and brown wash over black chalk. Circa
540 X 780 mm.

Provenance: Morosini-Gatterburg; Stucky.

Literature: Fiocco 1944, p. 15.

No. 9 Fig. 29

POPE ALEXANDER III MEETS DOGE SEBASTIANO ZIANI AFTER THE VICTORY
OF SALVORE. Circa 1730.
Venice, Vittorio Cini

White paper. Pen, brush and brown wash over black chalk. Circa
540 X 780 mm.

Provenance: Morosini-Gatterburg; Stucky.

Literature: Fiocco 1944, pp. 13-14.

This is a free copy of Francesco and Leandro Bassano's paint-

ing in the Ducal Palace, Sala del Consiglio dei Dieci (Zanotto 1846,

II, pl. CIV).

No. 10 Fig. 30

THE DOGE DISEMBARKING (?). Circa 1730.
Venice, Vittorio Cini.

White paper. Pen, brush and brown wash over black chalk. Circa
540 X 780 mm.

Provenance: Morosini-Gatterburg; Stucky.

Literature: Fiocco, 1944, pp. 13-14.

No. 11 Fig. 31

DOGE ENRICO DANDOLO PREACHING THE CRUSADE. Circa 1730.
Venice, Vittorio Cini.

White paper. Pen, brush and brown wash over black chalk. 526 X 770 mm.

Provenance: Morosini-Gatterburg; Stucky.

Exhibitions: Disegni veneti del Settecento della Fondazione Giorgio
 Cini e delle collezione venete, Venice: Fondazione Cini,
 1963, no. 38 (Catalogue by Alessandro Bettagno).

Literature: Max Goering, Francesco Guardi (Vienna, 1944), p. 18;
 Giuseppe Fiocco, "Il problema di Francesco Guardi," Arte
 Veneta, VI (1952), 116, fig. 124.

 Bettagno observed that this drawing was copied after Jean Le Clerc's

painting in the Ducal Palace, Sala del Maggior Consiglio.

No. 12 Fig. 32

THE DOGE DISEMBARKING (?). Circa 1730.
Venice, Vittorio Cini.

White paper. Pen, brush and brown wash over black chalk. Circa
540 X 780 mm.

Provenance: Morosini-Gatterburg; Stucky.

Literature: Fiocco 1944, pp. 13-14.

No. 13 Fig. 33

THE DOGE GREETING CATARINO CORNARO. Circa 1730.
Venice, Vittorio Cini.

White paper. Pen, brush and brown wash over black chalk. 537 X 780 mm.

Provenance: Morosini-Gattersburg; Stucky.

Literature: Fiocco 1944, pp. 13-14; Vittorio Moschini, Francesco
Guardi (Milan, 1952), fig. 10.

No. 14 Fig. 34

CATARINA CORNARO RECEIVING THE KEYS OF ASOLO. Circa 1730.
Venice, Vittorio Cini.

White paper. Pen, brush and brown wash over black chalk. 540 X 780 mm.

Provenance: Morosini-Gatterburg; Stucky.

Exhibitions: Canaletto e Guardi, Venice: Fondazione Cini, 1962, no. 51
(Catalogue by J. Byam Shaw); Mostra dei Guardi, 1965,
no. 16.

Literature: Fiocco 1944, pp. 13-14; Vittorio Moschini, Francesco
Guardi (Milan, 1952), fig. 12; Morassi 1953, p. 267n;
Pignatti 1967, no. IX.

No. 15 Fig. 35

RECEPTION OF THE QUEEN OF CYPRUS (?). Circa 1730.
Milan, Campanini-Bonomi.

White paper. Pen, brush and brown wash over black chalk. 540 X 780 mm.

Literature: Morassi 1953, p. 267, fig. 28; Pignatti 1957, p. 30,
fig. 14.

No. 16 Fig. 36

THE LEAGUE OF CAMBRAI. Circa 1730.
Venice, Vittorio Cini.

White paper. Pen, brush and brown wash over black chalk. Circa
540 X 780 mm.

Provenance: Morosini-Gatterburg; Stucky.

Literature: Fiocco 1944, pp. 13-14.

This drawing is copied after Palma Il Giovane's painting in

the Ducal Palace, Sala dei Pregati (Zanotto 1846, II, pl. XCIV).

No. 17 Fig. 37

UNIDENTIFIED HISTORICAL SUBJECT. Circa 1730.
Venice, Vittorio Cini.

White paper. Pen, brush and brown wash over black chalk. Circa
540 X 780 mm.

Provenance: Morosini-Gatterburg; Stucky.

Literature: Fiocco 1944, pp. 13-14.

No. 18 Fig. 38

THE ORDEAL OF PAOLO ERIZZO. Circa 1730.
Venice, Vittorio Cini.

White paper. Pen, brush and brown wash over black chalk.
528 X 781 mm.

Provenance: Morisini-Gatterburg; Stucky.

Literature: Fiocco 1944, p. 13; Vittorio Moschini, Francesco
Guardi (Milan, 1952), fig. 11.

No. 19 Fig. 39

SURRENDER OF TURKS TO A VENETIAN COMMANDER. Circa 1730.
Venice, Vittorio Cini.

White Paper. Pen, brush and brown wash over black chalk. 530 X 780 mm.

Provenance: Morosini-Gatterburg; Stucky.

Literature: Fiocco 1944; pp. 13-14.

No. 20 Fig. 40

THE SURRENDER OF BRESCIA. Circa 1730.
Venice, Vittorio Cini.

White paper. Pen, brush and brown wash over black chalk. 540 X 780 mm.

Provenance: Morosini-Gatterburg; Stucky.

Exhibitions: Disegni veneti del Settecento della Fondazione Giorgio
 Cini e delle collezioni venete, Venice: Fondazione Cini,
 1963, no. 37 (Catalogue by Alessandro Bettagno); Mostra
 dei Guardi, 1965, no. 14.

Literature: Fiocco 1944, pp. 13-14.

Bettagno observed that this drawing derives from the large paint-
ing of the same subject by Aliense in the Ducal Palace, Sala della
Bussola (Zanotto 1846, II, pl. CXIII).

No. 21 Fig. 41

BATTLE SCENE. Circa 1730.
Paris, Private Collection.

White paper. Pen, brush and brown wash over black chalk. 540 X 780 mm.

Literature: Morassi 1953, p. 267, fig. 21; Pignatti 1957, p. 31,
 no. 24.

No. 22 Fig. 42

VENETIANS FIGHTING PISANS. Circa 1730.
Venice, Vittorio Cini.

White paper. Pen, brush and brown wash over black chalk. Circa
540 X 780 mm.

Provenance: Morosini-Gatterburg; Stucky.

Literature: Fiocco 1944, pp. 13-14.

This drawing replicates, with slight variations, the ceiling

painting by Andrea Vicentino in the Ducal Palace, Sala dello Scru-

tino (Zanotto 1846, III, pl. CLXXIX).

No. 23 Fig. 43

THE CONQUEST OF CAFFA. Circa 1730.
Venice, Vittorio Cini.

White paper. Pen, brush and brown wash over black chalk. Circa
540 X 780 mm.

Provenance: Morosini-Gatterburg; Stucky.

Literature: Fiocco 1944, pp. 13-14.

This drawing is a free copy after Giulio dal Moro's ceiling in

the Ducal Palace, Sala dello Scrutino (Zanotto 1846, III, pl. CLXXXI).

No. 24 Fig. 44

THE STORMING OF PADUA IN 1405. Circa 1730.
Minneapolis, Richard S. Davis.

White paper. Pen, brush and brown wash over black chalk. Circa
540 X 780 mm.

Exhibitions: The Guardi Family, Houston: The Museum of Fine Arts,
 1958, no. 28 (Catalogue by J. Byam Shaw).

This drawing derives from Francesco Bassano's painting in the

Ducal Palace, Sala dello Scrutino (Zanotto 1846, III, pl. CLXXXIII).

No. 25 Fig. 45

THE RECAPTURE OF VERONA. Circa 1730.
Venice, Vittorio Cini.

White paper. Pen, brush and brown wash over black chalk. Circa
540 X 780 mm.

Provenance: Morosini-Gatterburg; Stucky.

Literature: Fiocco 1944, p. 15.

This drawing was made after Giovanni Contarino's painting of the

same subject in the Ducal Palace, Sala delle Quattro Porte (Zanotto

1846, II, pl. LXV).

No. 26 Fig. 46

NAVAL BATTLE BETWEEN VENETIANS AND TURKS. Circa 1730.
Venice, Vittorio Cini.

White paper. Pen, brush and brown wash over black chalk. Circa
540 X 780 mm.

Provenance: Morosini-Gatterburg; Stucky.

Literature: Fiocco 1944, p. 15.

This drawing is a free copy of Pietro Liberi's painting of the

same subject in the Ducal Palace, Sala dello Scrutino (Zanotto 1846,

III, pl. CLXXXLI).

No. 27 Fig. 47

THE CONQUEST OF CONSTANTINOPLE. Circa 1730.
Venice, Vittorio Cini.

White paper. Pen, brush and brown wash over black chalk. Circa
540 X 780 mm.

Provenance: Morosini-Gatterburg; Stucky.

Literature: Fiocco 1944, p. 15.

This drawing is a free copy of Domenico Tintoretto's painting

in the Ducal Palace, Sala del Maggior Consiglio (Zanotto 1846, III,

pl. CXLIV).

No. 28 Fig. 48

DEFEAT OF BRESCIA BY FRANCESCO BARBARO. Circa 1730.
Venice, Vittorio Cini.

White paper. Pen, brush and brown wash over black chalk. Circa
540 X 780 mm.

Provenance: Morosini-Gatterburg.

Literature: Fiocco 1944, p. 15; Vittorio Moschini, Francesco
 Guardi (Milan, 1952), fig. 10.

This drawing was derived, with significant changes, from

Tintoretto's ceiling painting in the Ducal Palace, Sala del Maggior

Consiglio (Zanotto 1846, III, CLV).

No. 29 Fig. 49

THE CELEBRATION OF THE VENETIAN VICTORY OVER KING RUGGERI OF SICILY.
Circa 1730.
Venice, Vittorio Cini.

White paper. Pen, brush and brown wash over black chalk. Circa
540 X 780 mm.

Provenance: Von Kühlmann.

Literature: Max Goering, Francesco Guardi (Vienna, 1944), p. 18,
 fig. 17; Pignatti 1957, p. 29, no. 1.

The model for this drawing was Marco Vecellio's painting in the

Ducal Palace, Sala dello Scrutino (Zanotto 1846, III, pl. CLXXI).

No. 30 Fig. 50

THE SIEGE OF ZARA. Circa 1730.
Venice, Vittorio Cini.

White paper. Pen, brush and brown wash over black chalk. Circa
540 X 780 mm.

Provenance: Morosini-Gatterburg; Stucky.

Literature: Fiocco 1944, p. 15.

Tintoretto's The Siege of Zara in the Ducal Palace, Sala dello

Scrutino, served as model for this drawing (Zanotto 1846, III,

pl. CLXXIII).

No. 31 Fig. 51

THE ASSAULT ON ZARA BY THE CRUSADERS. Circa 1730.
Venice, Vittorio Cini.

White paper. Pen, brush and brown wash over black wash. Circa
540 X 780 mm.

Provenance: Morosini-Gatterburg; Stucky.

Literature: Fiocco 1944, p. 15.

 The drawing derives from Andrea Vicentino's painting in the
Ducal Palace, Sala del Maggior Consiglio (Zanotto 1846, III, pl. CXL).

No. 32 Fig. 52

BATTLE SCENE. Circa 1730.
Venice, Vittorio Cini.

White paper. Pen, brush and brown wash over black chalk. Circa
540 X 780 mm.

 Some of the combattants derive from Francesco Bassano's histor-
ical ceiling painting The Victory of Giorgio Cornaro at Cadore in the
Ducal Palace, Sala del Maggior Consiglio. The figure of the soldier
with the drum is taken from Andrea Vicentino's Battle of Lepanto,
which decorates the same ceiling (Zanotto 1846, III, pl. CLVI).

No. 33 Fig. 53

BATTLE SCENE BETWEEN TURKS AND VENETIANS. Circa 1730.
Venice, Vittorio Cini.

White paper. Pen, brush and brown wash over black chalk. Circa
540 X 780 mm.

Provenance: Morosini-Gatterburg; Stucky.

Literature: Fiocco 1944, pp. 13-14.

No. 34 Fig. 54

BATTLE SCENE. Circa 1730.
Cleveland, Museum of Art.

White paper. Pen, brush and brown wash over black chalk. 543 X 769 mm.

Exhibitions: Mostra dei Guardi, 1965, no. 17.

Literature: Giuseppe Fiocco, "Il Problema di Francesco Guardi," Arte
Veneta, VI (1952), 116, fig. 126; Pignatti 1957, p. 29,
no. 6; Terisio Pignatti, I disegni veneziani del Sette-
cento (Venice, 1966), p. 155, no. 21.

No. 35 Fig. 55

THE FAMILY OF DARIUS. Circa 1728-1732.
Aalens (Württemberg), Koenig-Fachsenfeld.

White paper. Pen and brown wash over red chalk. 310 X 555 mm.

Provenance: Francesco Giusti.

Exhibitions: Unbekannte Handzeichnungen alter Meister, Basel: Kunst-
halle, 1967, no. 84 (Catalogue by Werner R. Deusch).

Literature: Antonio Morassi, "Antonio Guardi as a Draughtsman,"
Master Drawings, VI (1968), 135, 142n, pl. 27.

Morassi regards this sketch as a possible study for one of the
finished drawings of the Fasti Veneziani (Nos. 1-34). It does not
correspond to any of the sheets of the set, but the set is not complete.
It can indeed be associated with the Fasti Veneziani, stylistically,
but not thematically. The family of Darius would hardly be represented
in a set of works the rest of which all depict episodes of Venetian
history. Be that as it may, the sketch must have been made at approx-
imately the same time as the Fasti. In it, Antonio closed the composi-
tion at the top by means of a huge curtain, a facile device frequently
used in the Fasti as against his mature and late works. The somewhat
theatrical poses and arrangement of the figures recall Pellegrini, to
whom the sketch was originally assigned. It may well have been inspired
by--or derived from--one of the older master's compositions.

No. 36 Fig. 56

THE HOLY FAMILY. Circa 1730-1735.
Florence, Uffizi (15736 F.)

Blue-grey paper. Black crayon heightened with white chalk. 335 X
245 mm.

Inscribed 52 Ant. Guardi on the mount in contemporary handwriting.

Provenance: Emilio Santarelli.

Exhibitions: Mostra di disegni veneziani del Sei e Settecento,
 Florence: Gabinetto disegni e stampe degli Uffizi,
 1953, no. 88, fig. 58 (Catalogue by Michelangelo
 Muraro).

Literature: Pasquale Nerino Ferri, Catalogo riassuntivo della
 raccolta di disegni antichi e moderni (Rome, 1890),
 p. 232; Pignatti 1967, no. II.

 Muraro assigned this drawing to Antonio Guardi and published it
together with the engraving from which it was copied: Carpioni's Holy
Family (Mostra 1953, fig. 59). The draughtsman followed the prototype
rather faithfully, except that the background was left out and
the branches of the tree at the left were reshaped and enriched with
foliage to suggest a canopy over the Virgin's head. Compared with
known Guardiesque works, this drawing is different yet not discord-
ant, and there is no reason to question the soundness of the identify-
ing inscription made by a connoisseur (see Chapter III, p. 120-121).
Pignatti dates the drawing 1740-1745, but it is probably an early
work. It conveys the impression of careful application normally to
be expected in juvenilia, but not encountered to the same degree in
any of Antonio's mature works. However, similar tightly hatched
shadows displaying a great variety of tonal modulations adumbrate
the group of exquisite chalk drawings of Antonio's mature period
(cf. Nos. 63, 70, 74).

No. 37 Fig. 57

THE BEHEADING OF JOHN THE BAPTIST. Circa 1734-1738.
Florence, Uffizi (78015).

White paper. Pen and brownish wash over red chalk. 290 X 351 mm.

Provenance: Emilio Santarelli.

Literature: Michelangelo Muraro, "Novità su Francesco Guardi," Arte
 Veneta, III (1949), 124, fig. 138; Morassi 1953, p. 264,
 fig. 10.

This sketch and another one in the Rasini collection (No. 38)
are certainly studies or alternative solutions for the same project.
There are no differences in style or technique between them. The same
scene is represented in reverse from the one to the other, except that
the two architectural settings do not coincide in all particulars and
that the two executioners hold the swords in different positions. As
Morassi observed, both sketches are compositionally closely related
to the fresco representing the beheading of the Baptist which
Giambattista Tiepolo painted in the fall of 1733 in the Colleoni
Chapel in Bergamo (Antonio Morassi, A Complete Catalogue of the Paint-
ings of G. B. Tiepolo [London 1963], fig. 44). The sketches may
derive, rather than from the fresco itself, from one of the several
preparatory drawings and modelli which Tiepolo is reported to have
made for it. Morassi dates the sketches soon after 1733, though they
could as well have been made somewhat later.

No. 38 Fig. 58

THE BEHEADING OF JOHN THE BAPTIST. Circa 1734-1738.
Milan, Rasini

White paper. Pen and brown wash over red chalk. 280 X 335 mm.

Provenance: Giovanni Morelli; Argentieri.

Exhibitions: Kunstschätze der Lombardei, Zürich: Kunsthaus, 1948-
1949, no. 348.

Literature: Morassi 1953, p. 264, fig. 11; Pignatti 1957, p. 31,
no. 16.

See also No. 37. The drawing has not been accessible to scholars

for several years, and no photograph of it could be obtained. It is

reproduced on a small scale in The Burlington Magazine, XCI (1953),

fig. 11.

No. 39 Fig. 59

THE PRESENTATION TO THE TEMPLE. Circa 1735.
Florence, Uffizi (78485S).

White paper. Pen and brownish wash. 270 X 408 mm.

Provenance: Emilio Santarelli.

Literature: Emilio Santarelli, Catalogo della raccolta di disegni
autografici antichi e moderni donati dal prof. Emilio
Santarelli alla R. Galleria di Firenze (Florence,
1870), p. 512; Michelangelo Muraro, "Novità su Francesco
Guardi," Arte Veneta, III (1949), 124-125, fig. 135.

In the old catalogue of Emilio Santarelli's collection the owner

himself classified the drawing under Giambattista Tiepolo. The attri-

bution was changed to Francesco Guardi by Odoardo Giglioli. The

drawing was published by Muraro, who maintained the attribution. It

has since been neglected by Guardi specialists, probably out of reluc-

tance to pass judgment on one of the most problematical sheets of the Guardi.

Its authorship is not immediately evident. The angular linework points

to Francesco, the approximate rendering of figures and physiognomies to Antonio. But it is manifest that the sketch was drawn very hastily, which could account for the briskness of the handling if it is by Antonio or for the imprecision of the forms if it is by Francesco. Muraro links it to the drawings Francesco made after Pietro Longhi's Sacraments (FG: Nos. 13-19). Yet of all Guardiesque graphic works those akin to it are some sketches by Antonio Guardi, dated in this catalogue 1735-1740, such as The Education of the Virgin in the Institut Néerlandais (No. 42) and Bacchus and Ariadne at the Ashmolean Museum (No. 40). Particularly instructive is the comparison of the group of figures at the left of this sketch with those seen through the window at the right of The Beheading of John the Baptist at the Uffizi (No. 37), which certainly belongs to the late 1730's. With the caution due in so difficult a matter, an attribution to Antonio Guardi and a date of circa 1740 are here proposed.

Muraro remarked that the composition may be derived from a Venetian prototype. The sketch is actually a faithful copy of a painting by Sebastiano Ricci which was in the famous eighteenth-century collection of Antonio Zanetti and was engraved by Pietro Monaco (Joachim von Derschau, Sebastiano Ricci [Heidelberg, 1922], fig. 124) circa 1740. Giovanni Antonio Moschini mentions the painting and the engraving in his Dell'incisione in Venezia [circa 1808] (Venice, 1924), p. 74, with the title Gesù presentato al Tempio. The same title certainly applies to this drawing, which is currently known as a presentation of the Virgin.

The purpose of the drawing is not clear. It could hardly be a preparatory drawing as it faithfully replicates the engraving. Perhaps the Guardi did not own the engraving and copied it for future reference. There is no evidence that they ever used it for a painting.

No. 40 Fig. 60

BACCHUS AND ARIADNE. Circa 1735.
Oxford, Ashmolean Museum (1008).

White paper. Plumbago, pen and brown ink. 386 X 538 mm.

Inscribed Guardi in pen or lower right in contemporary handwriting and again on the verso.

Provenance: Randall Davies; J. Byam Shaw.

Exhibitions: Disegni veneti di Oxford, Venice: Fondazione Cini, 1958, no. 110 (Catalogue by K. T. Parker).

Literature: Morassi 1953, p. 264, fig. 14; Pignatti 1957, p. 31, no. 21.

This compositional study, donated by Byam Shaw to the Ashmolean Museum, was catalogued under Francesco Guardi. A more elaborate version of the same theme is at the Louvre, where it was assigned to Sebastiano Ricci (No. 41). Morassi published both together as works by Antonio. This one is of particular interest because it was not completed and thus gives insight into Antonio's working methods. The preliminary tracings are drawn faintly with plumbago. But all particulars are explicit, and pentimenti are visible everywhere. The style points to an early date. So does the painstaking preparation, for whenever underdrawings are discernible in Antonio's mature and

late works they are far more succinct. The charming group of the putto and goat charging the satyr-child brings to mind Castiglione's drawings of satyr family scenes, which may have inspired Guardi. Castiglione's graphic works were well known and highly praised in eighteenth-century Venice, especially by artists.

No. 41 Fig. 61
BACCHUS AND ARIADNE. Circa 1735.
Paris, Le Louvre (5331).
White paper. Plumbago, pen and brown wash. 202 X 348 mm.
Literature: Morassi 1953, p. 264, fig. 14; Pignatti 1967, No. XIII.

This is a more elaborate, perhaps the final, version of the same subject as in No. 40. The figures have been reduced in number and more pleasingly coordinated. Morassi dates this version and the Ashmolean one in the 1720's or 1730's; Pignatti suggests a date around 1750. Neither version fits into Antonio's later phases. Chronologically and stylistically, the Ashmolean study is best associated with The Beheading of John the Baptist at the Uffizi (No. 37), here dated 1734-1738, while the Louvre drawing is very similar to the allegories at Fermo (Nos. 49-53), which could only belong to Antonio's early maturity. The female type of the Ariadne and her languid pose most likely descend from Pittoni. In fact, both main figures come close to those in some of the versions of Bacchus and Ariadne that Pittoni painted during the 1720's or 1730's, particularly the charming one in Prague (Benatske Malirstvi XVIII Stoleti, Prague: Narodni Galerie, 1964, no. 28, fig. 28).

No. 42 Fig. 62

THE EDUCATION OF THE VIRGIN. Circa 1735.
Paris, Institut Néerlandais (7227).

White paper. Red chalk. 230 X 301 mm.

Provenance: John Skippe.

Literature: Ivan Fenyő, "An Unknown Drawing by Antonio Guardi,"
 The Burlington Magazine, CVII (1965), 256, fig. 62.

In this sketch the draughtsman was no doubt trying to group
elements borrowed from various sources into a new composition. The
result is not quite successful. The ecstatic pose of Saint Joseph
is somewhat inappropriate in a domestic scene, and there is no
reason for the angels to swing the censer. Fenyő regards the sketch
as an early work, no doubt rightly.

No. 43 Fig. 63

THE MARTYRDOM OF SAINT CLEMENT. Circa 1736-1740.
New York, Janos Scholz.

White paper, folded, stained. Black crayon, brush, greyish and dark
brown washes. 425 X 265 mm.

Provenance: Dan Fellows Platt.

Exhibitions: Venetian Drawings from the Collection Janos Scholz,
 Venice; Fondazione Cini, 1957, no. 90 (Catalogue by
 Michelangelo Muraro); The Guardi Family, Houston: The
 Museum of Fine Arts, 1958, no. 28 (Introduction by
 J. Byam Shaw); Venetian Drawings 1600-1800, Oakland:
 Mills College Art Gallery, 1960, no. 41 (Catalogue by
 Alfred Neumeyer); Italienische Zeichnungen vom 14. bis
 zum 18. Jahrhundert aus amerikanischem Besitz. Die
 Sammlung Janos Scholz, Hamburg: Kunsthalle, 1963,
 no. 77 (Catalogue by Wolf Stubbe).

Literature: Otto Benesch, Venetian Drawings of the Eighteenth
 Century in America (New York, 1947), no. 55, pl. 55;
 Rodolfo Pallucchini, "Disegni veneziani in America,"
 Arte Veneta, II (1948), 158; Byam Shaw 1951, p. 47n;
 Morassi 1953, p. 264, fig. 3; Pignatti 1957, pp. 25,
 31, no. 17; Terisio Pignatti, "Nuovi disegni di figura
 dei Guardi," Critica d'Arte, XI (1964), 60, fig. 92;
 Pignatti 1967, no. V.

 This is probably a preparatory drawing for an altarpiece. It

exemplifies the Guardiesque methods of composing. As Pallucchini

pointed out, it shows a dependence on Pittoni: both the angel hold-

ing the palm above the saint, and the central group with the excep-

tion of the figure pushing the saint in the background on the right,

are taken unaltered from the altarpiece Pittoni executed circa 1735,

or slightly earlier, for the Bishop of Cologne (Max Goering, "Die

Tätigkeit der Venezianer Piazzetta und Pittoni für den Kurfüsten

Clemens August von Köln," Westfalen, XIX [1934], 364, pl. XXXVII).

It has passed unobserved that, allowing for a modification of the

draperies to suit Guardi's subject, the small group at the left

appears to derive from Sebastiano Ricci's Camillus and Brennus, at the Detroit Museum, of which Francesco Bartolozzi had made an engraving (Joachim von Derschau, Sebastiano Ricci [Heidelberg, 1922], fig. 121). No engraving seems to have been made after Pittoni's altarpiece. The painting itself left Venice circa 1735. The drawing is usually considered contemporary with Pittoni's altarpiece, although it could have been copied slightly later from a Pittoni drawing or from an oil sketch or modello such as the one now in Uppsala (Fig. 64).

The attribution to Antonio is today generally accepted, but in publishing the drawing Otto Benesch alluded to the possibility of its being an early work by Francesco. Especially in the handling of the wash--applied somewhat in Tiepolo's manner--it does have a good deal in common with some little known graphic works by Francesco, such as the Lady with the Fan at the Fogg Museum (FG: No. 5) and The Charlatan and The Minuet, both at the Louvre (FG: Nos. 9, 10), which I believe among Francesco's earliest, dating from a period when he may have been under Antonio's influence. Pending further information on Francesco's early phase, the attribution to Antonio must remain tentative.

No. 44 Fig. 65

THE CANNONEER. 1735-1740.

Bassano, Museo Civico (Riva 197).

White paper. Pen and brown wash. 315 X 462 mm.

Provenance: Giuseppe Riva.

Exhibitions: Disegni del Museo Civico di Bassano, Venice: Fondazione
 Cini, 1956, no. 72 (Introduction and Catalogue by
 Licisco Magagnato); Mostra dei Guardi, 1965, no. 18.

Literature: Giuseppe Fiocco, "Francesco Guardi pittore di battaglie,"
 Critica d'Arte, II (1937), 251; Max Goering, Francesco
 Guardi (Vienna, 1944), p. 34; Terisio Pignatti, "Drawings
 from the Museo Civico, Bassano," The Burlington Magazine,
 XCVIII (1956), 374; Antonio Morassi, "Antonio Guardi as a
 Draughtsman," Master Drawings, VI (1968), 140-141, pl. 33.

 The activity of the Guardi as painters of battles has never been

studied, despite the many extant Guardiesque cabinet pictures of that

genre. The present sketch is the only known Guardiesque compositional

study for a battle scene. Opinions as to its attribution are mixed;

Pignatti even proposed that it be expurgated from the catalogue of both

Guardi. It exhibits features in common with some of Francesco's

sketches, such as the Bassano Pietà (FG: No. 24), but likewise with

some of Antonio's drawings, such as Time Abducting Beauty in Udine

(No. 54). In the present stage of knowledge it seems reasonable to

assign the drawing to Antonio, as it appears to be a study for his

painting in the Crespi Collection, The Cannoneer (Morassi 1968, fig. 4).

The Crespi piece, and thus the drawing for it, could hardly be regarded

as dating later than the 1730's (cf. Goering 1944, p. 34). The dexter-

ity of the handling is less surprising in an early sketch by Antonio

if one considers that he must have painted many battle scenes during

the 1730's (see Chapter I, p. 27).

No. 45 Fig. 66

APOTHEOSIS OF A SAINT. 1735-1740.

Philadelphia, The Pennsylvania Academy of Fine Arts.

Recto of No. 46.

White paper. Pen and brown wash over red chalk. 412 X 273 mm.

Inscribed on the verso in dark ink Guardi in eighteenth-century hand.

Provenance: G. Vallardi; G. Locarno; G. Pacini.

Literature: Otto Benesch, Venetian Drawings of the Eighteenth
 Century in America (New York, 1947), no. 54, pl. 54;
 Morassi 1953, p. 263, fig. 6; Pignatti 1957, p. 31,
 no. 26.

The ecstatic saint here is generally taken to be John Capestran.
As none of Capestran's attributes (star, cross on the habit, standard)
are represented, the identification should perhaps be omitted. The
sketch was published by Otto Benesch. It and one at the Staedelsches
Kunstinstitut (No. 47) are probably compositional studies or alterna-
tives for a projected church or convent ceiling, perhaps intended to
be executed in fresco. Both sheets exhibit the same degree of finish,
but the present composition is more coherent and compact and may be
the one finally adopted. In both, the linework is more broken but
also more tremulous than in Antonio's mature and late works. It is
closest to that in The Family of Darius in the Koenig-Fachsenfeld col-
lection (No. 35) and in the two sketches representing The Beheading of
John the Baptist, respectively at the Uffizi and in the Rasini collec-
tion (Nos. 37, 38), which were assigned in this catalogue to the
1730's. For the Frankfurt sketch Pallucchini proposed the plausible
date of 1730-1740, which would apply to the present sketch as well.

No. 46 Fig. 67

ANGELS CARRYING A HOLY PICTURE. 1735-1740.
Philadelphia, Pennsylvania Academy of Fine Arts.

Verso of No. 45.

White paper. Red chalk. 412 X 173 mm.

Inscribed Guardi in dark brown ink in lower right in contemporary hand-
writing. Numbered at the top 141 and at the upper left E387.

Provenance: G. Vallardi; G. Locarno; G. Pacini.

This unpublished sketch is probably not the primo pensiero that

one would suspect at first sight, but the underdrawing of a composi-

tional study abandoned at an early stage. What makes this likely is

that some unfinished passages are covered with wash. Antonio's finished

washed graphic works show that he usually applied the wash directly over

the preliminary tracings and only then proceeded with the actual drawing.

No. 47 Fig. 68

APOTHEOSIS OF A SAINT. 1735-1740.
Frankfurt-am-Main, Staedelsches Kunstinstitut (13288).

Recto of No. 48.

White paper. Pen and brown wash over red chalk. 402 X 268 mm.

Inscribed Ant.o Guardi in black ink in lower right corner in contempo-
rary handwriting, and again on the verso in the same hand.

Literature: Fiocco 1923, p. 62, fig. 2; Pallucchini 1943, p. 15;
 Morassi 1953, p. 263, fig. 7.

The sketch was discovered and published by Fiocco. See also

No. 45.

No. 48 Fig. 69

FAITH AND FLYING PUTTI. 1735-1740.
Frankfurt-am-Main, Staedelsches Kunstinstitut (13288).

Verso of No. 47.

White paper. Red chalk. 402 X 268 mm.

Inscribed in black ink Ant. Guardi in contemporary handwriting in
upper left in the same hand as on recto (No. 47).

This sketch has never been published. The slight di sotto in
su effect of the allegory suggests that the figure may have been
intended to appear on a ceiling. The flying putti, which are out-
lined in the same sketchy manner as the figures of No. 46 may be
connected with the same project.

No. 49 Fig. 71

ALLEGORY OF MARTIAL VIRTUE. 1736-1742.
Venice, Museo Correr (8221).

White paper. Black chalk, brush and brownish wash. 287 X 408 mm.

Inscribed in upper left corner in formal contemporary handwriting:
La Virtù Gueriera Trionfante / tirato Dal Tempo / che la conduce a
Tempio / con la Fama che la Corona / de lauoro e la Compagna / con
Tromba. Inscribed on the verso at the top: La Virtù Tirada dal
Tempo e la fama che l'incorona e la / conduce al Tempio; at the
right the same inscription again as on the recto but in cursive auto-
graph handwriting; signed at the bottom: Giovan Antonio Guardi
Veneto Pitore.

Provenance: Kurt Meissner; Antonio Morassi.

Exhibitions: La peinture italienne au XVIIIe siècle, Paris: Petit
 Palais, 1960-1961, no. 299 (Catalogue by Francesco
 Valcanover; Mostra dei Guardi, 1965, no. 10; Dal Ricci
 al Tiepolo, Venice: Palazzo Ducale, 1969, no. 113
 (Introduction and Catalogue by Pietro Zampetti).

Literature: Morassi 1953, p. 263, fig. 2; Pignatti 1957, pp. 22, 24,
 29-30, no. 11; Rodolfo Pallucchini, La pittura veneziana
 del Settecento (Venice, 1960), p. 133; K. T. Parker and
 J. Byam Shaw, Canaletto e Guardi (Venice, 1962), p. 48;
 Giuseppe Fiocco, Guardi (Milano, 1965), p. 14; Terisio
 Pignatti, I disegni veneziani del Settecento (Venice,
 1966), no. 18; Terisio Pignatti, "Il 'Trionfo della
 Virtù Gueriera' di G. A. Guardi," Bollettino dei Musei
 Civici Veneziani, XII, 1-2 (1967), pp. 17-26; Pignatti,
 1967, no. VII; Antonio Morassi, "Antonio Guardi as a
 Draughtsman," Master Drawings, VI (1968), 136.

Antonio Guardi's authentic signature and lengthy autograph in-

scription lend this drawing its importance (see Chapter III, p. 119).

It was discovered and published by Morassi. It is one of a group of

six drawings (Nos. 49-54) which may all be associated with lost

decorative paintings intended to adorn some fashionable dwelling.

The descriptive inscriptions in formal handwriting on the recto of

each sheet and the written indications on the verso concerning the

location of the decorations suggest that the drawings are modelli

submitted for approval. The series must originally have included

at least ten items as two that survive are numbered 6 and 8 (Nos. 51, 52), and as another is inscribed disegno segnato n. 10 (No. 50). Morassi has suggested that the decorations may have been executed in fresco; however, the inscriptions on the recto of two of the designs (Nos. 50, 52) each refer to a quadro, which indicates that easel paintings were projected. Fiocco took the present allegory to be probably the first drawing or among the first drawings by Antonio. Pignatti placed it circa 1746 on account of the putti, which resemble those in the Belvedere altarpiece of that date (Mostra dei Guardi [Dipinti], 1965, no. 16); on stylistic grounds, though, it appears to antedate the altarpiece by several years. It has also been linked to many of Antonio's other graphic and pictorial works. On the whole it finds its closest parallels in drawings that appear to belong to the draughts- man's early maturity, such as the Bacchus and Ariadne at the Louvre (No. 41).

No. 50 Fig. 72

PRUDENCE AND TEMPERANCE. 1736-1742.
Fermo, Biblioteca Comunale.

White paper. Pen and brownish wash. 225 X 295 mm.

Inscribed in pencil in the upper left corner Prudenza e / Temperanza,
and at the top Testa di quadro; on the verso at the top Prudenza
figura del quadro del volta della terza stanza nobile al disegno
segnato n. 10 / Temperanza.

Provenance: Giovan Battista Carducci.

Exhibitions: Dal Ricci al Tiepolo, Venice: Palazzo Ducale, 1969,
 no. 114.

Literature: Luigi Dania, "Three Drawings by Gian Antonio Guardi,"
 Master Drawings, IV (1966), 293-294, pl. 29.

See also No. 49. The inscription on the verso indicates that

the drawing was made for a ceiling painting. Seated Prudence is a

type of female figure to be found in some of Antonio's works which

I believe all belong to the 1730's (cf. Ariadne in No. 40; Ariadne

in No. 41; Venus in Venus and Putti [Mostra dei Guardi, Dipinti, 1965,

no. 44]).

No. 51 Fig. 73

FAITH, FORTUNE AND ELOQUENCE. 1736-1742.
Fermo, Biblioteca Comunale.

White paper. Pen and brownish wash. 263 X 365 mm.

Inscribed in pencil in upper left L'eloquenza con la Fortezza e
Fedelta, and on the verso at the top desegno segnato n. 6 / L'elo-
quenza la Fortezza et Fedeltà.

Provenance: Giovan Battista Carducci.

Literature: Luigi Dania, "Three Drawings by Gian Antonio Guardi,"
 Master Drawings, VI (1966), 293-294, pl. 31.

See No. 49.

No. 52 Fig. 74

FAME. 1736-1742.
Fermo, Biblioteca Comunale.

White paper. Pen and brownish wash. 228 X 350 mm.

Inscribed in pencil in upper left corner La Famma con il Sole in
Petto / e lamore che si dona / ale Virtù per otener / la Corona
e il Premio; on the verso: quadro del volto del Gabinetto del
disegno segnato n. 8 vicino ala camera del Letto / La Fama e amor
ale Virtù.

Provenance: Giovan Battista Carducci.

Literature: Luigi Dania, "Three Drawings by Gian Antonio Guardi,"
 Master Drawings, IV (1966), 293-294, pl. 30.

See also No. 49. The inscription on the verso indicates that

the sketch was made for a ceiling decoration. The cast above the

palette on the left is very similar to one of the three cherubs'

heads in The Holy Family with Saints (upper right) in the Anda-

Bührlé collection (No. 55).

No. 53 Fig. 75

PEACE AND JUSTICE. 1736-1742.
Paris, Moratilla.

White paper. Brush and brown wash. 229 X 340 mm.

Inscribed in pencil in upper left La Giusticia unita con la Pace.

Provenance: Anfuso.

Literature: A. Del Massa, Maestri italiani del disegno dal secolo
 XV al secolo XVIII (Rome, 1957), pl. CXVI; Luigi Dania,
 "Another Drawing by Gian Antonio Guardi," Master Draw-
 ings, VI (1968), 30, pl. 12.

See No. 49.

No. 54 Fig. 76

TIME ABDUCTING BEAUTY. 1736-1742.
Udine, Museo Civico (135).

White paper. Pen and brown chalk over traces of red chalk. 231 X
239 mm.

Inscribed in lower left Il Tempo che rapisse la Belezza, and in lower
right Belucci.

Literature: Antonio Morassi, "Antonio Guardi as a Draughtsman,"
 Master Drawings, VI (1968), 135-136, pl. 28b.

 See also No. 49. The name Belucci [sic] in the lower right is

in the same hand as on each of the other drawings belonging to the

same set as this one (Nos. 49-53). It may signify that Guardi

derived his composition from Bellucci, some of whose drawings he may

have owned. But the inscription must have been made by someone else,

as Antonio would hardly have misspelled his godfather's name.

No. 55 Fig. 77

THE HOLY FAMILY AND SAINTS. Circa 1740.
Zurich, Anda-Bührlé.

White paper. Red chalk, pen and brush and brown wash, blue-green
water-color, some touches of oil color. 300 X 231 mm.

Provenance: Antonio Morassi.

Exhibitions: Trésors de l'art vénitien, Lausanne: Musée cantonal
 des Beaux-Arts, 1957, no. 189 (Catalogue by Rodolfo
 Pallucchini).

Literature: Rodolfo Pallucchini, "Opere inedite alla Mostra di
 Losanna," Emporium, CVI (1947), 233; Byam Shaw 1951,
 no. 2; Pignatti 1957, p. 30, no. 15; Terisio Pignatti,
 I disegni veneziani del Settecento (Venice, 1966),
 p. 155, no. 20; Pignatti 1967, no. IV.

 This unusual sketch is considered a Guardi masterpiece. The

reason is surely the extraordinary luminosity which emanates from

it because of the subtle combination of media. Compositionally it

has no claim to praise. Although consensus on authorship has not

been reached, it is here confidently ascribed to Antonio. No corresponding painted version is known. Byam Shaw observed that the types are very close to those of the Belvedere altarpiece thought to be of circa 1746 (Mostra dei Guardi [Dipinti], 1965, no. 16). This does not warrant the inference that the sketch was made for the painting: the format and the arrangement of the figures do not seem suitable for an altarpiece, and the identities of the saints represented differ from those in the altarpiece. The dating is difficult. A date close to that of the organ parapet at S. Raffaele in Venice has been suggested by Pallucchini and Pignatti, though firmer points of reference are discernible in works that antedate the famous cycle of 1750. The head of the Virgin is of a type which appears in the very early, little known Annunciation formerly in a German collection (Fiocco 1923, fig. 10), in the little known early Madonna published by Aldo Rizzi ("Il Grassi e i Guardi," Emporium, CXXXV [1962], p. 98, fig. 1), and in The Mystical Marriage of Saint Catherine at Seattle, which could hardly be later than 1740 (Mostra dei Guardi [Dipinti], 1965, no. 19). The face of the Christ child, his morphology, and the cherubs are far more akin to the small angels of the Mocenigo-Robilant series (Fiocco 1923, figs. 51-54)--which I believe to be without question very early works by Antonio--than to those of the Tobias cycle (Mostra dei Guardi [Dipinti], 1965, nos. 28, 34). Finally, the cherub's head under the Christ child's left foot is very similar to the small Saint John in the above-mentioned Seattle painting of circa 1740. These connections point clearly to Antonio's early maturity. A date circa 1740 is here tentatively proposed, though one in the 1730's is quite possible.

No. 56 Fig. 78

CHRIST AT EMMAUS. Circa 1738-1742.
Zürich, W. Hugelshofer.

White paper. Black chalk, brush and greyish-brown and brown washes.
290 X 430 mm.

Provenance: J. P. Richter; Gutekunst und Klipstein.

Exhibitions: Mostra dei Guardi, 1965, no. 3.

Literature: Pignatti 1957, p. 29, no. 2; Pignatti 1967, no. III.

At the Gutekunst und Klipstein sale in Bern in 1956, this beauti-
ful drawing was catalogued together with works by Francesco Guardi.
Pignatti assigned it as a primo pensiero to Antonio's Christ and Saint
John in the Stramezzi collection, a painting generally dated circa
1742 (Mostra dei Guardi [Dipinti], 1965, no. 15). Insofar as drawing
and painting can be compared stylistically an undeniable similarity
obtains, especially in the masterly treatment of the soft lighting.
But the marked difference in subject and composition between the two
makes the connection proposed by Pignatti doubtful. Yet both certainly
belong to the same phase of Antonio's development. It has been observed
that Guardi derived his compositions from a painting by Piazzetta,
Christ at Emmaus, probably of circa 1730, preserved at the Cleveland
Museum of Art (Dal Ricci al Tiepolo, Venice: Palazzo Ducale, 1969,
no. 58). The composition was taken from Piazzetta with little altera-
tion. But the scene is represented in reverse, which suggests the use
of an engraving. Also, Piazzetta's compact composition was stretched
out horizontally to suit Guardi's format--rather to the advantage of
the drawing.

No. 57 Fig. 79

THE ANNUNCIATION. After 1740.
Munich, Staatliche Graphische Sammlung (6701).

Light grey paper. Pen and brown wash over traces of red chalk,
heightened with white. 390 X 286 mm.

Exhibitions: Canaletto e Guardi, Venice: Fondazione Cini, 1962,
 no. 54 (Catalogue by J. Byam Shaw), Italienische
 Zeichnungen, Munich: Staatliche Graphische Sammlung,
 1967, no. 38 (Introduction by Bernhard Degenhart).

Literature: Morassi 1953, p. 264, fig. 19.

Morassi discovered this beautiful sketch and attributed it un-

hesitatingly to Antonio Guardi. In his exhibition catalogue of 1962

Byam Shaw remained undecided between the two Guardi Since then the

drawing has been neglected by writers on the Guardi perhaps because

it is problematical. It presents a perfect case in which an attribu-

tion based on graphic handling alone would be inconclusive. However,

the balled right hand of the Virgin showing only one finger is of a

type which recurs frequently in Antonio's oeuvre and never in

Francesco's (cf. Nos. 40, 49, 91 and Venus and Putti [Mostra dei

Guardi, Dipinti, 1965, no. 44]); the booted angel with one wing

spread wide and with bent head is a familiar figure in Antonio's

iconographical repertory, as against Francesco's (cf. No. 59 and Tobias

Healing his Father [Mostra dei Guardi, Dipinti, 1965, no. 32], The

Marriage of Tobias [Mostra dei Guardi, Dipinti, no. 31d]); the awkward

rendering of the angel's anatomical structure partly disguised by the

heavy drapery and by the cloud is quite typical of Antonio in contra-

distinction to Francesco. But it is no doubt the striking similarity

of the Virgin in this sketch with the Ariadne in Bacchus and Ariadne

at the Louvre (No. 41) which most convincingly argues Antonio's
authorship. Byam Shaw remarked that the composition could derive
from Sebastiano Ricci, to whom the drawing had previously been
attributed. It seems indeed that the prototype for Guardi's Virgin
is the kneeling bride in Ricci's The Continence of Scipio at the
North Carolina Museum of Art (Sebastiano and Marco Ricci in America,
Memphis: Brooks Memorial Art Gallery, 1965-1966, fig. 62), though
in the drawing the draperies have been substantially amplified. It
is even possible that Guardi's Archangel Gabriel was inspired by the
figure of Scipio in the same painting, as the position of Gabriel's
arms and right leg is very much that of Scipio's. No date has ever
been suggested for the sketch, of which it is certain only that it
is not an early work.

No. 58 Fig. 80

VIRGIN AND CHILD AND SAINT NICHOLAS OF BARI. Circa 1738-1742.
London, Mr. and Mrs. F. J. B. Watson.

White paper. Pen and pink wash over black and red chalk. 224 X
274 mm.

Provenance: Zatzka.

Exhibitions: La Peinture italienne au XVIIIe siecle, Paris: Petit
 Palais, 1961, no. 296 (Catalogue by Francesco Valcano-
 ver); Canaletto e Guardi, Venice: Fondazione Cini,
 1962, no. 52 (Catalogue by J. Byam Shaw); Mostra dei
 Guardi, 1965, no. 1.

Literature: F. J. B. Watson, "Francesco Guardi. Text by Vittorio
 Moschini," Apollo, LXV (1957), 188-189; Pignatti 1957,
 pp. 25, 30, no. 13.

These two sketches were assigned to Francesco Guardi by Watson,
who published them as preparatory designs for the controversial altar-
piece at Vigo di Ton (Mostra dei Guardi [Dipinti], 1965, no. 10).
Pignatti and Byam Shaw subsequently switched the attribution to Antonio
Guardi. It is not at all certain that the sketches were made for the
Vigo di Ton painting with its quite different compositional setup and
its several saints of whom Saint Nicholas, the prominent one in the
present drawing, enjoys no special relief. It would be surprising
for a painter to have been given such great latitude with the subject
of a commissioned altarpiece.

In this drawing the composition is rather elaborately laid in
with red chalk reinforced only here and there with pen strokes. The
use of the underdrawing as an important defining element is particu-
larly evident in a few drawings which are to be associated with the
present one on other grounds as well: the two apotheoses in Frankfurt
and Philadelphia respectively (Nos. 45, 47), the Allegory of Martial

Virtue at the Correr Library (No. 49), and the Emmaus scene in Zurich
(No. 56). All these works must date from about the same period,
which I believe to be roughly 1738-1742.

No. 59 Fig. 81
THE ANNUNCIATION. After 1740.
London, Victoria and Albert Museum (D. 106-1885).

Verso of FG: No. 36.

White paper. Red chalk, pen and brown ink. 196 X 318 mm.

Literature: K. T. Parker and J. Byam Shaw. Canaletto e Guardi,
 Venice: Fondazione Cini, 1962, p. 52, fig. 60 verso;
 Egidio Martini, La pittura veneziana del Settecento
 (Venice, 1964), p. 149, no. 27.

This sketch, assigned by Muraro to Francesco Guardi and by
Martini to Mattia Bortoloni, is here attributed to Antonio Guardi.
The angel's large wings evolving from a narrow base, the oddly-
shaped vase, and the bulky drapes hanging down from nowhere are icono-
graphical elements dear to Antonio. Martini thinks that the composi-
tion may derive from Bencovich, whose painting Agar in the Desert at
Pommersfelden he considers very similar (Martini 1964, fig. 113).
The resemblance is not sufficient to evince a connection.

No. 60 Fig. 82

THE CORONATION OF THE VIRGIN. After 1740.
Moscow, Pushkin Museum (6154).

White paper. Pen and brown wash over pencil. 378 X 270 mm.

Recent inscription in lower right: Barvinovski.

Literature: Antonio Morassi, "Antonio Guardi as a Draughtsman,"
Master Drawings, VI (1968), 134, 141n, pl. 25.

A marked dependence on Tiepolo is to be sensed in this drawing.
The composition can be traced to none of Giambattista known works,
but the patches of very dark wash applied over half-shadows uniform
in tonality clearly reflect Tiepolo's graphic style. It can reason-
ably be assumed that Antonio here used a drawing by his brother-in-law
as a model. The deliberateness in handling tends to show that Antonio
was preoccupied with the exact rendering of his model.

No. 61 Fig. 83

THE HOLY FAMILY RETURNING FROM THE TEMPLE. 1740-1745.
Florence, Uffizi (3062S).

White paper turned yellow. Red chalk. 395 X 275 mm.

Provenance: Emilio Santarelli.

Exhibitions: Canaletto e Guardi, Venice: Fondazione Cini, 1962,
 no. 105 (Catalogue by J. Byam Shaw).

Literature: Terisio Pignatti, "Canaletto and Guardi at the Cini
 Foundation," Master Drawings, I (1963), 51.

This drawing corresponds to a small painting in the Brass col-
lection (Max Goering, Francesco Guardi [Vienna, 1944], pl. 59). The
painted version does not include the figure of God the Father. It
has the appearance of having been cut down substantially from its
original size, which may account for the absence of the godly figure.
Byam Shaw records another small painted version of the same composi-
tion, sold at Sotheby's on June 9, 1955, which he judged to be of
much lesser quality; its present whereabouts is not known. Possibly
this sketch was made for a projected large painting, of which the
Brass picture is the modello. But Pignatti believes the drawing to
be a mediocre copy made--possibly by Francesco--after the Brass paint-
ing. No agreement has been reached on the authorship of the Brass
painting, nor has the drawing been attributed conclusively. I believe
both are by Antonio Guardi. The Brass picture shows the same picto-
rial style as Antonio's four biblical scenes of circa 1740 at the
Museum in Cleveland (Antonio Morassi, "Conclusioni su Antonio e
Francesco Guardi," Emporium, CXIV [1951], plates 16, 17, 18, 19), and
the drawing appears as a natural predecessor to Antonio's late red
chalk drawings.

No. 62 Fig. 84

SAINT MARGARET. Circa 1740-1745.
New York, Janos Scholz.

White paper. Red chalk. 181 X 112 mm.

Bears an old inscription Guido at the lower right corner.

Provenance: Alfred Stix.

Exhibitions: Venetian Drawings from the Collection Janos Scholz,
 Venice: Fondazione Cini, 1957, no. 91 (Catalogue by
 Michelangelo Muraro); Venetian Drawings 1600-1800,
 Oakland: Mills College Art Gallery, 1960, no. 38
 (Catalogue by Alfred Neumeyer).

Literature: Janos Scholz, "Drawings by Francesco and Gianantonio
 Guardi," The Art Quarterly, XVII (1954), 386, 389,
 fig. 5; Klara Garas, Franz Anton Maulbertsch (Budapest,
 1960), p. 178n; Fernanda de Maffei, "La questione
 Guardi: precisazioni e aggiunte," in Arte in Europa
 (Milano, 1966), p. 855; Janos Scholz, "Figure Drawings
 by the Guardi Brothers," in Problemi Guardeschi
 (Venice, 1967), pp. 195-196; Antonio Morassi, "Antonio
 Guardi as a Draughtsman," Master Drawings, VI (1968),
 136, pl. 29.

The martyr saint leaning on a column, flanked by an unidentifi-
able animal figure, is usually taken to be Saint Margret. Klara Garas
saw her as Saint Agnes, and Janos Scholz thought that she could pos-
sibly be Saint Thecla. The inscription in the lower right seems to
read Guido, rather than S. Vido as was recently suggested, though
Guido Reni could not possibly be the author of this sheet. When
the sketch was still in the collection of Alfred Stix, it was cata-
logued under Francesco Guardi. Muraro in his catalogue of 1957
endorsed that attribution but mentioned Venetian Rococo and Maulbertsch
together. It is to Maulbertsch that both Klara Garas and Fernanda de
Maffei then assigned the drawing, which they judged similar in style
to a sketch by the Austrian master at the Graphische Sammlung in
Saint Florian (Fig. 85). At first sight the affinities between

Maulbertsch's sketch and the present one give pause, but the dis-
parity in the handling of the chalk medium soon becomes apparent:
Maulbertsch's linework is more or less of equal firmness throughout,
whereas the lineaments in the present sketch are each differently
accented. And as Janos Scholz sensibly observed, the contrast
between the "worldly Latin charm" of Guardi's elegant figure and
Maulbertsch's blunt martyr seems to exclude a common authorship. Yet
Scholz's attribution to Francesco is not convincing either. The
sketch had previously been linked to Francesco's Standing Saint at
the Correr Library (FG: No. 74) as well as to his famous allegories
at Sarasota (Mostra dei Guardi [Dipinti], 1965, nos. 70, 71), though
the resemblances it bears to these works are iconographical rather
than stylistic. Indeed, it is consonant with none of Francesco's
works stylistically. Recently Morassi proposed to assign it to
Antonio--rightly, I think. It has a close parallel in The Return
from the Temple at the Uffizi (No. 61) and should date from the
same period, 1740-1745. Both look like forerunners of the vibrant
chalk drawings of Antonio's late maturity.

No. 63 Fig. 86

THE ARCHANGEL RAPHAEL (?). 1745-1747.

Bergamo, Accademia Carrara (1014).

Recto of No. 64.

Light green-blue paper. Pencil and black chalk. 240 X 98 mm.

Exhibitions: Mostra dei Guardi, 1965, no. 5.

Literature: Carlo L. Ragghianti, Disegni dell'Accademia Carrara di
Bergamo (Venice, 1962), p. 62, no. 124; Terisio Pignatti,
"Canaletto and Guardi at the Cini Foundation," Master
Drawings, I (1963), 51; Egidio Martini, La Pittura vene-
ziana del Settecento (Venice, 1964), p. 275, no. 261;
Terisio Pignatti, "Nuovi disegni di figura dei Guardi,"
Critica d'Arte, XI (1964), 58, fig. 83; Terisio Pignatti,
I disegni veneziani del Settecento (Venice, 1965),
pp. 153-154, no. 17; Pignatti 1967, no. Xr.

This sketch, previously attributed to Tiepolo and then to

Francesco Guardi, is today accepted by most critics as a work by

Antonio Guardi. Pignatti linked it to the figure of the angel in

Tobias' wedding scene of circa 1750 in the church of S. Raffaele in

Venice (Mostra dei Guardi [Dipinti], 1965, no. 31d). The connection

is not certain in view of the differences in the respective poses of

the angels. The date 1745-1747 given for the verso (No. 64) unques-

tionably applies to this drawing as well.

No. 64 Fig. 87

HAREM SCENE. 1745-1747.

Bergamo, Accademia Carrara (1013).

<u>Verso</u> of No. 63.

Light green-blue paper. Pencil and black chalk. 98 X 240 mm.

Exhibitions: <u>Mostra dei Guardi</u>, 1965, no. 5.

Literature: Carlo L. Ragghianti, <u>Disegni dell'Accademia Carrara di
 Bergamo</u> (Venice, 1962), p. 62, no. 124; Rodolfo Palluc-
 chini, "Note alla Mostra dei Guardi," <u>Arte Veneta</u>, XIX
 (1965), 223; Pignatti 1967, no. Xv.

The drawing is associated with a small cabinet picture, <u>The Greek</u>

<u>Favorite</u>, in the Thyssen Bornemisza collection (<u>Mostra dei Guardi</u>

[<u>Dipinti</u>], 1965, no. 26). The figure of the seated Greek is copied

from an engraving by G. Scotin after Van Mour, and the standing figure

at the left holding a vase from an engraving by F. Simmonneau, also

after Van Mour (F. J. B. Watson, "A Series of 'Turqueries' by Francesco

Guardi," The Baltimore Museum of Art News, XXIV, Fall [1960], 11, figs.

12, 13). The painted version belongs to a set of forty-two cabinet

pictures representing Turkish scenes for which several payments were

made to Antonio Guardi by Marshal von der Schulenburg between 1742 and

1747 (see Appendix, pp. 330-331). It is clear that the still extant

<u>Turqueries</u> from the set are not all by the same hand, but the Thyssen

piece can only be assigned to Antonio. The pictorial handling is so

similar to the parapet depictions at the church of S. Raffaele in

Venice, of circa 1750, that it is reasonable to infer that <u>The Greek</u>

<u>Favorite</u> was one of the last <u>Turqueries</u> painted for Schulenburg.

Antonio Guardi's graphic oeuvre shows that he was always very atten-

tive to problems of lighting. This is particularly obvious in this

drawing, where the strong light streaming in from the left and diffus-

ing softly into the interior is rendered with great skill.

No. 65 Fig. 88

CHRIST AT EMMAUS. 1745-1750.

Frankfurt-am-Main, Staedelsches Kunstinstitut (6968).

White paper. Pen, brush and brown wash over faint traces of black chalk. 360 X 230 mm.

Literature: Max Goering, "An Unknown Sketch by Piazzetta," The Burlington Magazine, LXVIII (1936), 124-130; Pignatti 1957, pp. 26, 29, no. 10.

This drawing and another one in the Eisemann collection in London (No. 66) are two similar conceptions of the same subject. No Guardi painting corresponding to either of them exists. Both show the same degree of finish. But it may be surmised that the present sketch came after the London one, as the still life in it is more detailed and as its group of cherubs in the upper right is compositionally more sophisticated. Acquired by the Staedelsches Kunstinstitut as a work by Sebastiano Ricci, it was assigned by Goering to Piazzetta because it shows the same composition as a Piazzetta painting at the Museo Civico at Padua (Goering 1936, pl. A). A smaller version of the Padua painting is preserved at the Göteborg Museum (Goering 1936, pl. C). Byam Shaw's discovery of the London sheet and his attribution of it to Antonio Guardi sanctioned Antonio's paternity of the Frankfurt drawing as well. As the portal represented in the background of the drawings figures only in the smaller of Piazzetta's paintings, the Göteborg version has a stronger claim to having served as the model, unless Guardi used an engraving made after it. Antonio's main concern in making the sketches must have been to transform Piazzetta's nearly square composition into an upright one. The elongation created a void in the upper right which

may account for the introduction of fluttering putti. Piazzetta's

undated and undocumented paintings do not provide any terminus post

quem, though on stylistic grounds Pallucchini judged them to belong

to the mid-1740's (L'arte di G. B. Piazzetta [Bologna, 1934], p. 51).

The drawings are obviously mature works of Antonio's, executed after

1745.

No. 66 Fig. 89
CHRIST AT EMMAUS. 1745-1750.
London, Eiseman.

White paper. Pen and greyish and brown washes over black chalk.
308 X 248 mm.

Provenance: John Skippe; Mrs. A. C. Rayner Wood.

Exhibitions: Mostra dei Guardi, 1965, no. 4.

Literature: J. Byam Shaw, "Unpublished Guardi Drawings," The Art
 Quarterly, XVI (1953), 333; Pignatti 1957, pp. 26, 31,
 no. 18. Terisio Pignatti, "Nuovi disegni del Piazzetta,"
 Critica d'Arte, IV (1957), 403.

 See also No. 65. This sketch was first published by J. Byam

Shaw who attributed it to Antonio Guardi.

No. 67 Fig. 90

SAINT JOHN THE EVANGELIST. Circa 1745-1748.
Paris, Private collection.

Recto of No. 68.

White paper. Pen and brown ink. 293 X 197 mm.

The authorship of this unknown drawing is obvious, though no
other pure pen drawing by Antonio Guardi is known. The Evangelist
holds the pen in his left hand, which could suggest that the drawing
was made for the engraver. It is more likely that Antonio copied an
engraving, as the shape of the borderline enclosing his drawing sug-
gests that it was made for a devotional picture or for an altarpiece.
Its dating is difficult; circa 1745-1748 is tentatively proposed here,
though an earlier date is possible.

No. 68 Fig. 91

THE FLAGELLATION. Circa 1745-1748.
Paris, Private collection.

Verso of No. 67.

White paper. Red chalk. 293 X 197 mm.

This unknown drawing is here attributed to Antonio Guardi.
The Flagellation at the Printroom at Dresden (No. 69) is another con-
ception of the same theme. The techniques used are different, but
the handling is very similar. Both drawings are in all likelihood
compositional studies for the same project. Even their respective
formats may have originally been identical: the heaped-up draperies
at the low-left of the Dresden sketch clearly indicate that a figure,
or a figure group, was cut out at some point, and the work was

manifestly trimmed down on the right side as well. The present
drawing is of particular interest, as it shows more careful model-
ing of forms and more precise rendering of details than do most of
Antonio's other works. Maybe this means that an important commis-
sion was at stake. The subtle play of darks and lights recall such
drawings as the Virgin in Glory with Saints at the Uffizi and the
Saint Roch Visiting the Sick at Warsaw (Nos. 73, 74), though the
much softer chalk used in the present sketch endows it with a
mellower appearance, and individual hatching lines stand out less
distinctly than in the above-mentioned related drawings. The com-
position is not original. Figures corresponding to those of the
central group (Christ and the flagellating men), though varying in
some particulars, are found in a study of the same theme at the
Hermitage attributed to Salviati (Fig. 92). Guardi probably did
not know the Salviati study, but perhaps knew the painting for
which it had been made or an engraving made after the painting.

No. 69 Fig. 93

THE FLAGELLATION. Circa 1745-1748.
Dresden, Kupferstchkabinett (C 1896-29).

Light brown paper. Red chalk, pen and brown wash. 277 X 390 mm.
On the <u>verso</u> a sketch of the Dogana in pen and brown wash.

Literature: Lili Fröhlich-Bume, "Two Drawings by Guardi in the
 Dresden Printroom," <u>The Burlington Magazine</u>, XLIX
 (1926), 31-32, pl. A; Detlev von Hadeln, "Some
 Unpublished Figure Drawings of Francesco Guardi,"
 <u>Old Master Drawings</u>, I (1926), 3-4; Giuseppe Fiocco,
 "Il problema di Francesco Guardi," <u>Arte Veneta</u>, VI
 (1952), 106.

This sheet, previously assigned to Tiepolo, was published by
Lili Fröhlich-Bume and attributed to Francesco Guardi. At the time,
Antonio Guardi was still a shadowy figure. The sketch fell into
oblivion after Fiocco declared it Guardiesque, but not by either
Francesco or Antonio. On stylistic grounds it can convincingly be
given to Antonio, the more since it is related to the Paris <u>Flagel-</u>
<u>lation</u> (No. 68), which could not conceivably be by Francesco. The
sheet was visibly and markedly trimmed on all sides; only the
central portion of what may have been a very large drawing survived.
It shows a greater degree of finish than the Paris variant. Having
originally been much larger as well, it was evidently the more
advanced version, perhaps the final one. It gains greatly in inter-
est from the sketch found on the <u>verso</u>, which represents the Venetian
Customs House, the famous Dogana (Fröhlich-Bume 1926, pl. B). Fiocco
thought that this sketch could be by Nicolò Guardi, though no authen-
ticated works by Nicolò are available for comparison. Stylistically
it links up with a group of drawings which Byam Shaw rightly con-
siders to be early productions of Francesco as draughtsman of views

(Byam Shaw 1951, pp. 21-22). Seen beside these it seems to be of a particularly early date--circa 1750 or even earlier. This date roughly coincides with the one here tentatively assigned to The Flagellation on the recto. Thus either Francesco or Antonio utilized the reverse side of a drawing by the other. This is further evidence that in the middle years of the century the two brothers shared a bottega.

No. 70 Fig. 94
HEAD OF A MAGUS. Circa 1745-1748.
Formerly Paris, Adrien Fauchier-Magnan.

White paper. Red chalk. Measurements unknown.

Inscribed in the lower left in contemporary handwriting Orig. di [Anto]nio Guardi.

Literature: Fiocco 1923, p. 63, no. 3; Max Goering, "Francesco Guardi als Figurenmaler," Zeitschrift für Kunstgeschichte, VII (1938), 290; Pignatti 1957, p. 31, no. 25; Antonio Morassi, "Antonio Guardi as a Draughtsman," Master Drawings, VI (1968), 137, pl. 31.

The first name has been partly deleted from the inscription in the lower left, probably by a dealer and to make the sketch pass for a work by Francesco. The sketch could be a study for a detail of an Adoration of the Magi. Though in Goering's view it is a work of circa 1730, it is akin to Antonio's works of the late 1740's.

No. 71 Fig. 95

ALLEGORY OF SCIENCE (?). 1745-1750.

Cologne, Museum of Art.

White paper. Red chalk, pen and brown wash. 360 X 270 mm.

Literature: Antonio Morassi, "Antonio Guardi as Draughtsman,"
 Master Drawings, VI (1968), 134-135, 141, pl. 26.

This drawing was discovered by Morassi, who noticed the same

composition in a drawing by Tiepolo (Eduard Sack, Giambattista und

Domenico Tiepolo [Hamburg, 1910], fig. 294) apparently made for the

etching of one of the Scherzi di Fantasia to which it corresponds

in reverse (Pompeo Molmenti, Acque-forti dei Tiepolo [Venice, 1896],

p. 22). Even though Antonio reversed compositions with dexterity,

in this case he must have copied Tiepolo's drawing and not the etch-

ing, as he handled the wash after his brother-in-law's idiosyncratic

fashion. It is surprising for Morassi to have dated the drawing in

the late 1730's, as it is now generally believed that Tiepolo etched

the Scherzi roughly between 1743 and 1749 (George Knox, "Le Aqueforti

dei Tiepolo," The Burlington Magazine, XCVIII [1966], 585). Although

iconographical references to the Scherzi are found in certain of

Tiepolo's drawings of the 1730's, it is unlikely that the finished

drawings should have preceded the etchings by almost a decade. A

date circa 1745-1750 is here proposed for Guardi's drawing. Though

this drawing may represent Archimedes, the title given to it at the

Museum at Cologne is retained.

No. 72 Fig. 96

TRINITY, IMMACOLATA AND SAINT. Circa 1750.
Tarnow, Museum of Art.

White paper, turned yellow. Pencil and light brown wash. In parts
touched up with pen and black (faded) ink. 354 X 258 mm.

Exhibitions: Disegni veneti in Polonia, Venice: Fondazione Cini,
1958, no. 38 (Catalogue by Maria Mrozinska); Mostra
dei Guardi, 1965, no. 13.

Literature: Giuseppe Fiocco, "La Mostra della pittura italiana
nelle collezioni polacche," Arte Veneta, X (1956), 239;
Aldo Rizzi, "Il Grassi e i Guardi," Emporium, CXXXV
(1962), 103, fig. 14.

This is clearly a study for a projected ceiling, as the di sotto

in su composition enclosed within an oval-shaped outline suggests. It

is one of several of Antonio's drawings which provide evidence of his

having painted ceilings. Unfortunately, only one ceiling decoration

unquestionably his is known, the exquisite Diana at Ca' Rezzonico

(Giulio Lorenzetti, Ca' Rezzonico, 6th ed. [Venice, 1960], fig. 24).

It is executed in fresco and displays a command of the technique which

suggests more than casual practice in fresco painting. Possibly the

present sketch was also intended to be executed in fresco. Morpho-

logically, Christ in the drawing vividly recalls the figures of Christ

and Saint John in the Pasiano altarpiece, datable circa 1750 on docu-

mentary evidence (Mostra dei Guardi [Dipinti], 1965, no. 22). The

same date has been proposed by Aldo Rizzi for this drawing.

No. 73 Fig. 97

VIRGIN IN GLORY AND SAINTS. Circa 1750.
Florence, Uffizi (7837S).

Green paper. Red chalk. 410 X 185 mm.

Provenance: Emilio Santarelli.

Exhibitions: Mostra dei Guardi, 1965, no. 11; Disegni italiani della
collezione Santarelli, Florence: Gabinetto disegni e
stampe degli Uffizi, 1967, no. 99 (Catalogue by Anna
Forlani Tempesti et al.).

Literature: Emilio Santarelli, Catalogo della raccolta di disegni
autografi antichi e moderni (Florence, 1870), 510;
Michelangelo Muraro, "Novità per Francesco Guardi,"
Arte Veneta, III (1949), 124, fig. 136; Antonio Morassi,
"Conclusioni su Antonio e Francesco Guardi," Emporium,
CXIV (1951), 216; Morassi 1953, p. 264, fig. 12;
Pignatti 1957, pp. 26, 29, no. 8.

This drawing is a project for an altarpiece. In his catalogue,
Santarelli entered the sketch under Piazzetta; Muraro assigned it to
Francesco, and Morassi to Antonio Guardi. Morassi is unquestionably
right. The body of the Virgin with its over-long torso exhibits
faults of proportion characteristic of Antonio, and the delicate
small head from which long rays of light emanate recurs occasionally
in his oeuvre. The juxtaposition of this drawing with the inscribed
drawing of Saint Margaret at Warsaw (No. 75) should dispel all doubts
as to its authorship.

No. 74 Fig. 98

SAINT ROCH VISITING THE SICK. Circa 1750.
Warsaw, National Museum.

Recto of No. 75.

White paper, slightly yellowed. Red chalk. 277 X 399 mm.

Inscribed in dark ink Guardi in lower left in contemporary handwriting
and Sebastiano Ricci (crossed out) in a nineteenth-century hand.

Provenance: S. Smolikowski.

Exhibitions: Disegni veneti in Polognia, Venice: Fondazione Cini,
1958, no. 37 (Catalogue by Maria Mrozinska); Mostra
dei Guardi, 1965, no. 6.

Literature: Terisio Pignatti, "Nuovi disegni di figura dei Guardi,"
Critica d'Arte, XI (1964), 58, 61, fig. 88; Pignatti,
"Linguistica e linguaggio dei fratelli Guardi," in
Problemi Guardeschi (Venice, 1967), p. 177; Fernanda de
Maffei, "La questione Guardi: precisioni e aggiunte,"
in Arte in Europa (Milano, 1966), pp. 852-855; Pignatti
1967, no. XIv.

Unfortunately the left-hand corner of this sheet has been torn
away just in front of the name Guardi, which may originally have been
preceded by a first name as in the inscription on the verso. This
beautiful drawing, attributed to Antonio Guardi by Maria Mrozinska,
has been discussed at great length by Fernanda de Maffei, who assigned
it together with several other similar Guardiesque sheets to Antonio
Maulbertsch. There is no doubt, as Fernanda de Maffei points out,
that the graphic handling in Maulbertsch's The Good Samaritan at the
Albertina (Maffei 1966, fig. 578) comes remarkably close to that dis-
played here. But the view that this Saint Roch drawing is incompat-
ible with Antonio's graphic oeuvre is not easy to defend. It is true
that the manner of hatching the shadows in regular tidy strokes is
not typical of Guardi, but it does occur in some of his drawings such
as the Saint John the Evangelist in Paris (No. 67). Further,

Fernanda de Maffei's assertion that the long regular rays emanating
from the Christ's head are not encountered in any of Guardi's sheets
is refuted by the Virgin in Glory with Saints at the Uffizi (No. 73),
just as her assertion that the juxtaposition of large white zones with
large shaded ones is not in keeping with Antonio's treatment of light-
ing is refuted by the Philadelphia and Frankfurt sketches represent-
ing the Emmaus scene (Nos. 45, 47). The hands are, as Maffei noticed,
rendered in an unusual manner, but on the whole what is typical of
Antonio in this sketch far outweighs what is not. The juxtaposition
of the figure of Saint Roch with that of the disciple seated at the
left in Antonio's Emmaus scene in Zurich (No. 56) could hardly leave
authorship in doubt. Pignatti also maintained the original attribu-
tion to Antonio. This sketch, like the one of Saint Margaret on the
verso, expresses in graphic language the same fantastic, eerie and
poetic mood as pervades the painted Tobias stories at S. Raffaele in
Venice and certainly dates from the same period (cf. Mostra dei Guardi
[Dipinti], 1965, nos. 29, 30, 31d).

No. 75 Fig. 99

SAINT MARGARET. Circa 1750.
Warsaw, National Museum.

Verso of No. 74.

White paper, slightly yellowed. Red chalk. 277 X 399 mm.

Inscribed in lower right in black pencil Ant.o Guardi in contemporary
handwriting.

Provenance: S. Smolikowski.

Exhibitions: Mostra dei Guardi, 1965, no. 6.

Literature: Terisio Pignatti, "Nuovi disegni di figuri dei Guardi,"
 Critica d'Arte, XI (1964), 58, fig. 87; Giuseppe Fiocco,
 Guardi (Milan, 1965), p. 37; Rodolfo Pallucchini, "Nota
 alla Mostra dei Guardi," Arte Veneta, XIX (1965), 236;
 Terisio Pignatti, I disegni veneziani del Settecento
 (Venice, 1966), pp. 152-153, no. 15; Fernanda de Maffei,
 "La questione Guardi: precisazioni e aggiunte," in
 Arte in Europa (Milano, 1966), pp. 852-855; Terisio
 Pignatti, "Linguistica e linguaggio dei fratelli Guardi,"
 in Problemi Guardeschi (Venice, 1967), p. 177; Antonio
 Morassi, "Antonio Guardi as a Draughtsman," Master
 Drawings, VI (1968), 136-137, pl. 30.

This appears to be a compositional study for an altarpiece. It

goes by the name of Saint Margaret, which is probably correct, though

the oddly shaped form at the saint's right is not clearly identifiable

as a dragon. As Fernanda de Maffei pointed out, the elegant saint

derives iconographically from Pharaoh's daughter in Veronese's famous

painting The Finding of Moses in Dresden (cf. Pignatti 1966, p. 152).

Incidentally, a Guardiesque copy of the whole Veronese painting is

preserved in a private collection in Milan (Giuseppe Fiocco, "Guardi

pittore di fiori," Arte Veneta, IV [1950], fig. 20).

In spite of the contemporary inscription Ant.o Guardi in the

lower right, and even though the sketch evidences an artistic sensi-

tivity irreconciable with Francesco's, no consensus on attribution

has been reached. Fiocco and Pallucchini favor Francesco.

Fernanda de Maffei prefers Maulbertsch. But Antonio is certainly correct. The drawing is one of the finest specimens of Antonio's mature draughtsmanship in chalk. An analogy with the painted Tobias stories of circa 1750 is obvious: the Rocco elegance of the lovely saint is well in keeping with Sarah's in Tobias' wedding scene (Mostra dei Guardi [Dipinti], 1965, 31d). As Pignatti suggested, a date around 1750 is the most probable.

No. 76 Fig. 100

MADONNA AND SAINTS. 1750-1755.
Milan, Antonio Morassi.

White paper. Pen and brown wash over red chalk. 360 X 220 mm.

Provenance: Marius Paulme.

Exhibitions: Canaletto e Guardi, Venice: Fondazione Cini, 1962, no. 53 (Catalogue by J. Byam Shaw); Eighteenth-Century Venetian Drawings from the Correr Museum, Washington: National Gallery, 1963-1964, no. 5 (Catalogue by Terisio Pignatti); Disegni veneti del Settecento nel Museo Correr di Venezia, Venice: Fondazione Cini, 1964, no. 5 (Catalogue by Terisio Pignatti); Mostra dei Guardi, 1965, no. 2.

Literature: Morassi 1953, p. 264, fig. 18; Terisio Pignatti, I disegni veneziani del Settecento (Venice, 1966), pp. 154-155, no. 19; Pignatti 1967, no. VI.

The drawing is obviously a project for an altarpiece. No corresponding painted version has so far come to light. Some critics associate the sketch, as a possible primo pensiero, with the altarpiece at Belvedere (Mostra dei Guardi [Dipinti], 1965, no. 16), but iconographically the resemblances are rather tenuous. The saints in the drawing differ considerably from those in the altarpiece as to

number, identity and poses. As the Belvedere painting dates from circa 1746, Pignatti has assigned that date to the drawing. But Morassi rightly considers that the drawing may belong to the artist's last decade.

In this beautiful drawing Antonio's draughtsmanship in pen and wash assumes its most mature form. Here, as in the Saint Gregory drawing at the Fogg Museum of the same period (No. 86), Antonio shows himself affected by his younger brother's graphic style. This is particularly explicit in the figure of Saint Benedict, whose face vividly recalls Francesco's Saint in Ecstasy at Trento (Mostra dei Guardi [Dipinti], 1965, no. 66). It is also perceptible in the treatment of the draperies, which are here more pronouncedly angular in the manner of Francesco than in any of Antonio's earlier works. These affinities with Francesco's style may account for Byam Shaw's initial hesitancy in attributing the sheet.

No. 77 Fig. 101

VIRGIN ENTHRONED WITH ATTENDANT SAINTS. 1750-1755.
Oxford, Ashmolean Museum (1007).

White paper. Red chalk. 224 X 168 mm.

On the verso undecipherable scribbles.

Provenance: Springell.

Exhibitions: Disegni veneziani di Oxford, Venice: Fondazione Cini,
1958, no. 111 (Catalogue by K. T. Parker); La Peinture
italienne au XVIIIe siècle, Paris: Petit Palais, 1960-
1961, no. 297 (Catalogue by Francesco Valcanover);
Mostra dei Guardi, 1965, no. 12.

Literature: Ashmolean Museum, Report to the Visitors (Oxford, 1946),
p. 33; Byam Shaw 1951, no. 1, pl. 1; Antonio Morassi,
"Conclusioni su Antonio e Francesco Guardi," Emporium,
CXIV (1951), 219; Vittorio Moschini, Francesco Guardi,
(Milan, 1952), p. 15, fig. 3; Morassi 1953, p. 264,
fig. 16; Ragghianti 1953, p. 93, fig. 10; K. T. Parker,
Catalogue of the Collection of Drawings in the Ashmo-
lean Museum (Oxford, 1956), II, p. 506; Pignatti 1957,
pp. 23, 24, 25, 26, 31, no. 19, fig. 22; Giuseppe
Fiocco, Francesco Guardi, l'Angelo Raffaele (Turin,
1958), p. 27; Terisio Pignatti, "Nuovi disegni di
figura dei Guardi," Critica d'Arte, XI (1964), 58,
fig. 89; Pignatti 1967, no. XII.

The sketch is a compositional study, perhaps the primo pensiero,
for the altarpiece which the priest Francesco Ferri, a friend of the
Guardis, donated to the church of Cerete Basso (near Bergamo) in 1754
(Edoardo Arslan, "Ancora di una opera bergamasca di Gian Antonio
Guardi, Emporium, CXV [1952], 167). The sketch differs from the
painted version in that the attitudes of both the putto holding the
shield at the lower left and Saint Anthony are discrepant and the
acolyte with the staff in the painting is not in the sketch. A
more elaborate drawing must have come between this sketch and the
painting.

As Morassi pointed out, the Madonna and child and Saint
Silvester derive from Veronese's famous S. Zaccaria altarpiece

today at the Accademia in Venice (Guido Piovene, L'opera completa del Veronese [Milan, 1968], fig. 78). The Saint Catherine is almost identical (though represented in reverse) to the half-kneeling Saint Catherine in Veronese's The Holy Family and Saints in the church of S. Francesco della Vigna in Venice (Piovene 1968, fig. 22).

There has been a considerable controversy over the authorship of this drawing and of the painting to which it relates. The sketch is here attributed to Antonio Guardi. It belongs to a well-defined group of chalk drawings of Antonio's late period including the Aurora in Count Cini's collection (No. 79), the Head of a Magus, formerly in Paris (No. 70) and the Madonna Appearing to Two Saints in the Hermitage (No. 83). In all these works the draughtsman rendered figures and forms quite abstractly, dispensing almost entirely with contour lines and focusing predominantly on lighting.

It is generally assumed that the altarpiece of Cerete Basso was painted shortly before Ferri's donation of 1754. This is reasonable, yet not certain. The shield in the lower left does not bear the arms of the Ferri family, but those of the Venetian Patricians, the Pisanis (on this see Jean Cailleux, "Une Famille de peintres," L'Information d'Histoire de l'Art, XI [1966], 62). This could mean that in 1754 Ferri acquired an altarpiece which had been painted at some previous date for the Pisanis but for some unknown reason had remained on Antonio's hands.

No. 78 Fig. 102

<u>MINERVA</u>. 1750-1755.

Zürich, Private collection.

<u>Recto</u> of No. 79, Fig.

White paper. Pen, brush and brown wash over red chalk. 311 X 194 mm.

Provenance: Soldati; Calmann; Spector.

Exhibitions: <u>Mostra dei Guardi</u>, 1965, no. 7.

Literature: Pignatti 1957, pp. 26, 31, no. 27; Egidio Martini, <u>La</u>
<u>pittura veneziana del Settecento</u> (Venice, 1964),
p. 275, no. 261; Terisio Pignatti, <u>I disegni veneziani</u>
<u>del Settecento</u> (Venice, 1966), p. 156, no. 22; Pignatti
1967, no. XVr.

Pignatti published this sketch as a study for one of the fres-
coes originally located in Palazzo Dabalà in Venice, now in Ca' Rez-
zonico (Fig. 103). In spite of the iconographical similarities
between the two works, Pignatti's classification--generally accepted
--is not compelling. Even after due allowance has been made for the
difference in technique, medium, and scale in the two works, the disparity
of handling--primitive and awkward in the fresco, sophisticated and
bold in the drawing--points clearly to distinct phases of Antonio's
artistic development. He must have used the same compositional
scheme for two different projects widely separated in time. The rela-
tive layout of the composition also seems to preclude a correspondence.
The arrangement is upright in the drawing, horizontal in the fresco,
and the outlines for the frame indicated in the sketch differ totally
from those of the Ca' Rezzonico decoration. The sketch on the <u>verso</u>
of the same sheet is a study for the <u>Aurora</u> painting in the Cini col-
lection, one of several extant decorations said to have originally
adorned a room in Palazzo Suppiei in Venice. The indication is that
the <u>Minerva</u> sketch was made in connection with the same decorative

scheme. And indeed, its shape, the number of figures, and their disposition would make it a fit pendant for the Aurora.

No. 79 Fig. 104

AURORA. 1750-1755.
Zürich, private collection.

Verso of No. 78.

White paper. Red chalk. 194 X 311 mm.

Provenance: Soldati; Calmann, Spector.

Exhibitions: Mostra dei Guardi, 1965, no. 7.

Literature: Pignatti 1957, pp. 26, 31, no. 27; Antonio Morassi,
 "Pellegrini e Guardi," Emporium, CXXVIII (1958), 195-
 197; Terisio Pignatti, "Nuovi disegni di figura dei
 Guardi," Critica d'Arte, XI (1964), 57, 58, fig. 84;
 Terisio Pignatti, I disegni veneziani del Settecento
 (Venice, 1966), p. 156, no. 22; Pignatti 1967,
 no. XV v.

This is a fragment of what appears to have been a much larger drawing. Aurora's hand, which must have been holding a torch, has been cut out; so probably has the body corresponding to the head in the lower right. The drawing is connected with the decorative painting Aurora in the Cini collection (Mostra dei Guardi, 1965, no. 39). Compositionally and iconographically, it goes back to Pellegrini's fresco today in Baltimore (Morassi 1958, p. 195, fig. 1). The extant portion of the drawing follows Pellegrini rather faithfully, but the painted version diverges noticeably: the angel closer to the chariot has been pushed farther back, and the one closer to the viewer has been reversed in position--as better accords with his function of guide. It can be surmised that this sketch was the

initial compositional study, subsequently elaborated into a defini-
tive design for the painting. Stylistically this drawing should be
grouped with several others in red chalk, such as the study for an
altarpiece at the Ashmolean Museum (No. 77), the archangel in Bergamo
(No. 63) and the Madonna Appearing to Two Saints at the Warsaw Museum
(No. 83). In these drawings the artist etherializes forms and tran-
scends outlines to the point of impairing the readability of the sub-
ject. They certainly mark a specific phase of his development which
I believe fell in the middle years of the century (circa 1745-1755).
Two such chalk drawings of his are datable 1745-1747 (Nos. 63, 64),
and in his painting this proclivity to dissolution of forms reached
its climax with the Tobias series of circa 1750 (Mostra dei Guardi
[Dipinti], 1965, nos. 31d, 31e, 31f).

No. 80 Fig. 105
CENTAUR BEARING OFF DEJANIRA. 1750-1755.
Paris, Private collection.
White paper. Pen and brown wash over red chalk. 215 X 340 mm.
Literature: Morassi 1953, p. 264, fig. 17; Pignatti 1957, p. 31,
 no. 23.

This sketch is a specimen of Antonio's evolved draughtsmanship
in pen and wash. It certainly belongs to the last decade of his
activity, as Morassi suggested.

No. 81 Fig. 106

ALLEGORICAL FIGURE OF VENICE. 1750-1755.

London, British Museum.

White paper. Red chalk, pen, brush and water colour. 254 X 173 mm.

Provenance: Sir Joshua Reynolds; A. M. Champernowne.

Literature: Byam Shaw 1951, p. 57, no. 3, pl. 3; Ivan Fenyő, "An
Unknown Drawing by Gianantonio Guardi in the British
Museum," Master Drawings, II (1964), 276.

The name of Guardi was first linked with this sketch by Byam

Shaw, who thought Francesco to be its author. It had previously

been catalogued under Domenico Tiepolo. In comparing it with

Antonio's Irene Drawing the Arrows from the Body of Saint Sebastian

(No. 82), preserved at the same museum, Fenyő reached the convincing

conclusion that both were by the same hand: Antonio's. Antonio's

Centaur Bearing off Dejanira in Paris (No. 80), in which the draper-

ies are treated very much as in this drawing, corroborates Fenyő's

view. Incidentally, the eyes of the allegory are here rendered by

two slightly concave strokes, a graphic abbreviation frequently

employed by Antonio but never by Francesco.

No. 82 Fig. 107

IRENE DRAWING THE ARROWS FROM THE BODY OF SAINT SEBASTIAN.
London, British Museum (1931-5-11-59)

White paper. Red chalk, pen, brush and brown wash. 286 X 403 mm.

Inscribed at the base in the middle in contemporary handwriting:
Originale del Segalla; numbered in the upper right corner: 238.

Literature: Campbell Dodgson, "Giovanni Segala," Old Master Draw-
ings, X, 1935-1936, 26-27; Ivan Fenyö, "An Unknown
Drawing by Gianantonio Guardi in the British Museum,"
Master Drawings, II (1964), 276-277, pl. 26; Pignatti
1967, no. XIV.

The inscription at the bottom of this drawing is what must have

determined Campbell Dodgson to publish it as a work by Giovanni

Segala (1663-1720). Unfortunately, it cannot be compared with any

authenticated drawings by Segala, whose graphic oeuvre has never been

investigated. Segala's few extant paintings show him as a typical late

Baroque master, unlikely to have been the author of a drawing imbued

with Rococo spirit. The attribution to Antonio Guardi is due to

Fenyö, who found the drawing most closely paralleled by the Allegory

of Venice at the British Museum (No. 81). The misleading inscription

probably means that the drawing was made after a work by Segala.

Graphologically it bears a striking resemblance to Antonio's auto-

graphical inscription on the Correr sketch February (No. 91).

No. 83 Fig. 108

MADONNA AND CHILD RECEIVING SAINT THERESA'S APPEAL FOR A FRIAR.
1750-1755.
Moscow, Pushkin Museum (7943).

White paper. Red chalk, pen, brush and brown wash. 409 X 306 mm.

Provenance: Ivanovic Tinicew.

Literature: Antonio Morassi, "Antonio Guardi as a Draughtsman,"
 Master Drawings, VI (1968), 133, 141, pl. 24.

In his analysis of this drawing, previously attributed to
Nicola Grassi, Morassi advanced convincing arguments for Antonio's
authorship. The faces are rendered more incisively and more
coarsely, than in most of Antonio's works. Similar facial types
also occur in the Saint Gregory at the Fogg (No. 86): thus the
head of the child at the left of the Fogg piece compares closely
with that of the monk in the present one. In both works, moreover,
the figures are firmly but summarily traced, while the tonalities
are set down with the utmost care. Morassi placed this drawing circa
1740-1750, but I believe that it is of about the same date as the
Saint Gregory at the Fogg, circa 1750 or shortly after.

No. 84 Fig. 109

MADONNA APPEARING TO TWO SAINTS. Circa 1752-1756.
Leningrad, Hermitage (21919).

White paper, turned yellow. Red chalk. 355 X 275 mm.

Inscribed in black ink Guardi in eighteenth-century handwriting in
the lower right corner and again on the verso.

Provenance: Iussupov.

Exhibitions: Vistavka italianskich risunkov XVII-XVIII vekov,
 Leningrad: Hermitage, 1959, p. 25 (Catalogue by
 M. Dobroklonsky); Disegni veneti del museo di
 Leningrado, Venice: Fondazione Cini, 1964,
 no. 95 (Catalogue by Larissa Salmina).

Literature: M. Dobroklonsky, Risunki italianskoi shkoly XVII-XVIII
 vekov (Leningrad, 1961), p. 51, no. 207; Terisio
 Pignatti, "Nuovi disegni di figura dei Guardi,"
 Critica d'Arte, XI (1964), 61; Egidio Martini, La
 Pittura veneziana del Settecento (Venice, 1964),
 p. 275.

In the Printroom of the Hermitage the sketch was catalogued

by Dobroklonsky under Francesco Guardi, an attribution still accepted

by some critics, but modified to Antonio by Martini and Pignatti.

Here the draughtsman ventured so far in dissolving forms that he

came close to an abstraction of blacks, greys and whites. Thus

a second attending, half-kneeling saint at the left, who faces the

female figure lying on the right, has never been noticed. Dispensing

almost entirely with contour lines, as here, is a manner of drawing

inconceivable on Francesco's part.

No. 85 Fig. 110

EDUCATION OF THE VIRGIN. Circa 1752-1756.
New York, Donald Tapley.

White paper. Red chalk. 409 X 260 mm.

Inscribed da Giambattista Tiepolo at the base.

Exhibitions: Mostra dei Guardi, 1965, no. 8; Disegni di una colle-
zione veneziana del Settecento, Venice: Fondazione
Cini, 1966, no. 107 (Catalogue by Alessandro Bettagno).

Literature: Terisio Pignatti, "Nuovi disegni di figura dei Guardi,"
Critica d'arte, XI (1964), 61, fig. 96; Fernanda de
Maffei, "La questione Guardi: precisazioni e aggiunte,"
in Arte in Europa (Milano, 1966), 855; Terisio Pignatti,
I disegni veneziani del Settecento (Venice, 1966),
p. 153, no. 16; Pignatti 1967, no. I.

This drawing formed part of an eighteenth-century collection not
yet identified as to ownership. On the recto of each drawing in the
collection the artist's name was inscribed by the same hand. So far
none of the inscriptions has been invalidated. (On the collection see
Bettagno's catalogue of 1966.) The present sketch was originally
marked da Giambattista Tiepolo, but the da, though still faintly
legible, had subsequently been almost completely deleted. The draw-
ing is obviously a copy of Tiepolo's famous painting of 1732 made for
the Favà church in Venice. Compositionally the replication is exact.
Antonio's authorship, proposed by Pignatti, appears obvious, though
Fernanda de Maffei favors an attribution to Maulbertsch. It is very
unlikely that a drawing by Maulbertsch would have been included in an
eighteenth-century collection otherwise of Italian works exclusively.
Antonio's activity as copyist is well documented, and this sketch may
have been made for a commissioned painted copy of Tiepolo's famous
altarpiece. But the sketch must have been executed a long time after
Tiepolo's altarpiece, as it shows Antonio's most evolved style. It

is inconceivable to date the drawing circa 1740, as did Pignatti in

linking it to The Martyrdom of Saint Clement in Janos Scholz's col-

lection (No. 43). It is in fact in the very same lovely style as

the Madonna Appearing to Two Saints at the Hermitage (No. 84), and,

even more strikingly, as the Saint Gregory drawing at the Fogg

Museum (No. 86), which are both late works of Antonio's. In all

these drawings the subject is not immediately recognizable because

of a proclivity to visualize abstractly not encountered in the same

degree among any of Antonio's contemporaries.

No. 86 Fig. 111

SAINT GREGORY INVOKING THE VIRGIN AT THE TIME OF THE PEST. Circa
1752-1756.

Cambridge (Massachusetts), The Fogg Museum (1949.96).

Faded grey-bluish paper. Pen and brown wash over red chalk. 546 X
344 mm.

Recto of No. 87.

Inscribed in lower right Sebastiano Ricci.

Exhibitions: Eighteenth-Century Italian Drawings, Wellesley: Jewett
 Art Center, 1960, no. 32 (Catalogue by Janet Cox
 Rearick).

Literature: Morassi, p. 1953, 264, fig. 13; Pignatti 1957, p. 29,
 no. 4; Fernanda de Maffei, "Disegni di Sebastiano Ricci,"
 in Miscellanea Bibliotheca Hertzianae (Munich, 1961),
 pp. 446-449; Terisio Pignatti, "Nuovi disegni di figura
 dei Guardi," Critica d'Arte, XI (1964), 61; Fernanda de
 Maffei, "La questione Guardi: precisazioni e aggiunte,"
 in Arte in Europa (Milano, 1966), pp. 855-856; Pignatti
 1967, no. XXI.

Published by Morassi as a work by Antonio Guardi, this drawing

was later assigned to Sebastiano Ricci by Fernanda de Maffei and to

Francesco by Pignatti. These dissensions with Morassi's view are

understandable: the harsh handling, the excessive coarseness of some pen strokes and the untidy appearance of the whole come at first as a surprise in a drawing by the elder Guardi. But when it is seen side by side with The Education of the Virgin in the Tapley collection (No. 85)--generally accepted as being by Antonio--and with the Madonna Appearing to Two Saints in Leningrad (No. 84), doubts as to its authorship subside. And close stylistic parallels to it are to be found in none of Francesco's graphic works. A puzzling problem remains. The drawing shows the same composition as Sebastiano Ricci's altarpiece of circa 1700 painted for the church of Saint Giustina at Padua (Joachim von Derschau, Sebastiano Ricci [Heidelberg, 1922], fig. 28) except that the standing soldier at the left of the saint is absent from the painting. The sketch on the verso shows the same composition as another of Sebastiano's paintings, The Satyr Family, in the J. P. Durand collection in Geneva, executed at roughly the same time as the Padua altarpiece (Anthony Blunt, Venetian Drawings at Windsor Castle [London, 1957], p. 54, fig. 30). This fact led Fernanda de Maffei logically enough to assign the two sides of the sheet to Sebastiano. But on grounds of style the attribution to Sebastiano is hardly convincing. Besides, the soldiers standing at the right of Saint Gregory in the present drawing have Tiepolesque types hardly to be expected in a work by Ricci of circa 1700. And finally, several authenticated preparatory sketches by Sebastiano for the Durand painting are extant, all identical in style and technique and all dissimilar to the drawing on the verso of the present sheet (Blunt 1957, nos. 275, 276, 277).

No. 87 Fig. 112

SATYR FAMILY. Circa 1752-1756.

Cambridge (Massachusetts), The Fogg Museum (1949.96).

Faded grey-bluish paper. Red chalk. 546 X 344 mm.

Verso of No. 86.

Literature: Fernanda de Maffei, "Disegni di Sebastiano Ricci," in
 Miscellanea Bibliotheca Herzianae (Munich, 1961),
 pp. 446-449; Pignatti 1967, no. XXIv.

This drawing was once pasted (face down) on some mount, appar-
ently to provide support for the drawing on the recto. A layer of
dry glue still covers it, so that the composition is only faintly
visible. Pignatti, who thinks it is by Francesco, associated it with
the study for soldiers' heads at the Horne Museum (FG: No. 34), to
which it relates in technique but hardly in style. Its tonal zones
are rendered with irregular hatchings of greatly varying firmness,
very much as in many of Antonio's other graphic works, such as The
Archangel at Bergamo (No. 63) and The Madonna Appearing to Two Saints
in Leningrad (No. 84). As Antonio altered the composition of the
prototype he used, Sebastiano Ricci's The Centaur Family in the Durand
collection (see No. 86), we may surmise that this was no mere copy
made for its own sake, but a preparation for a projected painting
(cf. Pignatti 1967). It is certainly to be dated with the drawing
on the recto.

No. 88 Fig. 113

THE RIDOTTO. 1754-1758.

Chicago, The Art Institute of Chicago (44.579).

White paper. Pen and brown-greyish wash over black chalk. 295 X
516 mm.

Inscribed Ant.o Guardi on the verso in eighteenth-century handwriting.

Provenance: Gustavo Frizzoni; Paul von Schwabach.

Exhibitions: Venice, Cambridge, Fogg Museum, 1948, no. 41; Eighteenth-
 Century Italian Drawings, Wellesley: Jewett Art Center,
 1960, no. 33, pl. 15 (Catalogue by Janet Cox Rearick);
 Mostra dei Guardi, 1965, no. 41.

Literature: Hermann Voss, "Studien zur venezianischen Vedutenma-
 lerei," Repertorium fur Kunstwissenschaft, XLVII (1926),
 42, fig. 20; J. Byam Shaw, "Some Venetian Draughtsmen of
 the Eighteenth Century," Old Master Drawings, VII (1933),
 47-48; Pallucchini 1943, pp. 15, 37-38; C. O. Schniewind,
 Drawings Old and New (Chicago, 1946), p. 18, no. 29,
 pl. III; Otto Benesch, Venetian Drawings of the Eight-
 eenth Century in America (New York, 1947), pp. 38-39,
 no. 56, fig. 56; Pignatti 1957, p. 29, no. 5; Pignatti
 1967, no. XVI.

This drawing represents the Ridotto di San Moisè or Ridotto

Vecchio, the most notorious gambling salon of the eighteenth century.

It corresponds in every particular to a Guardiesque painting at Ca'

Rezzonico in Venice, one of two famous and controversial companion

pieces which have been discussed in literature for over half a

century--inconclusively (Mostra dei Guardi [Dipinti], 1965, no. 24).

The composition is derived from Pietro Longhi, who produced

several known Ridotto interiors all very similar compositionally.

Fiocco remarked that the Guardiesque Ridotto comes closest to

Longhi's small picture formerly in the Salom collection, of which

Alessandro Longhi made an etching in reverse (Vittorio Moschini,

Francesco Guardi [Milan, 1956], fig. 141). In Pignatti's view it is

Longhi who copied Guardi (Pietro Longhi [Venice, 1968], p. 97; cf.

Fiocco 1923, p. 68, no. 35). This is unlikely: the Guardi were

inveterate borrowers, and other instances of their having taken com-
positions or motives from Longhi are known (Jean Cailleux, "Les
Guardis et Pietro Longhi," in Problemi Guardeschi [Venice, 1967],
pp. 51-54). In publishing the drawing, Hermann Voss attributed it,
along with the corresponding Correr painting, to Antonio Guardi on
the basis of the inscription found on the verso of the sheet, which
he regarded as a signature. Without modifying the attribution, Byam
Shaw pointed out that the inscription could not be autograph in view
of its graphological incompatability with Antonio's authenticated
handwriting as on the sketch February in the Correr Library (No. 91).
The Ridotto painting at the Correr has been the object of consider-
able controversy. On stylistic grounds I believe it to be a work of
collaboration carried out predominantly by Francesco, only the loosely
painted country girl at the right and the harlequin having been con-
tributed by Antonio. Be that as it may, the connected drawing is
certainly by Antonio. The contemporary testimony furnished by the
inscription on the verso provides valuable evidence of Antonio's
authorship (see Chapter III, pp. 120-121). Stylistically, the drawing
does not match Francesco's manner at any period of his life, whereas
it does find counterparts in works conclusively established as
Antonio's, such the signed and dated February at the Correr Library
(No. 91) and the Historical Subject at the Ashmolean Museum (No. 89).
The function of the drawing is not self-evident. In Byam Shaw's
generally accepted view, it is the final preparatory design for the
picture. But the faithful correspondence it bears to the painting
had led Modigliani to observe that it may have been made after the

painting. A certain evenness and monotony in handling suggest
indeed that the artist was concerned with the faithful rendering of
a model, probably to be kept in the workshop as a _ricordo_ or for
future reference.

The Ridotto painting and this drawing are generally considered
to date from the 1750's, which is certainly correct. It has not been
observed that on the evidence of costume a rough _terminus ante quem_
can be established: in Guardi's painting several ladies wear the flat
oval _moretta_, a mask which fell out of fashion before or around 1760.
On the other hand, the depicted scene itself appears to provide a valu-
able _terminus post quem_ of circa 1753. In the innumerable eighteenth-
century versions of the Ridotto--Longhi's, Guardi's or others'--
certain specific episodic figures by no means typical of gambling
salons recur over and again: a country girl with a basket full of
vegetables accompanied by an harlequin, a hunchback with a muff, a
gentleman handing keys to a servant, a lady weaving, and so forth.
This argues a literary source. I suggest _Le Donne Gelose_, a play in
Venetian dialect, forgotten today but enormously popular at the time.
It was written and produced by Pietro Longhi's friend Carlo Goldoni
during the winter 1752-1753. The crucial scene is set in the Ridotto.
Most of Goldoni's protagonists find their counterparts in the Guardi
drawing. It is reasonable to assume that Longhi painted a Ridotto
based on Goldoni's popular play, perhaps even as an illustration of
it, and that thereafter his composition became a convenient model for
his imitators, who included the Guardi.

No. 89 114

HISTORICAL SUBJECT. Circa 1754-1758.
Oxford, Ashmolean Museum (1006).

White paper. Pen and brown wash over black chalk. 500 X 760 mm.

Inscribed Anto.o Guardi in black ink in contemporary handwriting in
lower left and again on the verso.

Provenance: R. Oppenheimer.

Exhibitions: Disegni veneziani di Oxford, Venice: Fondazione Cini,
 1958, no. 109 (Catalogue by K. T. Parker).

Literature: Herman Voss, "Studien zur venezianischen Vedutenmalerei,"
 Repertorium für Kunstwissenschaft, XLVII (1926), 41,
 fig. 19; Byam Shaw 1951, no. 8; Max Goering, "Francesco
 Guardi als Figurenmaler," Zeitschrift für Kunstgeschichte,
 VII (1938), 290; Pignatti 1957, p. 31, no. 20; Antonio
 Morassi, "Antonio Guardi as a Draughtsman," Master Draw-
 ings, VI (1968), 135.

The subject here has been variously--never quite convincingly--

identified. All that can be said with approximate certainty is that

the central figure is a sixteenth-century Venetian grandee--recogniz-

able by the head gear--and the seated Oriental a sultan. A man in

the back holds a sealed writ, probably the Venetian's credentials.

Pending further information, the generic simple title provided by Byam

Shaw is here retained. The drawing has the appearance of being an

independent work. Some critics consider it to belong to the set of

the Fasti Veneziani, which is not very probable in view of the differ-

ences in size, technique and style.

No. 90 Fig. 115

ALLEGORY OF REWARD. 1758-1760.
Vienna, Akademie der Bildenden Künste (2724).

White paper. Pen, brush and brownish wash over traces of black chalk.
566 X 430 mm.

Inscribed in the lower right corner in black ink G. B. Tiepolo over
the previous partly deleted inscription Ant.o Guardi; also F.o Guardi
in front of Tiepolo's name. Inscribed along the borderline of the
drawing at the base soasa doro la fama color bianco il merito verde
e il pano veludo and at the top pano colo di Giulipon.

Literature: Oswald von Kutschera-Woborsky, "Giovanni Battista Tie-
 polos Decke des "Merito" im Palazzo Rezzonico zu Vene-
 dig," Monatshefte für Kunstwissenschaft, IX (1916), 171-
 172; Morassi 1953, p. 263, fig. 15.

This is one of the rare Guardiesque drawings which can be dated

with relative precision. A terminus post quem is provided by the pro-

totype from which it derives: a ceiling fresco by Tiepolo in Ca' Rez-

zonico of circa 1758, two years before Antonio's death (Giulio Loren-

zetti, Ca' Rezzonico, 6th ed. [Venice, 1960], pp. 14-15, fig. 18).

The drawing was published by Kutschera-Woborsky as a preparatory

drawing by Tiepolo for the Rezzonico ceiling. On stylistic grounds

Morassi assigned it to Antonio Guardi. It reproduces the fresco faith-

fully except for a reduction in the number of putti and some rearrange-

ment in the right-hand group. Tiepolo's graphic style, especially his

idiosyncratic handling of the wash, is so obviously reflected in the

Vienna drawing that we may presume that Antonio's immediate model was

not the fresco but Tiepolo's preparatory design.

The drawing, which is not one of Antonio's most engaging works,

gains greatly in interest on account of the inscription which runs

along the borderline. It has not been observed that the handwriting

is unquestionably Antonio's, as a comparison with the inscribed verso

of the Allegory of Martial Virtue clearly indicates (see Chapter III,
pp. 119-120).

This authenticates Antonio's authorship of a datable drawing
and thus merits further scholarly attention.

No. 91 Fig. 116

FEBRUARY. 1760.
Venice, Correr Library (7040).

White paper. Pen and grey wash over black chalk. 285 X 205 mm.

Inscribed febraro at the top in black chalk, and at the bottom in
black ink Antonio Guardi fecit anno 1760.

Provenance: Carrer, Morassi.

Exhibitions: Il Settecento di Venezia, Venice: Palazzo delle Bien-
 nali, 1929, no. 8; Eighteenth-Century Venetian Drawings
 from the Correr Museum, Washington: National Gallery,
 1963-1964, no. 6 (Catalogue by Terisio Pignatti);
 Disegni veneziani del Settecento nel Museo Correr di
 Venezia, Venice: Fondazione Cini, 1964, no. 6 (Cata-
 logue by Terisio Pignatti); Eighteenth-Century Venetian
 Drawings from the Correr Museum, London: The Art
 Council of Great Britain, 1965, no. 4.

Literature: Giuseppo Fiocco, "La pittura veneziana alla Mostra del
 Settecento," Rivista di Venezia, August-September (1929),
 p. 571; Pallucchini 1943, pp. 16, 41; Fernanda de Maffei,
 Gian Antonio Guardi pittore di figura (Verona, 1951),
 p. 55; Byam Shaw 1951, p. 43; Morassi 1953, p. 260;
 Pignatti 1957, pp. 21-22, 31, no. 28, fig. 21.

The inscription febraro suggests that the drawing was made for a
set of twelve depicting the months of the year. February is one of
Antonio's most important drawings, less for its aesthetic appeal than
for the autograph inscription figuring at the bottom (see Chapter III,
p. 120).

B. THE DRAWINGS OF FRANCESCO GUARDI

No. 1 Fig. 117

SAINT LOUIS GONZAGA. Before 1750.

Aalens (Württemburg), Koenig-Fachsenfeld (II-708)

White paper. Pen and brown wash. 221 X 167 mm.

Exhibitions: Unbekannte Handzeichnungen alter Meister, Basel: Kunst-
 halle, 1967, no. 86 (Catalogue by Werner R. Deusch et
 al.).

This little known drawing, exhibited in Basel under the name of

Domenico Tiepolo, is here attributed to Francesco Guardi. It certainly

belongs to an early phase, when Francesco was still delineating his

forms clearly without using shorthand devices and graphic abbreviations.

The langorous pose of the saint and the mystical expression on his

face recall the elder Guardi at first, and are probably due to his

influence, but the earthy cherubs, the heavy ostensory and the ponder-

ous clouds attest the authorship of the realist Francesco.

No. 2 Fig. 118

IMMACOLATA. Before 1750.

Venice, Correr Library (5741).

White paper. Pen and brown wash. 330 X 235 mm.

Inscribed in lower left corner Ant. Piva (?)

Provenance: Molin.

Exhibitions: Dal Ricci al Tiepolo, Venice: Palazzo Ducale, 1969,
 no. 120 (Catalogue by Pietro Zampetti).

Literature: Pallucchini 1943, no. 8; Antonio Morassi, "Settecento
 Inedito," Arte Veneta, III (1949), 83.

An altarpiece showing the same composition and attributed to

Francesco Guardi by Alessandro Morandotti was exhibited in Rome in

1941 (Mostra di Pittura Veneziana del Settecento, Palazzo Massimo,

Rome, no. 78). Pallucchini linked it to the Correr drawing. Sub-
sequently Morassi published a small painted version of the altar-
piece, possibly its modello (Arte Veneta, III [1949], fig. 81).
Francesco's authorship of these three works has never been questioned
in spite of the inscription Ant. Piva found on the drawing, which
could be regarded as a signature. Pallucchini remarked that the
Thieme-Becker does not list any such painter, and Morassi suggested
that Piva may be a collector. The inscription may refer to the
painter Antonio Triva as author of an original that Guardi copied.

Morassi thought that the drawing and the corresponding paint-
ings belonged to Francesco's mature period. Pallucchini dated the
drawing prior to 1760, sensing Antonio's influence in the fluid, easy,
sinuous penwork. However, it certainly preceded the graphic works of
the 1750's, which show a firmer grasp of anatomical structure and pro-
portions and a better command in the handling of the wash, and in
which angular strokes and ragged outlines regularly coexist with fluid
lineaments (cf. Nos. 11, 12, 15, 16).

No. 3 Fig. 119

ALLEGORY OF FAITH. Circa 1750.
Venice, Correr Library (1002)

Buff paper. Pen and brown wash. 210 X 122 mm.

Literature: Michelangelo Muraro, "An Altarpiece and other Figure
 Paintings by Francesco Guardi," The Burlington Magazine,
 C (1958), 8, fig. 14.

The crude rendering of this ungainly allegory and of its com-
panion (No. 4) should perhaps not be viewed, as Muraro suggested it
should, as a deliberate expression of revolt against the academic
style. More likely, the primitive manner of drawing indicates that
Francesco was not yet in full command of draughtsmanship. In style,
most tangibly in the treatment of the faces, the sketch is akin to
the early drawing Lady with a Fan at the Fogg Museum (No. 5), though
it is probably of an even earlier date (cf. Muraro).

No. 4 Fig. 120

ALLEGORY OF HOPE. Circa 1750.
Venice, Correr Library (1003)

Buff paper. Pen and brown wash. 210 X 122 mm.

Literature: Michelangelo Muraro, "An Altarpiece and other Figure
 Paintings by Francesco Guardi," The Burlington Maga-
 zine, C (1958), 8, fig. 16.

See No. 3.

No. 5 Fig. 121

LADY WITH A FAN. Circa 1750.
Cambridge (Massachusetts), Fogg Museum of Art (1932.320).

White paper. Pen and brown wash over traces of pencil. 204 X 97 mm.

Inscribed in dark ink below the skirt <u>Francesco Guardi</u> in later hand-writing.

Provenance: J. C. Robinson; Charles A. Loeser.

Exhibitions: <u>Francesco Guardi</u>, Springfield: Museum of Fine Arts, 1937, no. 30 (Catalogue by John Lee Clarke); <u>Eighteenth-Century Italian Drawings</u>, Wellesley: Wellesley College, Jewett Art Center, 1960, no. 27 (Introduction by Janet Cox Rearick).

Literature: Agnes Mongan and Paul J. Sachs, <u>Drawings in the Fogg Museum of Art</u>, I (Cambridge, 1946), no. 319; Helen Comstock, <u>Eighteenth-Century Italian Figure Drawings at the Fogg Art Museum</u>, <u>The Connoisseur</u>, CXXXV (1955), 278, fig. 7.

This is probably a study for a figure to be inserted in a genre scene. A date has never been proposed. The style of dress worn by the woman makes a date after 1760 very unlikely. On stylistic grounds the work finds its place among Guardi's early drawings and appears to be of the earliest. The lineaments are still tranquil and fluid, but some passages, such as the veil and the lower edge of the skirt, already foreshadow Francesco's angular and spiky linework.

No. 6 Fig. 122

SAINT PHILIP NERI (?) SAYING MASS AND SAINT VINCENT FERRER. Circa
1754-1756.
New York, Metropolitan Museum

White paper. Pen and brown wash. 406 X 717 mm.

On the <u>recto</u> a sketch of the Grand Canal above the Rialto.

Provenance: Mylins, Richter.

Literature: Byam Shaw 1951, no. 9; Denis Mahon, "The Brothers at
the Mostra dei Guardi: Some Impressions of a Neo-
phyte," in <u>Problemi Guardeschi</u> (Venice, 1967), p. 129n.

The figure in the right-hand sketch has been identified as Saint

Vincent Ferrer by Mahon, who also suggested that the priest saying mass

on the other side may be Saint Philip Neri (cf. Byam Shaw). The view

sketched on the <u>recto</u> is one of a rather large group of drawings dat-

ing, as Byam Shaw demonstrated, from circa 1755-1765, when Francesco

was modeling himself on Canaletto. It is reasonable to presume that

<u>recto</u> and <u>verso</u> were executed at about the same time. This assumption

is confirmed by the style. The relatively fluid and tranquil penwork

is indicative of an early period. So is the absence of the familiar

tricks of penmanship and shorthand devices usually associated with

Guardi's mature works.

No. 7 Fig. 123

LADY AT THE SPINET. Circa 1755.
Paris, Louvre (5467).

Blue-grey paper. Pen and brown wash with some body colour. 330 X
254 mm.

Literature: J. Byam Shaw, "Some Venetian Draughtsmen of the Eight-
 eenth Century," Old Master Drawings, VII (1933), 50,
 pl. 58.

This little known sketch and the following one (No. 8) may be

preparatory studies for pendants. The attribution to Francesco Guardi

is due to J. Byam Shaw; both drawings had previously been ascribed to

Domenico Tiepolo. Except that the two ladies are engrossed in differ-

ent occupations, their poses do not differ very much. Each is attended

by the same Negro boy holding a cup of coffee, and both settings--down

to the hanging tassel--are very similar. It is possible that the two

studies derive from the same prototype. The flat hairdo of the lady

in this sketch precludes a date after the 1750's. Stylistically, it

can be grouped with the Lady with the Fan at the Fogg Museum (No. 5)

and with The Charlatan and The Minuet at the Louvre (Nos. 9, 10), which

are among Francesco's earliest known works.

No. 8 Fig. 124

LADY AT HER DRESSING TABLE. Circa 1755.
Paris, Louvre (5468)

Buff paper. Pen and brown wash with some body colour. 313 X 217 mm.

Literature: J. Byam Shaw, "Unpublished Guardi Drawings," The Art
 Quarterly, XVI (1953), 333-334, fig. 2.

 See No. 7.

No. 9 Fig. 125

THE CHARLATAN. 1756-1758.
Paris, Louvre (R. F. 70, 4253).

White paper. Pen and brown wash. 315 X 420 mm.

Literature: J. Byam Shaw, "Some Venetian Draughtsmen of the Eight-
eenth Century," Old Master Drawings, VII (1933), 48,
48n, 49.

This little known drawing and its companion (No. 10) correspond
faithfully to the two controversial Tiepolesque pendants ascribed by
some to Giambattista and by others to Domenico (Eduard Sack, Giambat-
tista and Domenico Tiepolo [Hamburg, 1910], figs. 107, 108). One of
these paintings is dated 1756. Guardi must have sketched his copies
soon afterwards, as the heavy wash he used falls in with his works of
the 1750's.

No. 10 Fig. 126

THE MINUET. 1756-1758.
Paris, Louvre (R. F. 70, 4252)

White paper. Pen and brown and mauvish-grey washes. 307 X 420 mm.

Literature: J. Byam Shaw, "Some Venetian Draughtsmen of the Eight-
eenth Century," Old Master Drawings, VII (1933), 48,
48n, 49.

No. 11 Fig. 127

THE RIDOTTO. Circa 1756-1758.
Leningrad, Hermitage (22136).

White paper. Pen and brown ink over black chalk. 146 X 280 mm.

Inscribed on the mount at the bottom in nineteenth-century (?) hand
Il Ridotto Vecchio and at the lower right Francesco Guardi. Inscribed
on the verso, probably in the author's hand, Fran.co de Guardi.

Provenance: Iussupov.

Exhibitions: Dessins des maîtres anciens, Leningrad: Hermitage, 1927,
 no. 24; Vistavka italianskich risunkov XVII-XVIII vekov,
 Leningrad: Hermitage, 1959, p. 24; Disegni veneti del
 Museo di Leningrado, Venice: Fondazione Cini, 1964,
 no. 74. (Catalogue by Larissa Salmina).

Literature: M. Dobroklonsky, "Die Zeichnungen-Sammlung der Eremitage,"
 Pantheon, II (1928), 477-478; Pallucchini 1943, pp. 37-38;
 M. Dobroklonsky, Risunki italianskoi shkoly XVII-XVIII
 vekov (Leningrad, 1961), pp. 50-51, no. 206.

This sketch was published by Dobroklonsky as a study by Antonio

Guardi for the controversial painting at the Museo Correr, The Ridotto

(Mostra dei Guardi [Dipinti], 1965, no. 24). Five of the figures seen

at the distance through the door and three of those forming the group

at the croupier's table do have counterparts in the Correr painting,

yet such correspondences can be deceptive. The Guardi painted several

versions of the Ridotto, using such Longhiesque motives as the crou-

pier's table repeatedly with only slight alterations. (For examples

of variants see Jean Cailleux, "Les Guardis et Pietro Longhi," in

Problemi Guardeschi, pp. 52-54, Plates 153, 181.) Of all extant

versions, the one to which the present sketch corresponds most closely

is the little known one by Francesco at the Rhode Island School of

Design; there the spatial proportions are different, though, as is the

seated lady's pose. Stylistically the sketch fits well into Francesco's

graphic oeuvre, yet it has never been assigned to him in spite of

attributive inscriptions on both sides of the sheet, of which the one on the back is in all likelihood autograph. The rather tall figures with disproportionately small heads and hats are indicative of an early date--the 1750's--when Francesco was still under the influence of Canaletto.

Pallucchini's suggestion that the drawing was made by Francesco's son Giacomo carries no weight. The Ridotto was suppressed by a decree of the Senate in 1774 (Cesare Biliotti, Il Ridotto [Venice, 1870], p. 14). Giacomo was then ten years old. It is hard to imagine that he later represented a suppressed gambling salon, the more since he is not known to have depicted genre scenes.

No. 12 Fig. 128
IL PARLATORIO. 1756-1758.
Venice, Correr Library.
White paper. Pen and brownish wash over pencil. 180 X 286 mm.
On the verso a group of peasant houses.
Inscribed Guardi in the lower right in eighteenth-century handwriting.
Provenance: Bartolommeo Gamba.
Exhibitions: Mostra dei Guardi, 1965, no. 19.
Literature: Gino Damerini, L'arte di Francesco Guardi (Venice, 1912),
 p. 45, pl. XXXIII; Fiocco 1923, p. 22, no. 33; Ugo Ojetti,
 Il Settecento italiano, I (Milan, 1932), pl. CXXIX; Pal-
 lucchini 1943, no. 33a; Arslan 1944, p. 9n; Terisio
 Pignatti, Il Museo Correr di Venezia (Venice, 1960),
 p. 97.

The drawing has faded and is not easy to read. Damerini and Fiocco assigned it to Francesco Guardi, surmising a possible connection with the painting known as The Parlatorio preserved at the Ca' Rezzonico in Venice (Fiocco 1923, pl. 33). The painting is a typical Guardiesque

pastiche of various motifs taken from Pietro Longhi (Jean Cailleux,

"Les Guardis et Pietro Longhi," in Problemi Guardeschi [Venice, 1966],

p. 54). Pignatti rejected the connection in view of the compositional

disparity. Yet the sketch may plausibly be regarded as an early com-

positional study for the Correr Parlatorio, subsequently reworked and

transformed. The setting is basically the same except that it appears

in reverse in the painting. And the lack of subtlety in the disposi-

tion of the figures is suggestive of an early stage of compositional

elaboration: the poses of the two nuns behind the windows are almost

identical, and the visitors are divided in two similarly structured

groups. Pallucchini suggested a date in the 1740's, as he judged the

"serpentine" and "unsynthetic" linework as indicative of Francesco's

early draughtsmanship. This opinion is difficult to endorse, as no

authenticated drawings by Francesco dating from his early period have

come to light, and the few which may be considered early are more

deliberate in handling than this one. This one was thus probably made

during the 1750's, a date supported by its possible connection with the

Parlatorio painting which belongs to that period (on the dating of

The Parlatorio see AG: No. 88). Moreover, the penwork--fluid in some

passages, angular in others--strikingly recalls some of the drawings

Francesco made after Longhi's Sacraments, which are also generally taken

to belong to the 1750's (cf. Nos. 15, 16).

No. 13 Fig. 129

THE SACRAMENT OF PENANCE. Circa 1756-1758.
Venice, Correr Library (7291).

White paper. Pen and brown wash over traces of black chalk. 311 X
257 mm.

Exhibitions: Konstens Venedig, Stockholm: Nationalmuseum, 1962-1963,
 no. 308; Mostra dei Guardi, 1965, no. 56.

Literature: J. Byam Shaw, "Some Venetian Draughtsmen of the Eighteenth
 Century," Old Master Drawings, VII (1933), 50; Lorenzetti
 1936, p. 77, no. 67; Pallucchini 1943, no. 2; Max Goering,
 Francesco Guardi (Heidelberg, 1944), p. 41; Arslan 1944,
 p. 9n; Pignatti 1967, no. XLI.

This sketch is one of a set of seven large drawings representing

the Holy Sacraments (see also Nos. 14-19). Before Byam Shaw drew atten-

tion to them as works characteristic of Francesco they had been thought

to be by Pietro Longhi, as they correspond to his series of seven small

paintings of the Sacraments preserved in the Querini Stampalia Gallery

(Vittorio Moschini, Pietro Longhi [Milano, 1956], figs. 123-129).

Longhi's series was engraved by Marco Pitteri (Terisio Pignatti, Pietro

Longhi [Venice, 1968], figs. 148a-154a) in the original cast and not in

reverse as is sometimes asserted. When Longhi painted the Sacraments

is not known, but Pitteri engraved them around 1755 (Pignatti, Longhi,

p. 112). It is generally assumed that Francesco used the engravings as

models, and consequently that his drawings are posterior to 1755. Most

likely he did, but it is just possible that he copied Longhi's originals

at a slightly earlier date. He seems to have known Pietro Longhi well

and must have had easy access to his works (on Longhi and Guardi see

Jean Cailleux, "Les Guardis et Pietro Longhi," in Problemi Guardeschi

[Venice, 1967], pp. 51-54). To judge by style, Francesco's drawings

seem to be relatively early works. Pallucchini and Goering thought

they belonged to the sixth decade. Only Pignatti suggested a late

date. In some of these drawings Guardi modified Longhi's composi-
tion slightly: certain secondary figures were eliminated and others
grouped more compactly, and the verticals were further accentuated.
The attribution to Francesco has not gone unquestioned. Arslan and
Ragghianti assigned the series to Antonio. However, the heavy wash
and the tormented, angular linework in some passages find no parallels
in Antonio's graphic oeuvre.

No. 14 Fig. 130

THE SACRAMENT OF EXTREME UNCTION. Circa 1756-1758.
Venice, Correr Library (7292).

White paper. Pen and brown wash over traces of black pencil. 310 X
250 mm.

Literature: J. Byam Shaw, "Some Venetian Draughtsmen of the Eight-
eenth Century," Old Master Drawings, VII (1933), 50;
Lorenzetti 1936, p. 77, no. 70; Pallucchini 1943, no. 3.

See No. 13.

No. 15 Fig. 131

THE SACRAMENT OF ORDINATION. Circa 1756-1758.
Venice, Correr Library (7293).

White paper. Pen and brown wash over traces of black pencil. 313 X
260 mm.

Literature: J. Byam Shaw, "Some Venetian Draughtsmen of the Eight-
eenth Century," Old Master Drawings, VII (1933), 50;
Lorenzetti 1936, p. 77, no. 69; Pallucchini 1943, no. 4.

See No. 13.

No. 16 Fig. 132

THE SACRAMENT OF MATRIMONY. Circa 1756-1758.
Venice, Correr Library (7274).

White paper. Pen and brown wash over traces of black chalk. 313 X
258 mm.

Exhibitions: Eighteenth-century Venetian Drawings from the Correr
 Museum, Washington: The National Gallery, 1963-1964,
 no. 75 (Catalogue by Terisio Pignatti); Disegni veneti
 del Settecento nel Museo Correr di Venezia, Venice:
 Fondazione Cini, 1964, no. 75 (Catalogue by Terisio
 Pignatti); Eighteenth-Century Venetian Drawings from the
 Correr Museum. London: The Art Council of Great
 Britain, 1965, no. 78 (Catalogue by Terisio Pignatti).

Literature: J. Byam Shaw, "Some Venetian Draughtsmen of the Eight-
 eenth Century," Old Master Drawings, VII (1933), 50,
 fig. 5; Lorenzetti 1936, p. 77, nos. 68; Pallucchini
 1943, no. 5; Pignatti 1967, no. XLI.

 See No. 13.

No. 17 Fig. 133

THE SACRAMENT OF BAPTISM. Circa 1756-1758.
Venice, Correr Library (7305).

White paper. Pen and brown wash over traces of black pencil. 310 X
250 mm.

Literature: J. Byam Shaw, "Some Venetian Draughtsmen of the Eight-
 eenth Century," Old Master Drawings, VII (1933), 50;
 Rodolfo Pallucchini, "Giunte al catalogo dei disegni
 di Francesco Guardi del Museo Correr di Venezia,"
 Emporium, XCVII (1943), 50.

 See No. 13.

No. 18 Fig. 134

THE SACRAMENT OF CONFIRMATION. 1756-1758.
Venice, Correr Library (7306).

White paper. Pen and brown wash over traces of black chalk. 310 X
257 mm.

Literature: J. Byam Shaw, "Some Venetian Draughtsmen of the Eight-
eenth Century," Old Master Drawings, VII (1933), 50;
Rodolfo Pallucchini, "Giunte al catalogo dei disegni
di Francesco Guardi del Museo Correr di Venezia,"
Emporium, XCVII (1943), 52.

See No. 13.

No. 19 Fig. 135

THE SACRAMENT OF THE EUCHARIST. Circa 1756-1758.
Venice, Correr Library (7307).

White paper. Pen and brown wash over traces of black chalk. 305 X
260 mm.

Literature: J. Byam Shaw, "Some Venetian Draughtsmen of the Eight-
eenth Century," Old Master Drawings, VII (1933), 50;
Rodolfo Pallucchini, "Giunte al catalogo dei disegni
di Francesco Guardi del Museo Correr di Venezia,"
Emporium, XCVII (1943), 53.

See No. 13.

No. 20 Fig. 136

STANDING FEMALE SAINT. Circa 1756-1758.
Venice, Correr Library (7295).

Grey paper. Pen and brown wash. 162 X 75 mm.

On the verso in black pencil studies for Rococo frames.

Literature: Pallucchini 1943, no. 6a; Ragghianti 1953, 91.

Pallucchini suggested that this sketch could be a study for a

Virgin in a crucifixion scene. In style, technique and expressive-

ness, the figure is very similar to the standing woman on the right

in the Sacrament of Penance (No. 13). The two drawings may have been executed at a close remove in time. Ragghianti thought the drawing too mediocre to be by Francesco.

No. 21 Fig. 137

MERCHANT DISPLAYING FABRICS TO A COUPLE. Circa 1756-1760.
Venice, Correr Library.
White paper. Pen and brown wash. 100 X 200 mm.
On the verso staffage figures.
Provenance: Teodoro Correr.
Literature: Fiocco 1923, p. 66, pl. 17; Pallucchini 1943, no. 23a.

Byam Shaw (1951, pp. 15n, 48) is certainly right in asserting that the macchiette on the verso were drawn by Francesco and not by elusive Nicolò as postulated by Fiocco and Pallucchini. They are of a type found in the early sketches of views of circa 1755-1760. During that period Francesco appears also to have been actively engaged in genre painting in addition to vedutismo. The present sketch showing a scene from everyday life probably dates from the sixth decade, the more since there is no evidence of Francesco's ever having been interested in painting genre scenes thereafter. Both recto and verso drawings are sketched with a small brush alone, a technique rarely used by Francesco. This tends to confirm the chronological coincidence of recto and verso.

No. 22 Fig. 138

BISHOP GIVING ALMS. Circa 1760.
Venice, Correr Library.

Grey paper. Brush and brown wash. 142 X 76 mm.

Literature: Lorenzetti 1936, p. 77, no. 83; Pallucchini 1943, no. 13.

The bishop may be Saint Thomas of Villanova. This is one of a very few drawings delineated entirely with the point of a brush. The figures are set down with an economy of means and sureness of touch suggestive of a long practice in draughtsmanship. Yet the sketch finds its closest parallels in two drawings at the Correr Library of relatively early date, the 1750's: The Grand Canal at the Entrance of the Cannareggio (Byam Shaw 1951, pl. 18) and the Walking Macchiette (Pallucchini 1943, pl. 23b). A date circa 1760 is tentatively suggested.

No. 23 Fig. 139

PIETÀ. Circa 1760.
Venice, Correr Library (1301).

Rough-textured buff paper; perforated for transfer. Pen and brown wash over black chalk. 365 X 280 mm.

Inscribed on the back in ink Guido Re[ni] and underneath in pencil piuttosto Francesco Guardi.

Exhibitions: La peinture italienne au XVIII siècle, Petit-Palais, Paris, 1960-1961, no. 313 (Catalogue by Francesco Valcanover); Mostra dei Guardi, 1965, no. 20.

Literature: Guiseppe Fiocco, "Guardi as Figure Painter," The Burlington Magazine, XLV (1925), 229; Lorenzetti 1936, p. 77, no. 72; Max Goering, "Francesco Guardi als Figurenmaler," Zeitschrift für Kunstgeschichte, VII (1938), 302, 307; Pallucchini 1943, no. 1; Arslan 1944, p. 16; Vittorio Moschini, Francesco Guardi (Milan, 1952), fig. 17; Ragghianti 1953, p. 93, no. 6.

The three-figure group represented in this and in the Bassano

drawing (No. 24) finds its counterpart in an altarpiece discovered by Max Goering which bears Francesco's authentic signature (Fig. 3). This drawing, even though it does not contain the cross in entirety as does the Bassano version, has the appearance of being the final design for the painting; it is far more elaborate throughout, and the central group is more compact.

The drawing seems to have served more than one purpose. The Virgin and Christ are identically replicated in a small devotional picture, previously in the Brandis collection (Fiocco 1923, pl. XLII). In fact the pricking on the drawing does not extend to the figure of Saint John. From this we may presume that the drawing was pricked to be used for the Brandis Pietà, as the latter does not include the apostle either and as the two figures it does include are represented on the same scale as in the drawing.

Goering regarded the Pietà painting and the related drawings as early works, made before 1747; Pallucchini dated them after 1750. The intense expressionism combined with the dramatic play of lights and darks point no doubt to the draughtsman's early maturity, when he was still under the influence of Piazzetta.

No. 24 Fig. 140

PIETÀ. Circa 1760.

Bassano, Museo Civico.

Light grey paper. Pen and brown wash over black chalk. 432 X 298 mm.

Provenance: Giuseppe Riva.

Exhibitions: Il Settecento di Venezia, Venice: Palazzo delle Bien-
 nali, 1939, p. 35, no. 82; Mostra di disegni del Museo
 di Bassano, Venice: Fondazione Cini, 1956, no. 73
 (Catalogue by Licisco Magagnato); Mostra del disegno
 italiano di cinque secoli, Florence: Gabinetto disegni
 e stampe degli Uffizi, 1961, no. 134.

Literature: Vittorio Moschini, "I disegni del '700 alla Mostra di
 Venezia," Dedalo, X (1929-1930), 307; Max Goering,
 "Francesco Guardi als Figurenmaler," Zeitschrift für
 Kunstgeschichte, VII (1938), 289; Vittorio Moschini,
 Francesco Guardi (Milan, 1952), fig. 18; Ragghianti
 1953, p. 93.

In a manuscript inventory of 1855 preserved at the Museum at

Bassano (no. 469), Giuseppe Riva recorded that this sketch was by

Francesco Guardi. As Magagnato observed, this attribution makes of

Riva by half a century the first proponent of Francesco's activity

as painter of histories.

This and another drawing at the Correr Library (No. 23) are

compositional studies for the signed altarpiece formerly in Munich

(Fig. 3). Of the two, the Bassano Pietà is less detailed and may have

been executed first. Ragghianti suggests that it was made at a later

date for a different project.

The clumpy black shadows, which bring the white areas strongly

to the fore, vividly recall Tiepolo's graphic manner. Possibly the

composition itself derives from Tiepolo. A drawing by Tiepolo of

circa 1750, at the Museum in Epinal, comes surprisingly close to

Francesco's (Tiepolo et Guardi dans les collections françaises,

Paris: Galerie Cailleux, 1952, pl. 15). When planning a painting,

Tiepolo frequently drew several slightly differing versions of the
subject in succession. Such a variant of the Epinal drawing may
well have served as model for Francesco's Pietà.

No. 25 Fig. 141
THE ADORATION OF THE SHEPHERDS. Circa 1760.
Chicago, The Art Institute (1961.48).
Faded white paper. Pen and brown wash over red chalk. 383 X 517 mm.
On the verso three sketches of views.
Exhibitions: Master Drawings from the Art Institute of Chicago,
 New York, Wildenstein Gallery, 1963, no. 20.
Literature: Terisio Pignatti, "Nuovi disegni di figura dei Guardi,"
 La Critica d'Arte, XI (1964), 63, 72, fig. 100.

This little-known drawing identified by Harold Joachim of the
Chicago Art Institute was published by Pignatti. The composition
derives from a famous altarpiece of the same subject painted by
Sebastiano Ricci circa 1705 for the Duomo di Saluzzo. A copy of the
altarpiece was in Joseph Smith's collection until 1762. Guardi may
have known Smith's painting, but most likely he used the engraving
Pietro Monaco made of it (Fig. 143) as a model for his composition.
A juxtaposition of prototype and drawing illustrates Guardi's typical
plagiaristic methods and explains the main purpose of the drawing:
compositional simplification. The figures are reduced in number, but
those derived are rendered unaltered and are disposed in a frieze-like
arrangement reducing depth. As in most cases of derivation, the play
of light and shadow has been maintained and the physiognomies coarsened.
The three sketches of views on the verso seem to belong to Francesco's
early phase as vedutista (1755-1765). The present sketch must have
been made at approximately the same period.

No. 26 Fig. 143

YOUNG COUPLE CONVERSING. Circa 1760-1764.
Truro, The Royal Institution of Cornwall (165).

Grey paper, stained. Pen and brown wash over black chalk. 242 X
184 mm.

On the recto the view of the Giudecca with S. Giorgio Maggiore.

Provenance: Alfred de Pass.

Exhibitions: Primitives to Picasso, London: Royal Academy, 1962,
 no. 350 (Catalogue by A. E. Popham); Mostra dei Guardi,
 1965, no. 34.

Literature: George Penrose, Catalogue of Paintings, Drawings and
 Miniatures in the Alfred A. de Pass Collection (Truro,
 1936), no. 165; Antoine Seilern, Italian Paintings and
 Drawings at 56 Princes Gate, London SW 7 (London, 1959),
 p. 96; Pignatti 1967, no. XXIIr.

This sketch forms a compatible group with four other drawings

(Nos. 27-30), each of which represents two young people in a summarily

indicated landscape setting. All five sheets are of a similar format

and of approximately the same size. The series may originally have

consisted of a larger number of sheets. Corresponding painted versions

are not known to exist. Max Goering (Francesco Guardi [Heidelberg,

1944], p. 41), who knew only three pieces of the series (Nos. 27, 29,

30), placed them in the 1740's, judging them in point of style to be

the logical antecedents to the virtuoso Sacraments drawings (Nos. 13-

19) of the following decade. The masterly draughtsmanship and the

extraordinary economy of means with which the figures are rendered

seem to exclude so early a date. The sketch of the Giudecca on the

recto of the present sheet vividly recalls several other studies of

views by Francesco to which Byam Shaw convincingly assigned a date

circa 1755-1765 (Byam Shaw 1951, pp. 20-22). A. E. Popham, who first

published this sheet, dated both sides of it circa 1760. There is no

reason to suspect that recto and verso are not contemporary; the

strongly accentuated shadowing in the figure sketch is well in keep-
ing with other drawings of views from that period (cf. Byam Shaw 1951,
figs. 11, 12, 13, 15, 16). The composition of the drawing derives
from the engraving La Terra made by Giuseppe Wagner after Amigoni
(Gli incisori veneti del Settecento, Venice, 1941, fig. 88). Wagner
came to Venice in 1739, but the date of the engraving is not known.

No. 27 Fig. 144.
TWO DANCING PEASANTS. Circa 1760-1764.
Venice, Correr Library (733).
Grey paper. Pen and brown wash over black chalk. 230 X 174 mm.
Provenance: Teodoro Correr.
Literature: Lorenzetti 1936, p. 78, no. 112; Fiocco 1923, no. 19;
 Pallucchini 1943, no. 21.

See No. 26. This was the first sheet of the Peasants' series
to become known. Its provenance from the estate of Teodoro Correr
gave Lorenzetti a sure clue for attributing it to Francesco Guardi.
Fiocco in publishing it pointed out thematic and stylistic affinities
with the two drawings at Frankfurt (Nos. 29, 30).

No. 28 Fig. 145

TWO DANCING PEASANTS. Circa 1760-1764.
London, Antoine Seilern (134)

Grey paper. Pen and brown wash over black and red chalk. 245 X
175 mm.

On the verso, faintly sketched in black chalk, some sailing boats and
a macchietta wearing a tricorne.

Literature: J. Byam Shaw, "Unpublished Guardi Drawings," The Art
 Quarterly, XVI (1953), 334, fig. 6; Antoine Seilern,
 Italian Paintings and Drawings at 56 Princes Gate
 London SW 7 (London, 1959), no. 134, pl. XCIV.

See No. 26. Byam Shaw first published this drawing. The sailing

boats on the verso are similar to those found on the recto of the Truro

sheet (No. 26).

No. 29 Fig. 146

YOUNG COUPLE CONVERSING. Circa 1760-1764.
Frankfurt-am-Main, Staedelsches Kunstinstitut (13986).

Grey paper. Pen and brown wash over black chalk. 207 X 162 mm.

On the verso in pen and ink a partial view of a town with soldiers on
guard duty.

Literature: Fiocco 1923, no. 20; Antoine Seilern, Italian Paintings
 and Drawings at 56 Princes Gate, London SW 7, London,
 1959, p. 96.

See No. 26. The study on the verso appears to be clearly by

Francesco--though Count Seilern is not of the same view--and in style

it is akin to the early drawings of views.

No. 30 Fig. 147

TWO PEASANTS DRINKING. Circa 1760-1764.
Frankfurt-am-Main, Staedelsches Kunstinstitut (13987).

Grey paper. Pen and brown wash over black chalk. 211 X 165 mm.

Literature: Fiocco 1923, no. 21.

See No. 26.

No. 31 Fig. 148

BUST OF THE VIRGIN. 1760-1770.
Arlesheim (near Basel), J. Zwicky.

Light grey paper. Pen and grey wash. 190 X 145 mm.

Inscribed Guardi in contemporary handwriting in the lower right corner.

Provenance: A. Klein.

Literature: Byam Shaw 1951, no. 4.

At the Mensing Sale in Amsterdam on November 21, 1929 (no. 51),
the drawing was assigned to Antonio Guardi. The Madonna's facial type,
her plain features and her wide brow clearly evidence Francesco's
authorship. So do the short spiky strokes strewn throughout the draw-
ing (see Chapter III, pp. 127-128). The attribution to Francesco was
proposed by Byam Shaw, who published the sketch as a preparatory draw-
ing for the small devotional picture in the Tecchio collection in Milan
(Mostra dei Guardi [Dipinti], 1965, fig. 67). The dates proposed for
the painting range from about 1740 to 1777. Yet the preparatory draw-
ing itself could hardly have been made much before 1765. This emerges
when it is seen juxtaposed with the two earlier sketches at the Metro-
politan Museum (No. 6) dating from the 1750's, works in which Franceco's
graphic idiosyncrasies are not yet apparent, and which display a far
more deliberate handling. A date circa 1760-1770 is proposed here.

No. 32 Fig. 149

SAINT FRANCIS OF PAOLA. 1760-1770.

Venice, Correr Library (1314).

Grey paper. Black chalk. 250 X 198 mm.

On the verso a sketch of Saint Mark's Campanile.

Inscribed in the lower right in brown ink Tiepolo.

Literature: Lorenzetti 1936, p. 78, no. 110; Pallucchini 1943,
 no. 10a; Ragghianti 1953, p. 90.

For Pallucchini, this beautiful half-figure by Francesco is
patterned after Bencovich's Saint Francis in the Albertina, of which
Pitteri made an engraving. Ragghianti attributed the drawing to
Antonio. It is not drawn in Francesco's most familiar idiom, but
the short, nervous strokes and the wave-forming contour lines find
closer parallels in Francesco's than in Antonio's graphic oeuvre.
The architectural study on the verso corroborates Francesco's author-
ship. There is no criterion by which this drawing can be dated, but
I believe that it is a mature rather than an early work.

No. 33 Fig. 150

SAINT THERESA. 1760-1770.

New York, Metropolitan Museum of Art (37-165-77).

White paper. Black chalk. 225 X 400 mm.

On the recto a sketch of gardens.

Inscribed in lower left: Villa del Correr a Fiesso vicino a Strà.

Literature: Michelangelo Muraro, "An Altarpiece and Other Figure
 Paintings by Francesco Guardi," The Burlington Magazine,
 C (1958), 8, fig. 15.

The sharply delineated drawing on the recto which shows through

on the verso represents a garden view from the Correr estate near

Strà. Another drawing representing the same garden is in the Correr

Library (Pallucchini 1943, no. 91). Both belong to Francesco's late

maturity. Most likely the faintly discernible Saint Theresa on the

verso was made at about the same time.

No. 34 Fig. 151

STUDY OF WARRIORS' HEADS. After 1765.
Florence, Fondazione Horne (5653).

Bluish paper. Red chalk. 242 X 204 mm.

On the recto a sketch for a capriccio.

Literature: Licia Ragghianti Collobi, "Disegni di Francesco Guardi
nella Fondazione Horne a Firenze," in Problemi Guar-
deschi (Venice, 1967), p. 182, fig. 209; Pignatti 1967,
no. XXIX.

The sketch on the recto (Mostra dei Guardi, 1965, no. 29),

derived from Canaletto's famous etching Portico con Lanterna, is the

preparatory drawing for Francesco's capriccio at the Verona Museum

(Mostra dei Guardi [Dipinti], 1965, no. 110). Licia Ragghianti

Collobi dates the capriccio sketch and the capriccio painting circa

1745-1755, while Zampetti (1965, p. 214) suggests, more plausibly, a

later date. The style of the present sketch (on the verso) is not

distinctive enough to permit accurate dating, but can be presumed to

belong to the same period as the one on the recto. Pignatti remarked

that three warriors' heads identical with these appear in Tiepolo's

large battle scene painting at the Metropolitan Museum (Antonio

Morassi, A Complete Catalogue of the Paintings of G. B. Tiepolo

[London, 1962], fig. 306). They were presumably Francesco's models.

For Licia Ragghianti-Collobi, Antonio is the likelier author of

this sheet.

No. 35 Fig. 152

SEATED ORIENTAL WITH DOG. After 1765.
New York, Janos Scholz.

Blue-grey paper; perforated for transfer. Pen, brown ink, the shading
done in black chalk heightened in white. 345 X 390 mm.

Exhibitions: Venetian Drawings from the Collection Janos Scholz,
Venice: Fondazione Cini, 1957, no. 96 (Catalogue by
Michelangelo Muraro); The Guardi Family, Houston: The
Museum of Fine Arts, 1958, no. 39 (Introduction by
J. Byam Shaw); Venetian Drawings 1600-1800, Oakland:
Mills College Art Gallery, 1960, no. 37, no. 73 (Intro-
duction by Alfred Neumeyer); Italienische Meister-
zeichnungen vom 14. zum 18. Jahrhundert aus amerika-
nischem Besitz. Die Sammlung Janos Scholz, Hamburg:
Kunsthalle, 1963, no. 73 (Catalogue by Wolf Stubbe).

Literature: Janos Scholz, "Drawings by Francesco and Gianantonio
Guardi," The Art Quarterly, XVII (1954), 385.

In Venice the vogue for orientalia and chinoiserie found expres-
sion mainly in the decoration of furniture. As Janos Scholz observed,
this singular drawing may have been made for transfer by a lacquer
worker on a door or on paneling (the size seems to exclude a commode
or a desk). It provides a further example of Francesco's varied
activity as decorator.

No. 36 Fig. 153

HEAD OF A YOUNG WOMAN. After 1765.
London, Victoria and Albert Museum (D.106-1885)

Recto of AG: No. 59.

White paper. Pen and brown ink. 196 X 318 mm.

Inscribed Salviati at the bottom.

Exhibitions: Canaletto e Guardi, Venice: Fondazione Cini, 1962,
no. 60 (Catalogue by J. Byam Shaw).

Literature: Michelangelo Muraro, "An Unknown Drawing by Francesco
Guardi," The Burlington Magazine, CIV (1962), 304;
Antonio Morassi, "Antonio Guardi as a Draughtsman,"
Master Drawings, VI (1968), 138, pl. 32.

According to Morassi, the original tracings at the bottom formed the word Guardi but were altered to read Salviati.

This expressive sketch has every appearance of having been made from life. Moreover, the sensitive rendering of light playing upon the dark hair conveys the impression that it was drawn in bright sunshine.

Muraro published the sketch as a work by Francesco Guardi. Morassi assigned it to Antonio, linking it to the figure of Saint Catherine in the altarpiece at Cerete Basso (Mostra dei Guardi [Dipinti], 1965, fig. 49. The similarity is not sufficient to warrant Morassi's conclusion that it was made for the altarpiece. The form is enclosed and compact in spite of the free handling, whereas in the painting the saint is an ethereal figure without weight or contours.

Support for an attribution to Antonio can be found--as it was by Morassi--in the sketch on the verso, assigned in this catalogue to Antonio (AG: No. 59). Yet the style of the present sketch appears so typical of Francesco that the original attribution is here maintained, the more since a reed was used, a tool dear to Francesco but apparently never used by Antonio.

No. 37 Fig. 154
PIETÀ. 1765-1770.
London, F. Matthiesen.

Light grey paper. Pen and brown wash over black chalk. 470 X 325 mm.

Exhibitions: European Masters of the Eighteenth Century, London:
 Royal Academy, 1954-1955, no. 592 (Catalogue by J. Byam
 Shaw et al.).

Literature: Byam Shaw 1951, no. 6.

In the London exhibition catalogue (1954-1955) this sketch was
described as "closely connected" with the two preliminary drawings--
respectively at the Correr Library and at Bassano (Nos. 23, 24)--which
Francesco made for his Pietà altarpiece in Munich (Fig. 3). However,
it differs from them in both composition and style and cannot be viewed
with certainty as an alternative solution for the Munich painting.
For Guardi's standards it exhibits a high degree of finish, and it may
have been made as an independent work in itself. I believe it to be
of slightly later date than the Correr and Bassano drawings, in which
the influence of the Baroque tradition is still sensibly felt, though
Byam Shaw judges it to be somewhat earlier. Such typical creations
as the two small dainty angels holding Christ's hands are encountered
relatively late in Francesco's oeuvre, in works such as the Sketch
for a Ceiling Decoration at the Ecole des Beaux-Arts in Paris (No. 42)
and in the sheets relating to it (Nos. 40, 41). Francesco's artistic
evolution seems to have lagged consistently behind his contemporaries.
During the heyday of the Rococo he remained much influenced by the
spirit of the Baroque, and he caught up with the Rococo when it has
already become a thing of the past.

No. 38 Fig. 155

MADONNA OF THE ROSARY. Circa 1768-1770.
Venice, Library Correr (4316).

White paper. Pen, brown ink and grey wash. 188 X 175 mm.

On the verso in another hand the head of a monk and coats of arms
drawn in black chalk.

Provenance: Cigogna.

Exhibitions: Il Settecento di Venezia, Venice: Palazzo delle Bien-
 nali (1929), unnumbered, catalogue p. 35; Eighteenth-
 century Venetian Drawings from the Correr Museum,
 Washington: National Gallery, 1963-1964, no. 76 (Cata-
 logue by Terisio Pignatti); Disegni veneti del Sette-
 cento nel Museo Correr di Venezia, Venice, Fondazione
 Cini, 1964, no. 76. Eighteenth-Century Venetian Draw-
 ings from the Correr Museum, London: The Art Council
 of Great Britain, 1965, no. 79 (Catalogue by Terisio
 Pignatti).

Literature: Giuseppe Fiocco, "La pittura veneziana alla Mostra del
 Settecento," Rivista della Città di Venezia, August-
 September (1929), 572; Lorenzetti 1936, p. 77, no. 78;
 Pallucchini 1943, no. 155a; Byam Shaw 1951, p. 47n;
 Ragghianti 1953, 90; Pignatti 1967, no. XL.

The kneeling figures must be Saint Domenic and Saint Catherine
of Siena. Antonio is generally considered the author of the sketch.
Byam Shaw was the first to advocate Francesco's authorship. His view
was endorsed by Pignatti alone, who judiciously observed that the
figures were drawn somewhat in the manner of Francesco's mature
macchiette. The most telling element for an attribution is the
Christ Child, who is typical of Francesco--muscle-bound and angry-
looking. The Virgin's pose is almost identical to the one on the
processional banner at Budapest though in reverse (The Burlington
Magazine, CX (1968), 60, fig. 1), and the Saint Domenic in the draw-
ing recalls the one on the banner. These correspondences do not prove
that the sketch was made for the banner, which is an early Guardiesque
product. Here again Francesco probably relied on the same model for
works widely separated in time.

No. 39 Fig. 156

PUTTI FLOATING IN THE CLOUDS. Circa 1768-1770.
New York, Janos Scholz.

White paper. Red chalk. 204 X 250 mm.

On the recto a study of sailing boats in pen, brush and brown ink.

Provenance: M. Komor.

Literature: Janos Scholz, "Figure Drawings by the Guardi Brothers,"
 in Problemi Guardeschi (Venice, 1967), pp. 194-195,
 fig. 228.

Janos Scholz published this fragment of a sketch as a possible
first study made for the same ceiling decoration as the more elabor-
ate drawing at Plymouth (No. 41). Scholz described the putti in his
sketch as dropping flowers. Possibly this fits, but the putto on the
left seems to be holding a string. If so, the connection with the
Plymouth sheet is even more obvious, as there the putti play with
birds attached to strings. Scholz dated both sides of this sheet
circa 1775-1780. A slightly earlier date is possible, as the sailing
boats on the recto are drawn in a manner displayed in sheets of
roughly a decade before, such as the sketch of the Grand Canal and
S. Geremia, which can be dated on topographical evidence circa 1762-
1765 (Byam Shaw 1951, no. 19).

No. 40 Fig. 157

SKETCH FOR A CEILING DECORATION WITH FLYING PUTTI. Circa 1768-1770.
Venice, Correr Library (7312).

Rough-textured dark grey paper. Pen and brown ink. 422 X 287 mm.

Exhibitions: Canaletto e Guardi, Venice: Fondazione Cini, 1962,
 no. 107 (Catalogue by J. Byam Shaw).

Literature: Gino Damerini, L'arte de Francesco Guardi (Venice,
 1912), 52, pl. L; Lorenzetti 1936, p. 78, no. 115;
 Pallucchini 1943, no. 60; Ragghianti 1953, p. 91;
 J. Byam Shaw, "A Sketch for a Ceiling by Francesco
 Guardi," The Burlington Magazine, CIV (1962), p. 73.

The oval borderline confining the composition suggests that a
ceiling decoration was intended. This sketch is one of several com-
positional studies all of which represent flying putti playing with
birds (see also 39, 41, 42). Of these the Scholz sketch may be the
earliest (see No. 39). Damerini in publishing the present
crude drawing--the first of the group to become known--assigned it
to Francesco Guardi. The attribution, endorsed by Lorenzetti and
Pallucchini, was rejected by Ragghianti, who judged the sketch to
be too mediocre for Francesco. The original attribution is here
maintained. Cherubs of the same type, with large heads, muscular
limbs and clumsy hands, recur frequently in Francesco's graphic
oeuvre (see Chapter III, pp. 131-132). And the putto in the center as
well as the one in the lower right in this sketch are replicated
exactly in the elaborate Plymouth design--made in connection with
the same decorative scheme--drawn in Francesco's most characteristic
idiom, and accepted by all critics as his (No. 41). According to
Byam Shaw, an unpublished version of the same composition is also
found on the verso of a capriccio study by Francesco, in the Manley
collection in New York, dating from his mature period.

No. 41 Fig. 158

SKETCH FOR A CEILING DECORATION WITH FLYING PUTTI. Circa 1768-1770.
Plymoth, City Museum.

White paper. Pen and water colour over black chalk. 485 X 380 mm.

Provenance: Alfred de Pass.

Exhibitions: Canaletto e Guardi, Venice: Fondazione Cini, 1962,
 no. 106 (Catalogue by J. Byam Shaw); Mostra dei
 Guardi, 1965, no. 33.

Literature: J. Byam Shaw, "A Sketch for a Ceiling by Francesco
 Guardi," The Burlington Magazine, CIV (1962), 73,
 fig. 20; Pignatti 1967, no. XLVIII.

 This is a fragment of what must have been an unusually large
sheet, possibly a presentation piece to be submitted for approval.
The drawing is a more developed version of the rough Correr sketch
(No. 40). The composition has undergone little change, but is here
enclosed within an elaborate framework. The large area taken up by
purely ornamental motifs and the very shape of the ensemble tend to
show that the decoration was to cover the entire ceiling surface and
may have been carried out in fresco. Byam Shaw believes that this
and the other studies connected with the same decorative scheme
(Nos. 40, 42) are late works, certainly after 1760. A date circa
1768-1770 is here proposed.

No. 42 Fig. 159

SKETCH FOR A CEILING DECORATION. Circa 1768-1770.
Paris, Ecole des Beaux-Arts.

White paper. Pen and water colour over black chalk. 270 X 395 mm.

Exhibitions: Mostra dei Guardi, 1965, no. 32.

Literature: Giuseppe Fiocco, "Guardi moderno," Vernice III (1948),
24, fig. 3; Giuseppe Fiocco, "Francesco Guardi pittore
di fiori," Arte Veneta, IV (1950), 82, fig. 84;
K. T. Parker and J. Byam Shaw, Canaletto e Guardi
(Venice, 1962), p. 76. Terisio Pignatti, I disegni
veneziani del Settecento (Venice, 1966), p. 218,
no. 128; Pignatti 1967, no. XLVII.

Thematically and stylistically this drawing relates to the Correr
and Plymouth studies discussed under Nos. 40, 41. It was certainly
made in connection with the same decorative scheme, though not neces-
sarily for the same ceiling. The composition is differently conceived:
it centers in the figure of the protagonist Diana, who does not come
into the other studies; the arrangement of the secondary figures is
also different, as are the frame and, to a lesser degree, the ornamen-
tation. The little sketch in the Scholz collection which represents
the upper part of an oval decoration complements the present drawing
harmoniously, though technically it belongs to a different working
stage. In all likelihood this sheet and the Scholz one refer to the
same ceiling, whereas the Correr and the Plymouth sheets refer to
another one, perhaps in an adjacent room. Byam Shaw placed these ceil-
ing studies in the artist's mature period, at any rate after 1760.
Pignatti advocates a date in the late 1780's because a Diana similar
to the present one is found on a design for a theater curtain which
is dated 1787 (No. 99)--though Francesco may have used the same com-
position at different moments of his career. Tentatively a date circa
1768-1770 is here suggested.

No. 43 Fig. 160
STUDIES FOR A MADONNA AND CHILD. 1770-1780.
Venice, Correr Library.
White paper. Pen and brown wash. 345 X 122 mm.
Literature: Pallucchini 1943, no. 156a.

This is a particularly interesting drawing, as it consists of
three successive compositional studies apparently made for the same
project, a rare instance in Francesco's oeuvre. Except that in the
second version the arm of the Virgin is just slightly more bent, the
composition is repeated three times in unaltered form. The only dif-
ferences lie in the degree of finish. Apparently it is the position
of the Virgin's arm in the second sketch which did not suit Francesco
and let him to return to his first conception for the final version.
Pallucchini assigned these studies to Antonio, though I think that
they are quite representative of Francesco's late maturity.

No. 44 Fig. 164
SAINT THERESA IN ECSTASY. 1770-1780.
Venice, Correr Library.
Rough-textured grey paper. Black pencil. 218 X 164 mm.
Literature: Lorenzetti 1936, p. 77, no. 81; Pallucchini 1943,
 no. 9; Ragghianti 1953, p. 90.

This sketch should be seen side by side with the study of the
Virgin and Child in the upper part of the preceding drawing (No. 43).
That both sketches are by the same hand is clear, and the small
angel's muscular arm in the present sketch is well in keeping with
Francesco's rendering of children's limbs. (see Chapter III, pp. 131-2).
Ragghianti, however, assigned the sheet to Antonio.

No. 45 Fig. 165

THE HOLY FAMILY. 1770-1780.

Berlin, Staatliche Museen, Kupferstichkabinett (9207).

Bluish-grey paper. Pen and brownish ink. 207 X 184 mm.

Inscribed in the lower middle ..t. Guardi.

Exhibitions: Mostra dei Guardi, 1965, no. 37.

Literature: Fiocco 1923, no. 13; Max Goering, Francesco Guardi
 (Vienna, 1944), pp. 17, 77; Vittorio Moschini, Francesco
 Guardi (Milano, 1952), fig. 51; Rodolfo Pallucchini, La
 pittura veneziana del Settecento (Venice, 1960), p. 136;
 Licia Ragghianti-Collobi, "Disegni di Francesco Guardi
 nella Fondazione Horne a Firenze," in Problemi Guardeschi
 (Venice, 1967), p. 185; Denis Mahon, "The Brothers at the
 Mostra dei Guardi: Some Impressions of a Neophyte," in
 Problemi Guardeschi (Venice, 1967), p. 130; Pignatti 1967,
 no. XXXIX.

This drawing is a preparatory study for a small painting preserved
in the Chrysler collection in New York (Mostra dei Guardi [Dipinti],
fig. 127). The figures in the painting appear to be rendered on the
same scale as in the sketch. The composition is based on an etching
by Bartolommeo Biscaino (Ivan Fenyő, "An Unknown Processional Banner
by the Guardi Brothers," The Burlington Magazine, CX [1968], 69n,
fig. 11). In publishing the sketch, Fiocco assigned it to Francesco,
remarking that it was signed F.(co) Guardi. This attribution has
remained unquestioned, although the first name of the presumed signa-
ture has been almost completely erased so that only the third letter
is still clearly recognizable--as a t. The study is not typical of
Francesco, yet it is far more consonant with his drawings than with
Antonio's. Pending further information, the original attribution is
here maintained with a reservation due to the problematical inscription.

It is not easy to date this sheet. Zampetti proposed a date
circa 1777 for the Chrysler painting on the ground of stylistic affini-
ties to the Roncegno altarpiece of that date (Zampetti, 1965, no. 127).

Yet the small Chrysler painting has been so heavily restored that to date it on stylistic considerations alone is hazardous. It is worth noting that a painting in a private collection in France, certainly an early work by Francesco, appears to have been derived from the same etching by Biscaino (Michelangelo Muraro, "An Altarpiece and Other Figure Paintings by Francesco Guardi," The Burlington Magazine, C [1958], fig. 11).

No. 46 Fig. 166
PRAYING VIRGIN. 1770-1780.
London, British Museum.
Blue paper. Black chalk heightened with white. 160 X 130 mm.
Provenance: George Simonson.
Literature: Byam Shaw 1951, no. 5.

In publishing this sketch, Byam Shaw remarked that the Virgin's pose was like the one in a little known picture attributed to Guardi that was formerly at the Minneapolis Institute of Arts (Francesco Guardi, Springfield: Museum of Fine Arts, 1937, fig. 14). The two poses are indeed similar, but not identical. Moreover, the Minneapolis painting with its strong Piazzettesque accents must have been painted at about the same time as the Saint in Ecstasy in Trento (Mostra dei Guardi [Dipinti], 1965, no. 66)--that is, by the mid-1750's--whereas in this sketch the crude linework and the coarse, irregular hatchings clearly evidence a late date. I think that the sketch is associated with another drawing at the Correr Museum which represents the same subject similarly treated (No. 47).

Both obviously belong to the same phase; in both the Virgin is drawn in black chalk heightened in white, a technique rarely used by Francesco; the Virgin's attitude is identical in both, except that it is in reverse; facial expression and features are most akin, down to the flat, rather ugly nose. The two studies must have been made for the same project, and this more crudely executed one must have preceded the Correr version.

No. 47 Fig. 167
PRAYING VIRGIN. 1770-1780.
Venice, Correr Library (6949).
Buff paper. Black chalk heightened in white. 340 X 243 mm.
Literature: Michelangelo Muraro, "Novità su Francesco Guardi," Arte
 Veneta, III (1949), 125, fig. 137; Pignatti 1967,
 No. XIX.

Muraro, who first identified this drawing, described it as "very close" to a small Guardiesque picture at the Museo Civico in Padua (Problemi Guardeschi [Venice, 1967], fig. 111), but the connection seems slight. Nor is it possible to endorse Pignatti's view that the drawing was preparatory for the small painting formerly in Mr. Haberstock's collection (see Fig. 186). It was certainly made for the same project as a drawing in the British Museum (see No. 46), though no corresponding painting is known. On grounds of style alone, both drawings seem to be late works (cf. Pignatti 1967, no. XIX).

No. 48 Fig. 168

THREE HEADS OF CHERUBS. Circa 1775-1778.
Vienna, Albertina (32977).

White paper. Pen and brown ink. 178 X 269 mm.

Provenance: O. Kutschera.

Exhibitions: Disegni veneti dell'Albertina di Vienna, Venice: Fonda-
 zione Cini, 1961, no. 113 (Introduction by Otto Benesch).

Otto Benesch attributed this drawing to Antonio Guardi and linked

it to one at the Correr Library that consists of four similar heads

(Fig. 51). In fact it appears to be just as closely related to two

other studies of cherubs' heads at the Correr Library (Figs. 49, 50).

All four drawings can be assigned to Francesco on solid grounds: see

Nos. 49, 50, 51.

No. 49 Fig. 169

THREE HEADS OF CHERUBS. Circa 1775-1778.
Venice, Library Correr (Album VII, 627).

Recto of No. 50.

Yellowish paper, stained. Pen and brown wash. 305 X 474 at top,
430 at bottom.

Provenance: Teodoro Correr.

Literature: Rodolfo Pallucchini, "Giunte al catalogo dei disegni di
 Francesco Guardi del Museo Correr di Venezia,"
 Emporium, XCVII (1943), 56-57.

In style, technique, and size, these heads are closely akin to

those on the verso of the same sheet (No. 50) and are thus clearly by

the same hand: Francesco's. The group reproduces almost exactly, if

more elaborately, the one on the Albertina sheet (No. 48), which can

therefore be assigned to Francesco as well.

No. 50 Fig. 170

THREE HEADS OF CHERUBS. Circa 1775-1778.
Venice, Correr Library (Album VII, 627).

Verso of No. 49.

Yellowish paper, stained. Pen and brown wash. 305 X 474 at top, 430 at bottom.

Provenance: Teodoro Correr.

Literature: Rodolfo Pallucchini, "Giunte al catalogo dei disegni di Francesco Guardi del Museo Correr di Venezia," Emporium, XCVII (1943), 56-57.

Pallucchini regards these small angels' heads as studies by Francesco for the cherubs on the processional banner at Trieste (Mostra dei Guardi [Dipinti], 1965, pl. 21b), which has never been dated later than 1765. The correspondence is not exact, although the facial types are undeniably similar. On the other hand, the cherub in the center of the drawing finds its exact counterpart in one of the two cherubs in a small unknown painting by Francesco--to all appearances a fragment of an altarpiece--preserved in a private collection in Venice (Fig. 171). Moreover, the cherubs in the fragment are of exactly the same size as those in the drawing. The fragment is certainly posterior to the banner; it should date from the 1770's, as the cherubs on it are painted in the same loose manner as those on the Roncegno altarpiece of 1775-1777 (Mostra dei Guardi [Dipinti], pl. 128). That the drawing also dates from 1770's is most probable, although Francesco could conceivably have made the studies of angels' heads when planning the Trieste processional banner and referred back to them for later works.

No. 51 Fig. 172

FOUR HEADS OF CHERUBS. Circa 1775-1778.
Venice, Correr Library (7303).

Grey paper. Black chalk, pen and brown ink. 268 X 165 mm.

Literature: Rodolfo Pallucchini, Die Zeichnungen des Francesco
 Guardi im Museum Correr zu Venedig (Florence, 1943),
 no. 20.

The cherubs in the upper part of this sketch correspond to the
pair beneath the Virgin in the drawing The Assumption of the Virgin
in Munich (No. 52), while those in the lower part correspond to those
fluttering above Saints Peter and Paul in the altarpiece at Roncegno
(Mostra dei Guardi [Dipinti], 1965, pl. 128). Francesco was commis-
sioned to paint the altarpiece around 1775-1777. The Munich drawing
cannot be dated on external evidence, but stylistically it would seem
to belong to the 1770's. The indication is that the present sketch
was executed during the 1770's as well. Francesco may have received
a commission for an Assumption of the Virgin at about the same time as
the one for the Roncegno piece and have worked on both simultaneously.
The heads in the lower part of the drawing are not of Francesco's
invention, but were derived unaltered from Tiepolo's etching The
Adoration of the Magi in the set Scherzi di Fantasia (Terisio Pignatti,
Le acqueforti dei Tiepolo [Florence, 1965], pl. I).

No. 52 Fig. 173

THE ASSUMPTION OF THE VIRGIN. Circa 1755-1778.
Munich, Eberhard Hanfstaengl.

White paper. Pen and brown wash. 350 X 235 mm.

Provenance: Gritti.

Exhibitions: Canaletto e Guardi, Venice: Fondazione Cini, 1962,
 no. 101 (Catalogue by J. Byam Shaw).

Literature: Morassi 1953, pp. 263, 263n, fig. 8; Terisio Pignatti,
 I disegni veneziani del Settecento (Venice, 1966),
 p. 217, no. 125. Pignatti 1967, no. XXXVIII.

The broad face of the Virgin is of a type which recurs frequently
in Francesco's works (cf. Nos. 8, 20, 31, 37), but which contrasts with
Antonio's oval-shaped dainty female visages. Yet in publishing the
drawing, Antonio Morassi assigned it unhesitatingly to the older Guardi
and linked it as a possible preparatory study to the small painting The
Assumption of the Virgin in the Ambrosiana in Milan, which Pallucchini
believed to be also by Antonio ("Cataloghi," Arte Veneta, V (1951), 195,
fig. 189). The authorship of the Ambrosiana piece is most difficult to
establish, but it is certainly a very early Guardiesque product (1730's),
whereas the drawing is characteristic of Francesco's late maturity.
For the drawing Francesco evidently took up a composition which he or
his brother had already used at a previous date. Byam Shaw, who con-
sidered the drawing to be by Francesco, suggested a date circa 1778-
1780 in view of the similarity between the cherubs in it and those
depicted on the Roncegno altarpiece of about that date. In fact, on
a sheet of studies for cherubs' heads at the Correr Library (No. 51), the
two cherubs in the lower part correspond exactly to those on the
Roncegno altarpiece, whereas the pair in the upper part finds its
counterpart in the present drawing. In view of this fact, this draw-
ing can be conclusively assigned to Francesco and dated circa 1775-1778.

No. 53 Fig. 174

THE ASSUMPTION OF THE VIRGIN. Circa 1775-1778.
Venice, Correr Library.

White paper. Pen and brown ink. 127 X 100 mm.

Literature: Pallucchini 1943, no. 157.

It is surprising for Pallucchini to have assigned this sketch

to Antonio on the basis of the broad and "fat" pen strokes and of the

physiognomy of the Madonna. The Madonna's features are not discern-

ible, and a broad and coarse linework is most untypical of Antonio.

The author is certainly Francesco, who seems here to have been trying

to visualize, somewhat abstractly, the distribution of light and dark

masses. This explains the lack of concern for rendering the subject

in clearly recognizable form.

No. 54 Fig. 175

WOMAN TAMING A LION. After 1775.
New York, Janos Scholz.

Grey paper. Pen and brown ink, faintly heightened with white over
traces of black crayon. 145 X 121 mm.

On the verso architectural study in pen and ink.

Provenance: Henry Oppenheimer.

Exhibitions: Venetian Painting of the Eighteenth-Century, London:
 Burlington Fine Arts Club, 1911, no. 84 (Catalogue by
 C. F. B); Venetian Drawings from the Collection Janos
 Scholz, Venice: Fondazione Cini, 1957, no. 95; The
 Guardi Family, Houston: The Museum of Fine Arts, 1958,
 no. 40 (Introduction by J. Byam Shaw); Venetian Drawings
 1600-1800, Oakland: Mills College Art Gallery, 1960,
 no. 36 (Introduction by Alfred Neumeyer); Mostra dei
 Guardi, 1965, no. 39.

Literature: Detlev von Hadeln, "Some Unpublished Figure Drawings of
 Francesco Guardi," Old Master Drawings, I (1926), 3,
 pl. 3; Pignatti 1967, no. XLIX.

The architectural study on the verso (Mostra dei Guardi,

1965, fig. 39 verso) is so characteristic of Francesco that it

can be considered almost a signature, while the hairdo of the figure

on the recto attests a date posterior to 1775 (see Chapter III,

p. 148).

The sketch is taken by some critics to represent Fortitude.

This is implausible, as Venetian eighteenth-century allegories

were not represented in modern accoutrements. This study was not

likely a study for a staffage figure either. More likely it was

made for a piece of furniture or overdoor decoration. Hadeln

reported that a study similar to the present one--perhaps a com-

panion piece--was formerly also preserved in the Oppenheimer collec-

tion.

No. 55 Fig. 176
LADY STANDING ON A CHAIR. After 1775.
London, British Museum (1909-1-9-3).

Light grey paper. Pen and brown ink. 282 X 144 mm.

Literature: Detlev von Hadeln, "Some Unpublished Figure Drawings
 of Francesco Guardi," Old Master Drawings, I (1926),
 4, pl. 6; Terisio Pignatti, I disegni veneziani del
 Settecento (Venice, 1966), p. 219, no. 130.

The figure may derive from Pietro Longhi. The hairdo of the

woman provides a terminus post quem of circa 1775 (on this, see

Chapter III, p. 148).

No. 56 Fig. 177

STUDY FOR A CEILING. Circa 1776-1780.
Venice, Correr Library (709).

Recto of No. 57.

White paper. Red chalk. 521 X 440 mm.

Literature: Pallucchini 1943, no. 59a; Terisio Pignatti, "Nuovi
disegni di figura dei Guardi," Critica d'Arte, XI
(1964), 61, fig. 99.

The drawing is a study for a ceiling. In the upper half it is
heavily worn, with some passages only faintly discernible. The scheme
is obviously patterned on Tiepolo. The awkward relationship of the
forms to one another and the poor scaling of the figures suggest that
passages from various Tiepolesque sources were assembled.

Pallucchini assigned the drawing to Francesco, Pignatti to
Antonio. Little doubt of Francesco's authorship can remain when the
sketch is viewed side by side with Francesco's datable and documented
The Archangel Michael and with his Standing Saint, both in the Correr
Library (Nos. 73, 74).

No. 57 Fig. 178

SAINT VINCENT FERRER. Circa 1776-1780.
Venice, Correr Library (709).

Verso of No. 56.

White paper. Red chalk. 521 X 440 mm.

Literature: Egidio Martini, La pittura veneziana del Settecento
 (Venice, 1964), pl. 280.

The saint is faintly sketched on a small scale but on a very
large sheet which also includes studies of war trophies, musical
instruments, Rococo decorations and a column. The sheet, neglected
by critics, is a valuable document, as it testifies to Francesco's
varied artistic activities (the recto of the sheet represents a study
for a large ceiling). Though drawn in a different medium, this study
of Saint Vincent is compositionally akin to those of Saint Mark and
Saint John, respectively in Count Seilern's collection and in the
Museum at Copenhagen (Nos. 58, 59). Like the Evangelists, the saint
here is seen as a half-figure, book in hand, with eyes uplifted antic-
ipating inspiration. The lilies identify him as Saint Vincent Ferrer,
yet the plagiarist Guardi, when planning his set of Evangelists, may
have made a quick copy of a Saint Vincent whose posture suited his
purpose and whose identity could easily be transformed. Martini
linked the sketch to a small devotional picture in a private collec-
tion in Venice (Martini 1964, pl. 281) which corresponds to it in all
particulars but which has every appearance of being a modern
imitation.

No. 58 Fig. 179

SAINT MARK. Circa 1776-1780.
London, Count Antoine Seilern (135).

Blue paper, slightly faded. Pen and brown wash over faint traces of
black chalk. 270 X 257 mm.

Provenance: The Archbishop of Belluno; Count Wodinski; Ritchie.

Literature: J. Byam Shaw, "Unpublished Guardi Drawings," The Art
 Quarterly, XVI (1953), 334, fig. 4; A. Seilern,
 Italian Paintings and Drawings at 56 Princes Gates,
 London SW 7 (London, 1959), no. 135.

The attribution of this sketch to Francesco Guardi is due to

its owner and to Byam Shaw. Count Seilern dated it circa 1765-1770,

judging it compatible in style and handling to the Peasant sketches

(Nos. 26-30), which he considered to be of that date. I believe the

Saint Mark to belong to a later phase of Francesco's activity. The

angular and approximate linework brings it closer to the late Lederer

Immacolata (No. 96)--one of Francesco's latest figure drawings--than

to the Peasant series. The style of Saint Mark's companion, the

Saint John at the Copenhagen Museum (No. 59), is indicative of a late

date as well.

No. 59 Fig. 180

SAINT JOHN THE EVANGELIST. Circa 1776-1780.
Copenhagen, The Royal Museum of Fine Arts.

Blue paper, slightly faded. Pen, brush and brown wash. 186 X 149 mm.

Provenance: Gustave Jacquet.

The drawing has been classified at the Copenhagen Museum under
Francesco Guardi. It has never been mentioned in art historical lit-
erature. It is in all likelihood a preliminary study for one of a set
of the Four Evangelists. A sketch in Count Seilern's collection,
representing Saint Mark, was certainly made in connection with the
same scheme. Both saints are drawn on the same scale and on the same
type of paper. In technique and handling they are similar as well:
here and there the contours were overlaid with a succession of short
pointed strokes. It is obviously a late drawing.

No. 60 Fig. 181

SAINT JOHN THE EVANGELIST. Circa 1776-1780.
Venice, Correr Library (7319).

Grey paper. Pen and brown wash. 332 X 246 mm.

Exhibitions: Il Settecento di Venezia, Venice: Palazzo delle Bien-
 nali, 1929, unnumbered (Catalogue, p. 35).

Literature: Giuseppe Fiocco, "La pittura veneziana alla Mostra del
 Settecento," Rivista della Citta di Venezia, August-
 September (1929), p. 78; Ugo Ojetti and Vittorio
 Moschini, Il Settecento Italiano (Milan-Rome, 1932), I,
 fig. 210; Lorenzetti 1936, p. 77, no. 74; Pallucchini
 1943, no. 154; Byam Shaw 1951, p. 15n; Ragghianti 1953,
 p. 93; Pignatti 1957, p. 31; Antoine Seilern, Italian
 Paintings and Drawings at 56 Princes Gate London SW. 7
 (London, 1957), no. 135.

This sketch has been attributed alternatively to Francesco and
to Antonio without ever having been discussed. At present it is

assigned by most critics to Antonio--wrongly, I think. The linework

consists of a multitude of short, brisk, for the most part V-shaped

strokes typical of Francesco's draughtsmanship (cf. the Lederer

Immacolata (No. 96), and the Studies for a Madonna and Child and

the Saint Teresa in Ecstasy (Nos. 43, 44). Count Seilern connected

the sketch with Francesco's drawing of Saint Mark in his own collec-

tion. Like the Seilern sketch of Saint Mark and the Copenhagen sketch

of Saint John (Nos. 58, 59), it must have been made circa 1776-1780

or even later and, to all appearances for a set of paintings repre-

senting the Evangelists, yet certainly for a different set from

those two rather than as an alternative Saint John for the same set,

since it represents the Evangelist as a full figure engaged in writ-

ing and not--as in the two other drawings--a three-quarter figure

awaiting inspiration. In this connection it is worth noting how

similar the right arm and hand of this Saint John are to those of

the Seilern Mark.

Count Seilern records a variant of the present drawing formerly

in the Soldan collection in Berlin, but I could not ascertain its

present whereabouts.

No. 61 Fig. 182

THE HOLY FAMILY. Circa 1776-1780.
Milan, Castello Sforzesco (B 953)

White paper, faded. Pen and brown wash. 243 X 184 mm.

Inscribed in the low left F. Fontebasso.

Exhibitions: Disegni de Settecento nelle collezioni del Museo
d'Arte Antica di Milano, Milan: Castello Sforzesco,
1969, no. 13 (Catalogue by Mercedes Precerutti-
Garberi).

The poor correlation of the figures makes one suspect that
here again Francesco borrowed from different sources. The Virgin
rests peacefully as in an adoration scene, while Saint Joseph strides
as if fleeing into Egypt. A corresponding painting is not known.

The sketch is a mature or late work. The foliage is treated
as in the late capricci sketches (cf. Pallucchini 1943, nos. 118a,
119a, 120, 123a). The same Virgin's head is seen in a late study
sheet in the Springell collection (No. 62).

No. 62 Fig. 183

TWO STUDIES OF THE HEAD OF THE VIRGIN. 1778-1782.
Portinscale, Dr. and Mrs. F. Springell.

White paper. Pen and brown ink. 83 X 152 mm.

Exhibitions: Canaletto e Guardi, Venice: Fondazione Cini, 1962,
no. 58 (Catalogue by J. Byam Shaw).

Literature: J. Byam Shaw, "Unpublished Guardi Drawings," The Art
Quarterly, XVI (1953), 334-335, fig. 5.

The identical format of these contiguous studies suggests at
first that companion pieces were intended, though two Virgins' heads
would hardly make suitable pendants. Janos Scholz suggested that one
of the figures may be a saint, but in that case Francesco omitted

any clue to her identity. More likely the two are

Madonna's heads that were meant respectively for the front and

back sides of a processional banner or a small devotional picture.

A double-sketch identical in style, obviously another study for

the same project, is preserved in the collection of Miss Margaret

Mower (No. 63).

No. 63 Fig. 184
TWO STUDIES OF THE HEAD OF THE VIRGIN. 1778-1783.
Princeton, Margaret Mower.

Recto of No. 71.

White paper. Pen and brown ink. 108 X 169 mm.

Inscribed on the mount in the lower right F. Guardi, probably in
nineteenth-century hand.

Provenance: Alfred de Pass.

This double-sketch and the one in the Springell collection

were obviously made for the same project (see also No. 62).

No. 64 Fig. 185
PRAYING VIRGIN. 1778-1782.
New York, Eugene Thaw.

White paper. Pen and brown ink. 125 X 88 mm.

Provenance: dal Zotto; J. R. Lancaster.

Literature: Janos Scholz, "Figure Drawings by the Guardi Brothers,"
 in Problemi Guardeschi (Venice, 1967), p. 197, fig. 232.

This sketch is the preliminary drawing for the small devotional
picture formerly in the Haberstock collection in Berlin (Fig. 186).
The only difference is that in the drawing the head of the Virgin is
bent slightly more to the right. The uneconomical method of indicat-
ing the tonal zones with crude and tight hatchings, amounting to
scribbles in some passages, was adopted by Francesco during his late
phase, to which this drawing unquestionably belongs. The painted
Haberstock version has always been considered a relatively early work
of the master. Yet the Virgin's clothing is foam-like, very much as
are the draperies in the Roncegno altarpiece of circa 1777--and very
much as those seen in Francesco's earlier pictorial works, such as the
Saint in Ecstasy in Trento (Mostra dei Guardi [Dipinti], 1965, no. 66),
are not. The drawing and the painted version are here dated 1778-
1782.

No. 65 Fig. 187
VIRGIN AND CHILD IN THE CLOUDS. 1778-1782.
Venice, Correr Library. (Album VII, 715).

Dark brown paper, stained. Pen and brown ink. 230 X 195 mm.

Provenance: Molin.

Literature: Michelangelo Muraro, "Novità su Francesco Guardi,"
 Arte Veneta, III (1949), 125, fig. 139.

This is a compositional study probably made for a small devotional picture. It is very similar in style and certainly close in date to the small Madonna in the Thaw collection (No. 64) and to the two Virgin's Heads belonging to Miss Mower (No. 63).

No. 66 Fig. 188
AN ALLEGORY OF MUSIC. After 1778.
U.S.A., Private Collection.
Pen and brown wash. 281 X 215 mm.
Literature: Byam Shaw 1951, no. 7.

The attribution of this drawing to Francesco Guardi is due to Byam Shaw, who judged it to be in the style of a study sheet of putti at the Correr Library (No. 70). Thematically as well as stylistically it can in fact be grouped with five other drawings, four of which are at the Correr Library and one in Margaret Mower's collection, each representing putti holding musical instruments or engaged in music making (Nos. 67-71). No corresponding painted works are known to exist. All six studies were probably made in connection with a commission for the decoration of an interior, probably a music room. The present drawing, including large figures beside putti, is probably the study for the central, or at all odds a prominent, decoration of the room. This and the related drawings are in concordance with Francesco's works of the late 1770's and 1780's.

No. 67 Fig. 189

PUTTI PLAYING MUSICAL INSTRUMENTS. After 1778.
Venice, Correr Library (912-911).

White paper. Pen and brown wash. 120 X 188 mm.

On the recto a sketch of a Venetian courtyard inscribed at the bottom
in Giacomo Guardi's handwriting: Cortile del Loco Pio al ponte del
Noris a S. Canziano.

Provenance: Teodoro Correr.

Literature: Gino Damerini, L'arte di Francesco Guardi (Venice, 1912),
 p. 52, pl. LIa; Pallucchini 1943, no. 68a.

See No. 66. The sketch of a Venetian courtyard on the recto

(Pallucchini 1943, no. 68a) belongs to a group of late drawings of

architectural views and capricci (cf. Pallucchini 1943, nos. 67, 70,

71, 73). The chances are that recto and verso were executed at no

great interval of time, the more since the provenance of the sheet and

the graphic handling of the verso point clearly to a late date.

No. 68 Fig. 190

PUTTO PLAYING THE HARP. After 1778.
Venice, Correr Library (Album XXV, 426).

White paper. Pen and brown ink. 118 X 100 mm.

Provenance: Teodoro Correr.

Literature: R. Pallucchini, "Giunte al catalogo dei disegni di
 Francesco Guardi del Correr," Emporium, XCVII (1943),
 55.

See No. 66. This is slightly more elaborate study of the

figure represented at the right of No. 67.

No. 69 Fig. 191

PUTTO PLAYING THE VIOLA. After 1778.
Venice, Correr Library (Album XXV, 427).

White paper. Pen and brown ink. 118 X 101 mm.

Provenance: Teodoro Correr.

Literature: Rodolfo Pallucchini, "Giunte al catalogo dei disegni di Francesco Guardi al Correr," Emporium, XCVII (1943), 55.

See No. 66. This is a slightly more elaborate study of the figure represented at the left in drawing No. 67.

No. 70 Fig. 192

PUTTI PLAYING MUSICAL INSTRUMENTS. After 1778.
Venice, Correr Library (7313).

White paper. Pen and brown wash. 156 X 220 mm.

On the verso eight sketches of door or wall decorations.

Literature: Pallucchini 1943, no. 61a.

See No. 66. The studies of Rococo motifs at the lower left and those of floral and rocaille decorations enclosed within rectangles on the verso of the same sheet suggest that the putti and instruments were to figure in the center of a lavishly decorated door, overdoor, or wall panel.

No. 71 Fig. 193

PUTTI PLAYING MUSICAL INSTRUMENTS. After 1778.
Princeton, Margaret Mower.

<u>Verso</u> of No. 63.

White paper. Pen and brown ink. 108 X 169 mm.

Provenance: Alfred de Pass.

See No. 66. The sheet has been cut down on all sides. What remains of the original ensemble shows that as in Nos. 66-70 the theme is music, and the performers <u>putti</u>. It must have been made for the same decorative scheme, possibly for a ceiling.

No. 72 Fig. 194

STUDIES OF FEMALE FIGURES. After 1778.
Venice, Library Correr.

White paper. Pen and brown wash. 153 X 272 mm.

Literature: Pallucchini 1943, no. 11.

These studies were probably made in preparation for some decorative work. The author was trying out alternative poses for an allegory or perhaps for a Venus. The sheet probably dates from Francesco's eighth or ninth decade, when he devoted a large part of his activity to decorations.

No. 73 Fig. 195

THE ARCHANGEL MICHAEL. After 1779.
Venice, Correr Library (4620).

White paper. Red chalk. 250 X 212 mm.

Provenance: Teodoro Correr.

Exhibitions: Trésors de l'art vénitien, Lausanne: Musée Cantonal des
Beaux-Arts, 1957, no. 178 (Catalogue by Rodolfo Palluc-
chini); Canaletto e Guardi, Venice: Fondazione Cini,
1962, no. 104; Eighteenth-Century Venetian Drawings from
the Correr Museum, Washington: National Gallery, 1963-
1964, no. 79 (Catalogue by Terisio Pignatti); Disegni
veneti del Settecento nel Museo Correr di Venezia,
Venice: Fondazione Cini, 1964, no. 79 (Catalogue by
Terisio Pignatti); Eighteenth-Century Venetian Drawings
from the Correr Museum, London: The Art Council of
Great Britain, 1965, no. 83 (Catalogue by Terisio
Pignatti); Mostra dei Guardi, 1965, no. 51.

Literature: J. Byam Shaw, "Some Venetian Draughtsmen of the Eight-
eenth Century," Old Master Drawings, VII (1933), 48n;
Lorenzetti 1936, p. 78, no. 107; Pallucchini 1943,
no. 24; Arslan 1944, p. 16; Byam Shaw 1951, pp. 33, 40;
Decio Gioseffi, "Per una datazione tardissima delle
storie di Tobiolo in S. Raffaele di Venezia con una
postilla su Bonifacio Veronese," Emporium, CXXVI (1957),
101, 106, passim; Terisio Pignatti, I disegni veneziani
del Settecento (Venice, 1966), pp. 217-218, no. 126,
fig. 126; Pignatti 1967, no. XLV.

Byam Shaw was the first to notice that this spirited sketch was

drawn on the back of a printed sonnet published in honor of Paolo

Renier's elevation to dogeship in January 1779. The terminus post

quem provided by the broadsheet makes an attribution to Francesco

unimpeachable, yet at first sight the sketch is vividly reminiscent

of Antonio's manner. During his later years Francesco occasionally

drew in chalk very much after his elder brother's fashion of some

decades before. Yet a juxtaposition of the archangel with some of

Antonio's sketches in the same technique, such as the Head of a Magus

(AG: No. 70) brings the brothers' contrasting personalities to the

fore.

The sketch has been and still is considered by several critics to be a study for the archangel in Tobias' wedding scene painted on the famous organ loft in S. Raffaele in Venice (<u>Mostra dei Guardi</u> [<u>Dipinti</u>], 1965, no. 31d), even though the iconographical resemblances do not suffice to warrant the assumption, and even though the Tobias cycle can be dated circa 1750 on documentary evidence (Terisio Pignatti, "I documenti dell'organo dell'Angelo Raffaele," <u>Arte Veneta</u>, IV (1950), 144-145; Roberto Gallo, "Note d'archivio su Francesco Guardi," <u>Arte Veneta</u>, VII [1953], 153). It is not known for what purpose the present drawing was made. Here again the composition was borrowed: it is a faithful copy of Bonifazio de Pitati's <u>The Archangel Michael</u>, located in the church of SS. Giovanni e Paolo in Venice (Gioseffi, 1957, p. 78, fig. 1).

No. 74 Fig. 196

STANDING SAINT. Circa 1780.
Venice, The Correr Library (7304).

Rough-textured white paper. Red chalk. 301 X 155 mm.

Exhibitions: 18e Euwse Venetiaanske Tekeningen, Rotterdam: Museum
 Boymens-van Beuningen, 1964, no. 41 (Catalogue by
 Terisio Pignatti); Mostra dei Guardi, 1965, no. 52.

Literature: Lorenzetti 1936, p. 78, no. 108; Pallucchini 1943,
 no. 25; Arslan 1944, p. 16; Terisio Pignatti, Disegni
 veneti del Settecento nel Museo Correr di Venezia
 (Venice, 1964), p. 59; Egidio Martini, La pittura
 veneziana del Settecento (Venice, 1964), 237, no. 104.

Those who have concerned themselves with this sketch connected
it with the two companion allegories at Sarasota, painted circa 1747,
which are thought to represent Faith and Hope respectively (Mostra
dei Guardi [Dipinti], 1965, nos. 70, 71). The similarity between
the sketch and the paintings lies less in the attitudes of the
figures than in the somewhat clumsy treatment of the draperies,
which seem to defy all laws of gravity. Yet it is not easy to recon-
cile this impressionistic sketch, with its multitude of short strokes
of different firmness, with those drawings of Francesco's which are
roughly contemporary to the Sarasota pieces. Zampetti (Mostra dei
Guardi, 1965, no. 52) sensitively pointed to the stylistic affinity
between the sketch and The Archangel Michael, which is posterior to
1779 (No. 73). The Standing Saint was probably made at about the
same time as the sketch of The Archangel Michael.

No. 75 Fig. 197

FOUR MALE BUSTS. 1780-1785.
Venice, Correr Library (685).

Yellowish paper. Pen and brown wash. 186 X 254 mm.

Inscribed verde, torchin, azuro, laca, rosso in Guardi's hand.

Provenance: Teodoro Correr.

Exhibitions: Eighteenth-Century Venetian Drawings from the Correr
Museum, Washington: National Gallery, 1963-1964, no. 77
(Catalogue by Terisio Pignatti); Disegni veneti del
Settecento nel Museo Correr di Venezia, Venice: Fonda-
zione Cini, 1964, no. 77 (Catalogue by Terisio Pignatti);
Eighteenth-Century Venetian Drawings from the Correr
Museum, London: The Art Council of Great Britain, 1965,
no. 80 (Catalogue by Terisio Pignatti).

Literature: Fiocco 1923, no. 25; J. Byam Shaw, "Some Venetian
Draughtsmen of the Eighteenth-Century," Old Master
Drawings, VII (1933), 51; Lorenzetti 1936, p. 78,
no. 118; Antonio Morassi, "Settecento inedito," Arte
Veneta, III (1949), 80-83, fig. 76; Vittorio Moschini,
Francesco Guardi (Milan, 1952), fig. 59; Pignatti 1967,
no. XLIII.

The Correr Library holds three study sheets--including the

present one--representing six male busts in all (see also Nos. 76,

77). Antonio Morassi discovered a group of small paintings of iden-

tical size--evidently belonging to a set--which correspond to five of

the Correr busts; the painted counterpart to the central figure in

the upper row of the present sketch has not come to light. On grounds

of style, the painted versions are generally considered late works.

This view is corroborated by the fact that all are painted on beech

wood, a type of support of which Guardi made frequent use during the

two last decades of his life but, to my knowledge, never before.

Evidently the Correr studies were late as well.

Fiocco thought that the four heads in the present sketch were

made from life. The seventeenth-century dresses suggest rather that

they were <u>teste di fantasia</u>, the more since the Venetians of Guardi's time wore neither mustaches nor beards.

Before the present drawing itself, the painted version of the head in the upper left was published by George Simonson, who thought it a probable self-portrait of Guardi because of the old inscription on the back <u>Guardi par lui-même</u> (<u>Francesco Guardi</u> [London, 1904], p. 16). That Guardi made a self-portrait during his later years rests on his nephew's testimony. Possibly he did lend his likeness to a <u>testa di fantasia</u> of much younger appearance than his own and patterned on some seventeenth-century model. But that he should have worn mustaches when no one else in Venice did is harder to believe.

No. 76 Fig. 198

MAN IN TURKISH DRESS. 1780-1785.
Venice, Correr Library (1476).

White paper. Pen, brown ink and light grey wash over black chalk.
164 X 124 mm.

Provenance: Molin.

Exhibitions: 18e Eeuwse Venetiaanske Tekeningen, Rotterdam: Museum
 Boymans-Van Beuningen, 1964, no. 39.

Literature: J. Byam Shaw, "Some Venetian Draughtsmen of the Eight-
 eenth Century," Old Master Drawings, VII (1933), 51;
 Pallucchini 1943, no. 29.

Byam Shaw published this drawing as a study for the small pre-

sumed self-portrait previously in George Simonson's collection. It

has a much better claim to be the preparatory drawing for the Bust of

a Turk, one of the set of male busts discovered by Morassi, though in

the painted version a fez has been substituted for the flat headgear

in the sketch (Antonio Morassi, "Settecento inedito," Arte Veneta, III

[1949], fig. 74). The study for the so-called self-portrait is unques-

tionably the study in the upper left row of No. 75.

No. 77 Fig. 199

BUST OF A GENTLEMAN IN SEVENTEENTH-CENTURY DRESS. 1780-1785.
Venice, Correr Library (4022).

White paper, Pen, brown ink and very light grey wash. 162 X 124 mm.

Inscribed F in black chalk in upper left. Inscribed on the verso in
eighteenth-century hand Piero Domenice S, Giacomo con, Don Zuanne,
Don Vincenzo, Giuseppe 5, and in another hand Antifona.

Provenance: Teodoro Correr.

Literature: J. Byam Shaw, "Some Venetian Draughtsmen of the Eight-
 eenth Century," Old Master Drawings, VII (1933), 52,
 52n, fig. 6; Lorenzetti 1936, p. 78, no. 116; Palluc-
 chini 1943, no. 28a.

Byam Shaw published this drawing as a possible portrait made from

life, perhaps of an actor in seventeenth-century costume.

No. 78 Fig. 200

PORTRAIT OF A NOBLEMAN. 1780-1785.
Venice, Correr Library (7290).

Recto of No. 79.

Thin light grey cardboard. Ink and brown wash over black chalk.
268 X 203 mm.

Provenance: Teodoro Correr.

Literature: J. Byam Shaw, "Some Venetian Draughtsmen of the Eight-
 eenth Century," Old Master Drawings, VII (1933), 52-
 53; Lorenzetti 1936, p. 78, no. 111; Arslan 1944,
 p. 9n; Ragghianti 1953, p. 89; Pallucchini 1943,
 no. 27a; Pignatti 1967, no. XVIII.

This sketch, probably based on a sixteenth-century portrait,

must be a preparatory drawing for a testa di fantasia, a genre most

popular among Guardi's Venetian contemporaries. Francesco's author-

ship seems obvious, yet it has not been accepted by all critics (see

Arslan and Ragghianti). Pignatti places the sketch in the 1730's or

1740's. An early date is highly improbable. Such graphic abbrevia-

tions as those seen in the sleeves bespeak long practice in draughts-

manship; the provenance is indicative of a late date; and Francesco

drew with a reed pen, a tool he used frequently during the two last

decades of his life but apparently not before.

No. 79 Fig. 201

SKETCH FOR AN OSTENSORY. 1780-1785.
Venice, Correr Library (7290).

Verso of No. 78.

Thin light grey cardboard. Black chalk heightened with white. 268 X 203 mm.

Provenance: Teodoro Correr.

Literature: J. Byam Shaw, "Some Venetian Draughtsmen of the Eight-
eenth Century," Old Master Drawings, VII (1933), 52-53;
Pallucchini 1943, no. 27b; Ragghianti 1953, 90; Fernanda
de Maffei, Gian Antonio Guardi pittore di figura (Verona,
1951), p. 67, pl. XXXII; Pignatti 1967, no. XVIIv.

The attribution of this sketch remains controversial--understand-

ably. At first sight it brings to mind some of Antonio's impression-

istic chalk studies, such as the Madonna Appearing to Two Saints at

the Hermitage (AG: No. 84). Yet the similarities are superficial.

In this sketch, the dark accents are set down in short incisive

strokes that here and there suggest contours without actually deline-

ating them and that are not at all consonant with Antonio's chalk

drawings, in which contour lines are transcended. This consideration

alone would not suffice to make the attribution convincing were it not

that a little known small group of Francesco's late studies for decor-

ations and views--three of which are preserved at the Correr Library--

is drawn in the same singular manner (Pallucchini 1943, figs. 58a, 65,

141). Pignatti proposed a very early date for this drawing, but the

sophisticated handling indicates an extraordinary command of draughts-

manship not encountered in any of Francesco's early works. The late

sketch on the recto of the same sheet, the provenance of the sheet,

and the above-mentioned small group of similar late studies provide

solid grounds for dating this drawing late as well.

No. 80 Fig. 202

THE HOLY FAMILY. 1780-1790.
Florence, Uffizi (3061/S).

White paper. Pen and brown ink. 190 X 263 mm.

Provenance: Emilio Santarelli.

Exhibitions: Canaletto e Guardi, Venice: Fondazione Cini, 1962,
 no. 55 (Catalogue by J. Byam Shaw); Mostra dei
 Guardi, 1965, no. 50.

Literature: Emilio Santarelli, Catalogo della raccolta di disegni
 autografici antichi e moderni donati dal prof. Emilio
 Santarelli alla R. Galleria di Firenze (Florence, 1870),
 p. 222; Terisio Pignatti, "Canaletto e Guardi at the
 Cini Foundation," Master Drawings, I (1963), 51, 52n.

Emilio Santarelli had catalogued the drawing under School of

Pietro da Cortona. Byam Shaw recognized it as a Guardiesque sketch

and suggested Francesco over Antonio as its likely author. There is

no reason to believe, though Pignatti suggested it, that the drawing

is connected with the painting The Holy Family in Vienna (Otto Benesch,

"Einige unbekannte Werke von Francesco Guardi," Arte Veneta, VIII

[1954], fig. 303). A certain resemblance obtains in the overall

arrangement of the figures, but only the Saint Joseph finds it iden-

tical counterpart in the painting. The Viennese painting is taken to

be by Francesco, but looks rather like an early work of Antonio's,

probably dating from the 1730's, a logical antecedent to the lunettes

at Vigo di Ton painted later in the same decade (Mostra dei Guardi

[Dipinti], 1965, nos. 7, 7a, 9). This drawing is clearly by Francesco.

No precise date has so far been suggested for it, though Pilo linked

it stylistically to the Allegories at Sarasota of circa 1747 (Mostra

dei Guardi [Dipinti], 1965, nos. 70, 71). The coarse, uneconomical

linework, amounting to scribbles in some parts, is characteristic of

Francesco's very late graphic idiom, and the sketch belongs certainly

to the last decade of his activity.

No. 81 Fig. 203

ALLEGORY OF FAITH
Venice, Correr Library (697). 1780-1790.

White paper. Pen and brown wash over black chalk. 177 X 251 mm.

Inscribed on the verso: Misura esatta di questa carta./ Una
vedutina del Sig.r Franco Guardi/ che rappresenti la piazza, e
Procuratie di S. Marco/ una seconda, che rappresenti S. Giorgio/
con fabricbriche [sic], e vista di laguna/ chi le desidera vuol
prezzo discreto,/ e le amerà più di tocco forte, che/ finite. Le
desidera abbondanti/ di figurine piene di tocco.

Provenance: Teodoro Correr.

Literature: Fiocco 1923, no. 16; Lorenzetti 1936, p. 77, no. 75;
 Pallucchini 1943, no. 26a; Egidio Martini, La pittura
 veneziana del Settecento (Venice, 1964), p. 237,
 no. 194, fig. 170.

This sketch comes from Teodoro Correr's collection, a fact
which attests to its authenticity. As Martini pointed out, it is a
faithful copy of the Allegory of Faith which Gaspare Diziani painted
on the ceiling above the main staircase in the Convento dei Gesuiti
in Venice. The fresco, completed in 1748, provides a terminus post
quem, but Guardi must have copied Diziani's composition--possibly from
an engraving--some three decades later. The style of the drawing is
indicative of a late date, as is its provenance.

The inscription on the verso adds interest to the sheet. It
pertains to a commission of two vedute given to Guardi; the unknown
patron requested emphatically that the views be painted in a loose
rather than a finished manner, a proof that patrons had their say in
matters of style.

No. 82 Fig. 204

CHRIST ON THE CROSS.

Venice, Correr Library (7296).

White paper. Pen and brown ink. 212 X 158 mm.

Literature: Lorenzetti 1936, p. 77, no. 80; Pallucchini 1943, no. 7.

Pallucchini thought this sketch to be Francesco's first idea--
subsequently altered--for his devotional picture of Christ on the Cross
and the Virgin (Mostra dei Guardi [Dipinti], 1965, no. 68), and con-
sidered both to date from the 1760's or 1770's. Some ineptitudes in
the painting, especially the poor rendering of the human form, cannot
be reconciled with Pallucchini's dating. The painting belongs to the
master's juvenilia, as Max Goering maintained (Francesco Guardi
[Heidelberg, 1944], p. 18). By contrast, the sketch is a solid
example of the powerful draughtsmanship of Francesco's late maturity.
Stylistically it is most consonant with some sheets which fall
roughly between 1775 and 1790, all characterized by dense, crude
hatchings drawn with a coarse pen, such as the group of studies of
macchiette at the Correr Library (Pallucchini 1943, nos. 37, 38, 39,
52, 53). Presumably the same prototype was used for the figure of
Christ in both the early painting and the late drawing.

No. 83 Fig. 205

PRIEST SAYING MASS AND HOLY FAMILY. 1780-1785.
Berlin, Staatliche Museen, Kupferstichkabinett (13670).

Recto of No. 84.

White paper. Pen and brown ink over traces of red chalk. 146 X
206 mm.

Exhibition: Canaletto e Guardi, Venice: Fondazione Cini, 1962,
 no. 57 (Catalogue by J. Byam Shaw).

This is one of several cases in which Francesco drew two com-
positions side by side of identical format but differing in subject.
Such double sketches look very much like two illustrated pages
of an open prayer book. The probable reason for making two adjoin-
ing sketches was to render them on the same scale. A set of pendants
may have been envisaged, or perhaps a small portable diptych commis-
sioned by some devotee. No date has ever been suggested for this
sheet. It certainly belongs to the group of drawings made in the
1780's. These late pure pen sketches by Francesco were frequently
drawn with a reed or--as in the present instance--with a badly cut
pen, which accounts for the scratchy linework.

No. 84 Fig. 206

DANAE RECEIVING THE GOLDEN SHOWER. 1780-1785.
Berlin, Staatliche Museen, Kupferstichkabinett (13670).

Verso of No. 83.

White paper. Pen and brown ink over red chalk. 146 X 206 mm.

Literature: K. T. Parker and J. Byam Shaw, Canaletto e Guardi
 (Venice, 1962), p. 51, pl. 57 verso.

The sheet has been trimmed down on all sides. What remains
must be the central portion of the original composition. The line-
work is loose and fluid, and thus very different from that found on

the _recto_ of the same sheet, a fact which suggests that the two draw-
ings are widely separated in date. Drastic changes of style are
rarely encountered among Francesco's drawings proximate in time, but
in the present case he may just possibly have absorbed the style of
some prototype he was copying.

No. 85 Fig. 207
MADONNA AND CHILD CROWNED BY ANGELS. 1780-1790.
Venice, Correr Library (7299).
Rough-textured grey paper. Pen and brown ink. 367 X 277 mm.
Literature: Lorenzetti 1936, p. 77, no. 73; Pallucchini 1943,
 no. 12; Ragghianti 1953, p. 91.

This sketch has received little attention from writers on
Guardi drawings: Pallucchini referred to it as a spirited sketch,
and Ragghianti dismissed it as too mediocre to be by Guardi. The
bulging muscles of the small angels' limbs and the broad, coarse
face of the Christ Child unmistakably bear Francesco's stamp. Simi-
larly rendered children's bodies are seen in other drawings by
Francesco, such as the athletic _putti_ in three sketches made for
ceiling decoration (Nos. 40, 41, 42).

No. 86 Fig. 208

SAINT ANTHONY (?) HOLDING THE CHRIST CHILD. 1780-1790.
Venice, Correr Library (7302).

Grey-bluish paper, faded. Pen and brown wash. 163 X 147 mm.

Provenance: Teodoro Correr.

Exhibitions: Mostra dei Guardi, 1965, no. 49.

Literature: Fiocco 1923, no. 12; Lorenzetti 1936, p. 77, no. 77;
 Pallucchini 1943, no. 18; Vittorio Moschini, Francesco
 Guardi (Milan, 1952), fig. 56.

Fiocco took the saint to be Saint Stanislas Kostka and the

sketch became known by that name even though Lorenzetti, in his guide

book of 1936, identified the figure as Saint Anthony, which it prob-

ably is. This sketch is executed in the same technique and on the

same type of paper as another drawing at the Correr that has a similar

composition except that the kneeling friar is in reverse position and

the Eucharist replaces the Christ child (No. 87). The two sketches

may possibly have been made for the same project. Both are late works.

No. 87 Fig. 209

THE VISION OF SAINT ANTHONY. 1780-1790.
Venice, Correr Library (731).

Grey-bluish paper, faded. Pen and brown wash. 262 X 176 mm.

Provenance: Teodoro Correr.

Exhibitions: Eighteenth-Century Venetian Drawings from the Correr
 Museum, Washington: National Gallery, 1963-1964,
 no. 78 (Catalogue by Terisio Pignatti); Disegni veneti
 del Settecento nel Museo Correr di Venezia, Venice:
 Fondazione Cini, 1964, no. 78 (Catalogue by Terisio
 Pignatti); Eighteenth-Century Venetian Drawings from
 the Correr Museum, London: The Art Council of Great
 Britain, 1965, no. 81 (Catalogue by Terisio Pignatti);
 Dal Ricci al Tiepolo, Venice: Palazzo Ducale, 1969,
 no. 122 (Catalogue by Pietro Zampetti).

Literature: Fiocco 1923, no. 14; Lorenzetti 1936, no. 36; Palluc-
 chini 1943, no. 19; Pignatti 1967, no. XLII.

This very late sketch and another similar one at the Correr

Library appear to be preparatory drawings for the same project

(see No. 86). If so, the present version is probably the more

advanced one as the composition is stated in clearer and more

definite terms (see also No. 86).

No. 88 Fig. 210

SAINT NICHOLAS WITH CROZIER, SAINT JOSEPH (?) HOLDING THE CHRIST
CHILD AND STUDIES FOR TWELVE MACCHIETTE. 1780-1790.
Venice, Correr Library (1221).

White paper, faded. Pen and brown ink. 174 X 148 mm.

Provenance: Teodoro Correr.

Exhibitions: Eighteenth-Century Venetian Drawings from the Correr
 Museum, London: The Art Council of Great Britain,
 1965, no. 82 (Catalogue by Terisio Pignatti).

Literature: Fiocco 1923, no. 23; Lorenzetti 1936, p. 77, no. 84;
 Pallucchini 1943, no. 14; Pignatti 1967, no. XLIV.

Only Pignatti has suggested a date for this sketch--sensibly,

a late one. The provenance of the sheet is itself indicative of a

late date (see Chapter III, pp. 146-147) and extravagant hairdo of

the lady-macchietta in the center excludes a date much before the

1780's. The distinctive graphic handling of this sketch, character-

ized by coarse penwork, by crude, zigzag hatchings of different firm-

ness, and by a most allusive rendering of details, is seen in a rela-

tively large number of drawings--in studies of views as well as in

large figure drawings--which have never been considered to form a

consistent, well-defined group of works representative of a specific

period. In fact these designs can all be presumed to date from the
1780's, as those that can be dated accurately fall within that period.
Thus the two study sheets for macchiette at the Horne Foundation and
the capriccio at the Victoria and Albert Museum are datable then on
the evidence of costume (Canaletto e Guardi, Venice, 1962, figs. 89,
90, and Byam Shaw 1951, fig. 60), and the view of Castel Cogolo at
the Correr Library is datable 1782 on a documentary basis (Pallucchini,
no. 88).

Fiocco linked the small figure holding the Christ Child to the
Saint Joseph in the painting at Toledo The Holy Family (Mostra dei
Guardi [Dipinti], 1965, no. 69). The pose of the saint in the paint-
ing is totally different, however, and the problematical painting is
certainly not a late work. Pallucchini judiciously observed that the
standing figure of Saint Nicholas on the left was repeated more
elaborately in another drawing at the Correr (No. 90).

The coexistence on the present study sheet of macchiette and
religious figures all drawn in the same technique and style (and
visibly with the same tool: a very coarse pen or a reed) is blatant
evidence that Francesco practiced view and figure painting simultane-
ously to the end of his life.

No. 89 Fig. 211

SAINT NICHOLAS WITH CROZIER IN AN ATTITUDE OF BENEDICTION. 1780-1790.
Venice, Correr Library (4623).

Light grey paper. Pen and brown ink. 222 X 135 mm.

Provenance: Teodoro Correr.

Exhibitions: Mostra dei Guardi, 1965, no. 22.

Literature: Gino Damerini, L'arte di Francesco Guardi (Venice, 1912),
 pl. XLIX: Fiocco 1923, no. 15; Lorenzetti 1936, p. 77,
 no. 79; Pallucchini 1943, no. 16; Vittorio Moschini,
 Francesco Guardi (Milan, 1952), fig. 57; Rodolfo Palluc-
 chini, La pittura veneziana del Settecento (Venice, 1960),
 pp. 136, 138; Denis Mahon, "The Brothers at the Mostra
 dei Guardi: Some Impressions of a Neophyte," in Prob-
 lemi Guardeschi (Venice, 1967), pp. 112, 113; Licia
 Ragghianti Collobi, "Disegni di Francesco Guardi nella
 Fondazione Horne a Firenze," in Problemi Guardeschi
 (Venice, 1967), p. 182.

This drawing is one of three preparatory studies for a religious
picture (see also Nos. 88, 90). The small figure of Saint Nicholas
sketched on the study sheet discussed previously (No. 88) was certainly
made first. It has the appearance of a primo pensiero. It is not
possible to determine in what order the two larger sketches were then
made. Fiocco correlated this drawing with the figure of Saint
Nicholas in the altarpiece at Vigo di Ton (Mostra dei Guardi [Dipinti],
1965, no. 10) painted shortly before 1740. The Saint Nicholas in the
drawing does not have enough in common--apart from his identity--with
the painted one to warrant the assumption that the drawing was made
for the painting. The drawing was dated circa 1746 by Denis Mahon,
before 1755 by Licia Ragghianti Collobi, and between 1760 and 1765 by
Pallucchini, on the common assumption that it was a preliminary study
for the frontal side of a Guardiesque processional banner at Trieste
which it does indeed resemble (Mostra dei Guardi [Dipinti], 1965,

no. 21a). The Trieste banner is undated and undocumented, but has always convincingly been assigned to the middle years of the century because of its style. For reasons set forth above (see No. 88), I regard the three sketches at the Correr Library as the most typical samples of Francesco's draughtsmanship during the 1780's and therefore hold that this drawing cannot be linked to the Trieste banner in spite of their iconographical resemblances. The Trieste banner, probably painted around 1760, may well have derived from an engraving or drawing which formed part of the bottega's reference material and was used again for a different purpose two or three decades later.

No. 90 Fig. 212

SAINT NICHOLAS WITH CROZIER. 1780-1790.
Venice, Correr Library (7301).

White paper. Pen and brown ink. 186 X 127 mm.

Exhibitions: Mostra dei Guardi, 1965, no. 21.

Literature: Lorenzetti 1936, p. 77, no. 82; Pallucchini 1943, no. 15.

 See No. 89.

No. 91 Fig. 213

SAINT ANTHONY HOLDING THE CHRIST CHILD. 1780-1790.
Venice, The Correr Library (6071).

Recto of No. 92.

Rough paper. Pen and brown wash. 212 X 150 mm.

Literature: Pallucchini 1943, no. 17a; Ragghianti 1953, p. 91.

Pallucchini attributed this sketch to Francesco Guardi,
Ragghianti to Antonio. The authorship of the younger Guardi is
obvious: the sketch is a perfect example of his late graphic
idiom. In style and technique it comes strikingly close to a
large group of capricci-sketches and studies for macchiette
which are unanimously regarded--and in some cases documented--
as belonging to Francesco's latest phase (cf. Pallucchini 1943,
figs. 45, 52, 53, 88, 90).

No. 92 Fig. 214

TWO PUTTI AT THE BASE OF A COLUMN. 1780-1790?
Venice, The Correr Library.

Verso of No. 91.

Coarse grey paper. Red chalk. 212 X 150 mm.

Literature: Pallucchini 1943, no. 17b.

Pallucchini's assignment of this drawing to Francesco Guardi
can only be maintained on the strength of the study drawn on the
other side of the sheet. The chalk used here has smudged all over
the page, so that the work is most difficult to read.

No. 93 Fig. 215

STANDING SAINT ANTHONY HOLDING THE CHRIST CHILD. 1780-1790.
Venice, The Correr Library.

Greyish paper. Pen and brown wash. 140 X 225 mm.

Literature: Michelangelo Muraro, "Novità per Francesco Guardi,"
 Arte Veneta, III (1949), 126, fig. 143.

This sketch has no great aesthetic appeal, a fact which perhaps
accounts for its having been neglected by critics. It is undeniably
by Francesco. This type of child with overdeveloped muscles recurs
frequently in his oeuvre. This sketch certainly belongs to the well-
defined group of "coarse" drawings of the ninth decade of the century.
Stylistically, it finds its closest parallels in another Correr sheet
representing the same saint (No. 91) and in the three studies for a
Saint Nicholas preserved in the same collection (Nos. 88-90). All
these drawings are, like the present sketch, executed in a badly cut
pen, or with a reed, a tool that Francesco seems to have favored in
his later life and that accounts for the crudeness of the linework and
the untidy appearance of the whole drawing.

No. 94 Fig. 216

A LADY WITH A BUNCH OF GRAPES. After 1785.
Venice, Correr Library (Album XXI, 391).

Coarse blue paper. Pen and brown ink. 230 X 190 mm.

Literature: J. Byam Shaw, "Some Venetian Draughtsmen of the Eight-
 eenth Century," Old Master Drawings, VII (1933), 51,
 pl. 31; Ragghianti 1953, p. 91.

This half-length figure and another one at the same Museum
(No. 95) are companion pieces. Byam Shaw thought that originally
they may have belonged to a set representing the five senses, since
a precedent for the representation of Taste as a female figure with
grapes can be seen in a mezzotint of 1739 by A. Vanhaecken after a
drawing by Amigoni. Yet the lady could represent Autumn as well; in
his set The Four Seasons, Francesco Bartolozzi had also rendered
Autumn as a female figure with grapes (Ugo Ojetti, Il Settecento
Italiano I [Milano, 1932], fig. 336). The penwork in this sketch
strikingly recalls Francesco's pure pen drawings of the ninth decade,
such as the Madonna Crowned by Angels (No. 85) and Saint Nicholas with
Crozier (No. 90). And Byam Shaw dated the sheet soundly on the evi-
dence of costume: straw hats à l'anglaise, like the one worn by the
lady here, had become fashionable around 1785. Ragghianti judged
this sketch and its pendant too mediocre to be by Francesco, but he
did not suggest another author.

No. 95 Fig. 217

LADY IN A TURKISH CAP. After 1785.
Venice, Correr Library (Album XXI, 394).

Coarse blue paper. Pen and brown wash. 228 X 182 mm.

Literature: J. Byam Shaw, "Some Venetian Draughtsmen of the Eight-
eenth Century," Old Master Drawings, III (1933), 51,
pl. 32.

See No. 94. Here the female figure is shown in an attitude of
attentive listening, which led Byam Shaw to suggest that she may
stand for the sense of Hearing. Possibly she does, but she could also
represent Spring. Thus Francesco Bartolozzi in his The Four Seasons
represented Spring as a woman--not unlike the one Guardi sketched here
--listening attentively to a bird singing (Ugo Ojetti, Il Settecento
italiano, I [Milan, 1932], fig. 334).

No. 96 Fig. 218

FRAGMENT OF A SKETCH FOR AN IMMACOLATA. After 1785.
Geneva. Erich Lederer.

White paper. Black chalk. 190 X 160 mm.

On the recto a sketch of an architectural capriccio.

Provenance: Marquis de Biron.

Exhibitions: Mostra dei Guardi, 1965, no. 53.

Literature: K. T. Parker and J. Byam Shaw, Canaletto e Guardi
 (Venice, 1962), pp. 60-61.

This fragment of an Immacolata is drawn on the verso of a
capriccio sketch (Canaletto e Guardi, 1962, no. 77). The recto
belongs to a group of stylistically closely related drawings of
architectural capricci, such as the sketches at the Correr Library
(Pallucchini 1943, figs. 144, 115, 116) or those belonging to the
Ashmolean and Victoria and Albert Museums (Byam Shaw 1951, nos. 37,
61). These are all undoubtedly late works, probably from the last
decade of Francesco's activity. A date posterior to 1785 for the
capriccio on the recto of the Immacolata is most probable. We may
reasonably presume that the verso of the sheet belongs to the same
late period, the more since Francesco's bent for short hook-form-
ing strokes--a tendency which increased with the passage of time--
is here indulged to an unprecedented degree.

No. 97 Fig. 219

MADONNA AND CHILD WITH SAINTS. After 1785.
Aix-en-Provence, Musee Granet.

White paper, turned yellow. Pen and brown wash. 254 X 158 mm.

Provenance: A. Pécoul.

Exhibitions: <u>Canaletto e Guardi</u>, Venice: Fondazione Cini, 1962,
 no. 59 (Catalogue by J. Byam Shaw).

 This striking sketch may be a compositional study for an altar-
piece no longer extant or perhaps never executed. Except for the
Madonna and Child, the figures cannot be identified. In publish-
ing the sketch, Byam Shaw pointed to its stylistic affinities with
the <u>Bishop Distributing Alms</u> at the Correr Library (No. 22), yet it
appears rather to belong to a much later period. The very approxi-
mate, slightly unsteady linework combined with the heavy and dark
wash patches are typical of old Guardi's manner. In style, the
drawing finds its closest parallels in two sketches for architec-
tural <u>capricci</u>, dating from the very end of Francesco's life, that
are respectively in the Victoria and Albert Museum (Byam Shaw 1951,
pl. 61) and in the Lederer collection in Geneva (<u>Canaletto e Guardi</u>,
pl. 77).

No. 98 Fig. 220

ALLEGORICAL SCENE WITH SATYRS. 1787.

Venice, Correr Library (6424)

White paper. Pen, brush and brown wash. 470 X 710 mm.

Inscribed on the column at the base pmo Giugno 1787.

Literature: Giuseppe Fiocco, "Francesco Guardi pittore di teatro,"
 Dedalo, XIII (1933), 360-367; Pallucchini 1943, nos. 62,
 63; Arslan 1944, p. 9n; Ragghianti 1953, pp. 87-88.

On June 1, 1787, the architect Pietro Bianchi submitted to Doge

Lodovico Manin a set of plans for a new theater. The project was

never carried out, but the set, still extant, comprises, besides the

actual plans, three drawings which Fiocco and Pallucchini attributed

to Francesco Guardi. Two of these, of no great aesthetic appeal, are

shaped as tondi and figure side by side on the very first page of

Bianchi's set. The subject in the left-hand tondo has not been eluci-

dated. Some allegorical representation of architecture may have been

intended, as the plan of construction at the right and the compass

held by the satyr child suggest. The allegory and the satyr in the

center bring to mind similar figures encountered in Tiepolo's etchings

Scherzi di Fantasia, which may have inspired Francesco. It is quite

unlikely that Francesco's son should have executed this tondo as

Arslan suggested. Young Giacomo could hardly have been entrusted

with an important frontispiece drawing when his father was still

alive. Besides, he did not draw "histories." The right-hand tondo

represents the projected theater in its natural setting (roughly the

site of today's Capitaneria di Porto). The pedestrian treatment of

the view led Ragghianti to ascribe it, together with its pendant, to

a bad imitator of Guardi, even though Fiocco had pointed out that the

view finds its full counterpart, including the never-to-be theater,

in a drawing that Francesco made for the engraver, which is also dated
1787, is inscribed F. G. pinxit and bears a dedication to Manin
(Fiocco 1933, p. 360). Lastly, a sketch unmistakably by Francesco
provides conclusive evidence as to authorship. It represents the pro-
jected theater alone, exactly as it appears in the frontispiece draw-
ing, and is evidently a study made for it (J. Byam Shaw, "Un altro
disegno del Guardi per il Teatro Manin," Arte Veneta, V [1951], 151).

No. 99 Fig. 221
DECORATION FOR A THEATER CURTAIN. 1787.
Venice, Library Correr (6424).

White paper. Pen and brown wash. 470 X 710 mm.

Exhibitions: Mostra dei Guardi, 1965, no. 68.

Literature: Giuseppe Fiocco, "Francesco Guardi, pittore di teatro,"
 Dedalo, XIII (1933), p. 367; Pallucchini 1943, no. 64;
 Rodolfo Pallucchini, "Nota per Giacomo Guardi," Arte
 Veneta, III (1949), 131.

This sheet formed part of the album presented by Pietro Bianchi
to Doge Manin in 1787 (see also No. 98). Only the central portion of
the design (the actual decoration for the curtain) is by Francesco.
It shows Diana seated in a chariot drawn by eagles; putti flutter
around her amidst clouds. Several of the figures have exact ante-
cedents in two drawings Francesco made for ceiling decorations at a
previous date: Diana and the putto at her right replicate the central
group in the drawing at the Ecole des Beaux-Arts in Paris (No. 42),
and the putto holding a bird by a string replicates the one in the
upper part of the study of flying putti at the Correr Library (No. 40).

No. 100 Fig. 222

HEAD OF THE VIRGIN. Circa 1788-1790.
Venice, The Correr Library.

White paper. Pen and brown ink. 136 X 169 mm.

On the recto two small studies for architectural capricci.

Provenance: Teodoro Correr.

Literature: Pallucchini 1943, no. 151b.

No date has ever been proposed for this sketch. The studies on
the recto can be grouped with a relatively large number of landscape
and view studies which certainly belong to Francesco's latest period
(Pallucchini 1943, nos. 140, 142, 143, 148 et al.). The Madonna
seems to have been drawn with the same coarse pen as the capriccio on
the recto and hence presumably at the same time.

C. DRAWINGS WRONGLY ATTRIBUTED TO THE GUARDI

No. 1 Fig. 223

THE RAPE OF EUROPA.
Kansas City, Nelson Gallery and Atkins Museum.

White paper. Pen and grey wash over lead pencil. 243 X 330 mm.

On the verso a study for an over-door decoration with a scene from Roman history.

Provenance: Coccoli; Janos Scholz.

Exhibitions: Venetian Drawings 1600-1800, Oakland: Mills College Art Gallery, 1960, no. 42.

Literature: Giuseppo Fiocco, "Il problema di Francesco Guardi," Arte Veneta, VI (1952), 106, fig. 102; Pignatti 1957, p. 29, no. 3.

Seen among Antonio Guardi's graphic works, this sketch would not jar and it has been attributed to Antonio by Fiocco, Pignatti and Scholz successively. Yet it does not find a single close parallel among Antonio's drawings. The small angels with dragon-fly wings and the staccato angularity of the linework point to Gaspare Diziani's circle, even to the Bellunese master directly (cf. the drawings by Diziani, especially nos. 72, 83 in Disegni veneti del Museo di Budapest, Venice: Fondazione Cini, 1965).

No. 2 Fig. 224

BUST OF A YOUNG BOY
New York, Janos Scholz.

Buff paper. Black and red chalks. 179 X 125 mm.

Provenance: House of Savoia and Aosta.

Exhibitions: Italian Drawings from the Collection of Janos Scholz,
Hagerstown: Washington County Museum of Fine Arts,
1960; Venetian Drawings 1600-1800, Oakland: Mills
College Art Gallery, 1960, no. 43; Italian Drawings
from the Collection of Janos Scholz, Staten Island:
Staten Island Institute of Arts and Sciences, 1961;
Italienische Meisterzeichnungen vom 14. bis zum 18.
Jahrhundert aus amerikanischem Beistz. Die Sammlung
Janos Scholz, Hamburg: Kunsthalle, 1963, no. 76.

Literature: Janos Scholz, "Figure Drawings by the Guardi Brothers,"
in Problemi Guardeschi (Venice, 1967), pp. 196-197.

This charming little portrait has been assigned to Francesco
Guardi by its owner, Janos Scholz, who sees "obvious parallels" to
it in the Praying Virgin at the British Museum (No. 46) and in the
Saint Francis of Paola at the Correr Library (No. 32). The parallels
are not close enough to make the attribution convincing. Besides, no
instance is known of Francesco's having combined chalks of different
colours in a drawing. Perhaps the author of the sketch is Sebastiano
Ricci, who drew heads during the 1720's somewhat in the manner of
Watteau and similar to this one. (Some of these are reproduced and
discussed in Anthony Blunt and Edward Croft-Murray, Venetian Draw-
ings. . . at Windsor Castle [London, 1957], pp. 61-63).

APPENDIX

REFERENCES TO ANTONIO GUARDI IN

MARSHAL VON DER SCHULENBURG'S

LIBRI-CASSA, 1730-1746

Date	Entries	Libro-cassa Number or Designation	Foglio
1730, 4 Maggio	Contati p ord^ne di S.E. al Pittor Guardi cecch^no uno.	No. 29	14
1731, 6 Gennaro	Contati al Pittor Guardi lire vinti sette al Solito	No. 45	17
1731, 3 Febraro	Contati al Pittor Guardi cecchino uno lire cinque	No. 45	27
1731, 3 Marzo	Contati al Pittor Guardi lire vinti sette	No. 45	37
1731, 6 Aprile	Contati al Pittor Guardi lire vinti sette	No. 45	47
1731, 9 Maggio	Contati al pittor Guardi lire vinti sette giusto la sua ricevuta in filza	No. 45	57
1733, 26 Gennaro	Contati al Pittor Guardi il suo deputato per il corrente con lire vinti sette	No. 51	120
1733, 2 Febraro	Contati al Pittor Guardi lire vinti sette giusto sua ricevuta in filza	No. 51	128
1733, 4 Marzo	Contati al Pittor Guardi p il mese corr^te lire vinti sette	No. 51	146

Date	Entries	Libro-cassa Number or Designation	Foglio
1733, 25 April	Contati al Pittor Guardi sua Mesata con lire vinti sette giusto sua ricevuta in filza	No. 51	158
1733, 3 Maggio	Contati al Pittor Guardi la sua mesata con lire vinti sette giusto la sua ricevuta in filza	No. 51	172
1733, 2 Giugno	Contati al Pittor Guardi la sua mesata con cecchino uno lire cinque giusto la sua ricevuta in filza	No. 51	182
1733, 8 Luglio	Contati al Pittor Guardi la sua mesata con lire vinti sette	No. 51	194
1733, 4 Agosto	Contati al Pittor Guardi la sua me mesata con lire vinti sette	No. 51	202
1733, 12 Settembre	Contati al pittor Guardi per sua mesata lire vinti sette	No. 51	212
1733, 28 Settembre	Contati al Pittor Guardi per ordne di S.E. per tella e per colori lire 36 in tutto cecchni tre lire due	No. 51	218
1733, 4 Ottobre	Contati al Pittor Guardi la sua mesata con lire vinti sette	No. 51	224
1733, 4 Ottobre	Contati al medo Pittore Guardi lire sessanta due per vito a due lire al giorno per copiare un quadro a S. Giorgi	No. 51	224
1733, 3 Novembre	Al Pittor Guardi la sua mesata lire vinti sette	No. 51	236

Date	Entries	Libro-cassa Number or Designation	Foglio
1733, 3 Novembre	Contati al Pittor Guardi per vito per far il quadro per S.E. lire sessanta due giusto L'ordine in filza	No. 51	238
1733, 4 Decembre	Al Pittor Guardi la sua mesata del corrte con lire vinti sette	No. 51	252
1733, 4 Decembre	Contati al Pittor Guardi lire sessanta due per vito per un quadro che va facendo per S.E.	No. 51	252
1734, 3 Gennaro	Contati al Pittor Guardi la sua mesata lire vinti sette	No. 51	270
1734, 4 Gennaro	Contati al Pittor Guardi l'ultima rata del vito per il quadro che va facendo per S.E. e cioè per ordine di S.E. cecchni due lire dieci otto	No. 51	270
1734, 10 Gennaro	Contati al Pittor Guardi per saldo del quadro p ordine di S.E. cecchni due	No. 51	274
1736, 30 Gennaro	Contati al Pittor Guardi per la copia del Paulo Veronese di S. Gorgi giusta la sua ricevuta cecchni due	No. 57	11
1736, 4 Marzo	Contati al Sigr Guardi Pittore per il mese di Marzo sin li 15 inclusive cecchni uno lire otto	No. 57	25
1736, 31 Marzo	Contati al Pittor Ant Guardi p saldo del presente mese cecchni uno lire dieci	No. 57	29

Date	Entries	Libro-cassa Number or Designation	Foglio
1736, 15 Maggio	Contati al Pittor Guardi p saldo del mese d'April e Mag a lire due al di cecchino uno lire dieci nove	No. 57	51
1736, 3 Giugno	Contati al Sig^r Antonio Guardi la sua mesata del $corr^{te}$ mese con lire sessanta giusta ricevuta	No. 57	61
1737, 20 Agosto	Contati al Sig^r Ant^o Guardi $cecch^{ni}$ due p quatro copie del ritratto di S.E. giusto la ricevuta in libro	No. 57	183
1738, 2 Marzo	Contati al Sig^r Guardi Pittor p due copie di ritratti di S.E. giusto ricevuta in libro $cecch^{no}$ uno	No. 61	16
1738, 2 Aprile	Contati p due copie del ritratto di S.E. al Sig^r Guardi $cecch^{no}$ uno giusta sua ricevuta	No. 61	24
1738, 28 Maggio	Contati p la copia del Ritratto della Sig^r Rosalba del figlio del Pretendente, al Sig^r Ant^o Guardi lire sedeci	No. 61	40
1738, 6 Luglio	Contati al Sig^r Guardi p copie del Ritratto di S.E. $cecch^{ni}$ uno lire undeci giusto ricevuta in libro	No. 61	56
1738, 11 Luglio	Simile ad Antonio Guardi a conto della Palla p chiesa di Doliz $cecch^{ni}$ quatro	No. 61	58

Date	Entries	Libro-cassa Number or Designation	Foglio
1738, 1 Settembre	Contati al Sig^r Antonio Guardi p la copia d'una cena del Sebastiano Rizzi destinata per la chiesa di Doehliz cecch^ni quatro	No. 61	76
1738, 13 Novembre	Contati al Sig^r Anto^o Guardi p ordine di S.E. a conto delle spese del quadro di Titian S. Gio: Battista che egli copia cecch^ni due giusto ricevuta in Libro	No. 61	96
1738, 24 Decembre	Simile al Sig^r Ant^o Guardi a conto della copia del S. Gio. Batt^a di Titian giusto ricevuta in Libro cecch^ni due	No. 61	108
1739, 12 Febraro	Contati al Sig^r Gio: Antonio Guardi p saldo della copia che ha fatto d'un quadro rappresenta S. Gio: Batt^a cecchni^ni quatro giusto ricevuta in Libro	No. 61	126
1739, 25 Febraro	Simile al Sig^r Ant^o Guardi cecchni^ni quatro e questi a conto de due figure del Tintoretto che gli deve copiar, giusto ricevuta in libro	No. 61	128
1739, 17 Marzo	P simile al Sig^r Ant^o Guardi a conto della copia del ritratto di S.E. da farsi, e spedirsi al Sig^r Co: Georg Lud^o d'Oeynhausen cecch^no uno e mezzo giusto ricevuta in Libro	No. 61	139

Date	Entries	Libro-cassa Number or Designation	Foglio
1739, 26 Marzo	Simile al Sig^r Ant^o Guardi p compimento della copia del Ritratto di S.E. p il Conte d'Oeynhausen ce $cecch^{no}$ uno e piu $cecch^{ni}$ due a conto del altro ritratto a quadro che va copiando giusto ricevuta in Libro	No. 61	140
1739, 13 Luglio	Simile al Sig^r Ant^o Guardi p saldo di due figure o quadri la temperanza e la fortezza copie d'originali del Tintoretto $Cecch^{ni}$ tre giusto ricevuta in Lib^o	No. 61	174
1739, 21 Luglio	Simile al Sig^r Guardi Pittor a conto della copia che va facendo della Nativita del nostro Signore del Bassano $cecch^{ni}$ quattro giusto ricevuta in Lib^o	No. 61	176
1739, 30 Settembre	Simile al Pittor Guardi a conto del quadro la Nativita del Bassan che copia $cecch^{ni}$ due giusto ricevuta in Lib^o	No. 61	196
1739, 25 Ottobre	Contati al Sig^r Ant^o Guardi Pittor per la copia fatta da esso della Nativita del Bassan giusto ricevuta in Lib^o $cecch^{ni}$ due	No. 61	204
1739, 15 Novembre	Simile al Sig^r Pittor Guardi p prezzo di tre quadri cioe due teste ed una cazziatori giusto ricevuta in filze $cecch^{ni}$ cinque e mezza	No. 61	214
1739, 29 Novembre	Simile al Sig Pittor Guardi p due teste dipinte una col Cinbano e l'altra la copia di Pauolo giusto Ricevuta in Lib^o $cecch^{no}$ uno e mezzo	No. 61	216

Date	Entries	Libro-cassa Number or Designation	Foglio
1739, 9 Decembre	Simile per due teste d'un vecchio con collana e l'altra un giovine con collana del Anto Guardi giusto ricevuta in Libro lire trenta	No. 61	222
1739, 26 Decembre	Simile al Sigr Anto Guardi Pittor p due copie ritratti di S.E. giusto ricevuta in filza cecchni quatro	No. 61	228
1740, 28 Marzo	Simile al Sigr Antonio Guardi in tre volte a conto delle copie che va facendo cecchni tre lire otto giusto ricevuta in Libo	No. 61	262
1740, 8 Aprile	Simile al Sigr Pittor Guardi p copie di due Ritratti del Re e Regina di Napoli cecchini due giusto ricevuta in Libo	No. 61	270
1740, 14 Giugno	Simile per tre ritratti al Sigr Anto Guardi, una di S.E. l'altro del Re di Polonia e della Principesse d' Holstein cecchni sei giusto ricevuta in Libo	No. 61	298
1740, 5 Agosto	Simile al Sigr Guardi p la copia in piccolo del ritratto di S.E. giusto ricevuta in filza cecchno uno	No. 61	322
1740, 12 Agosto	Simile al Signor Guardi p un'altra copia in piccolo del ritratto di S.E. cecchno uno giusto la ricevuta in Libo	No. 61	322
1740, 30 Settembre	Contati al Sigr Guardi per la copia dei ritratti d'Ali Passa, Ali Chiozza di Casa Emo cecchni tre	No. 61	338

Date	Entries	Libro-cassa Number or Designation	Foglio
1742, 22 Gennaro	Simile al Pittor Guardi a conto de Due Ritratti come sopa fogl: 123 cecch$^\underline{i}$2	No. 77 Anno 1742	84
1742, 1 Febraro	P simile al'Ant$^{\underline{o}}$ Pittor di Ca' Dona per 2 quadri Turchi, come sopa fogl 129 cecch$^{\underline{i}}$ 5	No. 77 Anno 1742	84
1742, 1 Febraro	Per simile al sudd$^{\underline{o}}$ Pittor Ant$^{\underline{o}}$ p il ritratto del nuovo Doge fogl 129 cecch$^{\underline{i}}$ 4	No. 77 Anno 1742	84
1742, 21 Marzo	p simile al Pittor Guardi p resto di due ritratti al naturale di S.E. foglio 141 cecch$^{\underline{i}}$ 4	No. 77 Anno 1742	84
1742, 1 Giugno	Simile al Pittor Guardi p due quadretti Turchi fol 159 cecch$^{\underline{i}}$ 5	No. 77 Anno 1742	84
1742, 14 Novembre	Simile al Pittor Guardi p 2 quadri l'uno rapa la marchia del Gr: Sig$^{\underline{te}}$ e l'altro un ballo de greci come sopra fol 159 cecch$^{\underline{i}}$ 5	No. 77 Anno 1742	181
1742, 26 Decembre	Contati al Putto Guardi per 5 quadri Turchi giusta Lib$^{\underline{o}}$ cassa fogl 196	No. 77 Anno 1742	181
1743, 28 Marzo	Simile fatti pagar in Venezia all'Antonio Guardi Pittore p 7 quadri de'Costumi Turchi fogl 120 cecch$^{\underline{i}}$ 17 lire 11	No. 77 Anno 1743	181
1743, 10 Aprile	Simile al Guardi per due quadri Turcheschi giusto libro cassa fogl. 126 cecch$^{\underline{i}}$ 5	No. 77 Anno 1743	181

Date	Entries	Libro-cassa Number or Designation	Foglio
1743, 10 Maggio	Simile al Guardi p otto Quadri Turchi libo csa fogl. 136 cecchi 20	No. 77 Anno 1743	222
1743, 5 Settembre	Simile per la compra di tre quadri Turchi uno rappresenta Baiazet nella Gheba il 2do Il Capitan Bassa nell'Arsenale il terzo il Monumto di Mahomet giusto R. in Filza 95 cecchi 7 lire 11	No. 77 Anno 1743	222
1743, 8 Ottobre	Simile p la copia di due Quadri giusto R. in filze no122 Cassa fogl. 122 cecchi 5	No. 77 Anno 1743	222
1743, 15 Decembre	Simile p due quadri Turchi giusto R. Libo Cass foglio 210 cecchi 5	No. 77 Anno 1743	222
1745, 13 Aprile	Simile al Anto Guardi p 5 ritratti della Casa d' Austria go Filza 49 e Cassa 27 cecchi 10	No. 77 Anno 1745	278
1745, 2 Ottobre	Simile p due ritratti del Re e Ra di Spagna e 4 stampe di Rubens go R in Lo e F. 123 Cassa 71 cecchi 7 lire 18	No. 77 Anno 1745	340
1745, 5 Decembre	Simile p due ritratti di D. Filippo e sua sposa F 140 fo 85 cecchi 6	No. 77 Anno 1746	370
1746, 23 Gennáro	Simile p due rittratti del Pr. d'Asturias et sua consorte F 17 cecchi 6	No. 77 Anno 1746	370
1746, 16 Maggio	Simile p 2 ritratti Re e Rega di Prussia e copie del Piacetta, Madona, Padre Aerno, e S. Giovani go Fil 44 e L. Cassa 119 cecchi 6	No. 77 Anno 1746	370

Date	Entries	Libro-cassa Number or Designation	Foglio
1746, 25 Luglio	Simile p una copia del ritratto grande di S.E. spedita in regalo al Sig. Gel. di Schulen- burg a Angern, ed un altro da coregersi spedito a Deliz g[o] L. e Cassa 131 cecch[i] tre lire 3	No. 77 Anno 1746	370
1746	Simile p 5 apostoli copiati dai original del Piacetta e più la deposizione di croce colla madonna addolorata dipinto sopra pietra del paragone con soaza debbano del Brussasorzi cecch[i] 23 lire 14	No. 77 Anno 1746	370

BIBLIOGRAPHY

A. Unpublished Sources

Almazzago (Trentino)
 Archivio della Canonica della Commezzadura

Denno (Trentino)
 Archivio Arcivescovile

Hannover
 Niedersächsisches Staatsarchiv

Salzburg
 Landesarchiv

Trento
 Archivio di Stato
 Biblioteca Comunale
 Curia Arcivescovile di Trento

Vaduz (Liechtenstein)
 Sammlungen des Regierenden Fürsten von Liechtenstein

Venice
 Archivio di Stato
 Biblioteca Correr
 Biblioteca Marciana
 Archivio dell'Accademia delle Belle Arti
 Archivio Parrocchiale dell'Angelo Raffaele
 Archivio Parrocchiale dei SS. Apostoli
 Archivio Parrocchiale di S. Canciano
 Archivio Parrocchiale di S. Maria Formosa
 Archivio Parrocchiale di S. Marina
 Archivio Parrocchiale di S. Marziale
 Archivio Parrocchiale di S. Polo
 Donà dalle Rose family archive

Vienna
 Akademie der Bildenden Künste
 Archiv der Stadt Wien
 Diözesanarchiv
 Gräflich Harrach'sches Familienarchiv
 Liechtenstein family archive
 Pfarre St. Stephan
 Schottenpfarre

Vigo di Ton (Trentino)
Archivio della Cononica di Vigo di Ton

B. Books and Articles

Albrizzi, Giambattista. Studij di pittura. Venice, 1760.

_____. Forestiero illuminato. Venice, 1765.

Arslan, Edoardo. "Contributo a Francesco Guardi," Bollettino d'Arte,
 XXIX (1935-1936), 441-448.

_____. "Per la definizione dell'arte di Francesco,
 Giannantonio e Nicolò Guardi," Emporium, C (1944), 1-28.

_____. "Ancora di un'opera bergamasca di Gian Antonio
 Guardi," Emporium, CXV (1952), 167-169.

_____. "Considerazioni sul vedutismo di Francesco Guardi,"
 in Problemi Guardeschi. Venice, 1967, 8-20.

Bassi, Elena. La Regia Accademia di Belle Arti di Venezia. Firenze,
 1941.

_____. L'Accademia di Belle Arti di Venezia nel suo bicenten-
 ario. Venice, 1950.

Bassi-Rathgeb, Roberto. "Un nuovo documento guardesco," Arte Veneta,
 IX (1955), 226.

Benesch, Otto. Venetian Drawings of the Eighteenth Century in America.
 New York, 1947.

_____. "Einige unbekannte Werke von Francesco Guardi," Arte
 Veneta, VIII (1954), 306-309.

Berengo, Marino. La società veneta alla fine del '700. Florence, 1950.

[Bernardelli, Pietro]. "Francesco Guardi pittore," La Gazzetta di
 Trento, November 12, 1862, p. 1.

Bernis, François-Joachim de Pierres de. Mémoires et lettres 1715-1758,
 ed. Fréderic Masson. 2 vols. Paris, 1878.

Bibliografia della Mostra di Francesco e Gian Antonio Guardi, ed.
 Pietro Zampetti. Venice, 1966.

Binion, Alice. "From Schulenburg's Gallery and Records," The Burling-
 ton Magazine, CXII (1970), 297-301.

Blanc, Charles. Histoire des peintres de toutes les ecoles. Paris,
 1868.

Blunt, Anthony and Edward Croft-Murray. Venetian Drawings of the XVII
 and XVIII Centuries in the Collection of Her Majesty the Queen
 at Windsor Castle. London, 1957.

Boni, Filippo. Biografia degli artisti. Venice, 1840.

Bottari, Giovanni, and Stefano Ticozzi. Raccolta di lettere sulla
 pittura, scultura ed architettura scritte da' più celebri per-
 sonaggi dei secoli XV, XVI, XVII. 8 vols. Milan, 1922.

Brosses, Charles de. Lettres familières écrites d'Italie en 1739 et
 1740. 2 vols. Paris, 1858.

Brunelli, Bruno, and Adolfo Callegari, Ville del Brenta e degli
 Euganei. Milan, 1931.

Brunetti, Estella. "Considerazioni guardesche in margine alla Mostra,"
 in Problemi guardeschi. Venice, 1967, pp. 41-50.

Byam Shaw, J. "Some Venetian Draughtsmen of the Eighteenth Century,"
 Old Master Drawings, VII (1933), 47-63.

_____. "Un altro disegno del Guardi per il Teatro Manin,"
 Arte Veneta, IV (1950), 154.

_____. The Drawings of Francesco Guardi. London, 1951.

_____. "Unpublished Guardi Drawings," The Art Quarterly XVI
 (1953), 331-335.

_____. "A Sketch for a Ceiling by Francesco Guardi," The
 Burlington Magazine, CIV (1962), 73.

_____. The Drawings of Domenico Tiepolo. Boston, 1962.

Cailleux, Jean. "Une Famille de peintres," L'Information d'Histoire
 de l'Art, XI (1966), 53-62.

_____. "Les Guardi et Pietro Longhi," in Problemi guardeschi.
 Venice, 1967, 51-54.

Calabi, Augusto. L'incisione italiana. Milan, 1931.

Canal, Vincenzo da. _Vita di Gregorio Lazzarini_ [1732]. Venice, 1809.

Casanova de Seingalt, Jacques. _Histoire de ma vie_. 6 vols. Paris, 1961.

Catalogo di quadri esistenti in casa del signor D.n Giovanni Vianelli. Venice, 1790.

Ciccolini, Giovanni. "La famiglia e la patria dei Guardi," _Studi trentini di scienze storiche_, XI (1953), 105-131, 324-354 and XII (1954), 29-56, 189-200, 341-356.

Comstock, Helen. "Eighteenth-Century Italian Figure Drawings at the Fogg Art Museum," _The Connoisseur_, CXXXV (1955), 274-280.

Constable, W. G. "Canaletto and Guardi," _Old Master Drawings_, III (1929), 20-22.

_____. _Canaletto_, 2 vols. Oxford, 1962.

Damerini, Gino. _L'arte di Francesco Guardi_. Venice, 1912.

Dania, Luigi. "Three Drawings by Gian Antonio Guardi," _Master Drawings_, IV (1966), 293-294.

_____. "Another Drawing by Gian Antonio Guardi," _Master Drawings_, VI (1968), 30.

Dandolo, Girolamo. _La caduta della Repubblica di Venezia ed i suoi ultimi cinquant'anni._ Venice, 1855.

Derschau, Joachim von. _Sebastiano Ricci_. Heidelberg, 1922.

Dobroklonsky, M. "Die Zeichnungen-Sammlung der Eremitage," _Pantheon_, II (1928), 475-482.

_____. _Risunki italianskoi shkoly XVII-XVIII vekov._ Leningrad, 1961.

Fanfani, Amintore. "Il mancato rinnovamento economico," in _La civiltà veneziana del Settecento_. Florence, 1960, pp. 29-67.

Fenyö, Ivan. "An Unknown Drawing by Gianantonio Guardi in the British Museum," _Master Drawings_, II (1964), 276-277.

_____. "An Unknown Drawing by Antonio Guardi," _The Burlington Magazine_, CVII (1965), 256.

_____. "An Unknown Processional Banner by the Guardi Brothers," _The Burlington Magazine_, CX (1968), 65-69.

Ferrari, Luigi. "Gli acquisti dell'Algarotti pel Regio Museo di
Dresda," L'Arte, III (1900), 150-154.

Ferri, Pasquale Nerino. Catalogo riassuntivo della raccolta di
disegni antichi e moderni. Roma, 1890.

Finberg, Hilda. "Canaletto in England," The Walpole Society, IX
(1920-1921), 22-55.

Fiocco, Giuseppe. Francesco Guardi, Florence, 1923.

_____. "Guardi as a Figure Painter," The Burlington
Magazine, XLVI (1925), 224-230.

_____. "Il Ridotto ed il Parlatorio del Museo Correr,"
Dedalo, VI (1925-1926), 538-546.

_____. "La pittura veneziana alla Mostra del Settecento,"
Rivista di Venezia, August-September (1929), 497-581.

_____. "Francesco Guardi pittore di teatro," Dedalo, XIII
(1933), 360-367.

_____. "Francesco Guardi pittore di battaglie," Critica
d'arte, XVI (1937), 251-253.

_____. "Francesco Guardi rittratista." Emporium, XCVIII
(1943), 91-102.

_____. "I Fasti Veneziani dei pittori Guardi," Le Tre
Venezie, July-December (1944), 9-15.

_____. "Il problema di Francesco Guardi," Arte Veneta, VI
(1952), 99-120.

_____. Francesco Guardi, l'Angelo Raffaele. Turin, 1958.

_____. Guardi. Milan, 1965.

Fogolari, Gino. "L'Accademia veneziana di pittura e scoltura del
Settecento," L'Arte, XVI (1913), 241-272, 364-394.

_____. "Dipinto settecentesco della chiesa di Belvedere
presso Aquileia," Arte cristiana, IV (1916), 97-98.

_____. "Le tavolette delle arti veneziane," Dedalo, IX (1928-
1929), 723-742.

Fröhlich-Bume, Lili. "Two Drawings by Guardi in the Dresden Printroom,"
The Burlington Magazine, XLIX (1926), 31-32.

Gabrielli, Noemi. "Aggiunte a Sebastiano Ricci," Proporzioni, III (1950), 204-211.

Gallo, Roberto. "Note d'archivio su Francesco Guardi," Arte Veneta, VII (1953), 153-156.

Garas, Klara. Franz Anton Maulbertsch. Budapest, 1960.

Gaudenzio, Luigi. "A proposito di Francesco Guardi figurista," Arte Veneta, II (1948), 148.

Gioseffi, Decio. "Per una datazione tardissima delle storie di Tobiolo in S. Raffaele di Venezia con una postilla su Bonifazio Veronese," Emporium (1957), 99-114.

_____. Canaletto and his Contemporaries. Bergamo, 1964.

Goering, Max. "Die Tätigkeit der Venezianer Piazzetta und Pittoni für den Kurfürsten Clemens August von Köln," Westfalen, XIX (1934), 364.

_____. "An Unknown Sketch by Piazzetta," The Burlington Magazine, LXVIII (1936), 124-130.

_____. "Francesco Guardi als Figurenmaler," Zeitschrift fur Kunstgeschichte, VII (1938), 289-315.

_____. Francesco Guardi. Vienna, 1944.

Gradenigo, Pietro. Notizie d'arte, ed. Lina Livan. Venice, 1942.

H. A. "Scoperti due affreschi di Francesco Guardi," Emporium, CXXVII (1958), 81.

Hadamovski, Franz. Die Familie Galli-Bibiena in Wien. Vienna, 1961.

Hadeln, Detlev von. "Some Unpublished Figure Drawings of Francesco Guardi," Old Master Drawings, I, June (1926), 3-4.

Haskell, Francis. "Stefano Conti, Patron of Canaletto and Others," The Burlington Magazine, XCVIII (1956), 296-300.

_____. "Francesco Guardi as vedutista and some of his Patrons," Journal of the Warburg and Courtauld Institutes, XXIII (1960), 256-276.

_____. Patrons and Painters. New York, 1963.

Haskell, Francis, and Michael Levey. "Art Exhibitions in 18th Century Venice," Arte Veneta, XII (1958), 179-185.

Hauman, Irene. Das oberitalienische Landschaftsbild des Settecento. Strasbourg, 1927.

Heinemann, Fritz. "Mostra dei Guardi," Kunstchronik, XVIII (1965), 233-243.

Holst, Niels von. "La pittura veneziana tra il Reno e la Neva," Arte Veneta, V (1951), 131-140.

Kutschera-Woborsky, Oswald von. "Giovanni Tiepolos Decke des 'Merito' im Palazzo Rezzonico zu Venedig," Monatshefte fur Kunstwissenschaft, IX (1916), 170-180.

Lalande, Joseph Jerôme le Français de. Voyage d'un Français en Italie fait dans les années 1765-1766. 8 vols. Yverdon, 1769.

Lanckoronska, Marie. Die venezianische Buchgraphic des XVIII. Jahrhunderts. Hamburg, 1950.

Lasareff, Victor. "Francesco and Gianantonio Guardi," The Burlington Magazine, LXV (1934), 53-71.

Leporini. "Die Versteigerung von Handzeichnungen bei A. Weinmüller," Pantheon, XXII (1938), 332.

Levey, Michael. The Later Italian Pictures in the Collection of Her Majesty the Queen. London, 1964.

Levi, Cesare. Le collezioni veneziane d'arte e d'antichità. Venice, 1900.

Longhi, Alessandro. Compendio delle vite de' pittori veneziani istorici piu rinomati del presente secolo. Venezia, 1762.

Lorenzetti, Giulio. Ca' Rezzonico. Venice, 1936.

_____. Il quaderno del Tiepolo al Museo Correr di Venezia. Venice, 1946.

_____. Venice and its Lagoon. Rome, 1961.

Maffei, Fernanda de. Gian Antonio Guardi pittore di figura. Verona, 1951.

_____. "Disegni di Sebastiano Ricci," in Miscellanea Bibliotheca Hertzianae. Munich, 1961, pp. 446-449.

_____. "La questione Guardi: precisazioni e aggiunte," in Arte in Europa. Milano, 1966, pp. 839-867.

Mahon, Denis. "The Brothers at the Mostra dei Guardi: Some Impressions of a Neophyte," in Problemi Guardeschi. Venice, 1967, pp. 66-155.

_____. "When did Francesco Guardi become 'vedutista'?" The Burlington Magazine, CX (1968), 69-73.

Maiers, Johann Christoph. Beschreibung von Venedig. 4 vols. Leipzig, 1795.

Malamani, Vittorio. Il Settecento a Venezia. Turin, 1891.

Mariette, Pierre-Jean. Abecedario, ed. Ph. de Chennevières. 6 vols. Paris, 1851-1853.

Martini, Egidio. La pittura veneziana del Settecento. Venice, 1964.

Massi, Ernesto. Sulla Storia del teatro italiano nel secolo XVIII. Florence, 1891.

Modigliani, Ettore. "Capolavori veneziani del Settecento ritornati in Italia," Dedalo, V (1924), 333-357.

_____. "Ancora sul 'Ridotto' di Giovanni Antonio Guardi al Museo Correr," Dedalo, VII (1926-1927), 438-442.

Molmenti, Pompeo. La storia di Venezia nella vita privata dalle origini all caduta della repubblica. Turin, 1880.

_____. Acque-forti dei Tiepolo. Venice, 1896.

Mongan, Agnes, and Paul J. Sachs. Drawings in the Fogg Museum of Art. 2 vols. Cambridge, 1946.

Monnier, Philippe. Venise au XVIIIe siecle. Paris, 1908.

Morassi, Antonio. "Francesco Guardi as a Figure Painter," The Burlington Magazine, LV (1929), 293-299.

_____. Disegni antichi della collezione Rasini in Milano. Milan, 1937.

_____. "Francesco Guardi als Schlachtenmaler," Pantheon, XX (1937), 197-200.

_____. Tiepolo. Bergamo, 1943.

_____. "Settecento inedito," Arte Veneta, III (1949), 80-84.

_____. "Conclusioni su Antonio e Francesco Guardi," Emporium, CXIV (1951), 194-219.

_____. "Settecento inedito. Un ritratto del Maresciallo Schulenburg dipinto da Antonio Guardi," Arte Veneta, VI (1952), 85-90.

_____. "A Signed Drawing by Antonio Guardi and the Problem of the Guardi Brothers," The Burlington Brothers, XCI (1953), 260-267.

_____. "Fasti e nefasti del Settecento veneziano," Emporium, CXXVI (1956), 3-28.

_____. "Pellegrini e Guardi," Emporium, CXXVIII (1958), 194-212.

_____. "Circa gli esordi del vedutismo di Francesco Guardi con qualche cenno al Marieschi," in Studies in the History of Art. Dedicated to William E. Suida on his Eightieth Birthday. London, 1959, pp. 338-352.

_____. "Novità du Francesco Guardi," Arte Veneta, XIII-XIV (1959-1960), 162-173.

_____. "Antonio Guardi ai servigi del feldmaresciallo, Schulenburg," Emporium, CXXXI (1960), 147-164, 199-212.

_____. "Aggiunta al Guardi. Le cinque tele 'Storie' della Gerusalemme Liberata," Emporium, CXXI (1960), 247-256.

_____. A Complete Catalogue of the Paintings of G. B. Tiepolo. London, 1962.

_____. "Francesco Guardi as a Pupil of Canaletto," The Connoisseur, CLII (1963), 159-158.

_____. Morazzoni, Giulio. La Moda a Venezia nel secolo XVIII. Milan, 1931.

Moschini, Giovanni Antonio. Della letteratura veneziana del secolo XVIII fino a' nostri giorni. 3 vols. Venice, 1806.

_____. Nuova guida di Venezia. 2nd ed. Venice, 1847.

_____. Dell'incisione in Venezia 1808 Venice, 1924.

Moschini, Vittorio. "I disegni dell' 700 alla Mostra di Venezia," Dedalo, X (1929-1930), 301-330.

_____. Francesco Guardi. Milan, 1952.

Muraro, Michelangelo. "Novità du Francesco Guardi," Arte Veneta, III (1949), 123-130.

_____. "An Altar-piece and other Figure Paintings by Francesco Guardi," The Burlington Magazine, C (1958), 3-8.

_____. "Further Information about the Roncegno Guardi," The Burlington Magazine, CII (1960), 79-80.

_____. "The Guardi Problem and the Statutes of the Venetian Guilds," The Burlington Magazine, CII (1960), 421-428.

_____. "An Unknown Drawing by Francesco Guardi," The Burlington Magazine, CIV (1962), 305.

Pallucchini, Rodolfo. L'arte di G. B. Piazzetta. Bologna, 1934.

_____. Die Zeichnungen des Francesco Guardi in Museum Correr zu Venedig. Florence, 1943.

_____. "Giunte al catalogo dei disegni di Francesco Guardi del Museo Correr di Venezia," Emporium, XCVII (1943), 51-57.

_____. "Opere inedite o poco note alla Mostra di Losanna," Emporium, CVI (1947), 244.

_____. "Disegni veneziani del Settecento in America," Arte Veneta, II (1948), 157-158.

_____. "I Guardi di Vigo d'Anaunia esposti a Trento," Arte Veneta, II (1948), 174.

_____. "Nota per Giacomo Guardi," Arte Veneta, III (1949), 131-135.

_____. "La Mostra dei disegni del Museo di Bassano," Arte Veneta, X (1956), 255-256.

_____. La pittura veneziana del Settecento, Venice, 1960.

_____. "Nota alla Mostra dei Guardi," Arte Veneta, XIX (1965), 215-236.

Panizza, Pietro. Francesco Guardi. Trento, 1912.

Parker, K. T. The Drawings of Antonio Canaletto in the Collection of His Majesty the King at Windsor Castle. Oxford, 1948.

Pignatti, Terisio. "I documenti dell'organo dell' Angelo Raffaele," Arte Veneta, IV (1950), 144-145.

_____. "Drawings from the Museo Civico, Bassano," The Burlington Magazine, XCVIII (1956), 373-374.

_____. "Nuovi disegni del Piazzetta," Critica d'arte, IV (1957), 396-403.

_____. "Un disegno di Antonio Guardi donato al Museo Correr," Bollettino dei musei civici veneziani, II, 1-2 (1957), 21-32.

_____. Il Museo Correr di Venezia: dipinti del XVII e XVIII socolo. Venice, 1960.

_____. "Nuovi disegni di figura dei Guardi," Critica d'arte, XI (1964), 57-72.

_____. "La fraglia dei pittori di Venezia," Bollettino dei musei civici veneziani, X, 3 (1965), 16-39.

_____. I disegni veneziani del Settecento. Venice, 1966.

_____. I disegni dei Guardi. Florence, 1967.

_____. "Il Trionfo della Virtù guerriera," Bollettino dei musei civici veneziani, XII, 1-2 (1967), 17-26.

_____. Pietro Longhi. Venice, 1968.

Pittaluga, Mary. Acquafortisti veneziani del Settecento. Florence, 1953.

Posse, Hans. "Die Briefe des Grafen Algarotti an den sächsischen Hof," Jahrbuch der preussischen Kunstsammlungen, LII (1931), Beiheft.

Pozzo, Bartolomeo dal. Le vite de' pittori degli scultori et architetti veronesi. Aggiunta. Verona, 1718.

Querini, Vittorio. "I documenti sulla pala di G. Antonio Guardi della arcipretale di Pasiano di Pordenone," Messagero Veneto, November 21, p. 3.

Ragghianti, Carlo. "Epiloghi guardeschi," Annali della Scuola Normale Superiore di Pisa, XXII (1953), 75-107.

_____. Disegni dell'Accademia Carrara di Bergamo. Venice, 1962.

Rasmo, Nicolò. "Per una biografia del pittore Giuseppe Alberti," Cultura Atesina, I (1947), 85-88.

_____. "Recenti contributi a Giannantonio Guardi," Cultura Atesina, IX (1955), 150-159.

Rava, Aldo. Pietro Longhi. Bergamo, 1923.

Rizzi, Aldo. "Il Grassi e i Guardi," Emporium, CXXV (1962), 98-110.

Rossi, Attilio. "Di una battaglia del Guardi," Arte figurativa antica e moderna, VII, 2 (1959), 38.

Sack, Eduard. Giambattista und Domenico Tiepolo. Hamburg, 1910.

Sagredo, Agostino. Sulle consorterie delle arti edificative in Venezia. Venice, 1957.

Santarelli, Emilio. Catalogo della raccolta di disegni autografi antichi e moderni donati dal prof. Emilio Santarelli alla R. Galleria di Firenze. Florence, 1870.

Sartori, Antonio. "Il Piazzetta della Basilica del Santo a Padova," Arte Veneta, XIII (1959), 231-236.

Schniewind, C. O. Drawings Old and New. Chicago, 1946.

Scholz, Janos. "Drawings by Francesco and Gianantonio Guardi," The Art Quarterly, XVII (1954), 385-390.

Seilern, Antoine. Italian Paintings and Drawings at 56 Princes Gate London SW. London, 1959.

Simonson, George. Francesco Guardi. London, 1904.

_____. "Guardi and Tiepolo," The Burlington Magazine, XI (1907), 247-248.

Siren, Osvald. Dessins et tableaux de la Renaissance italienne. Stockholm, 1902.

Tassi, Francesco Maria. Vite de'pittori scultori e architetti bergamaschi. 2 vols. Bergamo, 1793.

Temanza, Tomaso. Zibaldon, ed. Nicola Ivanoff. Venice-Rome, 1963.

Ticozzi, Stefano. Dizionario dei Pittori. Milan, 1818.

Valcanover, Francesco. Le storie di Tobiolo. Milan, 1964.

Verci, Giambattista. Notizie intorno alla vita e alle opere de' pittori scultori e intagliatori della città di Bassano. Venice, 1775.

Vivian, Frances. "Joseph Smith and Giovanni Antonio Pellegrini," The Burlington Magazine, CIV (1962), 330-333.

Voss, Hermann. "Studien zur venezianischen Vedutenmalerei des 18. Jahrhunderts," Repertorium fur Kunstwissenschaft, XLVII (1926), 1-45.

Watson, Francis J. B. Canaletto. London, 1949.

_____. "Francesco Guardi. Text by Vittorio Moschini," Apollo, LXV (1957), 188-189.

_____. "A Series of 'Turqueries' by Francesco Guardi," The Baltimore Museum of Art News Quarterly, XXIV (1960), 3-13.

_____. "The Guardi Family of Painters," Journal of the Royal Society Arts, XIV (1965-1966), 266-289.

_____. "Guardi and Englnad," in Problemi Guardeschi. Venice, 1967, pp. 209-212.

Wittkower, Rudolf. "Imitation, Eclecticism, and Genius," in Aspects of the Eighteenth Century. Baltimore, 1965, pp. 143-161.

Zanetti, Antonio Maria. Della pittura veneziana, e delle opere pubbliche dei veneziani maestri. 2 vols. Venice, 1792.

Zanotto, Francesco. Il Palazzo Ducale di Venezia. 4 vols. Venice, 1846-1861.

C. Exhibition Catalogues

Canaletto e Guardi. Venice: Fondazione Cini, 1962 (Catalogue by
K. T. Parker and J. Byam Shaw).

Dal Ricci al Tiepolo. Venice: Palazzo Ducale, 1969 (Introduction
and Catalogue by Pietro Zampetti).

Dessins des maîtres anciens. Leningrad: Hermitage, 1927 (Catalogue
by M. Dobroklonsky).

Disegni del Museo Civico di Bassano. Venice: Fondazione Cini, 1956
(Introduction and Catalogue by Licisco Magagnato).

Disegni del Settecento nelle collezioni del Museo d'Arte Antica di
Milano. Milan: Castello Sforzesco, 1969 (Catalogue by
Mercedes Precerutti-Garberi).

Disegni della Fondazione Horne in Firenze. Florence: Palazzo Strozzi,
1963 (Catalogue by Licia Ragghianti Collobi).

Disegni di una collezione veneziana del Settecento. Venice: Fonda-
zione Cini, 1966 (Catalogue by Alessandro Bettagno).

Disegni italiani della collezione Santarelli. Florence: Gabinetto
disegni e stampe degli Uffizi, 1967 (Catalogure by Anna Forlani
Tempesti et al.).

Disegni veneti del Museo di Budapest. Venice: Fondazione Cini, 1965
(Catalogue by Ivan Fenyö).

Disegni veneti del Museo di Leningrado. Venice: Fondazione Cini,
1964 (Catalogue by Larissa Salmina).

Disegni veneti del Settecento della Fondazione Cini e delle collezioni
venete. Venice: Fondazione Cini, 1963 (Introduction and Cata-
logue by Alessandro Bettagno).

Disegni veneti del Settecento nel Museo Correr di Venezia. Venice:
Fondazione Cini, 1964 (Catalogue by Terisio Pignatti).

Disegni veneti dell'Albertina di Vienna. Venice: Fondazione Cini,
1961 (Introduction and Catalogue by Otto Benesch).

Disegni veneti di Oxford. Venice: Fondazione Cini, 1958 (Catalogue
by K. T. Parker).

Disegni veneti in Polonia. Venice: Fondazione Cini, 1958 (Catalogue
by Maria Mrozinska).

Eighteenth-Century Venetian Drawings from the Correr Museum. Washington: National Gallery, 1963-1964 (Catalogue by Terisio Pignatti).

Eighteenth-Century Venetian Drawings from the Correr Museum. London: The Art Council of Great Britain, 1965 (Catalogue by Terisio Pignatti).

Eighteenth-Century Italian Drawings. Wellesley: Wellesley College, Jewett Art Center, 1960 (Catalogue by Janet Cox Rearick).

European Masters of the Eighteenth Century. London: Royal Academy, 1954-1955 (Catalogue by Brinsley Ford, J. Byam Shaw and Francis J. B. Watson).

18e Euwse Venetiaanske Tekeningen. Rotterdam: Museum Boymens-van Beuningen, 1964 (Catalogue by Terisio Pignatti).

An Exhibition of Drawings from the Alfred de Pass Collection Belonging to the Royal Institution of Cornwall. Truro: The Art Council of Great Britain, 1957 (Catalogue by A. E. Popham).

Le feste e le maschere veneziane. Venice: Ca' Rezzonico, 1937 (Catalogue by Giulio Lorenzetti).

Francesco Guardi. Springfield: Museum of Fine Arts, 1937 (Catalogue by John Lee Clarke).

The Guardi Family. Houston: The Museum of Fine Arts, 1958 (Catalogue by J. Byam Shaw).

Italienische Zeichnungen. Munich: Staatliche Graphische Sammlung, 1967 (Introduction and Catalogue by Bernhard Degenhart).

Italian Art and Britain. London: Royal Academy, 1960 (Introduction by Ellis Waterhouse).

Italian Drawings from the Collection of Janos Scholz. Hagerstown: Washington County Museum of Fine Arts, 1960.

Italian Drawings from the Collection of Janos Scholz. Staten Island: Staten Island Institute of Arts and Sciences, 1961.

Italienische Meisterzeichnungen vom 14. zum 18. Jahrhundert aus amerikanischem Besitz. Die Sammlung Janos Scholz. Hamburg: Kunsthalle, 1963 (Catalogue by Wolf Stubbe).

Konstens Venedig. Stockholm: Nationalmuseum, 1962-1963.

Kunstschätze der Lombardei. Zurich: Kunsthaus, 1948-1949.

Master Drawings from the Art Institute of Chicago. New York: Wilden-
stein Gallery, 1963.

Mostra dei Guardi. Venice: Palazzo Grassi, 1965 (Introduction and
Catalogue by Pietro Zampetti).

Mostra degli incisori veneti del Settecento. Venice, 1941 (Catalogue
by Rodolfo Pallucchini).

Mostra del disegno italiano di cinque secoli. Florence: Gabinetto
disegni e stampe degli Uffizi, 1961.

_Mostra delle opere di Francesco e Gianantonio Guardi esistenti nel
Trentino._ Trento, 1949 (Introduction by Giuseppe Fiocco).

Mostra di Nicola Grassi. Udine: Chiesa di San Francesco, 1961
(Catalogue by Aldo Rizzi).

Mostra di pittura veneziana del Settecento. Rome: Palazzo Massimo
alle Colonne, 1941 (Catalogue by Alessandro Morandotti).

La peinture italienne au XVIIIe siècle. Paris: Petit Palais, 1960-
1961 (Catalogue by Francesco Valcanover).

Primitives to Picasso. London: Royal Academy, 1962 (Catalogue by
A. E. Popham).

Sebastiano and Marco Ricci in America. Memphis: Brooks Memorial
Art Gallery, 1966 (Catalogue by Michael Milkovich).

Il Settecento di Venezia. Venice: Palazzo delle Biennali, 1929.

Tiepolo et Guardi dans le collections françaises. Paris: Galerie
Cailleux, 1952 (Catalogue by Jean Cailleux).

Tresors de l'art vénitien. Lausanne: Musee cantonal des Beaux-Arts,
1947 (Catalogue by Rodolfo Pallucchini).

Unbekannte Handzeichnungen alter Meister. Basel: Kunsthalle, 1967
(Catalogue by Werner R. Deusch).

Venetian Drawings from the Collection Janos Scholz. Venice: Fonda-
zione Cini, 1957 (Catalogue by Michelangelo Muraro).

Venetian Drawings 1600-1800. Oakland: Mills College Art Gallery,
1960 (Catalogue by Alfred Neumeyer).

Venetian Painting of the Eighteenth Century. London: Burlington
Fine Arts Club, 1911 (Catalogue by C. F. B.).

Venice. Cambridge: The Fogg Museum, 1948.

Vistavka italianskich risunkov XVII-XVIII vekov. Leningrad: Hermitage
1959 (Catalogue by M. Dobroklonsky).

ILLUSTRATIONS

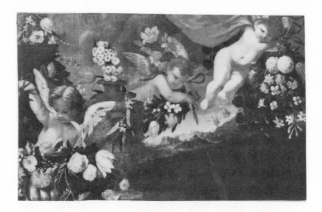

Fig. 1 Antonio Bellucci (workshop): <u>Putti with Garlands</u>. Treviso, Museo Civico.

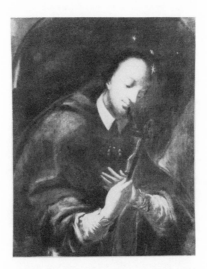

Fig. 2 Antonio Guardi: <u>Saint John of Nepomuk</u>. Treviso, Cogo Collection.

Fig. 4 Unknown author: Genealogical Tree of the Giovanelli Family. Venice, Cini Collection.

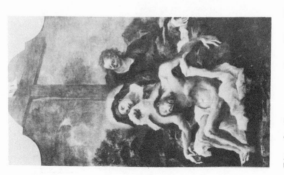

Fig. 3 Francesco Guardi: Pietà. Whereabouts unknown.

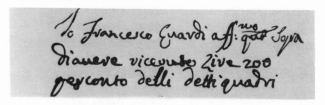

Fig. 5 Sample of Francesco Guardi's handwriting. Berlin,
formerly Sarre Collection.

Fig. 6 Sample of Francesco
Guardi's handwriting. New
York, Scholz Collection.

Fig. 7 Sample of Antonio Guardi's handwriting.
Venice, Correr Library.

353

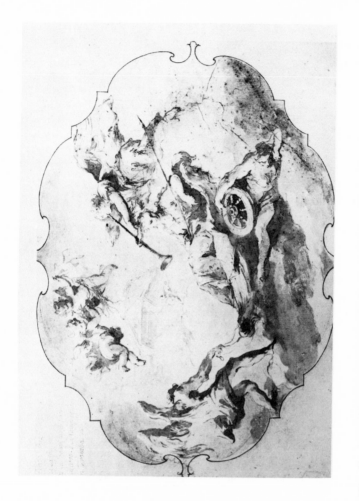

Fig. 8 AG: _Allegory of Martial Virtue_, Venice, Correr Library.

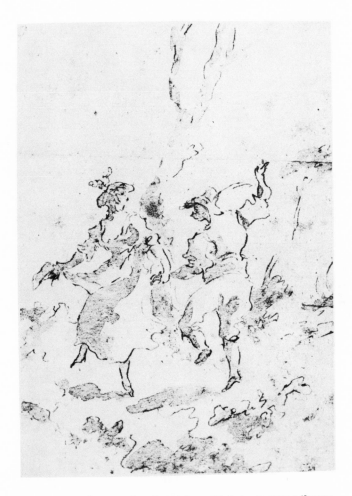

Fig. 9 FG: <u>Two Dancing Peasants</u>. Venice, Correr Library.

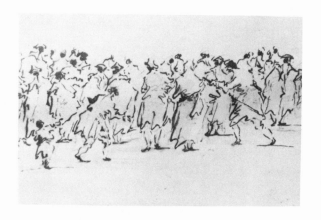

Fig. 10 FG: <u>Macchiette</u>. Venice, Correr Library.

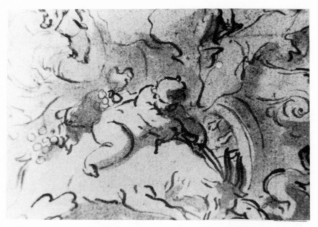

Fig. 11 AG: <u>Bacchus and Ariadne</u>, detail of a <u>putto</u>.
Oxford, Ashmolean Museum.

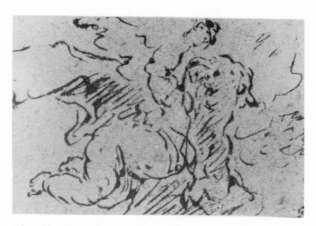

Fig. 12 FG: <u>Flying Putti</u>, detail of a <u>putto</u>.
Venice, Correr Library.

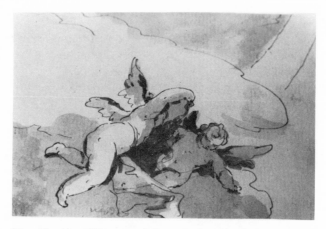

Fig. 13 AG: <u>Allegory of Reward</u>, detail of the angels.
Vienna, Akademie der Bildenden Künste.

Fig. 14 FG: <u>Madonna Crowned by Angels</u>, detail of the
angel at the left. Venice, Correr Library.

Fig. 16 FG: Putti Playing Musical Instruments, detail of the putto at the left. Venice, Correr Library.

Fig. 15 AG: Minerva, detail of the putto. Zurich, Private Collection.

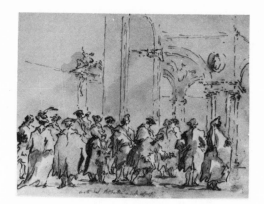

Fig. 17 FG: <u>Macchiette</u>. Venice, Correr
Library.

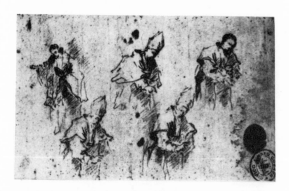

Fig. 18 FG: <u>Figure Studies</u>. Venice, Correr
Library.

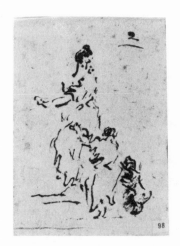

Fig. 19 FG: <u>Woman and Child</u>.
Venice, Correr Library.

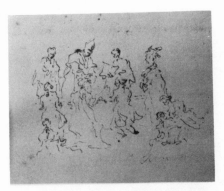

Fig. 20 FG: <u>Figure Studies</u>. Venice,
Correr Library.

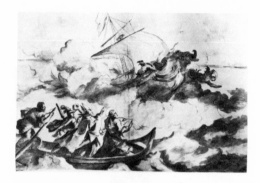

Fig. 21 AG: <u>The Arrival of Saint Mark on the Lagoons</u>.
Venice, Cini Collection.

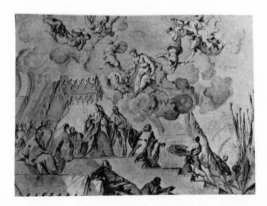

Fig. 22 AG: <u>Doge Nicolò Ponte Presenting the Senate
to Venice</u>. Munich, formerly Weinmüller Collection.

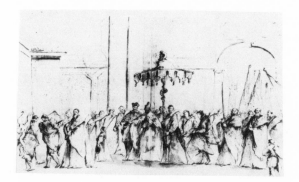

Fig. 23 AG: <u>Procession of the Doge</u>. Venice, Cini Collection.

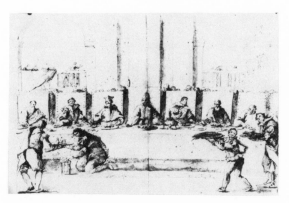

Fig. 24 AG: <u>Banquet with the Doge Presiding</u>. Venice, Cini Collection.

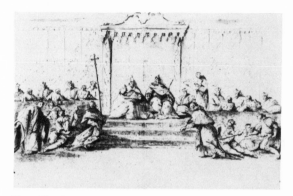

Fig. 25 AG: <u>The Peace of Bologna</u>. Venice, Cini
Collection.

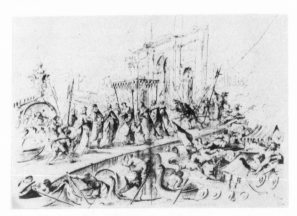

Fig. 26 <u>The Triumphal Entry of Henry III into Venice</u>.
Venice, Cini Collection.

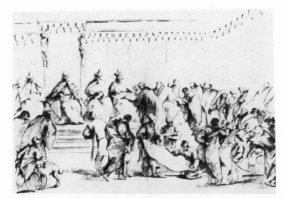

Fig. 27 AG: <u>Persian Ambassadors Presenting Gifts to the Doge</u>. Venice, Cini Collection.

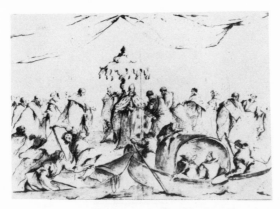

Fig. 28 AG: <u>Patricians Paying Their Respects to the Doge</u> (?). Venice, Cini Collection.

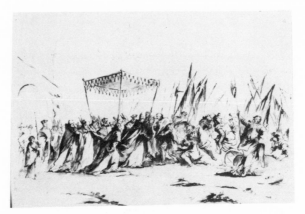

Fig. 29 AG: Pope Alexander III Meets Doge
Ziani After the Victory of Salvore. Venice,
Cini Collection.

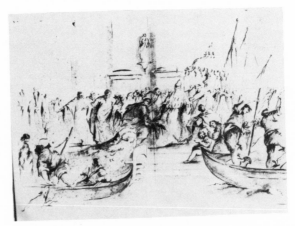

Fig. 30 AG: The Doge Disembarking (?).
Venice, Cini Collection.

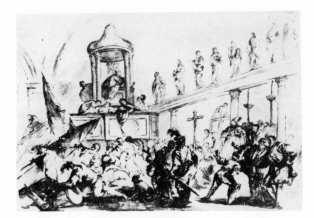

Fig. 31 AG: <u>Doge Enrico Dandolo Preaching the</u>
<u>Crusade</u>. Venice, Cini Collection.

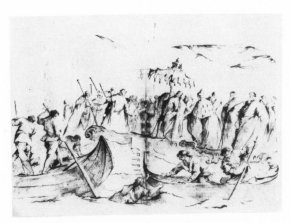

Fig. 32 AG: <u>The Doge Disembarking</u> (?)
Venice, Cini Collection.

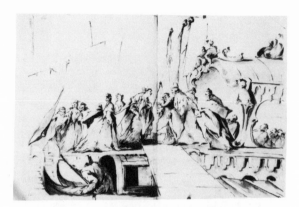

Fig. 33 AG: The Doge Greeting Catarino
Cornaro. Venice, Cini Collection.

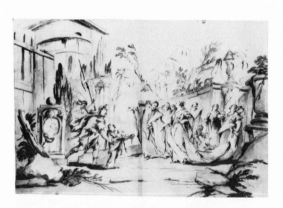

Fig. 34 AG: Catarino Cornaro Receiving
the Keys of Asolo. Venice, Cini Collection.

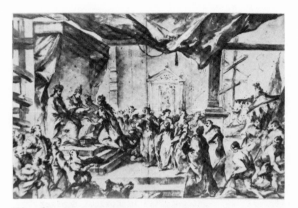

Fig. 35 AG: <u>Reception of the Queen of Cyprus</u> (?).
Milan, Campanini-Bonomi Collection.

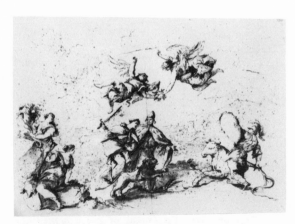

Fig. 36 AG: <u>The League of Cambrai</u>. Venice,
Cini Collection.

369

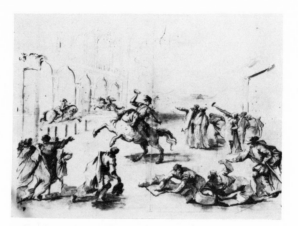

Fig. 37 AG: <u>Unidentified Historical Subject</u>.
Venice, Cini Collection.

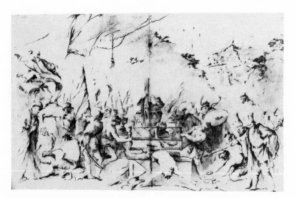

Fig. 38 AG: <u>The Ordeal of Paolo Erizzo</u> (?).
Venice, Cini Collection.

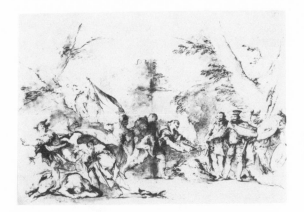

Fig. 39 AG: __Surrender of Turks to a Venetian__ Commander. Venice, Cini Collection.

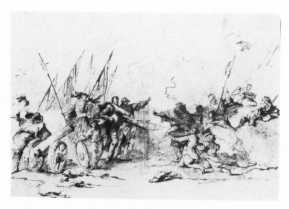

Fig. 40 AG: __The Surrender of Brescia.__ Venice, Cini Collection.

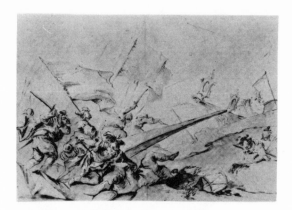

Fig. 41 AG: **Battle Scene**. Venice,
Cini Collection.

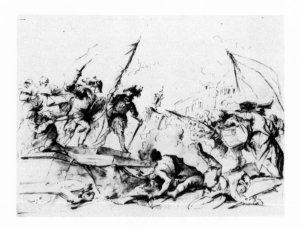

Fig. 42 AG: **Venetians Fighting Pisans**.
Venice, Cini Collection.

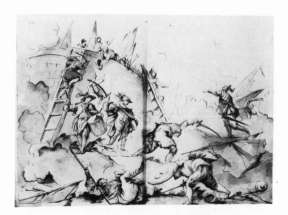

Fig. 43 AG: The Conquest of Caffa. Venice,
Cini Collection.

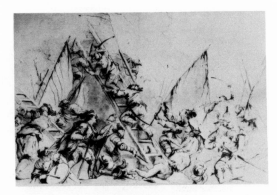

Fig. 44 AG: The Storming of Padua in 1405.
Minneapolis, Davis Collection.

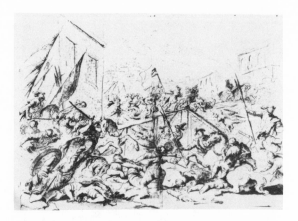

Fig. 45 AG: The Recapture of Verona. Venice,
Cini Collection.

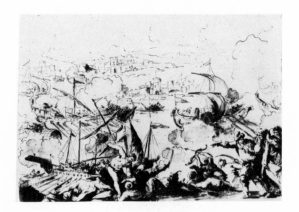

Fig. 46 AG: Naval Battle Between Venetians
and Turks. Venice, Cini Collection.

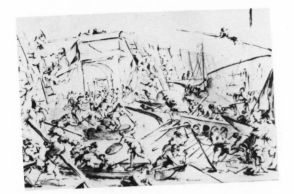

Fig. 47 AG: The Conquest of Constantinople.
Venice, Cini Collection.

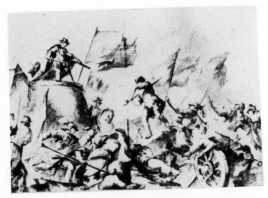

Fig. 48 AG: Defeat of Brescia by Francesco
Barbaro. Venice, Cini Collection.

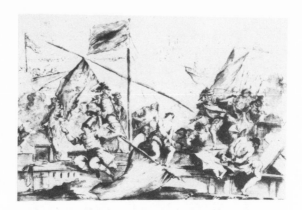

Fig. 49 AG: <u>The Celebration of the Venetian</u>
<u>Victory over King Ruggeri of Sicily</u>. Venice,
Cini Collection.

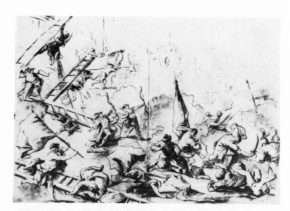

Fig. 50 AG: <u>The Siege of Zara</u>. Venice,
Cini Collection.

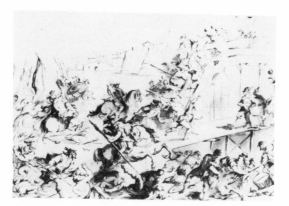

Fig. 51 AG: <u>The Assault on Zara by the</u>
<u>Crusaders</u>. Venice, Cini Collection.

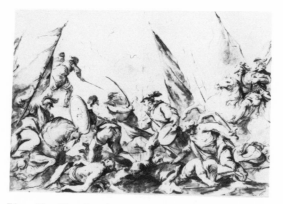

Fig. 52 AG: <u>Battle Scene</u>. Venice,
Cini Collection.

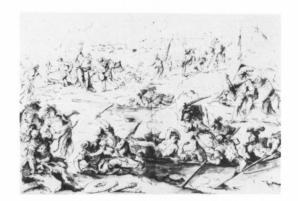

Fig. 53 AG: Battle Scene Between Turks and Venetians. Venice, Cini Collection.

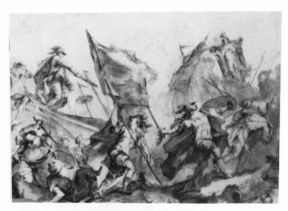

Fig. 54 AG: Battle Scene: Cleveland, Museum of Art.

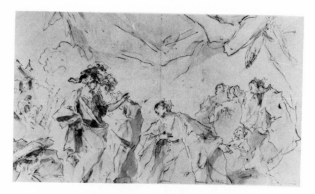

Fig. 55 AG: <u>The Family of Darius</u>. Aalens
(Wurttemberg), Koenig-Fachsenfeld.

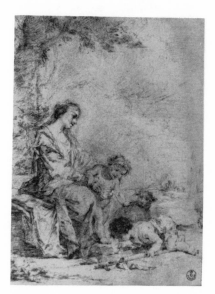

Fig. 56 AG: <u>The Holy Family</u>.
Florence, Uffizi.

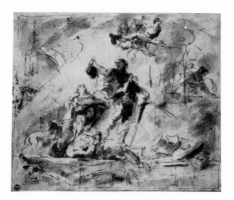

Fig. 57 AG: <u>The Beheading of John the Baptist</u>. Florence, Uffizi.

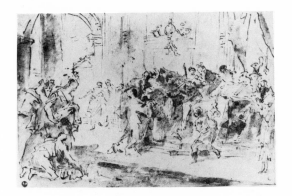

Fig. 59 AG: The Presentation to the Temple.
Florence, Uffizi.

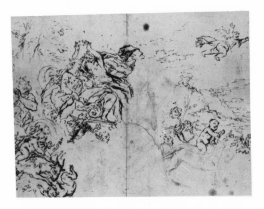

Fig. 60 AG: Bacchus and Ariadne. Oxford,
Ashmolean Museum.

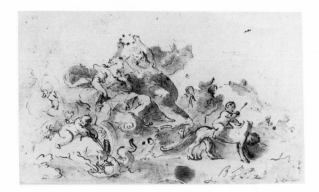

Fig. 61 AG: <u>Bacchus and Ariadne</u>. Paris, Louvre.

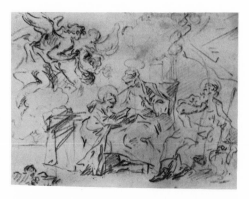

Fig. 62 AG: <u>The Education of the Virgin</u>. Paris,
Institut Néerlandais.

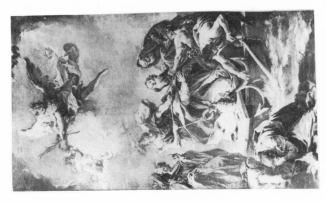

Fig. 64 Giambattista Pittoni: The Martyrdom of Saint Clement. Upsala, Museum.

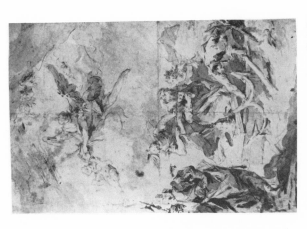

Fig. 63 AG: The Martyrdom of Saint Clement. New York, Scholz Collection.

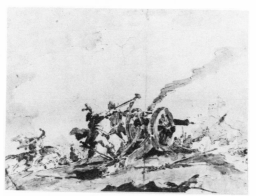

Fig. 65 AG: <u>The Cannoneer</u>. Bassano, Museo Civico.

Fig. 67 AG: Angels Carrying a Holy
Picture. Philadelphia, The Pennsylvania
Academy of Fine Arts.

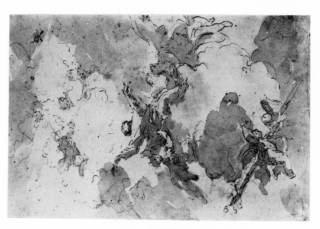

Fig. 66 AG: Apotheosis of a Saint.
Philadelphia, The Pennsylvania
Academy of Fine Arts.

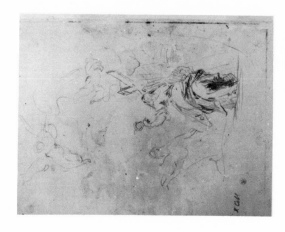

Fig. 69 AG: Faith and Flying Putti. Frankfurt-am-Main, Staedelsches Kunstinstitut.

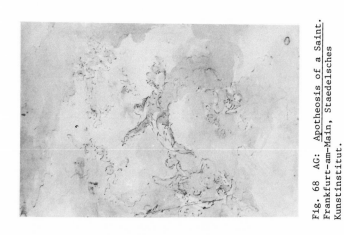

Fig. 68 AG: Apotheosis of a Saint. Frankfurt-am-Main, Staedelsches Kunstinstitut.

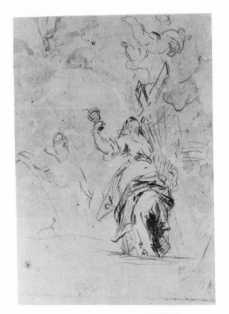

Fig. 70 AG: Faith and Flying Putti, detail of Faith. Frankfurt-am-Main, Staedelsches Kunstinstitut.

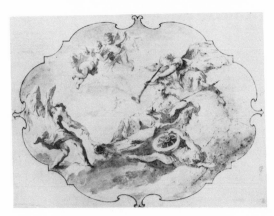

Fig. 71 AG: Allegory of Martial Virtue. Venice, Correr Library.

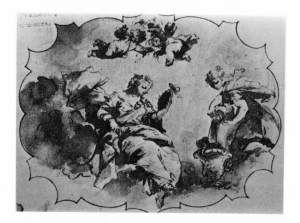

Fig. 72 AG: <u>Prudence and Temperance</u>. Fermo,
Biblioteca Comunale.

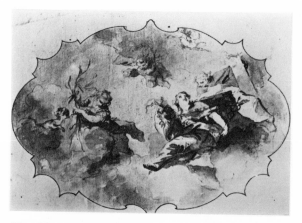

Fig. 73 <u>Faith, Fortitude, and Eloquence</u>. Fermo,
Biblioteca Comunale.

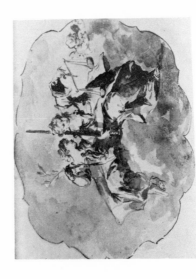

Fig. 75 AG: Peace and Justice. Paris, Moratilla Collection.

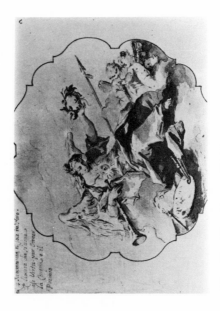

Fig. 74 AG: Fame. Fermo, Biblioteca Comunale.

Fig. 76 AG: <u>Time Abducting Beauty</u>.
Udine, Museo Civico.

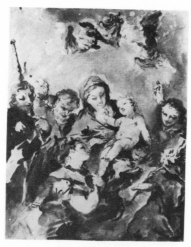

Fig. 77 AG: <u>The Holy Family and
Saints</u>. Zurich, Anda-Bührle
Collection.

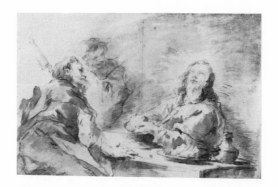

Fig. 78 AG: <u>Christ at Emaus.</u> Zurich, Hügelshofer Collection.

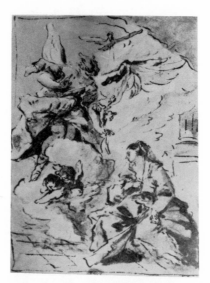

Fig. 79 AG: <u>The Annunciation.</u> Munich, Staatliche graphische Sammlung.

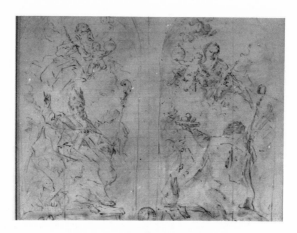

Fig. 80 AG: <u>Virgin and Child and Saint</u>
<u>Nicholas of Bari</u>. London, Watson Collection.

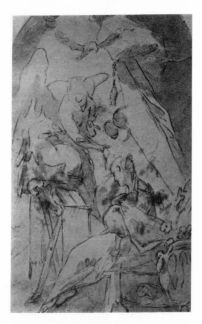

Fig. 81 <u>The Annunciation</u>.
London, Victoria and Albert
Museum.

Fig. 83 AG: The Holy Family Return-
ing from the Temple. Forence, Uffizi.

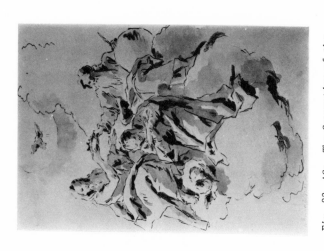

Fig. 82 AG: The Coronation of the
Virgin. Moscow, Pushkin Museum.

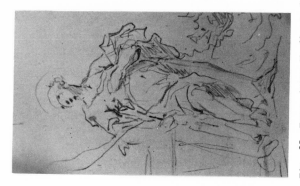

Fig. 85 Franz Anton Maulbertsch:
Saint Margaret. St. Florian,
Graphische Sammlung.

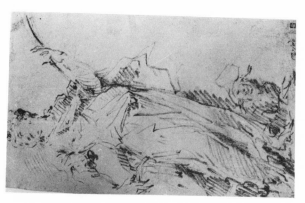

Fig. 84 AG: Saint Margaret.
New York, Scholz Collection.

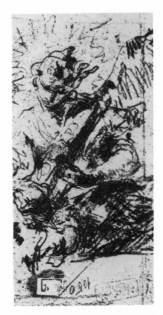

Fig. 86 AG: <u>The Archangel
Raphael</u>. Bergamo, Accademia
Carrara.

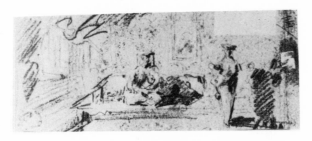

Fig. 87 AG: <u>Harem Scene</u>. Bergamo, Accademia Carrara.

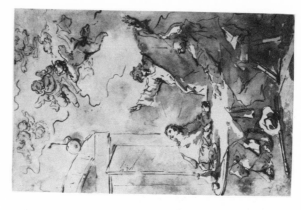

Fig. 89 AG: Christ at Emaus.
London, Eiseman Collection.

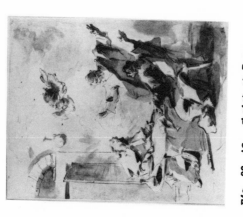

Fig. 88 AG: Christ at Emaus.
Frankfurt-am-Main, Staedelsches
Kunstinstitut.

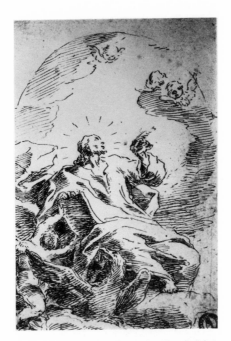

Fig. 90 AG: <u>Saint John the Evangelist</u>.
Paris, Private Collection.

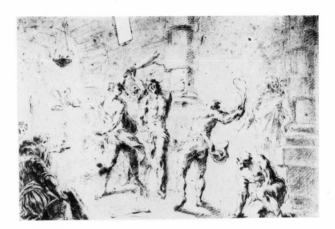

Fig. 91 AG: The Flagellation. Paris,
Private Collection.

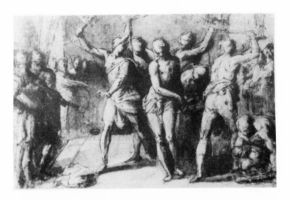

Fig. 92 AG: Salviati (?): The Flagellation,
Leningrad, Hermitage.

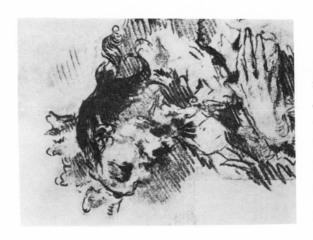

Fig. 94 AG: Head of a Magus.
Paris, formerly Fauchier-Magnan
Collection.

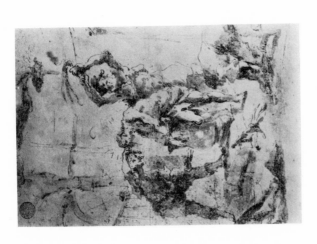

Fig. 93 AG: The Flagellation.
Dresden, Kupferstichkabinett.

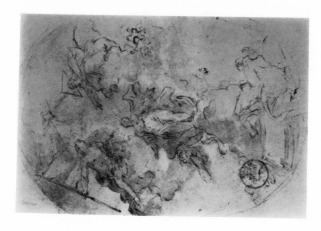

Fig. 96 AG: Trinity, Immacolata and Saint. Tarnow, Museum of Art.

Fig. 95 AG: Allegory of Science. (?). Cologne, Museum of Art.

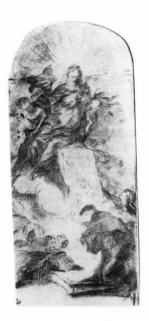

Fig. 97 AG: <u>Virgin in Glory and Saints</u>. Florence, Uffizi.

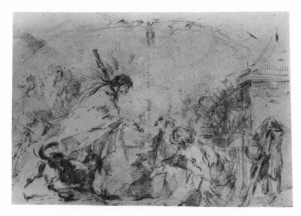

Fig. 98 AG: <u>Saint Roch Visiting the Sick</u>. Warsaw, National Museum.

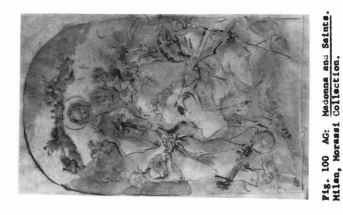

Fig. 100 AG: Madonna and Saints.
Milan, Morassi Collection.

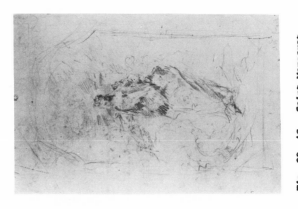

Fig. 99 AG: Saint Margaret.
Warsaw, National Museum.

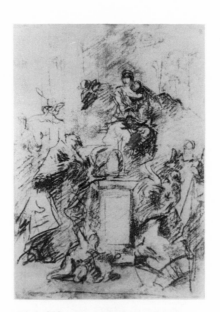

Fig. 101 AG: Virgin Enthroned
with Attendant Saints. Oxford,
Ashmolean Museum.

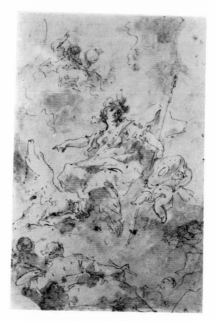

Fig. 102 AG: <u>Minerva</u>. Zurich,
Private Collection.

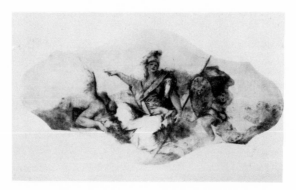

Fig. 103 AG: <u>Minerva</u>. Venice, Ca' Rezzonico.

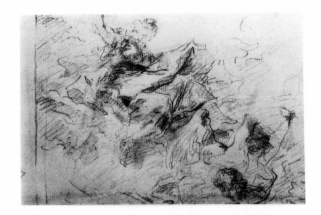

Fig. 104 AG: <u>Aurora</u>. Zurich, Private Collection.

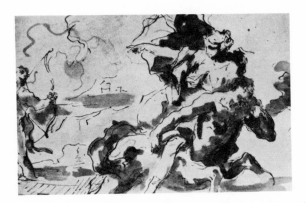

Fig. 105 AG: <u>Centaur Bearing off Dejanira</u>. Paris,
Private Collection.

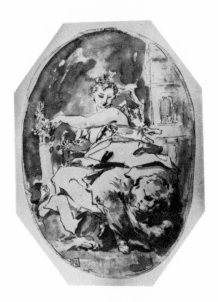

Fig. 106 AG: <u>Allegorical Figure of
Venice</u>. London, British Museum.

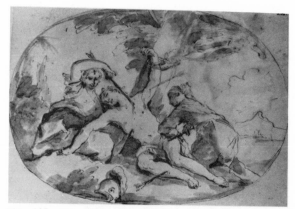

Fig. 107 AG: <u>Irene Drawing the Arrows from the Body
of Saint Sebastian</u>. London, British Museum.

Fig. 109 AG: <u>Madonna Appearing to Two
Saints</u>. Leningrad, Hermitage.

Fig. 108 AG: <u>Madonna and Child
Receiving Saint Theresa's Appeal
for a Friar</u>. Moscow, Pushkin
Museum.

Fig. 111 Saint Gregory Invoking the Virgin at the Time of the Pest. Cambridge (Massachusetts), Fogg Museum.

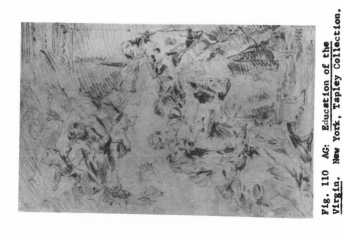

Fig. 110 AG: Education of the Virgin. New York, Tapley Collection.

Fig. 112 AG: <u>Satyr Family</u>. Cambridge (Massachusetts),
Fogg Museum.

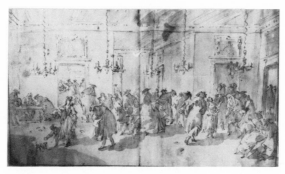

Fig. 113 AG: <u>The Ridotto</u>. Chicago, The Art Institute.

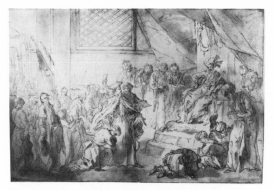

Fig. 114 AG: Historical Subject, Oxford,
Ashmolean Museum.

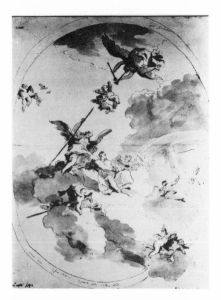

Fig. 115 AG: Allegory of Reward.
Vienna, Akademie der Bildenden Künste.

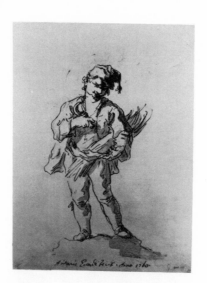

Fig. 116 AG: February. Venice,
Correr Library.

Fig. 118 PG: Immacolata. Venice, Correr Library.

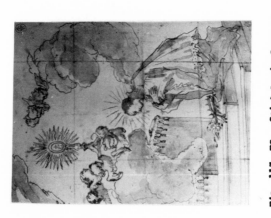

Fig. 117 PG: Saint Louis Gonzaga. Amiens, Koenig-Fachsenfeld Collection.

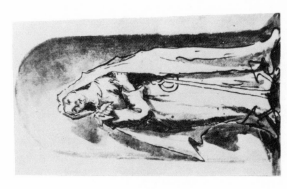

Fig. 120 FG: Allegory of Hope.
Venice, Correr Library.

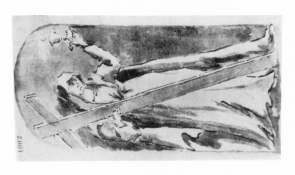

Fig. 119 FG: Allegory of Faith.
Venice, Correr Library.

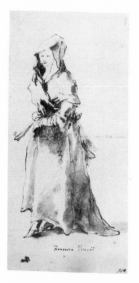

Fig. 121 FG: Lady with a Fan.
Cambridge (Massachusetts), Fogg
Museum.

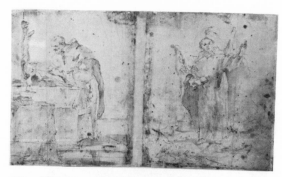

Fig. 122 FG: Saint Philip Neri and Saint Vincent
Ferrer. New York, Metropolitan Museum.

Fig. 124 FG: Lady at her Dressing Table. Paris, Louvre.

Fig. 123 FG: Lady at the Spinet. Paris, Louvre.

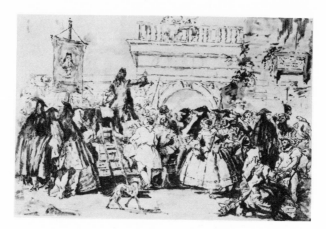

Fig. 125 FG: <u>The Charlatan</u>. Paris, Louvre.

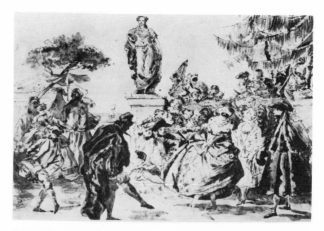

Fig. 126 FG: <u>The Minuet</u>. Paris, Louvre.

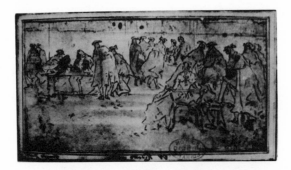

Fig. 127 FG: <u>The Ridotto</u>. Leningrad, Hermitage.

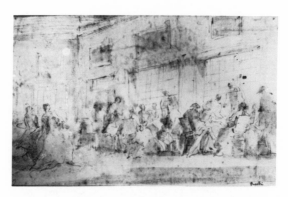

Fig. 128 FG: <u>The Parlatorio</u>. Venice, Correr Library.

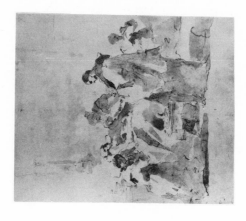

Fig. 130 FG: The Sacrament of
Extreme Unction. Venice, Correr
Library.

Fig. 129 FG: The Sacrament of
Penance. Venice, Correr Library.

418

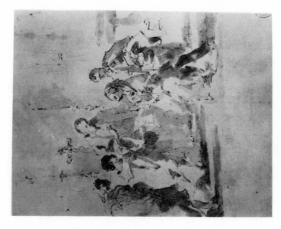

Fig. 132 FG: The Sacrament of
Matrimony. Venice, Correr Library

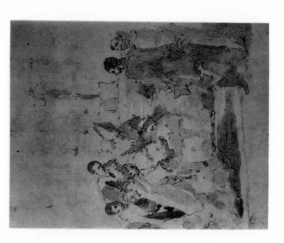

Fig. 131 FG: The Sacrament of
Ordination. Venice, Correr Library.

Fig. 134 FG: The Sacrament of
Confirmation. Venice, Correr
Library.

Fig. 133 FG: The Sacrament of
Baptism. Venice, Correr Library.

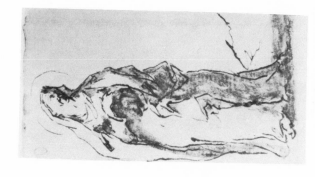

Fig. 136 FG: Standing Female Saint.
Venice, Correr Library.

Fig. 135 FG: The Sacrament of the
Eucharist. Venice, Correr Library.

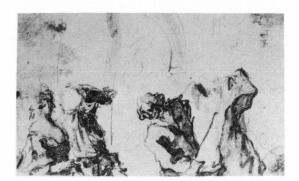

Fig. 137 FG: Merchant Displaying Fabrics to a Couple.
Venice, Correr Library.

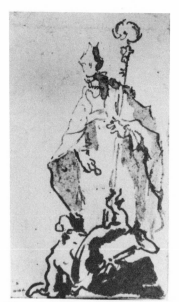

Fig. 138 FG: Bishop Giving Alms.
Venice, Correr Library.

Fig. 140 FG: _Pietà_. Bassano, Museo Civico.

Fig. 139 FG: _Pietà_. Venice, Correr Library.

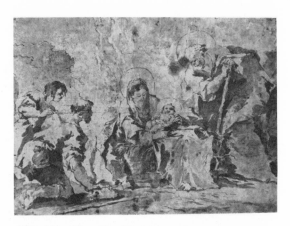

Fig. 141 FG: <u>The Adoration of the Shepherds</u>. Chicago,
The Art Institute.

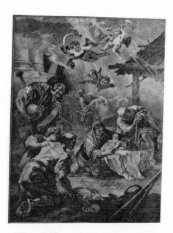

Fig. 142 After Sebastiano Ricci, <u>The
Adoration of the Shepherds</u>. Engraving.

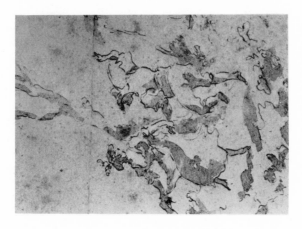

Fig. 144 FG: Two Dancing Peasants. Venice, Correr Library.

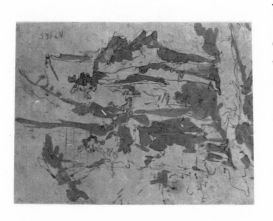

Fig. 143 FG: Young Couple Conversing. Truro, Royal Institution of Cornwall.

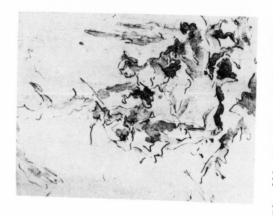

Fig. 146 PG: Young Couple Conversing. Frankfurt-am-Main, Staedelsches Kunstinstitut.

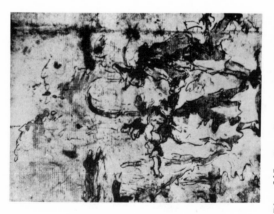

Fig. 145 PG: Two Dancing Peasants. London, Seilern Collection.

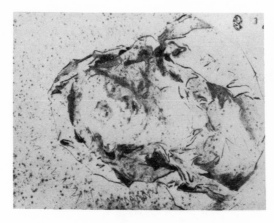

Fig. 148 FG: Bust of the Virgin.
Arlesheim, Zwicky Collection.

Fig. 147 FG: Two Peasants Drinking.
Frankfurt-am-Main, Staedelsches
Kunstinstitut.

Fig. 150 FG: Saint Teresa. New York, Metropolitan Museum of Art.

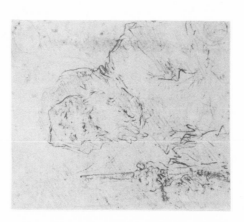

Fig. 149 FG: Saint Francis of Paola. Venice, Correr Library.

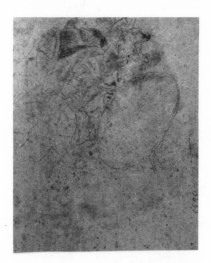

Fig. 151 FG: Study of Warriors'
Heads. Florence, Fondazione Horne.

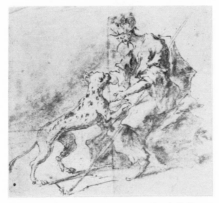

Fig. 152 FG: Seated Oriental with Dog.
New York, Scholz Collection.

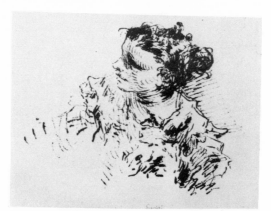

Fig. 153 FG: <u>Head of a Young Woman</u>. London,
Victoria and Albert Museum.

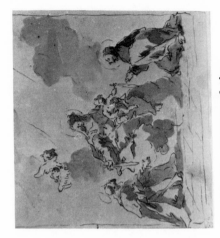

Fig. 155 FG: Madonna of the
Rosary. Venice, Correr Library.

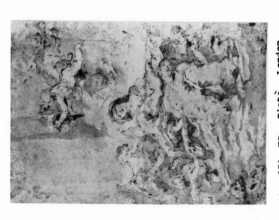

Fig. 154 FG: Pietà. London,
Matthiesen Collection.

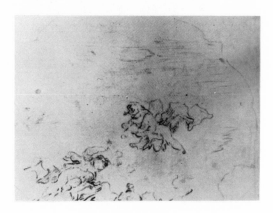

Fig. 156 FG: <u>Putti Floating in the Clouds</u>.
New York, Scholz Collection.

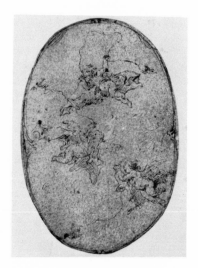

Fig. 157 FG: <u>Sketch for a Ceiling
Decoration with Flying Putti</u>.
Venice, Correr Library.

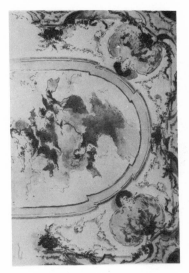

Fig. 159 FG: Sketch for a Ceiling Decoration. Paris, Ecole des Beaux-Arts.

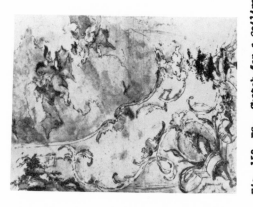

Fig. 158 FG: Sketch for a Ceiling Decoration with Flying Putti. Plymouth, City Museum.

Fig. 161 FG: Studies for a Madonna and Child, detail of the first Madonna. Venice, Correr Library.

Fig. 160 FG: Studies for a Madonna and Child. Venice, Correr Library.

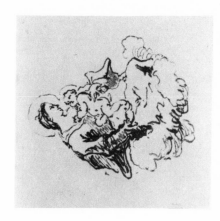

Fig. 163 FG: Studies for a Madonna and Child, detail of the third Madonna. Venice, Correr Library.

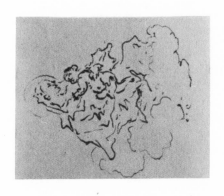

Fig. 162 FG: Studies for a Madonna and Child, detail of the second Madonna. Venice, Correr Library.

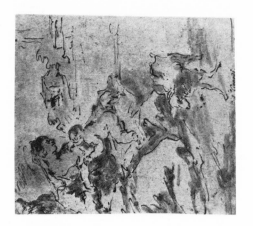

Fig. 165 FG: <u>The Holy Family</u>. Berlin, Staatliche Museen.

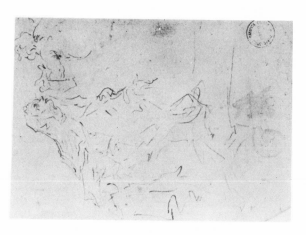

Fig. 164 FG: <u>Saint Teresa in Ecstasy</u>. Venice, Correr Library.

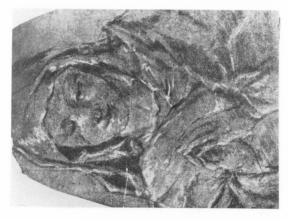

Fig. 167 FG: Praying Virgin.
Venice, Correr Library.

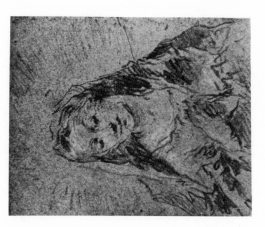

Fig. 166 FG: Praying Virgin.
London, British Museum.

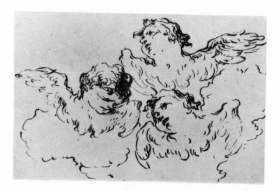

Fig. 168 FG: <u>Three Heads of Cherubs</u>. Vienna,
Albertina.

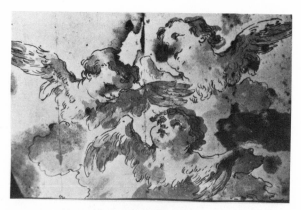

Fig. 169 FG: <u>Three Heads of Cherubs</u>. Venice, Correr
Library.

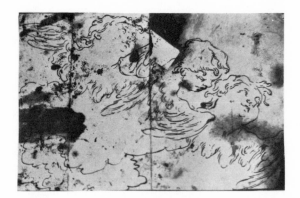

Fig. 170 FG: Three Heads of Cherubs. Venice, Correr
Library.

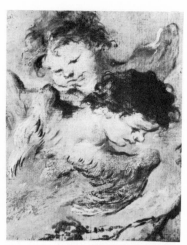

Fig. 171 FG: Two Heads of Cherubs.
Venice, Private Collection.

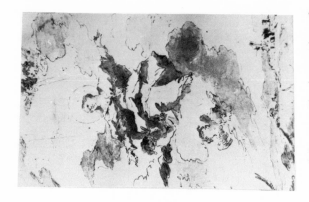

Fig. 173 FG: The Assumption of the Virgin. Munich, Hanfstaengl Collection.

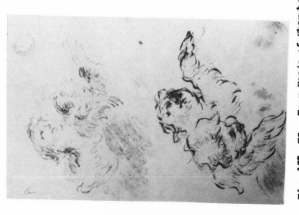

Fig. 172 FG: Four Heads of Cherubs. Venice, Correr Library.

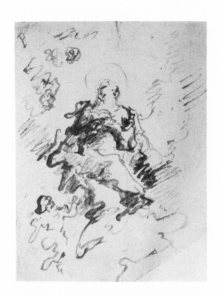

Fig. 174 FG: The Assumption of the
Virgin. Venice, Correr Library.

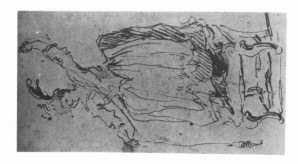

Fig. 176 FG: Lady Standing on a Chair, London, British Museum.

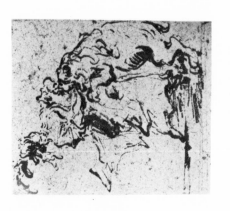

Fig. 175 FG: Woman Taming a Lion. New York, Scholz Collection.

Fig. 178 FG: Saint Vincent Ferrer.
Venice, Correr Library.

Fig. 177 FG: Study for a Ceiling.
Venice, Correr Library.

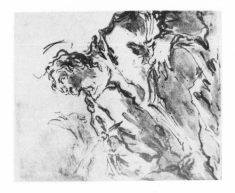

Fig. 180 FG: Saint John the Evangelist. Copenhagen, Royal Museum of Fine Arts.

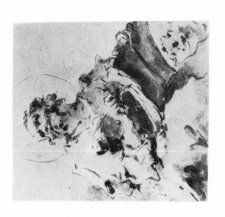

Fig. 179 FG: Saint Mark. London, Seilern Collection.

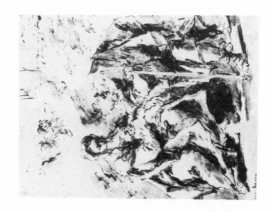

Fig. 182 FG: The Holy Family.
Milan, Castello Sforzesco.

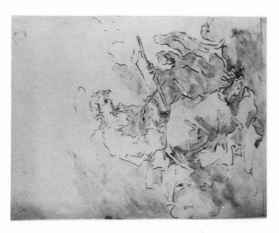

Fig. 181 FG: Saint John the
Evangelist. Venice, Correr Library.

444

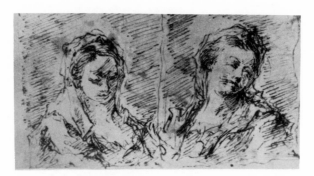

Fig. 183 FG: Two Studies of the Head of the Virgin.
Portinscale, Springell Collection.

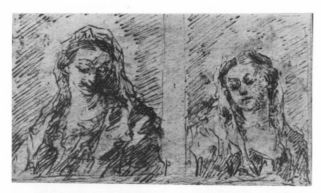

Fig. 184 FG: Two Studies of the Head of the Virgin.
Princeton, Mower Collection.

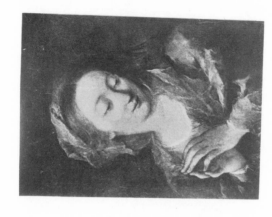

Fig. 186 FG: Praying Virgin.
Berlin, formerly Haberstock
Collection.

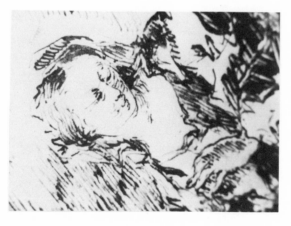

Fig. 185 FG: Praying Virgin.
New York, Eugene Thaw.

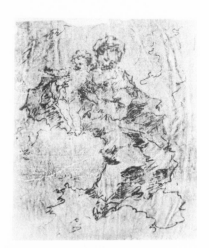

Fig. 187 FG: <u>Virgin and Child in
the Clouds.</u> Venice, Correr Library.

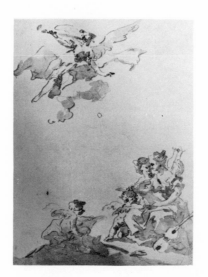

Fig. 188 FG: <u>An Allegory of Music</u>.
U.S.A., Private Collection.

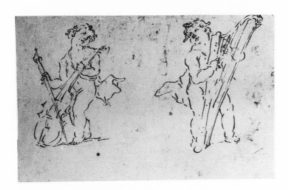

Fig. 189 FG: <u>Putti Playing Musical Instruments</u>.
Venice, Correr Library.

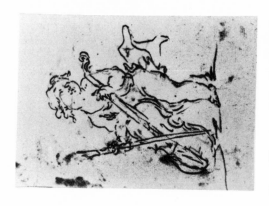

Fig. 191 FG: Putto Playing the
Viola. Venice, Correr Library.

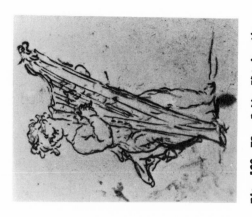

Fig. 190 FG: Putto Playing the
Harp. Venice, Correr Library.

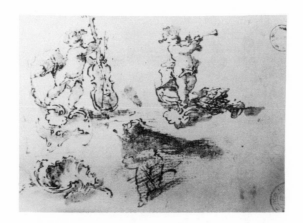

Fig. 192 FG: <u>Putti Playing Musical Instruments</u>.
Venice, Correr Library.

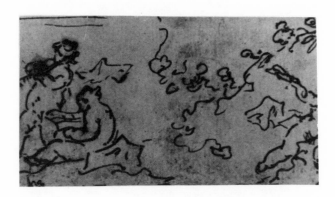

Fig. 193 FG: <u>Putti Playing Musical Instruments</u>.
Princeton, Mower Collection.

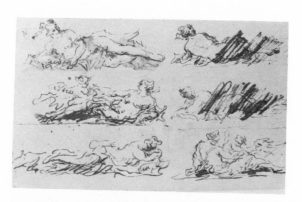

Fig. 194 FG: Studies of Female Figures. Venice,
Correr Library.

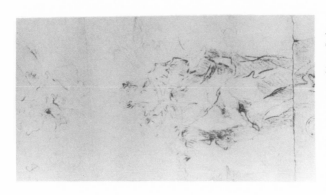

Fig. 196 FG: Standing Saint.
Venice, Correr Library.

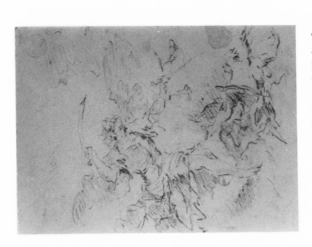

Fig. 195 FG: The Archangel Michael.
Venice, Correr Library.

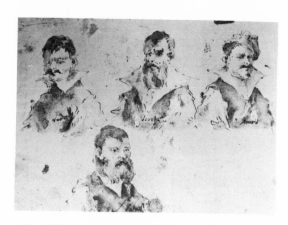

Fig. 197 FG: Four Male Busts. Venice, Correr Library.

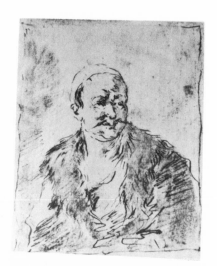

Fig. 198 FG: Man in Turkish Dress.
Venice, Correr Library.

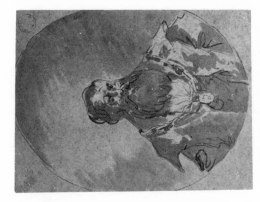

Fig. 200 FG: Portrait of a Nobleman. Venice, Correr Library.

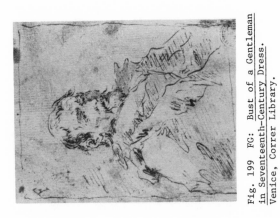

Fig. 199 FG: Bust of a Gentleman in Seventeenth-Century Dress. Venice, Correr Library.

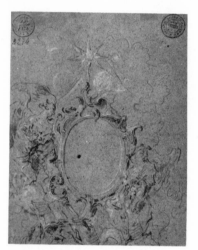

Fig. 201 FG: Sketch for an
Ostensory. Venice, Correr
Library.

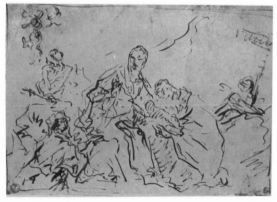

Fig. 202 FG: The Holy Family. Florence, Uffizi.

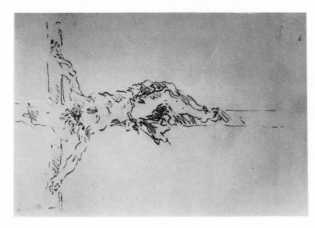

Fig. 204 FG: Christ on the Cross.
Venice, Correr Library.

Fig. 203 FG: Allegory of Faith.
Venice, Correr Library.

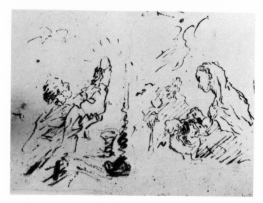

Fig. 205 FG: Priest Saying Mass and Holy
Family. Berlin, Staatliche Museen.

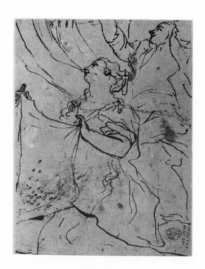

Fig. 206 FG: Danae Receiving
the Golden Shower. Berlin,
Staatliche Museen.

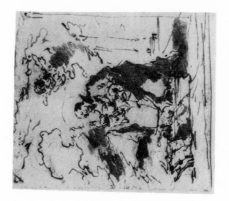

Fig. 208 FG: Saint Anthony
Holding the Christ Child.
Venice, Correr Library.

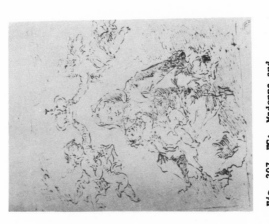

Fig. 207 FG: Madonna and
Child Crowned by Angels.
Venice, Correr Library.

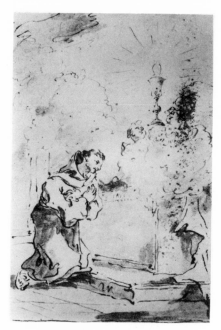

Fig. 209 FG: The Vision of
Saint Anthony. Venice,
Correr Library.

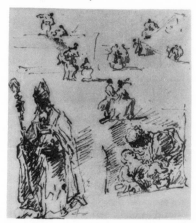

Fig. 210 FG: Saint Nicholas with Crozier,
Saint Joseph Holding the Christ Child and
Studies for Twelve Macchiette. Venice,
Correr Library.

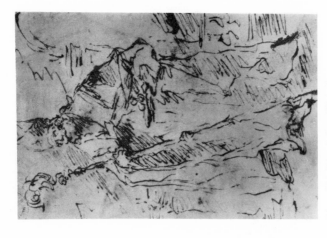

Fig. 212 FG: Saint Nicholas with Crozier. Venice, Correr Library.

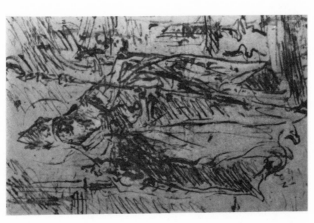

Fig. 211FG: Saint Nicholas with Crozier in an Attitude of Benediction. Venice, Correr Library.

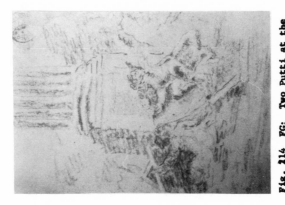

Fig. 214 FG: Two Putti at the
Base of a Column. Venice,
Correr Library.

Fig. 213 Saint Anthony Holding
the Christ Child. Venice,
Correr Library.

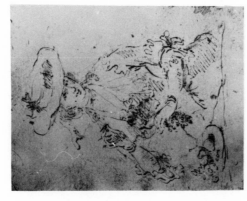

Fig. 216 FG: A Lady with a Bunch of Grapes. Venice, Correr Library.

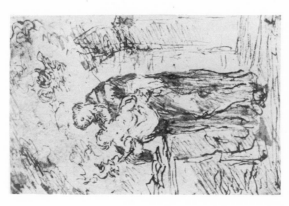

Fig. 215 FG: Standing Saint Anthony Holding the Christ Child. Venice, Correr Library.

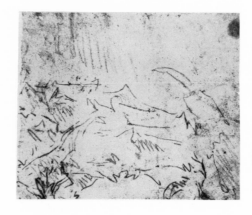

Fig. 218 PG: Fragment of a Sketch for an Immacolata. Geneva, Lederer Collection.

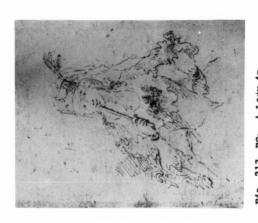

Fig. 217 PG: A Lady in a Turkish Cap. Venice, Correr Library.

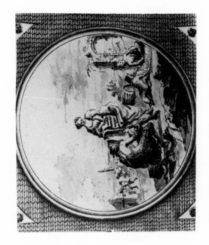

Fig. 220 FG: Allegorical Scene with Satyrs. Venice, Correr Library.

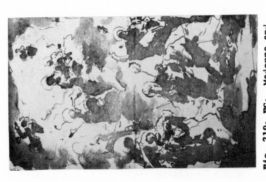

Fig. 219: FG: Madonna and Child with Saints. Aix-en-Provence, Musee Graner.

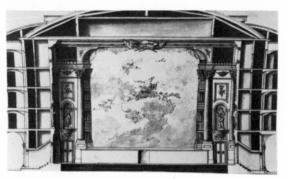

Fig. 221 FG: <u>Decoration for a Theater Curtain</u>. Venice, Correr Library.

Fig. 222 FG: <u>Head of the Virgin</u>. Venice, Correr Library.

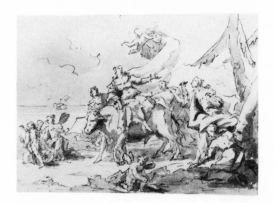

Fig. 223 Gaspare Diziani's circle. The Rape
of Europa. Kansas City, Nelson Gallery and
Atkins Museum.

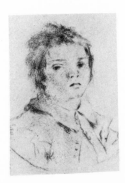

Fig. 224 Attributed to Sebastiano
Ricci. Bust of a Young Boy. New
York, Scholz Collection.